ART
HARDWARE

Steven L. Saitzyk

ART HARD WARE

The Definitive Guide to Artists' Materials

WATSON-GUPTILL PUBLICATIONS/NEW YORK

WARNING

The author and publisher take no responsibility for any harm that may be caused by the use or misuse of the information contained in this book or by the use or misuse of any materials, formulas, recipes, techniques, or processes mentioned in this book.

I dedicate this book to my son Brian,
to the members of my family,
to my teacher,
and to all sentient beings.
May any merit gained be theirs.

Copyright © 1987 by Steven L. Saitzyk

First published in New York by
Watson-Guptill Publications,
a division of Billboard Publications, Inc.,
1515 Broadway, New York, N.Y. 10036

Library of Congress Cataloging-in-Publication Data

Saitzyk, Steven L.
 Art hardware.

 Bibliography: p.
 Includes index.
 1. Artist's materials. 2. Artist's tools.
I. Title.
N8530.S35 1987 702'.8 87-8142
ISBN 0-8230-0266-7

Distributed in the United Kingdom by Phaidon Press Ltd., Littlegate House, St. Ebbe's St., Oxford.

Manufactured in U.S.A.

First printing, 1987
2 3 4 5 6 7 8 9 10/92 91 90

Acknowledgments

THESE ARE some of the individuals and companies who helped make this book possible. Susan Bell & Victor Moulding Co., Best Moulding Inc., California Fomeboards Inc., Jerry J. Dunn & Binney & Smith Inc., Kenneth Eastman & Koh-I-Noor Inc., David W. Ford & Cosmos Brushes, Val Gajic, Katharina Halperin & Andrews/Nelson/Whitehead Inc., Scott Halem, Michael Hamilburg, Robert Hatch & M. Grumbacher Inc., Peter Hess & Schmincke Inc., Peter Hopper & Holbein Inc., Calvin Jones, Steven Kowalski, Abby Lazerow, 3M Inc., Gary of McManus & Morgan Co., Edward Moses, National Artist's Materials Trade Association, David H. Pottenger & the Strathmore Paper Company, the Professional Picture Framers Association, Nobuyoshi Matsui & Boku-undo U.S.A. Inc., Arno Rossler & Paper Technologies Inc., Jan Saether, Linda Shaffer, Jean-Roc Sauer & Raphael/Sauer Co., Dominique Sennelier & the Sennelier Co., Seth Cole Co., Alexis Smith, Michelle Smith, Victor Takakata, Ann M. O'Roark & Talens Inc., Stace Tackaberry & Crescent Cardboard Co., Sheldon Tarrant, Gene Takei & Sakura Color Products, Toshi Sekiyama & Yasutomo & Co., Chogyam Trungpa Rinpoche, Shannon Van Kirk, David White, Michael Wilder, Tom Wudl.

Contents

3. PAPER 85

5. PAINTING SURFACES

DEFINITION OF TERMS 128

PORTABLE SUPPORTS 129

Auxiliary Supports 129
Frame Supports • Framed Panel Supports • Stretcher Bars

Stretched Supports 135
Linen • Cotton • Commercially Prepared Canvas

Stretching Canvas 137
Unstretched Supports 138
*Plywood • Fiberboard • Particle Board • Metal • Unstretched
Canvas • Paper*

Sizing 141
Sizing Paper • Sizing Canvas • Sizing Panels

The Ground 144
*Grounds for Paper • Grounds for Canvas • Grounds for Wood or Wood
Particle Panels • Grounds for Metal*

Priming 147

FIXED SUPPORTS (WALLS) 148

6. PIGMENTS

CHARACTERISTICS OF PIGMENTS 153

Names of Pigments 153
Permanence 154
Compatibility of Pigments 156
Toxicity 158
Purity 158

TYPES OF PIGMENTS 160

Natural Inorganic Pigments 160
Synthetic Inorganic Pigments 161
Synthetic Organic Pigments 161
Natural Organic Pigments 162

PIGMENTS AND COLORS 163
Table of Pigments and Colors 166

9. OIL MEDIA, SOLVENTS, AND VARNISHES 251

Introduction

ACCORDING TO a Harris poll taken recently, fifty million people in the United States paint or draw. But the horrendous truth is that the average house painter knows more about the materials that he or she uses than the average contemporary artist does. Although many artists have learned early in their careers to pretend otherwise, the high stakes involving financial risks, as well as health hazards, have made it difficult to continue this pretense of knowledge. This situation has arisen not because artists are less professional about their endeavors than people in other occupations, but because of the serious lack of accurate information about contemporary artists' materials. In such other professions as medicine, engineering, and even interior decorating, there are vast libraries of information about tools and materials. But training in art has been primarily an oral tradition, resulting in little information actually reaching the printed page. All the available books on artists' materials would take up only about twelve inches of shelf space. In addition, many of these books are out of date and out of touch with contemporary painting and drawing and many of the materials discussed are no longer commonly available or applicable.

There is also the implicit belief that dealing with the technical and practical concerns of producing art will inhibit creativity. For how can artists be creative or intuitive if they must think about what they are doing? Nevertheless, any artist producing fine art knows there is no escape from practical considerations. The one consideration that always interferes with creativity, more than any notion of permanency or durability, is the economics of producing artwork. The cost of the tools and materials needed to create a major piece of artwork, not to mention archival framing and storage, can be astronomical for the average artist.

The ABC television series "Nightline" devoted thirty minutes to the subject of the impermanency of contemporary art. On this program, Larry Rivers explained that the reason for this problem is that information about contemporary materials "does not seem to be part of art education. . . . No one told me that tape eats paper and I used it for years." Virtually all institutions, schools, and universities that offer art education programs today provide no formal background in materials and do not require their instructors to have such training.

The need for this kind of training has, however, become increasingly evident, as more and more money is invested in artists' materials and in collecting art. Sotheby's estimates that as much as four hundred billion dollars worth of art is held in private collections, twenty-five billion dollars of which is sold each year. In 1986, Sotheby's sold *Out the Window* by Jasper Johns for more than three and a half million dollars, setting a record for a work by a living artist.

Today, too, an artist's creativity is no longer immune from legal attack. One prominent contemporary artist was sued and forced to buy back a painting for one hundred thousand dollars because the center of the work had faded. Another artist was sued because his paintings were turning to dust. He, in turn, sued the manufacturer for inadequate product labeling, which ultimately resulted in the catastrophe.

In addition to financial considerations, potential dangers to artists' health make learning about materials imperative. The National Cancer Institute did a study that linked toxic artists' materials to chronic disease and cancer. It showed that the cancer rate for artists may be two to three times the national average. The *New York Times* ran a front-page story on the toxicity and the labeling of artists' materials. In response to this, California passed a labeling law that may result in the disappearance of many traditional materials from the marketplace.

The trend toward the disintegration of practical information about artists' materials began with the industrial revolution. This new world had neither time nor patience for the traditional method of transmitting knowledge orally from master to apprentice. Consequently, a great deal of information was lost. The formation of artists' academies helped to recapture some information temporarily, but the academies eventually disappeared. Colleges and universities with art programs not only did nothing to reverse this trend but fostered it by emphasizing the philosophical and conceptual side of art over the practicalities of producing it. A unique philosophical point of view developed, and it dominates today. It is referred to as "process over product," which means that the artist's concern is mainly with the artistic process rather than with the nature of what is produced. If what is produced happens to fetch a great sum of money and tends to self-destruct rapidly, it is no concern of the creator. This point of view has led to an unparalleled expansion in the art of restoration. Jasper Johns has been quoted as saying, sarcastically, that he could make a better living restoring his work than creating it.

Although I feel that producing temporary art forms is perfectly valid, it should be a conscious choice by the creator and should be understood by the collector. Unfortunately, for most artists process over product developed primarily as a justification to spare themselves the embarrassment of saying that they don't know why something is falling apart or what to do about it.

The range and type of materials that are now available bear little resemblance to those available during the eras of Rembrandt, Van Gogh, or even of Max Beckman. Most of the materials and techniques used today have actually been developed since World War II, yet information about them is almost nonexistent. Technical information about a product is often withheld from the user by a manufacturer seeking to conceal "trade secrets." Consequently, a contemporary artist

commonly finds it necessary to "reinvent the wheel" every time he or she begins a new project.

After sixteen years of painting, drawing, and taking art classes, I got tired of reinventing the wheel. I would also experience occasional embarrassment upon finding, after several months of research, that if I had read and understood the fine print or asked a manufacturer or someone who knew about the materials in question, I would have saved a great deal of time and expense. It wasn't until I opened my own art supply store and frame shop that I realized just how little I knew. I learned more in the first six months of operating the store than I had in those sixteen previous years.

When I began to gather information for myself by going to conventions and talking to manufacturers and inventors of artists' materials, fellow artists began asking me for trade information. As I shared what new knowledge I had gained, so, too, did many contemporary artists share their "trade secrets" with me. As a result of what I have learned, I began lecturing and training other instructors as well as consulting for contemporary artists. I have continued to do so for more than a decade. And I have discovered that having more knowledge about materials does not inhibit creativity but, on the contrary, liberates. All the knowledge and experience that I have gathered and shared consists of vital information that is basically unavailable elsewhere and yet is of the type that an apprentice would gather if that method of teaching still existed. It is this information that I have compiled in this book, which provides the first comprehensive literature about brushes, contemporary drawing materials, artists' papers, boards, and commercially prepared artists' paints, and also deals with the subjects of hazardous materials, product labeling, archival framing, and storage. It also includes extensive information on Oriental artists' materials. In addition, vital commonplace artists' terms such as "permanence," "fugitive," "archival," and "nonarchival" are fully explained here for the first time.

STEVEN L. SAITZYK

A Word About the Use of Brand Names

THE DECISION to use selected brand names as examples in this book emerged from the many lectures and consultations that I have given for more than a decade. Early on, it became obvious to me that discussions rapidly became confusing, patronizing, and very boring when I avoided brand names. The use of brand names became a helpful reference point with which many people could better understand the materials being discussed. As it turned out, my audiences were not unduly influenced by the examples I gave. People easily saw through any bias I had, and used my opinions as an armature on which to hang their own.

The brand names used in this book were chosen primarily because I feel that they are good examples, for the sake of discussion, not as product endorsements. When I have endorsed or criticized a product, it should be regarded as my subjective opinion. I have yet to hear, read, or state an opinion that is truly objective. There always seems to be another way of looking at things.

Part One

THE RETURN of representational images to contemporary artwork has stimulated an unparalleled interest in all types of drawing materials. In an effort to profit from this resurgence, several manufacturers have developed new materials for drawing. Some of the effects that can be created with these products have resulted in a blurring of the boundary between painting and drawing. Yet, the general principles remain the same whether the drawing material is in a form that is dry, waxy, or wet.

Dry drawing materials, such as charcoal, depend entirely on the texture of the ground. Their overall appearance is reflected by the pattern, or lack of it, that is present in the surface texture. Bits of drawing material are rubbed off, just as sandpaper scrapes off bits of wood, and are trapped within the surface and held there. These collected bits of dry drawing material can be brushed off easily if they are not fixed with a gum or resin. Waxy drawing materials, like crayons and oil pastels, are not so easily brushed off because of the wax binder. Wet drawing materials often have the advantage of a resin binder and the ability to soak into a surface. But whether wet, waxy, or dry, all drawing materials depend on the nature of the surface for their overall appearance. It is this fact that has led many artists to study, often for months and sometimes for years, various grounds and their finishes in a effort to find the one that best reflects their vision.

Dry Drawing Materials

DRY DRAWING MATERIALS are either carbon-based or chalk-based. Although the use of both types dates back to prehistoric times, carbon-based drawing material, and particularly charcoal, is credited with being older because it was common to every fireplace, whereas deposits of pure chalk are quite rare.

A dry drawing material can be easily applied to any surface as long as the surface has some tooth to bite and hold its powdery consistency. It can also be easily blended or erased. Blending can be done by rubbing or by wetting the drawing with either water or turpentine. At one time, a technique was developed of dipping the dry drawing material first in a drying oil, such as linseed oil, to create a darker line and improve adhesion. However, this tends to form a yellow stain around the edges of the applied drawing material and to acidify and rot the paper. The primary disadvantage of dry drawing materials is the difficulty of storing and protecting the final drawing. The use of a fixative will help, but it will not completely protect the surface. Protective coatings and picture framing in combination provide the only long-term protection.

CARBON-BASED DRAWING MATERIALS

There are two forms in which carbon is commonly found in nature: crystalline and amorphous. The crystalline form has two further divisions. One type of crystal involves six carbon atoms, which combine to form a ring. Carbon rings of this type tend to arrange themselves in sheets, which slide easily over one another. They are so slippery that this crystalline form is often used as a lubricant. When the first natural deposits of carbon were uncovered they were mistaken for lead and named plumbago, or black lead. After many years of use as a drawing material, it was discovered that the substance was not lead and the name was changed to graphite, from the Greek word *graphein*, which means "to write."

In the second form of crystalline carbon, the carbon atoms link together to form a rigid structure. This structure results in a highly transparent and very hard crystal, which cannot be used as a drawing material. This type of crystal is a diamond.

There are four kinds of amorphous carbon—charcoal, lampblack, coal, and

coke. Charcoal is an impure form of carbon and is obtained through the incomplete combustion of plant matter, wood, or bone. Lampblack is obtained by collecting the soot from the burning of oil. Coal and coke are mined and are not workable as artists' materials. Carbon black is a term used to describe any intense black made from amorphous carbon that has been divided into fine particles. Soot has some of the most finely divided particles known. The smallness of these particles is what gives such subtlety to the ink paintings of the Orient. The particle size can be varied during production to create various effects. Another interesting fact is that charcoal can be turned into graphite at 5400°F.

Charcoal is the carbon-rich residue of incompletely burned wood, bone, or vegetable matter. Artists' charcoal is made by heating wood in a chamber or kiln without air. This process produces a piece of charcoal that makes a uniform black line.

Vine Charcoal is produced by burning sticks or twigs of wood in a kiln without air. Some manufacturers shape them to produce sticks of a more uniform appearance. Willow is the wood of choice, because of its even consistency and fineness of particles; however, linden is more commonly used. Vine charcoal is available in soft, medium, and hard consistencies.

Vine charcoal is easily removed by dusting and by erasure. This makes it ideal for preliminary sketches for oil painting where changes are frequently made before the final outline is completed. Before painting begins, however, the charcoal sketch must be fixed to the canvas or the paint will pull the charcoal off the surface and mix with it. It is best to use a retouch varnish to fix the sketch.

Compressed Charcoal is available in round and square sticks. The charcoal powder is mixed with a gum binder and compressed into sticks. The amount of binder that is used regulates the degree of hardness, which gives a wider selection and greater consistency of quality from stick to stick. Several degrees of hardness—HB, B, 2B, 3B, 4B, and sometimes 6B—are available. Sticks of compressed charcoal do not break or erase as easily as vine charcoal. Vine charcoal has an irregular shape that does not allow the edge to be used for broad strokes, but compressed charcoal sticks are ideal for this.

Charcoal Pencils are made from compressed charcoal. The charcoal is protected with wood, or a paper wrapping, which is the only real advantage of the pencils. The covering helps to keep your hands and your working environment clean while drawing; it also reduces breakage and permits by sharpening to produce a point. In the paper-wrapped version, the charcoal is exposed by peeling rather than by sharpening. The pencils are available in the same general range of degrees of hardness found in compressed charcoal sticks, and are classified as extra soft (96B), soft (4B), medium (2B), and hard (HB). They are best used for making smaller, more tightly rendered drawings, which require greater control, or for adding detail.

Carbon Pencils are made from lampblack, which is purer than charcoal and is therefore more consistent in quality. This consistency is maintained throughout

the available range of degrees of hardness, which is generally identical to that of compressed charcoal.

Graphite was used as a marking tool by the Aztecs long before Columbus went on his Caribbean cruise. Europe did not discover graphite until 1400, when it was found in Bavaria and promptly mistaken for lead. The substance was not called graphite until 1789. The purest deposits of graphite ever found were discovered in Cumberland, England, in 1564 and were in continuous production until 1833.

The advantage of graphite over charcoal is that it is less dusty and naturally adheres better to a ground. It can easily be fashioned into a variety of writing and drawing instruments, which can be used to express great detail and subtlety. Graphite is also more easily fixed to a ground and in general has a more durable surface.

Graphite Sticks are relatively new. Originally, graphite was sold in pieces for marking stone. Later it was shaped into sticks, which resembled today's artists' graphite sticks. Today's sticks, however, are not pure graphite, but mixtures of powdered graphite and clay, which has been fired at about 1900°F. The amount of clay present determines the degree of hardness; the more clay, the harder the stick. A narrow range—2B, 4B, 6B—comprises the available degrees.

The Pentalic Corporation has imported a graphite stick that has a heavy resin coating. It is called the Woodless Pencil and is ¼-inch round, as opposed to the rectangular graphite stick. The Woodless Pencil is available in HB, as well as 2B, 4B, and 6B, and can be sharpened easily in an ordinary pencil sharpener. Of course, the edges cannot be used for broad strokes, as can the edge of the uncoated rectangular stick.

Graphite Pencils are the most common writing and drawing tools today. In Latin *pencillus* means "little tail" and describes a small brush used in medieval times for drawing with ink. The term "pencil quill" is still used sometimes to describe a type of small pointed brush used for signmaking and graphic arts work. In some cultures, the word "pencil" is still used to refer to a small brush. It would seem that the graphite pencil derived its name from the fact that it has a wooden handle, like a brush, and a small tip that can be fashioned into a point.

The first graphite pencils were blocks of graphite that were shaped into sticks and wrapped with string. Since graphite was at first mistaken for lead, they were called lead pencils. Soon after the discovery of the graphite deposits in England, it became clear that the amount of available graphite was limited and conservation measures rapidly followed. Several attempts to extend powdered graphite with gums, resins, and glues, which were pressed into blocks of grooved wood, had only limited success.

The invention of the modern pencil has been credited to Nicolas-Jacques Conté, a French scientist under the commission of Napoleon. In 1795, he developed a manufacturing process of roasting a mixture of clay, purified graphite, and water in a kiln, and then encasing the substance in wood. Soon after, Joseph Hardmuth found that the greater the amount of clay used in the mixture, the harder the pencil point. This led to the development of the various degrees of

hardness of pencils. The modern process for making pencils involves producing a paste, like that of Nicolas-Jacques Conté, and partially drying it through filtration. It is then extruded into long strands and fired at 1900°F. The strands, which are still slightly porous, are then filled with natural waxes for the purpose of lubrication and to help the graphite adhere to the ground. They are either packaged for use in a lead holder or inserted into a wood casing.

Today, graphite pencils are made in different degrees of hardness by regulating the amount of clay added. The greater the quantity of clay, the harder the lead and the lighter the overall drawn line will appear. It is common to have several different degrees of pencils to vary the detail and the light and dark areas of a drawing. The more "Hs," the harder the lead. The more "Bs," the softer the lead. HB and F are intermediate grades between the two types. B through 10H are commonly used in drafting. 8B through F are preferred for artwork. Writing pencils have their own hardness scale, which roughly coincides at certain points with the drafting scale.

SCALE OF DEGREES FOR ART AND DRAFTING PENCILS

8B. . .4B—3B—2B—B—HB—F—H—2H—3H—4H—5H. . .10H
<<<softer<<<　　　>>>harder>>>

SCALE OF DEGREES FOR WRITING PENCILS

1(3B)*—2(B)—21/2(F)—3(2H)—4(3H)

*degree within parentheses is the rough equivalent to the drafting scale

The primary differences between school-grade pencils and professional-grade pencils are the larger range of degrees and the uniformity in the manufacturing and performance of the professional-grade pencils.

There are several unique graphite pencils such as the Blackwing, which has an oversized eraser; the Negro Pencil, available in three thicknesses of leads; and the Eagle #314 Draughting Pencil. All of these are soft drawing pencils that are similar to a 6B art pencil. Most have slightly thicker leads than the average drafting pencil, yet are less expensive. Flat sketching pencils have a rectangular-shaped lead enclosed in a similarly shaped wood covering, which is sharpened with a razor or a knife. They come in a limited range of degrees—2B, 4B, and 6B. All of these graphite pencils are used primarily for broader, more expressive drawing or for quick sketching.

Drafting Leads and Metal Lead Holders were developed before the wood graphite pencil. The lead, which is the same as that used to make graphite pencils, is held in place with a three- to four-part vise. A button at the top of the lead holder, which acts like a clutch, is pressed to open the vise and release the lead. Caution must be exercised to prevent the lead from falling out of the holder. A test of the quality of a lead holder is to see if the lead slips in the clutch when it is locked in place. The primary advantage of a lead holder is that the implement does not get shorter as you sharpen the lead, and a sharper, more

tapered point can be produced with the aid of a lead pointer than can be had with a pencil and pencil sharpener.

Drafting lead is available in the same degrees of hardness as pencils. There are also limited selections of colored lead available, as well as leads designed specifically for the surface of drafting film. The "E" series of drafting-film leads produces well-defined lines and less graphite dust on the drafting film.

Mechanical Pencils were first introduced in 1822 by S. Mordan and J. I. Hawkins. The first spring-loaded mechanical pencil was patented in 1877 and a twist-feed mechanism was developed in 1895. The primary differences between mechanical pencils and lead holders is that the mechanical-pencil lead is advanced in increments and will not accidentally drop out, and the lead does not have to be sharpened. Since a vise is not used to hold the lead, it is free to rotate as a line is drawn so that a consistent line width is produced. Consequently, the lead is available in four widths—0.03mm, 0.05mm, 0.07mm, and 0.09mm. The 0.09mm was introduced in 1938 and led the way for the rest. Today, mechanical pencils are designed to be self-feeding and several leads can be loaded through the top at one time. The technology has advanced so that there are mechanical pencils that automatically advance the lead as it is worn down, eliminating even the need to stop and make adjustments. These are expensive, however, and are not widely available.

The major disadvantage of mechanical pencils that use very thin leads is that the leads break easily. The softer the lead, the more easily it breaks. Some manufacturers impregnate their leads with a polymer to make them less breakable. But only a narrow range of degrees—from 4H to 2B—is available.

CHALK-BASED DRAWING MATERIALS

Natural chalk is composed of tiny, prehistoric, salt-water organisms with a high calcium content, which formed a sediment that turned rocklike. Its appearance ranges from white to gray and, occasionally, red, or sanguine, when it is naturally impregnated with ferric oxide (rust). Chalk-based drawing materials have been in use almost as long as carbon-based materials. Although chalk itself is abundant, the number of deposits of rock chalk is not, and it is this scarcity that prevented its widespread use. Until the fifteenth century, red and white chalks were used primarily for quick sketching. When an effective method was devised to pulverize chalk, wash out the sand, and combine the chalk powder with pigments in a usable form, chalk-based drawing materials were taken more seriously.

In the sixteenth century, the Italians developed the pastel. It had a narrow range of colors consisting of some earth colors, white, and black. It was not until the introduction of a broad range of synthetic mineral pigments in the nineteenth century that the color range broadened to the hundreds of colors and shades that we are familiar with today. *Pastello,* which means "little paste" in Italian, was shortened by the French to "pastel." Today, pastel is the common name for chalk-based drawing materials; the chalk is mixed with pigment and a binder to a paste and then shaped and dried into sticks. Modern pastels may contain chalk, or such chalklike materials as kaolin (white clay) or lithopone

(half barium sulfate and half zinc sulfide) as the white filler. The filler is mixed with a pigment and a binder such as gum tragacanth or methyl cellulose. (The binder for oil pastels is primarily wax and is discussed later under that heading.)

Pastels can be used either as a drawing or a painting material, depending on the technique used. It is therefore common to find works called pastel paintings, as well as pastel drawings. Pastels lend themselves to blending with the fingers or with stomps. They may also give a more painterly appearance when wetted with a mist of water (however, this technique cannot be used on glue-sized canvas) or with turpentine. A more or less painterly appearance can be effected by the type of ground used (paper or canvas), its surface finish (laid or irregular), and color. The main advantage of pastels is that the appearance does not change with age, as do oil paintings, which yellow in time. The main disadvantage is that the surface is easily damaged and is difficult to protect. The use of fixatives and final protective sprays will provide limited protection, but these tend to darken the overall appearance of pastels. (For information about proper use of fixatives and final protective sprays, see page 41. For more information about storage and protection, see *Framing and Storage,* pages 275 to 307.)

It is important to take note of the health hazards that are involved in using pastels. Although most manufacturers have stopped using some of the most hazardous pigments, such as lead and lead compounds, professional artists' pastels should not be considered safe. Precautions should be taken to prevent inhalation and accidental ingestion of dusts. (See *Hazards,* pages 309 to 323, for more information.)

Soft Pastels are soft because they are low in chalk or chalk substitute and are primarily pigment with very little binder. Chalk has a cementing quality that is used to best advantage in the manufacture of hard pastels. Most manufacturers of artists' soft pastels use a substitute for white chalk, such as kaolin, lithopone, or titanium dioxide, as the base. This facilitates easy blending and results in stronger colors.

Every manufacturer of pastels begins with a set of colors that it considers to be pure and then creates additional colors, or tints, by adding a specific percentage of white (kaolin, lithopone, or titanium dioxide) or black (carbon). Manufacturers each have their own recipes for creating the colors and tints they offer, as well as their own symbols for indicating which are the basic colors and their tints. Talens Company, for example, the manufacturer of Rembrandt Pastels, adds decimal points to its color reference numbers to signify the percentage of white or black. Of its one hundred and sixty-three colors, thirty-eight are pure colors, indicated by a three-digit number followed by a decimal point and the number 5. The number 205.5, for example, indicates the pure color lemon yellow. Thirty-six of the colors are mixed with a percentage of black and they are indicated by a three-digit number followed by a decimal point and the number 3. (For example, 205.3 is lemon yellow mixed with black.) The remaining eighty-nine colors are pure colors mixed with white, indicated in the same way by following the color number and decimal with either a 7, 8, or 9. The higher the number, the more white. (For example, 205.9 is the palest tint of lemon yellow.)

Soft pastels cannot be blended on the palette, like paint, to create additional colors or tints. Virtuosity of color in pastel drawings is restricted by the available colors and the ability to blend them on the working surface. Since pastels are an opaque medium, they are difficult to blend and it is hard to get intermediate shades. Therefore, if you think you will need a particular color or tint, it is best to acquire it before proceeding. I recommend that you purchase the largest set of pastels that you can find and afford, and continue to build your color range whenever practical. The greater your choices of pastels, the greater your freedom. To accommodate this freedom, some manufacturers make up to six hundred colors.

Chalk Pastels are harder than soft pastels because of the higher percentage of chalk. They are also less expensive because they contain less pigment. Not all of the commonly available chalk pastels are of artists' quality, they give no assurance of lightfastness; they are therefore not recommended. The color range is often quite limited, ranging from thirty-six to forty-eight colors.

Hard Pastels are harder than soft pastels and the average chalk pastel. At this time, however, there is only one effectively marketed hard pastel—Nupastel made by Eberhardt Faber Company. Although Nupastel is technically a chalk pastel, it is far denser than the average chalk pastel. Its primary advantage is that it is better for drawing thin lines and for holding details. Hard pastels can be sharpened to some degree, while soft pastels cannot. They are also less dusty and adhere better to the working surface, but this characteristic makes them harder to blend. Nupastel offers an acceptable range of seventy-two colors. This pastel is commonly used as artists' pastel, although the company's literature makes no claims of lightfastness.

Pastel Pencils are chalk pastels with a wood covering. They are also known as colored charcoal pencils because their consistency resembles that of charcoal pencils. The advantages of the pencil form of pastel is that it can be sharpened for more detailed drawing and it is less messy to work with. Pastel pencils were originally developed for the graphic artist and illustrator. As with chalk pastels, claims to lightfastness are rarely found. The available range is between forty-eight and seventy-two colors, depending on the manufacturer.

Conté Crayons are named after their developer, Nicolas-Jacques Conté, who invented the modern pencil. They were originally a mixture of graphite and clay formed into hard drawing sticks. The process Conté used was similar to that used for his pencils. Today, Conté crayons are made with an alumina chalk (aluminum oxide) base. Because they are readily available in differing degrees of hardness, a range of effects can be consistently produced with these crayons. The white crayons are pure alumina chalk; the blacks and grays are carbon and alumina chalk. The reddish-browns, or sanguines, are ferric oxide (rust) and alumina chalk. Several shades of sanguine are widely available and the black and white are available in different degrees of hardness.

Conté crayons have the consistency of graphite sticks and the appearance of hard pastels.

Waxy Drawing Materials

WAXY DRAWING MATERIALS are relatively modern and differ from dry drawing materials in two fundamental ways—they cannot be blended easily unless a solvent is used, and drawings done with waxy materials have more durable surfaces. It is basically a trade off—durability for blending.

The basic recipe for a waxy drawing material is to mix a coloring material with a filler, then add a lubricant and a binder. The coloring material, or pigment, may be water soluble or not, depending on whether the blending solvent is water or organic (mineral spirits or turpentine). The filler is usually clay or talc. The lubricant is a natural wax, if blending is to be done with an organic solvent, or a fatty acid, if blending will be done with water. The binder may be fatty acid or wax, as well as gum tragacanth or methyl cellulose. The mixture is blended and is not fired.

It is important to note that all drawings done with waxy drawing material must be fixed with a fixative or a final protective coating. This prevents the tendency of wax to rise slowly to the surface of the drawing, giving a chalky, or milky, apperance.

OIL PASTELS

Oil pastels are a cross between wax crayons and encaustic (wax) paint in stick form. The amount of wax used in oil pastels varies considerably from brand to brand. With more wax, the pastel is greasier and less dusty, and is also much less subject to mechanical blending. Oil pastels were originally made by first mixing pigments into a solution consisting of a slow drying oil, such as poppy oil, and mastic resin dissolved in turpentine. This mixture was then given body by the addition of wax so that it could be shaped into sticks. As the turpentine evaporated, the sticks hardened. This recipe produces a high-quality oil pastel with a limited shelf life. Today, virtually all oil pastels are primarily made with pigment dissolved into a fossil wax. Some brands have a small amount of a nondrying oil, such as mineral oil, to improve the shelf life. Consistency varies greatly among brands and you should experiment to find the brand that best suits you. Oil pastels can be blended easily with a brush soaked in turpentine or mineral spirits.

Several years ago, almost all the oil pastels on the American market were of poor quality and lightfastness, and were primarily designed for use by children. This was not because there were no professional artists' pastels manufactured, but because it was felt there was no market for them in this country. Today, several professional-quality brands can be found. The Holbein Company offers two hundred and twenty-five colors that are rated for lightfastness. They are less waxy and have a consistency closer to a soft pastel than most other brands. The Sennelier Company makes seventy-two colors, twenty-four of which are iridescent. They are also introducing a jumbo version, approximately 1¼ inches in diameter and 3½ inches long, in selected colors. These oil pastels contain a small amount of mineral oil, which increases shelf life and eases application; however, the drawing's surface does not harden for a long time and should not be painted over with oil paints or encaustic (wax) paint materials. Many manufacturers make both professional and nonprofessional oil pastels. The labeling is often unclear as to which is which, so you should ask before you make a selection.

PAINT STICKS

Currently there are two types of paint sticks available—pigment in wax and pigment in acrylic lacquer. The first type is just a giant oil pastel called a paint stick.

Paintstiks, made by Markall for the Shiva Company, is a widely available brand of paint stick. It comes in twenty-seven conventional colors, six fluorescent colors, which are not lightfast, white, black, gold, silver, and a colorless blender. There is a skin over the surface of the stick that has to be peeled away or dissolved with thinner before use. The skin will re-form when not in use. Paintstiks work equally well as encaustic paint or as oversized oil pastels. They dry to the touch in approximately twenty-four hours, but, like any encaustic, they take several years to cure and harden fully. Paintstiks may be used in mixed media drawing; however, in mixed media painting they should be treated as an encaustic paint, and are best used over dry oil paint or under oil paint mixed with a wax medium.

There is currently only one brand of acrylic lacquer paint stick on the market. The Edding 650 Grafic Painter is available in eighteen colors, white, and black. The Sakura Company will soon be introducing a larger version. These paint sticks appear to have stronger colors, which is probably due to the absence of wax. Their consistency is that of lipstick. They may be blended mechanically while they are still wet, but cannot be blended with solvents wet or dry. Acrylic lacquer paint sticks dry in fifteen minutes after application. Although they cannot be blended into such other wet media as oil paint, they can safely be used under oil paint or over dry oil paint.

CRAYONS

The difference between a crayon and an oil pastel is that the crayon is harder and often has a great deal more filler, which may be either wax or clay or both. Crayons are composed primarily of kaolin (white clay), wax or fatty acids, and dyes. School, or children's, crayons are not for professional use because they are

not designed to meet the artist's need for lightfastness and permanence. One product, Caran D'Ache (forty colors), is popular among both children and professionals, although several of the blues and violets did not pass our tests for lightfastness. Artists occasionally complain about many brands that claim lightfastness yet seem to have a few colors that do not hold up well over time. Consequently, I recommend that when you buy a set of crayons, you do your own test. Simply take a piece of drawing paper, preferably bristol, and apply each color so that when the paper is cut in half each sample of color will also be cut in half. Place one half in direct sunlight for several weeks and store the other half in the dark. At the end of the test put each half together and compare them. This simple test will indicate the colors to avoid.

There are several crayons currently available that claim to meet minimum standards for professional use. Among these are Berol Art Stix (sixty colors matching Prismacolor Pencils) and Derwent (seventy-two colors), which are simply blocks, or sticks, of the same material the manufacturer uses in making its pencils. These crayons are made for working in larger areas than are practical with pencils, yet they are much firmer than oil pastels and can be sharpened. Caran D'Ache offers water-soluble crayons as well as wax crayons.

COLORED PENCILS

Colored pencils were originally developed for the illustrator and graphic artist. The development of the New Realism art movement has given new respectability to the colored pencil as a material for fine artwork. Colored pencils have been used to create detailed drawings that in many ways resemble paintings in egg tempera.

Colored pencils are produced in the same way as crayons, and the same precautions regarding quality and lightfastness must be taken into account when selecting a brand. Prismacolor Pencils (sixty colors), Derwent No. 19 Artist Pencils (seventy-two colors), and Caran D'Ache are popular pencils that are said to meet minimum standards for the artist's use. Caran D'Ache produces water-soluble pencils as well as pencils that can be blended with an organic solvent. Prismacolor and No. 19 Artist Pencils blend only with organic solvents. The wax pencils may be used as a colored resist for the water-soluble pencils, so that when water is used for blending, the areas covered with wax pencil will remain undisturbed.

Pens

THE PRINCIPLE of transferring a colored liquid to a drawing surface via a brush, pen, marker, or, in uninhibited moments, the fingers, is based on capillary attraction. Capillary attraction is the natural attraction of a liquid for a solid and its tendency to flow toward it. Gravity also plays an important role in keeping the flow in one general direction. Capillary attraction allows a liquid, such as an ink, to be held by a tube, a point with a split end, or a collection of filaments or hairs and then be transferred to a more absorbent surface such as paper.

The pen was in use long before the first true brushes made with hair. Simple pens, made from hollow reeds, were already being used by the Egyptians in 4000 B.C. The Greeks were using them in 1296 B.C. Not long afterward, the Romans used simple pens for making drawings on papyrus. During the Renaissance, such pens were preferred for drawing rather than writing. The popularity of pens among such artists as Rembrandt, and later Van Gogh and even Expressionists like George Grosz, stems from the great expressiveness that can be transmitted to a drawing with the flexible pen tip. The tip of a reed pen widens greatly with the slightest pressure, transferring larger amounts of color to the working surface. The relaxation of pressure allows the line width to narrow. It is this characteristic that is the standard to which all modern pens are compared and, in most cases, that they attempt to duplicate using a more durable tip. Reed pens are not durable and several are often needed to complete even a single drawing.

Reed pens are made by first removing the barbs from the shaft. The larger end is cut across the shaft. That end is then cut again, about ½ inch from the end, halfway through, curving toward the end. The cut is completed by continuing toward the end and cutting down the middle of the shaft. The same type of cut is made again along the remaining half of the shaft, starting about ¼ inch from the end. The resulting tapered point can then be further shaped to a point or left in a chisel. The edge of a chisel point is made sharper by cutting the tip to a 45-degree angle from the top of the point. The tapered point that is created is split in two. The hollow part of the reed, just behind the point, is filled with an absorbent material that acts as a reservoir for the liquid.

The Romans improved the durability of writing and drawing instruments by

developing pen nibs (writing points) made of bronze. These early pen points closely resemble those used today. Yet metal nibs were not commonly available until the nineteenth century, when steel, a more durable metal, was developed, as was a machine-manufacturing process.

Quill pens made from the feathers of such large birds as geese, ravens, and swans were common during the sixth century B.C. Crow quills were used for fine line work and the name is still used today for its steel substitute. Turkey quills have now replaced most other feathers because of price and availability. Quill pens are made by first tempering the quill. This is done by gently heating the quill, without scorching it, to remove any oil and fatty acid. The tip of the quill is then cut similarly to that of a reed, but the taper is shorter and a piece of the quill is often used internally to create a reservoir. A quill pen is more durable than a reed pen and almost as responsive, but still not as durable as a metal nib. The need for a metal nib became clear when, by the early nineteenth century, European countries (especially England) began importing 30 million quills a year. The best quills came from Russia and Holland. Some early attempts at more durable nibs ranged from tortoise shell to gold with precious stones set in the tip.

The development of modern steel manufacturing, during the early nineteenth century, led to practical metal replacements for the quill. In 1780, in England, Samuel Harrison made steel pens by hand. Such pens, which were small steel tubes cut into crow-quill-style points, were not marketed until 1803. In 1828, an Englishman, John Mitchell, developed the first practical machine-manufacturing process for the production of metal nibs.

The metal nib, which tended to be very stiff and not conducive to expressiveness, was modified in the 1830s by putting additional slits along the side of the nib as well as by cutting a hole in the top of the middle slit. The nature of steel, with its strength and resiliency, made it possible to make not only durable nibs, but also a wide variety of shapes and styles. Many styles of nibs evolved to accommodate the numerous writing and drawing styles. Some were designed to work with the then readily available varieties of machine-made paper; this paper made the artwork look stiffer and more mechanical.

Today, many types of metal are used to make pen points, including gold and platinum. Often the tip is coated with such specially developed alloys as iridium, ruthenium, and osmium because of their resistance to wear.

Although the principles applied in the production of the fountain pen were known since the mid-seventeenth century, a practical pen was not invented until 1884. L. E. Waterman, a New Yorker, is credited with this feat. Yet, if it were not for the development, during the nineteenth century, of synthetic ink dyes, which are fluid enough to make a fountain pen practical, Waterman's invention would have been worthless. The ball-point pen was patented in 1888, shortly after the fountain pen. But it was not until 1944, when World War II demanded an improved technology for the production of precision ball bearings, that Lazlo Biro was able to produce the first practical ball-point pen and patent it. Improvements made during the 1950s, involving methods of coating the ball with ink, as well as producing a micro-texture on the ball's surface, helped it surpass the fountain pen as the universal tool for writing, but not for drawing. With the

exception of a few styles of fountain pen, most ball-point pens are unsatisfactory for sketching and drawing because they are designed more for durability than for expressiveness. The pen holder with nib, known as the dip pen, is still the most common pen for fine artwork and calligraphy.

The development by the Japanese of a precision nylon filament led to the introduction of the nylon artist's brush and the fiber-tipped pen. In 1964, Americans switched by the tens of thousands to the fiber-tipped pen for drawing and writing. It was not until 1985 that sufficient technological progress was made to allow lightfast ink or pigments, necessary for fine artwork, to flow freely through a fiber tip.

BAMBOO PENS
Bamboo pens were first made by the ancient Egyptians and can be found in art supply stores today. They resemble reed pens, but are larger and much stiffer. Bamboo pens produce scratchy and somewhat crudely expressive lines.

DIP PENS
A dip pen has two to three parts—the nib, the holder, and sometimes a reservoir. Most reservoirs are permanently attached either to the holder or to the nib. The Mitchell Pen Company, however, makes reservoirs for its nibs that are sold separately and are theoretically removable for cleaning. Once on the pen, and used, however, they are often difficult to remove.

The primary advantage of a dip pen is that waterproof inks can be used without concern about clogging. Since the pen is loaded by dipping it into the ink, rather than through an internal reservoir such as that of a fountain pen, dried ink can easily be removed by cleaning or by redissolving in the same ink. Because of the need to dip constantly to reload the nib with ink and to blot and test before restarting, as well as the need to clean up after each use, most users have been induced to switch to nonwaterproof inks and fountain pens.

There are three basic categories of pen nibs—writing, drawing, and calligraphy. The three categories frequently overlap and at times certain groupings are based on traditional justifications that no longer apply. Drawing pen nibs are simple metal versions of traditional quill pens. They are capable of downward as well as side-to-side strokes. Because of the pointed tip, an upward stroke results in the pen point stabbing the surface. Most writing pen nibs have a semicircular shape at the tip, which has the appearance of a droplet of metal or looks as if the tip had been folded back and underneath. This allows for making the upward stroke without stabbing the surface. You might think this would also be ideal for drawing, and you would be right. With this nib, however, some control of precision will be sacrificed for freedom and speed.

Calligraphy pen nibs are generally one of two types—lettering or calligraphic. A lettering calligraphy nib has a tip that resembles a round plate. This will produce letters of a consistent line width throughout the stroke. A calligraphic calligraphy nib has a chisel edge so that the letters vary in thickness if the letter is drawn with the edge held at a consistent 45-degree angle. Calligraphy pens are available in sizes up to 1½ inches. The Steel Brush, Automatic Lettering Pens,

and Coit Lettering Pens are some of the larger styles. Scroll nibs, which have several points at the tip to draw multiple lines, are also available. A number of artists have created abstract watercolor paintings of interlocking grids of lines using various sizes of large calligraphy nibs.

FOUNTAIN PENS

Fountain pens are composed of four elements—pen nib, delivery system, reservoir, and shell. It is the reservoir that makes the fountain pen convenient to use. You are limited, however, to using primarily nonwaterproof inks. Although there are several new waterproof inks designed for use in fountain pens, their use violates virtually all pen manufacturers' warranties. The basic problem is that if the bladder, or delivery system, clogs with dried waterproof ink, it is difficult, if not impossible, to restart or properly clean the parts to get the pen back in working order.

The available fountain pen styles are the same as dip pens, although the range is much smaller. Platignum and Osmiroid are the two most common brands of calligraphy fountain pens, although these manufacturers also produce lettering and sketch pens. A new arrival to the United States is the Rotring Artpen, which comes in a limited but finely made variety of calligraphy, lettering, and sketching fountain pens. Because the art of calligraphy is most often performed at a slow pace, expensive pens with improved flow characteristics and gold nibs, although desirable, are not necessary to produce excellent results. Writing and sketching are performed at a much quicker pace, and flow characteristics, as well as the quality of the metal used in the nib, become more important factors when choosing a pen.

Waterman Pens, which are made in France, and Mont Blanc pens, made in Germany, are recognized as among the world's finest writing pens and are in high demand among sketch artists. One of the reasons for this is that both companies use solid gold nibs. The characteristics of gold allow ink to flow along it with minimum resistance. Gold also has the right balance of softness and strength for ideal responsiveness, and a gold nib will do a great deal to improve a writing pen's performance. A sketching pen, however, requires more than just a gold nib. It requires a larger nib (although not necessarily a larger point) and quality design, such as the comblike structure underneath the pen nib, which holds a quantity of ink ready without flooding the tip of the nib. The best writing pens usually make the best sketching pens. It is not difficult to justify a fine-quality pen if drawing is your primary medium of expression. Just as a watercolorist will have at least one brush of the finest quality, so will a sketch artist have at least one fine pen.

TECHNICAL PENS

Even though technical pens were originally designed to meet the needs of the drafting industry, they have great appeal to the contemporary artist. The primary characteristics of technical pens are that they produce an unvarying, even line and that they use a waterproof ink. They differ from fountain pens in that they have a point that consists of a round hollow tube with a needle or pin that runs

down the center, rather than a traditional pen point. This design allows the ink to leave the tip and deposit on the drawing surface in a consistent and precise width. For best results, the pen should be held perpendicularly to the drawing surface and drawn, slowly, across a smooth surface. Tilting the pen too much, drawing too quickly, or using a moderately textured surface will produce a broken line. Using soft or heavily textured paper can contribute to clogging of the ink flow, for fibers can collect in the tip and prevent flow. Most technical pens can be kept ready to use, loaded with ink, for several weeks if they are properly capped. Each manufacturer has developed a technical device within its pen caps to help keep the ink in the point from drying out. Koh-I-Noor Rapidograph makes humidifiers for its pens. Rotring Rapidograph has a new style of technical pen, which recently entered the American market. If you use its ink system with its cartridges, the pen is significantly less sensitive to clogging as the result of ink drying in the tip. Because technical pens use a waterproof ink, filling, maintenance, and cleaning must be done according to the instructions provided by each manufacturer.

Since the line width produced by a technical pen remains the same, several pens of different point sizes are often used to give a more expressive look to the artwork. There are several high-quality brands of technical pens on the market. Koh-I-Noor Rapidograph is the most recognized brand name and this is the pen that all others use for comparison; therefore, we will use Koh-I-Noor's scale for describing the various sizes of pen points. There are thirteen points ranging in size from 0.13mm to 2mm in width. A number is assigned to each width: $6 \times 0 = 0.13$mm, $4 \times 0 = 0.18$mm, $3 \times 0 = 0.25$mm, $00 = 0.3$mm, $0 = 0.35$mm, $1 = 0.5$mm, $2 = 0.6$mm, $2.5 = 0.7$mm, $3 = 0.8$mm, $3.5 = 1.0$mm, $4 = 1.2$mm, $6 = 1.4$mm, $7 = 2.0$mm. Most technical pen points are made from stainless steel, but some are made with a harder tungsten carbide tip or a sapphire for use on polyester drafting film. (Drafting film and tracing papers have very abrasive surfaces that can wear down steel tips quickly.) Refograph, made by the Alvin Company, and Unitech, made by the Charvoz Company, have a slightly polished edge to their points, which serves two basic purposes. First, it allows for adequate ink flow even if the pen is held at the same angle that a fountain pen would be held, and second, it allows the pen to be drawn across the surface at a slightly faster pace. However, the polished edge can result in lines with slight inconsistencies in width. This might be considered a drawback by a draftsman, but is usually insignificant to the sketch artist.

To prevent damage to a technical pen, use only those inks made specifically for technical pens. (For more information about ink, see pages 214 to 215.) If your pens are not to be used for several weeks, clean them out.

MARKERS

A fiber tip is a collection of thin synthetic fibers that are roughly parallel to one another. The ink flows along the fibers with the help of capillary attraction and gravity. Fiber-tipped pens, or markers, were originally developed for graphic art use where permanence is second to convenience. Most artists' pigments, because they are composed of solid particles, cannot be made to flow through a fiber tip,

whereas most dyes are pure liquid and can. Dyes, therefore, are the colorant of choice. Since few dyes are as lightfast as the most fugitive of artists' pigments, fiber-tipped pens, with rare exception, are not safe to use for fine artwork where permanence is the first consideration.

Many fine artists do not realize that there is a difference between materials made for graphic art use and those produced for fine art, and they often incorrectly assume that all artists' materials found in art stores are made with utmost permanence in mind. Fiber-tipped pens are the best example of this confusion. When most fine artists see the label "permanent" attributed to markers, they do not realize that it only means that the colorant is waterproof, not lightfast. In graphic art materials in general, and fiber-tipped pens in particular, if it does not say lightfast on the label, it should be assumed it is not. And when it does say lightfast, it should still be used with some caution in fine artwork, because the lightfastness of these products often meets only the minimum standards that would be applied to artist-grade materials.

Graphic artwork is stored with a cover, and most writing is not done with display in mind but rather in books, or notebooks, which are left closed until used or read. Under these conditions, most graphic art materials and fiber-tipped pens would be considered durable. However, if exposed to direct sunlight or intense fluorescent light for even several hours, many of these materials will undergo visible changes.

Recent advances in the technology of dye making and fiber tips have allowed the manufacture of some lightfast markers. There are two types of such markers that have recently been made available—paint markers in 1983 and a limited selection of fine-point markers for writing in 1985. Paint markers have a fluid consistency of a thin paint, which will adhere permanently to almost any surface. They greatly resemble a lacquer paint. These pens, however, are not practical for ordinary writing. The nibs are often too large and the flow characteristics are not consistent. They are best for labeling, making signs, decorating T-shirts, and for artwork where precision is not crucial.

The Sakura Company has recently introduced a waterproof and lightfast (it claims lightfastness equivalent to one hundred years of tropical sun) marking pen called Pigma Micron. It comes in ten colors and black, and in three point sizes—0.01mm, 0.03mm, and 0.05mm. This pen is a revolutionary development. I have tested several prototypes over the years with poor results and this pen is the first successful version. It is only a matter of time before all marking pens use this technology. Until that time you should use extreme caution in selecting any marker for fine artwork.

THE BALL-POINT PEN

The black inks used in many ball-point pens (as opposed to the so-called rolling ball-tipped pens) are paste inks of carbon and would be considered safe for fine artwork. Few manufacturers, however, identify the nature of their ball-point inks. The ones that do are calling theirs "India Ink" ball-point pens. Roller-ball pens use a liquid ink and write more like a marker, but are more durable because of the metal, or ceramic, ball tip. There are two brands, both introduced

in 1985, which claim to be lightfast and waterproof. The Pigma Ball, made by Sakura Company, is offered in three colors and black. Roll Pen, manufactured by the Tombo Company, is available in black and blue. Both companies use the latest technology to produce these pens so that they are lightfast and become waterproof when dry. All other ball, or rolling-ball, pens should not be considered safe for fine artwork unless lightfastness is specified.

The ball-point pen is recommended to the artist who likes the appearance of sketches with consistent line, as well as being able to sketch quickly. A further note is that ball-point pens often do not start immediately when first used or when left standing for long periods. This is a sign of quality workmanship. Pens that start too easily often leave undesirable ink deposits that can later smudge.

Drawing
Accessories

MOST DRAWING ACCESSORIES do at least one of three things. They blend, erase, or protect all or part of a drawing. The first drawing accessory was a finger. The finger, however, is only good for smudging and rubbing out areas of moderate size. The earliest replacements were small bits of rolled leather, later followed by rolled paper, called a tortillon. Over the centuries many tools have developed, from duck wings to vinyl erasers.

PENCIL EXTENDERS

At one time pencil extenders were considered frivolous, somewhat like cigarette holders. When artists' pencils passed the fifty cent mark, racing toward a dollar, however, many artists reconsidered. And it is not unusual for people who use colored pencils to have between a hundred and a hundred and fifty assorted pencils. If you use colored pencils frequently and find yourself throwing away one-third to one-half of your investment just because you can't get a grip on it, you could save a great deal with the aid of a pencil extender. Pencil extenders, which attach in much the same way as a cigarette holder does to a cigarette, also provide better balance and alleviate hand fatigue.

ERASERS

Before the modern eraser, people used fresh bread. The inside of a slice of bread was simply rolled up into a usable shape. In the mid-eighteenth century, natural rubber began to replace bread. Today, virtually all erasers are made from plastic.

An ideal eraser is one that removes the graphite, charcoal, and other drawing media without smudging or disrupting the surface of the ground. Although there is no ideal all-purpose eraser, there are several kinds of erasers that are ideal in particular situations.

Gum Erasers, which are made from a rubberlike compound and a dry cleaner, are one such example. This type of eraser is excellent for general clean-up of pencil drawings. I have found that some testing must be done when this eraser is to be used with colored papers and colored boards because, in rare instances, the surface color is affected by the soap present in the eraser and a bleached or discolored area may result with its use.

Soft Vinyl Plastic Erasers are excellent for graphite pencil and all drawing papers. Their nonsmudging and nonabrasive qualities, combined with an ability to lift the graphite off the working surface, have made this eraser especially popular.

Pink Rubber Erasers are classic and the most common erasers used today. This eraser is not as effective with graphite as a vinyl eraser. Pink erasers are much better for colored pencils. They are slightly more abrasive and must be used with some caution on nondurable working surfaces.

Kneaded Erasers are most effective with charcoal and soft pastels. As charcoal or pastel dust build up on the eraser's surface, it can be kneaded to produce a fresh working surface. This type of eraser can also be plied into various shapes and used as a drawing tool to make highlights on charcoal, pastel, and pencil drawings.

Ink Erasers are available in two types—those that are abrasive and the kind that are chemically imbued and nonabrasive. Most of us are familiar with the old-fashioned abrasive ink eraser that removes ink by, more often than not, sanding it away along with the surface. Unless the surface is extremely durable, the results are often less than desirable. A recent improvement on the ink eraser is the chemically imbibed eraser, a conventional vinyl eraser combined with a chemical that reacts with ink to remove it from the working surface. The major improvement is the nonabrasiveness of such erasers.

Dry Cleaning Powders and Pads consist of crumpled vinyl eraser that is sprinkled over the surface and rubbed or rolled around over it before beginning the drawing. This cleans the surface of skin oils, which may have collected during handling, as well as dirt and smudges. Having a clean surface is particularly important when working with wet media, which can bead up on a dirty, nonabsorbent surface.

TOOLS FOR BLENDING

Stomps, tortillons, chamois, and duck wings are tools often used for blending dry drawing materials. The names "stomp" and "stump" are used interchangeably. Some manufacturers attempt to use both names to distinguish different styles of cigar-shaped, compressed paper cylinders; however, there is no generally accepted distinction between these terms. The name "stump" is older than stomp, yet the name "stomp" refers specifically to cigar-shaped compressed paper cylinders, while stump has more than twenty other meanings. Stomps have a diameter ranging from ⅛ to ½ inch, are approximately 5 inches long, and are pointed at one or both ends. A tortillon is made of rolled paper and has only one point, which is usually smaller and more tapered than that of a stomp. Both stomps and tortillons are used for delicate blending in areas where a finger is too large.

Duck-wing blenders and chamois (rectangular suede or leather) pieces are used for removing charcoal from a surface or for blending larger areas than fingers can accomplish.

FIXATIVES AND FINAL PROTECTIVE SPRAYS

Fixatives are "workable," which means they only gently fix the drawing material to the surface so the drawing can be reworked or added to. This feature is particularly good when working with dry drawing materials. Not only is a fixative helpful in keeping the dusty quality at a minimum, but, without its assistance, it is difficult to apply subsequent layers of material and not disturb layers underneath. The major drawback of fixatives is that they darken the appearance of pastel drawings. This can be minimized by using a fixative more frequently and more lightly, rather than less frequently and more heavily.

The mouth atomizer, an ancient tool for spraying liquids by mouth, has been replaced by commercial spray cans and airbrushes. An airbrush is used to apply homemade fixatives, for which many older, excellent formulas can be found. It is the commercial spray fixatives in a can, however, that are used by most artists because of their convenience and effectiveness. Most of these fixatives are made from an acrylic resin dissolved in an organic solvent, such as lacquer thinner. There are two types of spray fixatives—regular, which is scented, and odorless. The odorless is newer to the marketplace, and I feel it is not an improvement. The purpose of the annoying scent is to warn you that there is something in the air that is not good to breathe. The odorless fixative tends to give a false sense of security. Proper ventilation, and in some cases personal protection, should be used with all such sprays.

When applying fixative, the paper should be placed flat on a table and sprayed lightly, holding the can about 12 inches from the surface. If it is held too close, the spray will pool and the results will appear blotchy; if the can is held too far away the spray will tend to dry in route and will not be as effective and will result in a chalky appearance. It is best to apply two to three very light coats rather than one heavy coat. The spray should begin off the edge of the paper and end off the edge of the paper in a consistent parallel motion from one edge to the other. Creativity at this point is not appropriate.

A final protective spray is basically a heavier version of a fixative. It is designed to fix the drawing material permanently to itself and to the drawing surface. It is impossible to store or to handle unprotected soft pastel and charcoal drawings without disturbing, if not permanently damaging, them. Even protecting them through framing is best accomplished after a protective spray has been used.

A protective spray is most effective when used in combination with a fixative. Frequent, light applications of a fixative will mean less protective spray is needed in the end. This will also result in less darkening of the drawing. Protective sprays are not 100 percent effective in totally fixing dry drawing materials. In fact, to do so would severely affect the appearance of the artwork. Consequently, some care still has to be exercised in handling, presentation, and storage of such artwork. (For more information about framing and storage, see pages 275 to 307.)

Final protective sprays are available in gloss or matte finish. Since soft pastels and charcoal produce a matte appearance, it would seem that the choice of spray should be matte. This is not the case. Soft pastel and charcoal are very absor-

bent, and a gloss spray, when used lightly, will appear matte over these materials. The purpose of using a gloss spray whenever possible is that it dries with a clear film, while a matte spray dulls the appearance of the drawing as well as producing a matte look. This would not be the case, however, with oil pastels, paint sticks, and heavily applied graphite. A gloss spray will leave a shine on these materials. A matte spray will not leave a shine, yet some caution must still be used because the spray will tend to dull the appearance. Whatever the choice, drawing materials with a high wax content, such as oil pastels and colored pencils, should be sprayed with at least a workable fixative to prevent the wax from developing a chalky surface appearance over time.

Always test a spray before using it on your original or final work.

TAPES

Of the many types of tapes, four are the most relevant to the production of artwork. For the sake of discussion, and because two of the four tapes are produced only by 3M, products made by 3M are used as examples.

Masking Tape is primarily an industrial tape that is easily adapted for the artist's use. Masking tape is produced in several weights and tack (stickiness). The lighter the weight, the more easily the tape will tear during application and removal. Lightweight tapes can tear too easily and make removal a laborious process. Because the heavier weights cost significantly more money and several rolls are often needed, most retail stores are cost conscious and carry only the lighter weights. Technical information about these tapes is rarely available; therefore, it is best to make your own crude test of the tape. A tape of adequate weight should peel off the roll without tearing, and when applied to a glass surface it should also release without tearing.

Masking tape, in general, is considered a high-tack, or very sticky, tape and cannot be used on paper or board without damaging the surface during removal. It is best used on a hard, durable surface. When using masking tape to mask off an area that is to be painted, a crisply painted edge can be obtained by burnishing down the edge of the tape before painting. When masking for acrylic paints, it is helpful to apply a thin coat of polymer medium along the burnished edge of the tape. This will provide extra protection from paint creeping under the edge during painting.

Masking tape ages poorly and is not meant to be a permanent part of the artwork. After several years the adhesive weakens, crystallizes, stains, and releases from the working surface. In fact, virtually all pressure-sensitive tapes are unsafe to be used as part of permanent artwork.

Drafting Tape (No. 230 by 3M) greatly resembles masking tape in appearance. The primary difference is that it has a lower tack, which is designed not to disturb the surfaces of most papers when it is removed. Yet it is strong enough to hold the paper in place. The harder the surface of the paper, the better this tape will perform.

Artists' White Tape (No. 285 by 3M), is a low-tack, flat, white tape designed as a paper tape, primarily manufactured for the graphic arts industry. The top

surface is designed to accept writing. When this tape is applied to a paper surface, it exhibits a lower tack than drafting tape. On a slick, nonporous surface, however, it exhibits a higher tack than drafting tape. The major flaw with this product is that if it is applied to a nonporous, glasslike surface and left for several days, removal often results in some of the adhesive separating from the tape and remaining attached to the surface.

In recent conversations with 3M it was explained that further development of the tape would be too costly and that they plan to discontinue this product. Instead, 3M will develop for this market a less costly and less versatile tape called Post-it Cover-up Tape #651.

Removable Transparent Tape (No. 811, formally 281 by 3M) is a new tape, which in appearance resembles Magic Tape by 3M. It is primarily designed for the graphic arts. Dry transfer lettering, for example, can be applied to the top surface of the tape; then whole words, sentences, or designs can be easily be lifted and transferred to another position. The advantage of being able to see through the tape is that it allows exact positioning. Since widths up to 3 inches are available, this tape can be ideal as an airbrush frisket (a low-tack transparent film that is used for airbrush masking). A new "improved" version released in 1985 is not as good quality as the prototype No. 281. I have had some complaints about it not performing as well as a frisket since some paint tends to creep under the edge of the tape. For the fine artist, this tape is excellent for assisting in producing working models or mock-ups, or for use in temporary labeling of delicate working surfaces.

Part Two

BRUSH

THE BRUSH is said to date back at least thirty thousand years. The brush was probably first developed for the purpose of writing and later evolved into a tool for drawing and painting. Originally, brushes were made from plants or feathers. The bamboo brush is an example of a plant brush that is still made today in Japan. It is produced by sticking one end of a short stalk of bamboo into moist earth and leaving it to decompose. The ground surrounding the bamboo is kept moist for three to five weeks. The end of the stick is then sufficiently decomposed so that it can be mashed with a mallet to form strands of fibers that resemble coarse hairs.

The earliest records of brushes made with hair are found in Chinese writings dating from about 250 B.C. Commercial brush making in Europe did not begin until the late eighteenth century. The Max Sauer Company of France, one of the oldest brush makers in the West, established in 1793, still produces brushes under such names as Raphael, Sauer, Renard, and Gerard. The Raphael name is used primarily for its artists' brushes. Today, however, there is a proliferation of brushes in the marketplace sold under many company names; in reality there are few companies that actually manufacture the brushes available under their names. This makes it possible to see the same style and quality of brush sold under different names and for different prices. Although the reputation of some manufacturers can help in making a decision about buying a particular brush, this is still no substitute for basic knowledge of how to test for quality and performance.

The purpose of this section is not only to show you how to get your money's worth, but also to help you to acquire the correct style and type of brush to accomplish what you wish. After all, what is the point of getting the best value in a brush that will not do the job?

Types of Hair and Bristle

HAIRS, BRISTLES, and nylon filaments work as devices for holding and applying ink or paint because of capillary attraction—the natural attraction of a liquid for a solid and its tendency to flow toward it. When hairs, bristles, and nylon filaments are grouped together to form a brush and dipped into a liquid, the liquid will tend to be drawn up between the hairs and be held in place. When the tip of the brush is touched to an absorbent surface, the liquid will be transferred to it with the help of gravity. Thick paints rely more on pressure than on gravity to be transferred to an absorbent surface.

There are two main characteristics that distinguish one hair from another, as well as hair from bristle and nylon filaments. The first and most important characteristic is the hair's degree of absorbency. Hairs have scales, and the more scales, the greater the surface area to attract and hold liquids. This increased absorbency provides greater control in the application of inks or paints because they are held within the body of the brush, allowing for even flow off the tip of the brush. Brushes made of less absorbent hairs, or nonabsorbent synthetic filaments, accumulate liquids at the tip. Inks or paints tend to run quickly and often uncontrollably off the tips of such brushes during application.

Spring or stiffness is the second most important characteristic. The presence or lack of it in a particular hair will define how it can be used and with what type of liquid. The large variety of hairs, bristles, and nylon filaments, as well as the way they can be blended and shaped into brushes, provides a vast opportunity for differing styles of expression. Only a knowledgeable painter can, however, take full advantage of this potential.

The availability of choice, natural hairs for brushes is shrinking while the price is rising. One of the major causes for this situation is the increasing number of animals placed on endangered-species lists by importing and exporting countries. The current explosion of new regulations about what is legal for one country to export and what is legal for another country to receive has led to absurd occurrences. There is one story of an importer of hairs from around the world who was attempting to declare to customs the importation of some nylon "hair." The customs agent insisted on knowing the name of the animal from which nylon "hair" was obtained so he could check it against his list of

endangered animals. No amount of explanation that these were synthetic hairs would deter this agent from his appointed duty. Ultimately, it took a phone call to a local congressman to get the shipment released.

The following descriptions are of hairs, bristles, and nylon filaments that are considered in most countries to be both desirable and legal for brush making.

SABLE

The name "sable" was made up by trappers to refer to the marten, and especially one particular marten, *Martes zibellina*. The name "red sable" was used to denote both the weasel and the Asian mink (also known as the kolinsky), which have a yellow-reddish tint to their brown hair. All these animals are so closely related that they are part of the same family, *Mustelidae*. The red sable is of primary interest to the artist because the finest sable brushes are made from its fur. White sable and golden sable are merely trade names for synthetic filaments used as substitutes for animal hair.

Sable is chosen for its spring (the ability to return quickly to its original shape) and its point (the ability to return to a fine pointed shape). The shape of an individual hair resembles an elongated pear. There is greater width in the middle of the hair than at the tip, which is pointed. This hair shape is what gives sable its strength to spring back and to come to a very fine point. The strength

Types of Hair and Bristle

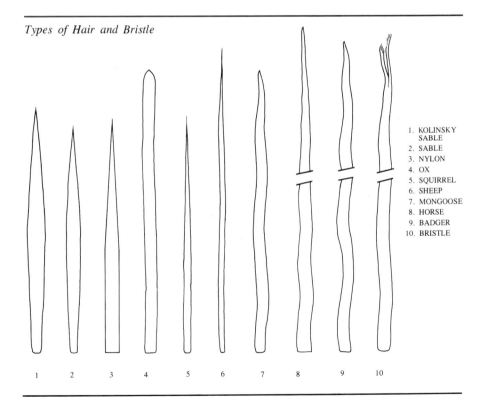

1. KOLINSKY SABLE
2. SABLE
3. NYLON
4. OX
5. SQUIRREL
6. SHEEP
7. MONGOOSE
8. HORSE
9. BADGER
10. BRISTLE

of the spring and the length and fineness of the tip of the hair together determine the quality and the price of the brush. Consequently, hairs collected from wild animals that live in colder climates are preferred because their fur grows thicker and longer. The best-quality brushes are made with hairs that are collected from the middle, or belly, of the tail. The hairs are longer at the end of the tail, but also are thinner, have less body, and are usually damaged, blunted, or kinked from the animal's activity. These hairs are used in lower-quality sable brushes and sometimes as filler in medium-quality brushes.

Kolinsky is a particular strain of mink that lived at one time in the Kola Peninsula in the western part of Russia and was the source for the finest red sable brushes. Today, there are no kolinskys left in the area. This animal is virtually extinct and is, therefore, a protected species in Russia. The name "kolinsky," however, is currently used to denote the hair acquired from the Asian mink, *Mustela siberica*, that lives in Siberia, northern China, and Korea. Hairs from the tail of this animal were highly prized and set the world standard for length (up to 2¼ inches), spring, and point. The finest varieties, the longest and the thickest hairs, come from the coldest climates and, because Siberia is farthest north, the best kolinsky comes from the Soviet Union.

The longest and strongest hair is taken from the male winter coat of the kolinsky. The Soviets have severely restricted trade of the animal, and at this time the German brush manufacturer da Vinci (who produces brushes under the names Realité and Cosmos), is the only one who claims still to be trading with them and using this hair. It is the only manufacturer that I have found that will volunteer information about its finest brushes, such as whether it is using male winter coat hair and how much is being used. Other manufacturers, such as Grumbacher, claim still to be using old stock that they accumulated before the restrictions. Manufacturers that have exhausted their stock are now using the Chinese and Korean kolinsky.

The color of Siberian kolinsky hair is brown with a distinctive yellowish-red tint. The Chinese variety tends to be slightly darker with less red. Tiny dark spots running the length of the hair are not unusual. The term "red sable" comes from the reddish tint this hair naturally possesses. Because this hair often sells for several thousands of dollars per pound, it is not uncommon to find hair that has been cosmetically treated to look like the Siberian variety. Crudely treated hairs can often be recognized by an unnatural bright orange tint.

Red Sable is a large category, which includes hair from "seconds" of kolinsky and hair from the weasel. The kolinsky hairs are called seconds because they are thinner overall, particularly in the longer hairs. Hair from the marten, particularly *Martes zibellina*, is included in this category by some manufacturers more because of the quality than the color. The finest red sable is always separated from the rest and called either "kolinsky sable," "kolinsky mink," or just "kolinsky."

Red sable hair has slightly less spring than kolinsky and is a little stiffer, and the tips are a little blunter. These characteristics can be attributed more to the warmer climates in which the animals are found than to the differences among

species. Most red sable hair, darker in appearance than kolinsky, can vary widely in quality and appearance. In some cases, the better red sable is almost indistinguishable from the kolinsky. In general, red sable makes fine-quality brushes when the hairs are selected for quality and are arranged properly during brush making. When hairs from the end of the tail, which are often thin and kinked, are used, and quality control is poor, the performance can be far less than that of synthetic "sables."

Weasel is a Mustela, as is the kolinsky. The hair is similar, but of inferior quality, shorter and with less thickness, or belly. This hair is commonly used as a filler in sable brushes. Weasel hair is preferred in certain styles of Oriental brushes.

Sable or Brown Sable brushes that are not designated either red sable or kolinsky, are made of hairs obtained from varieties of the marten, or are left over from the production of the other sable brushes. The quality of brushes made from these hairs varies greatly, from a brush that is virtually useless to an adequate student-grade brush.

Ermine was used a century ago in Europe and America when better sables were less common. The hairs are very short by comparison and could only be used for making small brushes. Ermine has essentially been replaced by red sable.

Synthetic Sables are known by many names. The two most common are White Sable, created by the Simmons Brush Company, and golden sable. White or colored, all synthetic sables are some variation of nylon filaments developed and manufactured in Japan. Most of the brushes, with or without handles, are assembled in Japan, regardless of the label. There are some differences in synthetic brushes because of variations in the assembly of the filaments, which are specified by those commissioning their manufacture. These differences are small, however, when compared to the difference between synthetic and natural sables.

The shape of the nylon filament is pointed at the tip, and the body is straight and uniform. The filaments used to duplicate hairs range in diameter from 0.08mm to 0.15mm; those for bristles are 0.20mm or more. Nylon has remarkable spring, so much so that many professionals feel it is a drawback. Some manufacturers have attempted to deal with this by varying the width of the filaments or blending the synthetic with natural hair.

Another common complaint is the nonabsorbency of the synthetic hair. This is a particular problem with watercolor because the color gathers excessively at the tip and runs quickly off the brush onto the more absorbent surface, making control difficult. Recently, some manufacturers began trying to increase the absorbency of nylon either by etching the surface of the filament to simulate the scales of natural hairs or by coating the hairs to reduce the surface tension. Both do help a bit, but there is the question of whether the improvement is worth the extra expense.

There are significant advantages to synthetic brushes. These include the cost of the larger-size brushes, which can be one-tenth the price of red sable. A good synthetic filament is better than a bad red sable.

OX (SABELINE)

Sabeline is light ox hair dyed to a reddish tint so that the brush's appearance will resemble that of red sable. Only the astronomical price of sable and the lack of absorbency in synthetic hairs keep ox hair in use. Ox hair, which comes from the ears of oxen, has springiness similar to that of sable, but it does not have the fine tip. The tip of the hair is actually quite blunt when compared to sable and will not form a fine point when used to make a round brush, or a fine edge when used to make a flat brush. Both Grumbacher and Winsor & Newton claim that the lighter shades of ox hair are superior to the darker shades. Max Sauer Company claims that the color has less to do with quality than do the method of preparation and the origin of the animal. I believe, light or dark, you should test the brush first to see if it is right for you. (For more information about testing brushes, see pages 56 to 57.)

Since the darker varieties of ox hair are longer, they are more commonly used in large flat brushes. The lighter-colored hairs are shorter and are usually used in watercolor flat and round brushes.

CAMEL

There is no such hair as camel hair used in the making of brushes. "Camel hair" is a trade term for various inexpensive, poor-quality hairs such as pony, bear, sheep, lesser grades of squirrel, or whatever else is available at the time. These brushes are unprofessional and have no redeeming qualities, except that they are inexpensive and resemble artists' brushes.

SQUIRREL

Squirrel hair, with one exception, is a thin hair with a pointed tip and a more or less uniform body. It is soft and absorbent, and it has a natural affinity for itself, which means that when a brush made of squirrel hair is fully wet, it can come to an exceptionally fine point. Squirrel hair, however, has little or no spring.

Squirrel is basically misunderstood. When sable rose dramatically in price, many artists turned to squirrel as a less expensive alternative and became disillusioned when it did not perform like sable primarily because of the lack of spring. A good-quality squirrel brush was never meant to be used as a cheap sable replacement. Its particular qualities make it ideal for watercolor wash technique, lettering, and for the application of paints when an exceptionally smooth finish is required.

There are four kinds of squirrel that are primarily used in the making of artists' brushes.

Kazan Squirrel is named for its home province in the Soviet Union. Hair derived from the tail of this animal is highly prized for its superb tip and elasticity, and is considered the best of the squirrel hairs. This hair is used in making the finest watercolor brushes. It can range in color from black to black with red tips and flecks of gray along the shaft.

Blue Squirrel hair is similar to kazan, except that it is longer and of slightly lower quality. The hairs are blue-black with a gray root.

Taleutky hair is stronger and longer than the other squirrel hairs and is primarily used to make lettering quills.

Canadian or Golden Squirrel hair is shorter and thicker than the other Soviet varieties; it is the only squirrel hair that possesses a "belly." This belly resembles sable hair not only in appearance but also in handling. Although it is too short for round brushes and possesses little spring, it does make a fine-quality watercolor flat and is a reasonable alternative to the high cost of sable. The hair appears variegated with gold and black coloring.

BRISTLE

Hog, boar, and pig hairs are called bristles because of their stiff and coarse appearance. They are actually so stiff that they were used as the balance spring in the first pocket watch. Bristle has a relatively uniform body with natural curve and a "flagged," or split end. The curve is either removed or reduced during the boiling and preparation of the bristles. Interlocked brushes are made from hairs that have been boiled for only two hours so that some curve remains. An interlocked brush takes advantage of the curve; the bristles are assembled so that the curved bristles oppose one another. As with a broom, this helps keep the tip from splaying to give better control.

One of the desirable characteristics of hog bristle is flagging—the multiple tips provided by split ends. The greater the flagging, the better the control. Wild hogs have more split ends than the domesticated animal. Currently, the best hog bristle comes from China, where there are more wild hogs. Bristle from the Chungking province of China is said to be the best.

BADGER

Badger hair, which has a variegated black and white appearance, is not commonly used to make artists' brushes. The one important exception is in blending brushes, for which it is excellent. Sable is too expensive for this purpose, and because of the fineness of the hair it has to be frequently cleaned of paint build-up. Badger, however, is longer and thicker than sable and less costly.

MONGOOSE

There are more than forty species of mongoose throughout Asia, Africa, and Europe, all of which are considered in most countries to be endangered. India at this time seems to have far more mongoose than it cares to, and is, therefore, one of the few legal sources for this hair.

Mongoose hair is closer to sable in appearance and performance than it is to bristle. The tip of the hair comes to a tapering point like sable, but the belly is much thicker and therefore stiffer. The hairs, on average, are a bit longer than most sable. Mongoose is also similar in appearance to badger; both have a variegated colored body. Badger is often used as a cheap filler for mongoose brushes. One way to tell the difference is that mongoose hair has a dark tip and badger hair has a white tip.

Brushes made of mongoose are made primarily for oil painting, and are excellent for times when bristle is too crude and sable is not stiff enough to push

thicker paint mixtures over the painting surface. Mongoose is priced between sable and bristle, and is often sold as a cheaper alternative to sable. It makes a fine brush for certain jobs, regardless of the price.

MISCELLANEOUS HAIRS

Fitch, pony, and monkey, as well as the lesser grades of badger and mongoose hair, are animal hairs used in the making of Western brushes to produce less expensive alternatives to such hairs as sable and squirrel. These hairs are most often used as fillers. A percentage of sable, for example, will be replaced with fitch hair to produce a more moderately priced brush. I tend to avoid brushes that have filler because their performance is unpredictable.

Monkey Hair, a relatively short hair that often appears light brown in the middle and almost blond at the tip, is usually found in combination with other hairs. These brushes are produced as a less expensive sablelike oil painting brush. I find the savings and the performance not great enough to overcome my own inhibitions about using brushes made of primate hair.

Fitch Hair, which is from the polecat (a close relative of the weasel), is similar to but coarser than weasel. The hair ranges from dark brown to almost black. Brushes made from fitch hair can be a cost-effective alternative to sable oil painting brushes. I have found that these brushes are not manufactured with the same quality control, possibly due to the low cost, and should be examined carefully for defects and for tips that have been cut to make them even. Fitch hair brushes are sometimes called Russian sable, black sable, or Russian black sable as a marketing gimmick to promote sales.

Pony Hair is coarse, often kinked, and very inexpensive. This hair is used to manufacture school brushes and can sometimes be found as a filler in squirrel hair brushes. Pony hair does not perform well and should be avoided.

HAIRS PRIMARILY USED IN ORIENTAL BRUSHES

Samba, horse, deer, weasel, cat, sheep, and goat are the animals whose hair is most often used in the manufacture of Chinese and Japanese brushes. The coarsest and stiffest hair is that of the samba, the horse, and the back of the deer. The hair of the weasel and the inner arch of the deer is less coarse and stiff. The hair of the cat, sheep, and goat is softer, finer, and has less spring. Brushes made of bamboo resemble samba hair in coarseness and behavior.

There are Oriental brushes that are labeled or called wolf hair. All such brushes that have been shown to me were actually sable or combinations of sable and weasel. One of the oldest importers of Oriental artists' materials explained that the confusion lies in some old and poor translation from Chinese to Japanese. Today, when a Japanese importer orders wolf from a Chinese exporter he knows that sable or weasel will be delivered. This situation is further complicated by the recent involvement of Western importers and the English language. Rather than add to this confusion, suffice it to say that Chinese brushes called sable are usually made of high-quality sable and Chinese brushes called wolf are usually sable and weasel mixed, and are of a slightly lesser quality.

The Samba, or Sambar, which is also called the mountain horse in the Orient, is a large Asian deer that is the source of a stiff and coarse hair used in the making of Oriental calligraphy brushes. The hair appears slightly kinked and has a variegated dark brown and tan appearance.

Horsehair is one of the commonest hairs used in Japanese brush making; it is particularly popular for calligraphy brushes. Horse hairs do not have a great affinity for themselves even when wet; they will not necessarily maintain a brushlike shape without assistance. Consequently, horsehair brushes are often left partially starched near the ferrule, or are wrapped with a layer of sheep hair, which can keep the horsehair in shape. In general, horsehair is strong, slightly coarse, resilient, and long. The better hairs are a cream-colored brown; the darker the shade the poorer the quality. White horsehair is strong like other horsehair, but more flexible and used fully loosened. Microscopically, horsehair appears as a series of tapering scales stacked on top of one another. Where one scale ends and the next begins there are little pockets that trap the ink and hold it until used. It is these pockets that make horsehair more absorbent than most other hairs. (The exception is sheep hair, which has many more pockets.)

The quality of a horsehair brush is, to a great extent, determined by the part of the animal from which the hairs come. Hair from the mane or back is coarse and of poor quality. Tail hair varies greatly in quality. It is often sorted into various grades and is used primarily for making large brushes. The finest horsehair is obtained from the belly and the ears. The shorter, better-quality hairs are used mostly in watercolor brushes, the longer and coarser hairs in calligraphy brushes.

Deer Hair From the Back is similar to that of the samba, but is not as coarse and has more spring than stiffness. The hair is usually variegated white and tan. This hair is used as an additive to increase the resilience of softer combinations of hairs.

The Weasel is common to both Japan and China, while sable is found only in China. Greater availability of weasel than sable has played an important role in its popularity, but since a brush made of weasel hair has less spring than sable it is even more desirable. Too much spring is considered a drawback. The Chinese, who do not generally distinguish between calligraphy and painting brushes, use weasel for both. In Japan, weasel is used mainly for detail-painting brushes.

Deer Hair From the Inner Arch is similar to so-called wolf hair, but is a little coarser. The combination of deer with other, softer hairs adds resilience to a brush. Deer hair is used for painting brushes in Japan.

Cat Hair is popular for making detail brushes. It is therefore not uncommon in the Orient to find the village cat missing large clumps of hair, yet not suffering from any particular ailment. Cat hair is soft with some spring and has a natural affinity for itself, causing it to hold a good shape.

Sheep or Goat Hair is the hair most used in Oriental brush making. It is made into large calligraphy brushes and flat wash brushes, and is combined with other

hairs. The hairs are boiled to straighten them, and resemble squirrel hair in behavior. They have no spring, but do have a fine point and a uniform body that, under a microscope, appears to consist of tapering, individual scales that are attached end to end. As on horsehair, there are small pockets where these scalelike shapes meet that allow ink to be trapped and held until used. Both sheep and goat hairs have these pockets, which contribute to their absorbency, but sheep hair has many more. The Japanese word *jofuku* is used to describe calligraphy brushes made of sheep hair. It means, "dip once, lot of ink." The best-quality sheep or goat hair has a very fine tapering tip. When made into a brush, this tip will have a distinctly yellow tint, but brushes of this quality are rarely found in the West and are extremely expensive.

Miscellaneous Animal Hair, including badger, rabbit, and tiger, is used in Oriental brush making.

Badger hair has a variegated black and white appearance. The hair is longer and thicker than sable, especially the belly of the hair. Badger is used in combination with other hairs to lend resiliency and to act as a filler in Japanese painting brushes.

Rabbit hair, from nondomesticated rabbits, is similar to badger hair but is shorter. It is used in combination with other hairs to make Japanese painting brushes and in China, for both calligraphy and painting brushes.

Tiger hair resembles a longer wolf hair. It is white, yellow, and black. It is said that the best hairs are obtained by plucking from a startled wild animal. Brushes of this type are extremely rare and may now exist only in legend.

Brushes made from goats' eyelashes, squirrel and rat whiskers, and even human baby hair (taken from the first haircut) are not uncommon in the Orient. These brushes are more novelties than practical artists' brushes and are not available in the West.

Types of Western Brushes

EACH STYLE of brush is designed to have the optimum performance with a particular type of paint or with a certain technique. Nevertheless, at this time there is no government agency regulating their use, and if you wish to use, for example, a watercolor brush for oil painting, the only penalty you might suffer is that the brush will not last as long and will no longer work with watercolor. The following are only guidelines. The rest is up to your own creativity.

BRUSHES FOR WATERCOLOR

The process of watercolor is extremely sensitive to the quality of the brushes used. Watercolor paint is too light to pull together a badly shaped brush the way oil paints can; it is also too sensitive to hide any imperfections in the tools used. All the finest watercolor paints and all the most expensive watercolor papers cannot compensate for a brush that does not perform well. The selection of at least one fine-quality watercolor brush is an absolute must.

Watercolor brushes perform best when they are soaked in water for a minimum of five to ten minutes before they are used. Wetting a brush first allows for the expulsion of all air bubbles, which can create streaks in the applied color, and permits the hairs to soften and come into a proper shape. To take the fullest possible advantage of a well-made watercolor brush, it should be held as perpendicular to the working surface as can be managed. A technique has developed over the years to compensate for badly made or badly worn brushes. It involves holding a round brush at a 45-degree angle to the working surface and slowly twisting the brush as the tip is drawn across the surface to produce a consistently drawn line. I have known people who spent years developing this technique and were startled to learn that a well-made brush held at the appropriate 90-degree angle produces this effect with little skill and effort.

There are also differences in watercolor brushes, other than quality and the name brand on the handle. There are considerable differences in style within the different shapes. The most common round brush sold for watercolor, for example, is an English-style round, although the English style of watercolor is not nearly as popular as styles that have developed through the years in North America. People who do detail rendering, or draw, or do line work, all require differ-

How Brushes Are Constructed

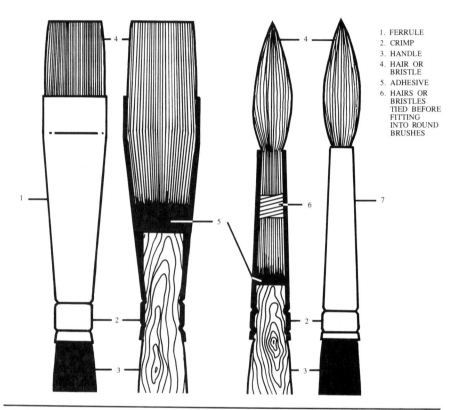

1. FERRULE
2. CRIMP
3. HANDLE
4. HAIR OR BRISTLE
5. ADHESIVE
6. HAIRS OR BRISTLES TIED BEFORE FITTING INTO ROUND BRUSHES

ent variations on the watercolor brush. Equipped with sufficient information, you should be able to make the best selection for your own needs.

Testing is of prime importance when buying a brush. Whenever possible you should test, or at least thoroughly inspect, a brush before you buy it. The following are some methods of inspection.

Check Uniformity. Many brushes have starch in the hairs to protect them until use. The starched tip has to be loosened to inspect it. This may be done by gently rolling the starched brush tip between two fingers. After you have done this, the individual hairs can be spread out by gently pressing the hairs near the ferrule to fan them out for inspection. Look for uniformity in length and appearance. There should be no blunt ends (hairs that are inverted), and the tips should not have been cut or trimmed in any way.

Check Fullness. The hairs of a brush should be gathered tightly so that there is a feeling of fullness when the hairs are pinched together near the point where they enter the ferrule. Brushes made with fewer hairs are gathered loosely to give a full look; these brushes have a hollow feel and compress easily when pinched. When the hairs of a genuinely full brush are bent sharply to one side

near the ferrule, there should be no gap between the lip of the ferrule and the hairs.

Check the Point or Edge. To do this, it is necessary to wet the brush. To give it a fair test you should wet it thoroughly, not just dip it and flick it around a few times. Sable or sablelike brushes will readily present a point in the rounds, or an edge in the flats, when removed from the water and the excess water is flicked off the brush. Small, soft-hair brushes like squirrel will point, or edge, like sable, but larger ones have to be shaped to a point.

Check Spring. Spring is the ability of a brush to return to its original shape after use. One method for testing the spring of a dry sable brush is to place the brush near your ear. Bend the hairs and quickly release them. You should hear the hairs snap back. To test a wet brush, bring it to a point and hold it perpendicular to a piece of paper. Then draw a line that starts thin and is made wider by slowly pushing the brush down. When the brush is pushed down halfway along the length of the hairs, lift it as the line is completed. The line should look like a cross section of a discus, and the degree to which the brush returns to its original shape determines its spring. The finest kolinsky brush will not only return to its original shape, but can perform this maneuver quickly and repeatedly. Kazan squirrel can perform this maneuver only if the first quarter of the brush is used and will not return at all if the entire brush is used. (This characteristic is ideal in squirrel and a drawback in sable because these hairs are used for different purposes.)

Standard Watercolor Rounds are the workhorses for traditional watercolor technique. Currently, the most popular brand and style is Series 7 by Winsor & Newton. The name is derived from the time when Queen Victoria commissioned Winsor & Newton to make her a brush in her favorite size, which was seven. It is said that it was made of the finest kolinsky with a silver ferrule and an ivory handle. Although brushes of this quality are no longer available, the name remains on the finest Winsor & Newton kolinsky sable brushes. With the excep-

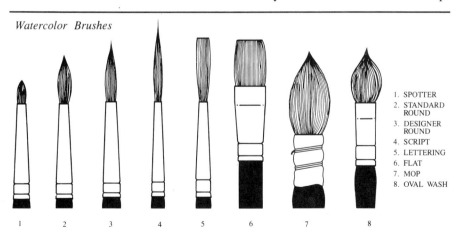

Watercolor Brushes

1. SPOTTER
2. STANDARD ROUND
3. DESIGNER ROUND
4. SCRIPT
5. LETTERING
6. FLAT
7. MOP
8. OVAL WASH

1 2 3 4 5 6 7 8

tion of the West German brush manufacturer da Vinci, which exports under the names Cosmos and Realité, Soviet prohibitions on the export of the finest Siberian kolinsky have resulted in a change to the Asian kolinsky. Da Vinci claims that its finest watercolor brushes are made with 100 percent Siberian male, winter coat, kolinsky. The ferrules of the brushes are gold plated. Sizing of the da Vinci brushes is modeled after the English. Grumbacher claims that in its finest watercolor brushes it's using old reserves of Siberian kolinsky that it had stockpiled before the restrictions.

Series 7 has dominated the American market because of its quality and its availability in larger sizes. The hairs needed to make such sizes as 12 and 14, which are difficult to find, must be quite long, between 1½ and 2½ inches (to obtain maximum spring the hair must be crimped at its belly resulting in half the length being buried in the ferrule). Winsor & Newton claims it requires six hundred tails in the size 12 and one thousand tails in the size 14 to find sufficient hairs of quality and length to make one dozen of each of these sizes.

The increasing rarity of quality long hair and the astronomical prices of the larger brushes have resulted in a greater openness toward other brands and styles of rounds. Some attention has focused on Raphael brushes, which is the artist brush division of the Max Sauer Company, one of the oldest Western brush manufacturers. Americans have not yet quite adjusted to the different size standards between the French or International and the English. English brush companies, although not as old as the French, are better established in the North American marketplace. I once asked the representative of a French brush company, in a typically American way, "Why do the French make their larger watercolor brushes smaller than the English?" To which he replied, "Why do the English make theirs so different from us? We have been making brushes for forty years longer than they!" In any case, French brushes seem to gain some of their economy, in the larger sizes, by using shorter hairs. This can often be a reasonable tradeoff when money is short as well.

Both English and French brushes are the same diameter in the small sizes up to about size 7, but the French brushes are a little longer, particularly in sizes 000 through 1. After size 7, they do not increase in diameter and length as much as the English brushes do. A French size 12 brush, for example, would be roughly equivalent to an English size 10. French brushes are shaped or cupped a little differently, resulting in a bit more point. English or French, companies such as Winsor & Newton, Realité, and Raphael still make among the finest watercolor brushes available today. When buying a Winsor & Newton brush, always look for the "made in England" stamp on the brush to be certain it is actually made by Winsor & Newton.

Kolinsky. Very few brush manufacturers are using the Siberian kolinsky, which is recognized by its light yellowish-red hairs. Commonly seen in the marketplace are shades that range from light to medium reddish-brown. The darker Chinese sable is used in the lesser-grade sable brushes. A sign of a well-made sable brush is a dark tip that lightens toward the ferrule. The best indicator of quality is whether or not the brush performs well. You should, therefore, always test a sable brush before you buy it.

Hair Assembly in Watercolor Brushes

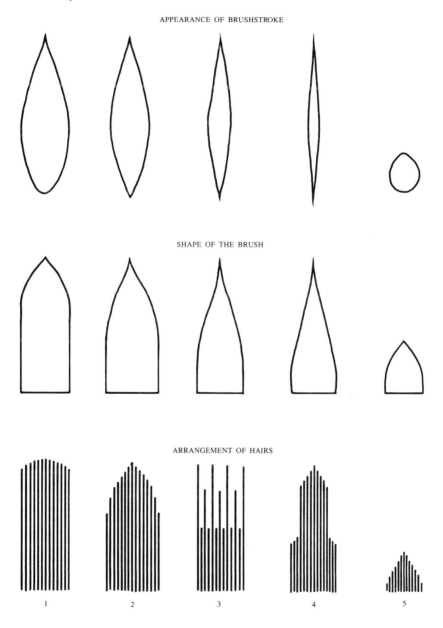

APPEARANCE OF BRUSHSTROKE

SHAPE OF THE BRUSH

ARRANGEMENT OF HAIRS

1 2 3 4 5

1. ENGLISH WATERCOLOR ROUND
2. FRENCH WATERCOLOR ROUND
3 and 4. DESIGNER'S QUILL OR ILLUSTRATOR ROUND
5. SPOTTING BRUSH

Red Sable. The dividing line between a fine-quality red sable brush and a lesser kolinsky sable brush is often unclear. A beginner might not be able to tell the difference. In the marketplace, however, there is often a clear difference between the "average" red sable brush and the "average" kolinsky sable brush. Whether a red sable brush is average or not, it should still point easily and well and, despite the reduced spring and responsiveness, should return to some semblance of its original shape. The sable hairs used to make red sable brushes are usually of the darker shades.

Sable, or Brown Sable. Sable hairs from the various marten animals are becoming more common as red sable continues to increase in price and diminish in availability. Well-constructed brushes of this hair are excellent for student use.

Nylon. White or golden sable, which are nylon substitutes for sable, are less costly and do get the job done. Brushes made from these filaments do come to a point, but have difficulty maintaining it, especially in the larger sizes, in spite of an excessive amount of spring. There are many inexpensive sable brushes that still cost more than nylon, yet will not point well to start with and have little spring at all. Point and spring are still more desirable than absorbency, which is nylon's most serious drawback. Nylon has no absorbency and watercolor tends to run quickly off the tip of the brush when brought into contact with a more absorbent surface such as watercolor paper.

Attempts to improve the ability of synthetic brushes to hold more paint have met with only limited success. Etching or coating the surface of nylon filaments does help reduce the surface tension (which improves capillary attraction) and slow the runoff of color, but the total volume of liquid held by the brush is not significantly changed. Synthetic filament brushes just do not hold the same volume of liquid that natural hair brushes do and, therefore, their value in applying washes or large amount of color is limited. It often takes two to five times more applications of material to cover the same area with a synthetic filament brush than with a natural hair brush.

One encouraging development in the attempt to improve the characteristics of nylon brushes has been made by the new company ProArte, which is attempting to market what it claims is a third-generation nylon named Prolene. The surface tension does seem to be lower than conventional nylon filament brushes. This can be seen by wetting a flat watercolor brush and then draining it until it is almost dry. A conventional nylon flat will develop a serrated edge and a Prolene flat will not. This indicates that watercolor should flow more slowly and evenly with this new filament. However, it still does not seem to resolve significantly the question of the small total volume of liquid held by synthetic brushes. Prolene is among the best performing of all synthetic brushes that I tested, and is also the most expensive. For a bit more money it is possible to buy a serviceable red sable brush.

Nylon filaments wear differently than natural hair; the filaments tend to curl at the tip rather than wear down. The curl can usually be removed by running almost-boiling water over it. This method will also restore the shape of nylon filaments that have been accidentally bent. (Never do this with natural hairs.)

Blends of Nylon and Natural Hairs. The addition of natural hairs to a nylon

filament brush does improve the performance without substantially increasing the price. This combination has reduced the excessive spring of nylon and increased the brushes' absorbency. Although such brushes are not equivalent to an average red sable brush, they do perform well and are an acceptable alternative when cost is a serious consideration.

These blended brushes consist of 10 to 15 percent natural hair with the balance made of synthetic filaments. Several manufacturers have used misleading advertising, which implies that their brushes consist mostly of natural hair when they do not. Natural hairs can be distinguished from synthetic filaments on close inspection with the naked eye, although it is easier with a magnifying glass. I have tested blends with sable and those with sheep, and I feel the less expensive sheep blends perform better. The use of sable blends seems to be more of a marketing gimmick. Sheep is more absorbent and has less spring than sable, which is precisely what a nylon brush needs.

Ox (Sabeline). Sabeline, or ox hair, has excellent spring and no point because of the nature of the hair. Consequently, it makes a poor round and I would recommend a brush that is a blend of nylon and natural hair instead.

Squirrel. A well-made squirrel brush can be just as valuable a tool as a well-made sable brush, for there are times when a softer, more fluid look is needed. Since squirrel has little spring and greater absorbency than sable, it would be a far better tool for producing this effect. Squirrel brushes should not be acquired as a substitute for sable, but as an adjunct. A squirrel brush should be at least twice the size of the red sable brush that is used most often. Squirrel brushes that come in extra-large sizes are called mops, which describes their use as well as their appearance. These brushes hold a tremendous amount of liquid and make excellent wash brushes.

Soft hair brushes like these need to be thoroughly wet, and soaking them in water for five to fifteen minutes (the larger the brush, the longer the time) before use will remove trapped air and reduce the natural surface tension of the hairs. Using a brush like this upright, or perpendicular, to a level working surface will give a better result than holding it like a pencil. In the larger sizes, squirrel has to be shaped to a point, which the brush will tend to maintain if it is held upright and only if the tip and not the belly of the brush is used.

Designer Rounds are virtually the same as the standard kolinsky sable round watercolor brush, but are shaped to give a longer tapered point. This particular shape is ideal for quick and precise brushwork, and is also better for line work and illustration. This style of brush is quite versatile and I feel should be the brush of choice for the watercolorist, graphic artist, and illustrator who prefers a detailed appearance over that of a semiabstract one.

Designer Quills are similar to the rounds except that the shape is thinner and longer, and the hairs are held in ferrules made of quills or a plastic substitute. The reason for the quill ferrule is in part tradition and in part to protect the hairs from the hard metal ferrules that might damage them during manufacture or during use. With this type of ferrule, the brush cannot be used when harsh solvents are involved.

These brushes are made of red sable or kolinsky sable, and are constructed with two to three lengths of sable hairs "stacked," or arranged in levels. "Stacking" can be done by taking a group of short hairs of equal length and surrounding them with a second group of longer hairs of equal length, and then repeating this with a third group of still longer hairs. This creates a brush that holds liquid color up close to the ferrule so that it can then be fed to a extraordinarily fine pointed tip.

This brush is known for its point, spring, and quick response, in which it has no equal. Designer quills are superb for line work, illustration, and egg tempera.

Script Brushes have the longest hairs of all the watercolor round brushes discussed so far. Script brushes are lettering, or showcard, brushes and have a pointed rather than a chiseled tip. This is a large category of brushes in which various qualities and types of hairs are used. They may be set in metal or quill ferrules and they are primarily used for commercial lettering. The advent of dry transfer lettering and other innovations in the sign and lettering industries have considerably reduced the demand for these brushes. However, they are also used for special effects in watercolor, line work, and illustration.

Many script brushes are made of sable hair, but squirrel and sabeline are also commonly used. The longest sable hair does not possess much spring because the belly of the hair is exposed beyond the tip of the ferrule to gain usable length. The great length of the hair enables a skilled artist to draw a long, consistent line without all the stops that would be necessary when using a conventional watercolor round.

Spotter Brushes are used to apply little round dots of liquid color. There is a common misunderstanding that a spotting brush is an extraordinarily small brush with a long narrow point. Such a brush produces tiny dashes, not tiny dots.

A true spotter is a very short-haired sable or kolinsky brush that has a short taper to a definite point. Although spotters are made in extremely small sizes, sizes up to 10 and 12 are useful not only to graphic artists and restorers, but also to watercolorists who need to apply color in a tight corner in one stroke rather than with the many overlapping strokes that are necessary when using a conventional round brush.

Lettering, or Showcard, Brushes include riggers, lettering quills, and one-stroke brushes. Riggers and lettering quills are round brushes that have long hairs that are shaped to a chisel tip, rather than a pointed tip. The one-stroke brush is the same as a regular flat watercolor brush, but the hairs are $1/4$ to $3/8''$ longer. These brushes are used primarily for lettering, but many are also used for special watercolor effects.

Riggers are like script brushes that come to an abrupt end, which is shaped, not cut. They are made of sable and have a metal ferrule. They range in size from approximately $1/16$ to $1/4$ inch in diameter. The numbering system for each size may vary, depending on the manufacturer, since there does not seem to be an agreed-upon size standard.

Lettering Quills are like riggers, except that they have quill ferrules instead of metal ferrules. They are available with hairs of squirrel, nylon, and ox

(sabeline), as well as sable. Squirrel, with its minimal spring and greater length, works best with paints that are of a heavier consistency such as that of enamels. Sable, nylon, and sabeline, with their greater spring and control, work better with more fluid paints such as watercolor.

Watercolor Flats are used for watercolor washes, for rendering edges or geometric shapes, and for filling in large areas. The most common numbering of sizes is in inches such as ¼, ⅜, ½, ¾, and 1 inch. Flats have the same short style of watercolor handles, but with an additional variation—a plastic handle that has a beveled end. Grumbacher was the first to market this style of brush, which it called Aquarelle. The name has stuck and is commonly used when describing this style of brush without regard to the actual manufacturer. The beveled handle serves as a tool for burnishing areas of a watercolor to produce a special effect. Beveled handled brushes are made only with hair that has spring, such as sable, ox (sabeline), nylon, or nylon blends.

Sable flats for watercolor have become increasingly rare because of their high price and the unwillingness of manufacturers to produce brushes that are slow-selling. A great deal of sable hair is required to make a 1-inch flat sable, and it would sell for between sixty and one hundred dollars. Most people find it hard to justify the expense of a brush that is used less frequently. For an individual who uses a flat watercolor brush more often, however, sable does have some distinct advantages.

Because sable hair has spring, absorbency, and point, a flat sable brush can form narrow edges at the tip. This can easily be seen by wetting the brush and flicking off the excess water, then turning the brush sideways. As you look down the edge, the shape will resemble the cross section of an airplane wing; the hairs near the ferrule will be tightly compacted, the body of the brush will be the thickest part, and the tip will come to a razorlike edge. This unique edge allows the brush to be used in two ways; the first is simply to use the flat part of the brush to cover large areas; the second is to use this edge to draw or paint a narrow line, which is accomplished by placing the brush edge perpendicularly to the working surface and moving the brush along the narrow edge rather than the flat edge. It is far easier to paint a straight line with this kind of flat brush than with a round brush.

A poor flat sable brush, or one on which the tip has been cut to correct poor craftsmanship, will not give this edge. You can inspect a dry, flat sable brush by first looking down the length of the hairs, with the tips pointing toward you; if the brush has been cut it will have a faint, two-tone suede look. Wetting the brush will provide the final test to see if it produces a fine edge.

Ox (Sabeline) has spring but no point. Flat brushes made with this hair behave similarly to sable flats when used to cover large areas with color, but sabeline will not form a narrow edge that could be used for drawing lines.

Nylon has spring and when used in a flat brush it will form a narrow edge for drawing. But since nylon has no absorbency, it does not perform as well as a natural hair with wash techniques. One wash technique, for example, involves the slow application of color, and also a dry brush to soak back up part of the still wet color. The nonabsorbency of nylon makes this difficult.

Blends of Synthetic and Natural Hairs are good, low-cost substitutes for sable. I particularly recommend the blends of nylon filaments and sheep hair where 10 percent or more of the brush is natural hair.

Sheep or Goat have excellent absorbency but no spring. Consequently, the brushes made of these hairs are excellent for washes, but are not adequate for rendering.

Squirrel, like sheep, lacks spring but has great absorbency. The better-quality squirrel hairs, such as kazan, are finer and softer than sheep and are therefore better for more delicate washes or applications of color.

Watercolor Ovals look like squashed, round brushes. In appearance, they are halfway between round and flat brushes, and are made primarily of squirrel hair, the best ones being of kazan squirrel hair. This style of brush is designed for creating washes where the color is applied gradually. When you apply color with a traditional flat brush, the straight edge of the brush begins the application of color abruptly, leaving a hard edge. With an oval brush, the application of color starts more gradually with a narrow point and then expands for wider coverage.

An oval brush should not be purchased as a substitute for a sable or a sablelike flat. It is best used as an adjunct to a flat brush.

Mops are large squirrel hair brushes. The first choice in squirrel hair is kazan squirrel, with blue squirrel a close second. The lesser-grade mop brushes are often made with pony hair or with other less costly hairs, which produce a coarser brush. Large, good-quality mops are difficult to make and it is not uncommon to find that the lesser grades of mop brushes have been cut into shape with scissors. If your sole concern is the application of a great deal of color, these lower-cost and lesser-quality mops should prove adequate. If you wish to have more painterly control, however, it will be necessary to select mops made of hairs like kazan squirrel. Inspection is particularly important because if the brush has been cut, it will not point or provide good control.

There are mops in which the hair is built up around a "plug," or spacer, to save on the amount of hair needed to fill the brush and also to provide a better point. In the larger sizes you can feel for this plug by pressing your little finger toward the center of the gathered hairs near the ferrule. The reduced concentration of hairs will reduce the amount of liquid that the mop can carry at one time. This is not a serious drawback if a point is more important to you than the ability to carry truly large amounts of color.

BRUSHES FOR OILS

Quality is not as important in an oil painting brush as it is in a watercolor brush because the viscosity of the oil helps pull together and give control to a brush that would be questionable for use with watercolors. This is not to say that quality is not important, but rather that the techniques of conventional oil painting are not as sensitive to small imperfections in brushes as are the techniques of watercolor. Possible exceptions are tole painting, miniatures, and photorealism, where the quality of the brush may be integral to the technique. For these styles, the finest oil painting brushes and, in some cases, the finest watercolor sables, are selected for use, regardless of price.

There is also a greater cost consideration with oil painting brushes. With watercolor brushes, it is not unreasonable to spend a great deal of money on brushes. When cared for properly, the brush can last for decades. When painting in oils, it is not uncommon to use up a set of brushes, especially sable brushes, in the production of one painting. With the exception of pig bristle, the guidelines for brush testing and inspection are the same as those for watercolor brushes. (For more information about testing brushes, see pages 56 to 57.)

The primary reason for using sable oil painting brushes is to be able to apply paint with a minimum of texture and a maximum of control. Kolinsky sable provides the greatest control, but kolinsky oil brushes are rare. They are not as expensive as kolinsky brushes made for watercolor because shorter hairs are used in oil painting brushes, which makes for better control in pushing around thicker oil paint. Unless meticulous detail and control is needed, kolinsky sable oil painting brushes are unnecessary with conventional techniques.

Red sable oil brushes are adequate for figurative painting where control is needed to render details, and for abstract painting when a smooth surface or a sharply defined edge is desired. (Blends of nylon and natural hair are not yet available in oil painting brushes.) Nylon oil brushes have filaments of a thicker diameter than those used in watercolor brushes and are therefore stiffer. At one time a still thicker nylon filament was used to make a substitute pig bristle, but it never caught on. The brushes were more expensive than natural bristle and did not perform as well.

The lack of absorbency of nylon is not a serious problem in oil painting. There are, however, two additional drawbacks to oil painting with nylon brushes. The first of these drawbacks is that when a nylon brush is rubbed vigorously over a gessoed canvas surface, the friction causes the ends of the nylon filaments to curl. (The curl can sometimes be removed by placing the tip of the brush in water that has been brought to a temperature just below boiling.) The other drawback is due to the thicker nylon filaments, which result in a brush with excessive spring. Too much spring in a brush can cause previous layers of paint to be disturbed during application of fresh layers of paint. The great advantage of nylon is the cost savings, which can sometimes outweigh the drawbacks.

Oil bristle (hog, pig, or boar) brushes are used for the application of thick paint, for scrubbing and scumbling (a technique of applying a lighter, semi-transparent color over the surface of a darker color), and to impart texture to the painted surface. Sable brushes apply paint smoothly and consistently, while bristle applies paint roughly and inconsistently, giving a more impressionistic appearance to the painting. The stiff quality of bristle can leave streaks or gaps in the application of a fresh layer of paint, and this can allow the underpainting to show through for effect. Sables are used to create a more refined version of this technique by glazing (a small quantity of paint is dissolved into medium and applied thinly over another layer of paint so that the layer beneath can be seen through the top layer of paint).

To inspect a bristle brush, check the amount of flagging and see if the tips of the bristle have been cut. The flagging should be plentiful because it is the softer split ends of that flagging that give control to the tip of the brush. If the flagging is minimal, because the bristle has been taken from domesticated animals, or

because the tips have been cut to improve the appearance of a poorly made brush, the performance of the brush will be excessivly coarse and erratic.

There are two styles of brushes for which the bristles are treated and assembled to make oil bristle brushes. There are "interlocked" and "non-interlocked" brushes. Part of the process of treating bristles is to boil them to clean them and remove part or all of their natural curve. The longer the bristles are boiled, the straighter they will become. Noninterlocked bristle brushes are produced from bristles that have been boiled until they are straight. These are then made into a brush that resembles a small broom in appearance. In a finely made brush this broomlike appearance means that there is plenty of flagging and the brush has not been starched to improve its appearance. When such a brush is loaded with paint, the splayed, broomlike look will change as the weight of the paint draws the bristles of the tip closer together. In a cheap brush made with inferior bristles, the splayed broomlike appearance will change little when loaded with paint, and the bristles tend to spread even farther apart with the slightest pressure.

Interlocked bristle brushes contain bristles that still have part of their natural curve, and in which the curved bristles are assembled so that the brush narrows toward the tip. For example, a flat brush would be made from two groups of curved bristles, each gathered into the ferrule so that one side is curved toward the other. This gives the brush the opposite appearance to that of a splayed broom—the bristles curve outward rather than inward. The purpose of making a brush this way is to give greater control to the tip of the brush so that it resists spreading under pressure. Greater care is needed to make an interlocked bristle brush, and such brushes are therefore more expensive than those with non-interlocked bristles.

Although it is common practice to starch the hairs of a brush to help protect them from damage until they are sold, you should beware of noninterlocked, lesser-quality brushes that have been heated, starched, and molded to look like interlocked brushes. Visual inspection of a bristle brush can indicate only some of its strengths and weaknesses. Unfortunately, there is no adequate pre-sale testing procedure for bristle brushes as there is for sable brushes. After you have checked the flagging and tested the spring by pressing the brush down, bending the hairs in a 90-degree angle in the palm of your hand, and comparing the resistance, the next step is to buy the brush and test it under actual use.

It is my experience that buying the very best bristle brush you can afford is not always a good idea. Many artists have established styles that depend on the lack of consistency and control that is derived from lesser-quality brushes.

Oil Sable Rounds are made with shorter hairs than the traditional watercolor round brushes. This is to allow for the manipulation of the heavier oil paint. A few brush makers still produce rounds of shorter and longer lengths for special effects. These brushes, however, are not generally stocked by retailers in North America, although they can be specially ordered. When a special-purpose brush is desired, most artists make a selection from the more available styles in the watercolor rounds.

Oil Brushes

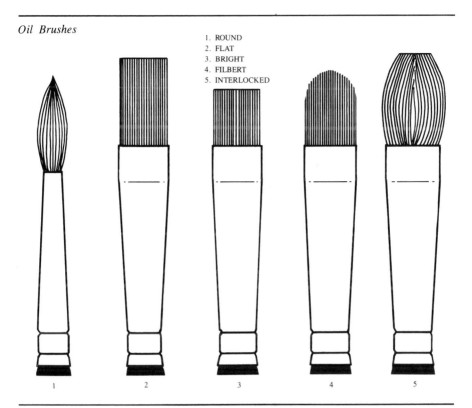

1. ROUND
2. FLAT
3. BRIGHT
4. FILBERT
5. INTERLOCKED

1 2 3 4 5

Oil Sable Flats also have shorter hairs to allow for the heavier consistency of oil paint. The term "flat" in reference to a sable flat oil brush is misleading. There are two basic styles of sable flat oil brushes, one is a "bright," which is a flat brush with short hairs, and the other, a "flat," which is a flat brush with long hairs. The brights are better for general painting and the flats for glazing. Since the glazing technique has not been as popular in North America as in Europe, most of the flats that are available here are brights.

The purpose of an oil sable flat is to cover larger areas, to render edges, and to apply thin, smooth layers of paint with a minimum of texture.

Oil Sable Filberts are said to resemble worn flat brushes. The shape of a filbert is halfway between that of a round brush and that of a flat brush. So what is so good about a brush that has neither a point nor an edge? When paint is applied with a filbert, there is little or no textural beginning or end to the brush stroke. Consequently, paint can be applied smoothly and the brush strokes that are left behind in the paint film are difficult to see.

Bristle Rounds are used for impressionistic rendering, or drawing with oil or acrylic paints. The coarse bristle does not permit detail rendering as sable does. A noninterlocked brush that is not starched and has good flagging will appear to have a very blunt tip, although when the brush is loaded with paint the tip should narrow considerably to a workable point. An interlocked round bristle

will display this tapered point before use, and will spread considerably less than the noninterlocked round, and will maintain better control with extended use.

Bristle Brights are flat brushes with less bristle exposed. The bristle used is approximately one-third shorter than that used in the round or flat bristle brushes. Using this length provides a much stiffer brush and allows the handling of very thick paint mixtures (almost as if the brush were a miniature palette knife), and enables the use of such techniques as scumbling (scrubbing the paint into the surface for effect). Here again flagging is important, and if more precise control is desired, the interlocked bristle is preferable.

Bristle Flats have approximately the same length of bristle exposed as the round bristle brushes. This length allows for a softer technique where heavy paint can be applied with less texture than would be left by a bristle bright. Interlocked bristle is most effective in the larger sizes of flat brushes.

Bristle Filberts look like flat bristle brushes with the edges worn down. It is not uncommon to find that a painter's favorite tool is a flat bristle brush with the edges worn down, yet few such painters have tried a filbert. A filbert is a bristle brush made to duplicate this oval shape. The rounded edges allow the application of paint without the abruptness that occurs when painting with a flat or a bright bristle brush. With a filbert, an artist can draw thin lines by using the edge, or thick lines using the flat of the brush, giving an overall softer look to the painting.

Oil Blenders are used primarily to remove brush marks and texture. The painted surface, while still wet, is rubbed with the tip of a blender. There are fan-shaped blenders and round blenders. Blenders, particularly those that are fan-shaped, are also used to apply paint when special effects are desired.

The round blenders are actually large, round, squirrel lettering quills or mops. Fan-shaped blenders are available in bristle, badger, sable, and nylon. Bristle fans are the least expensive and, in most cases, the least effective because of the coarseness of the hair. Sable fans are very expensive and most effective in areas where precise and delicate blending is necessary. Nylon is more expensive than bristle but far cheaper than sable and, in most instances, is adequate only for blending. Nylon does not hold up well if the blending requires a great deal of scrubbing because the filaments tend to curl. Badger blenders are an excellent compromise because they are significantly less expensive than sable and perform almost as well.

A blender rapidly becomes ineffective if paint is allowed to build up on the tip of the brush. It is helpful to clean the blender frequently.

Winsor & Newton and the da Vinci Company still make a pure red sable fan blender. Raphael (Max Sauer Company) makes a uniquely large badger fan blender, which is labeled "12 12," or "double 12."

EXTRA-LARGE BRUSHES

With the one exception of Winsor & Newton, size 14 Series 7 watercolor brush, the Max Sauer Company sets the world standard for extra-large artists' brushes.

This company is one of the few brush makers that still makes fine-quality extra-large brushes. Raphael is the name placed on the brushes made primarily for artistic use, and Sauer is the name on brushes made primarily for industrial use. Raphael supplies conventional artists' brushes with extra-long handles (36 inches long), as well as extra-large bristle (or ox hair) brushes (up to 120mm or approximately 4¾ inches wide) with conventional handles. Sauer's industrial brushes are made primarily of bristle, have heavy-duty handles, and are available in flat sizes up to 300mm (or 11¾ inches) wide, and round bristle brushes up to 2 inches in diameter.

Industrial brushes, regardless of the manufacturer, are certainly acceptable for artistic use if they will get the job done. There is a great range in quality among industrial brushes and proper examination is important. In addition to inspecting these brushes as you would any artists' brush, it is important to look for an excessive amount of loose hairs, cut hairs (some cut hairs can be tolerated in extra-large brushes), weak handles or badly crimped ferrules, and plastic spacers, which are sometimes set into the ferrule to cut down on the amount of hair needed to fill out a big brush.

Loose hair can be checked for in a large round by spinning the brush in the palm of the hand, and in a flat brush by slapping the ferrule against the palm of the hand. This will help force loose hairs up and out of the brush. Most large brushes will lose some hairs at first, but this shedding should stop with normal use. Weak handles or badly crimped ferrules are easily checked by applying some pressure at these points. (One buyer for an industrial paint store used to test brush handles by breaking them over his knee.)

The hardest thing to test for is a plastic spacer that is used to scrimp on the amount of bristle. The outside of the brush will appear quite normal, but in use it will not carry, or hold, very much paint. Medium to large spacers can be felt for by pushing the small finger into the center of the bristles near the ferrule. Small spacers, however, are difficult to detect without destroying the brush in the process.

Because of price, nylon has almost totally replaced natural bristle in the large brushes available in hardware and house paint stores. Nevertheless, I do not recommend large synthetic brushes because of their lack of absorbency. All professional house, or industrial, painters know that it takes twice as much work to paint something with a synthetic brush as it does with a natural bristle brush, because the brush has to be dipped into the paint twice as often and there is also far less control.

ACRYLIC BRUSHES

At one time, a variety of synthetic filament brushes were specifically marketed as "acrylic brushes." They rapidly fell into disfavor when people discovered that these brushes had no special advantages and, in some cases, were priced higher than brushes made for other media.

When acrylics or vinyls are to be used like oil paints, oil painting brushes are best. If the acrylics or vinyls will be used in a watercolor technique, then traditional watercolor brushes are best.

Types of Oriental Brushes

IN THE WEST, a brush is considered simply a tool for self-expression; it needs little character of its own. A brush should also be multipurpose—the "vegematic" approach to brush selection—so one or two brushes fulfill all needs. In the East, however, there is a tradition of treating artists' materials as friends, rather than as slaves to artistic expression. Artwork is a cooperative process that involves the unique characteristics of the tool as well as those of the artist. The belief is that no single brush does everything well, and to have true versatility several styles of brushes are needed. Thus it is common to find many different shapes and styles of Oriental brushes.

The actual selection of a brush is based on the calligrapher's aesthetic attitude and choice of technique. There are two major types of aesthetic attitudes. The first proposes that calligraphy involves producing readable characters and that their appearance should follow traditional laws, or rules, of writing. This point of view is similar to the Western notion of fine penmanship. In the East, this attitude is referred to as the Old Style, or Chinese style, of calligraphy, and the selection of the right brush for the correct form is critical. The second, and more modern, attitude is more concerned with the state of mind and the aesthetic appearance of the characters than with readability. The emphasis here might be more on the ink or the paper than on the brush that is used. This style is referred to as the Japanese style, even though both styles are commonly used in Japan.

Technique is the other major determining factor in choosing a brush. In Japan, there are four techniques, or styles, of writing. *Jofuku*, which means "dip once," is a style where the brush is dipped only once and narrow lines are produced. Part of the idea is to finish before the ink runs out, as well as to do the stroke without hesitation. Of all the Japanese calligraphic styles, this one is most easily applied to Western watercolor techniques.

Cultural differences affect not only style and attitude but also the composition of the brushes themselves. Chinese brushes, for example, are often composed of just one type of animal hair: weasel, rabbit, or goat. While the Chinese do not differentiate between brushes that are used for calligraphy and those used for painting, the Japanese do make a clear distinction between the brushes intended for each purpose. Japanese brushes may contain one or more types of hair

selected from horse, badger, sheep, goat, deer, cat, and, in some cases, weasel. Hair such as horsetail, badger, deer (from the animal's back), and weasel are selected for their firmness and are commonly used as the central core in building a brush. The softer hairs—sheep, goat, cat, and deer (from the inner arch)—are selected for absorbency and are often wrapped around the firmer central core. The softer and more absorbent hairs have a great inclination to stay together when wet. When used as the outer wrap, they tend to bind together the less absorbent firmer hairs of the core and give the brush more control. Brushes that are made primarily of coarse dark hairs such as horsetail are left partially starched, up to one-third the length of the hairs near the ferrule, to give added control, and only the first half of the brush is actually used.

Oriental brushes are heavily starched to protect them until they are purchased. Before use, the starch should be removed by washing the brush in room-temperature water until the working length of the brush is fully loosened. The softer brushes, particularly the painting brushes, are always fully loosened.

A particular style of brush may have several names. One name given to the brush may, for example, be taken from the family who originally made that style of brush. It might be a poetic description, or simply a listing of the composition of the brush. In some cases, no name is used. Since names cannot be relied upon, it is important to understand both the intended function and the composition of an Oriental brush to make a proper selection. It might be helpful, however, to know that the Japanese have five descriptive terms that they use to distinguish the general appearance of round brushes. Flat brushes, as opposed to round brushes, are all lumped into one category and called *hake*.

The first category of round brushes is *choho*, which means "long tip" in relation to the diameter of the handle. The Japanese use this type of brush in the *jofuku* style. The Chinese have a version of this brush in which the hair can be up to one-third the total length of the brush. This type of brush is commonly used in the Zen style of painting, which resembles the *jofuku* style of calligraphy.

Chuho, which means "regular long hair," is the second category. *Chuho* refers to the basic painting brush.

Category three is *tanpoh*, which translates as "short hair" and is used to describe brushes used for coloring.

Menso, category four, means "small detail" and describes small brushes used for detail.

The fifth category, *jakuto*, or "peacock head," is an ancient style of calligraphy brush, which is neither popular nor even found in the West. This brush has a long, thin handle with a ferrule that resembles a bulb and holds cat hair.

For the sake of simplicity, all the commonly used Oriental brushes have been broken down into two major types based on their intended use, whether for calligraphy or painting. The Japanese term for calligraphy is *sumi*, meaning ink. The term for painting is *sumi-e*. Therefore, *sumi* brushes are for calligraphy and *sumi-e* brushes are for painting. Because of the dominance of Japanese brushes in the market, it has become common practice to refer to all Oriental brushes, regardless of national origin, by the Japanese terms *sumi* and *sumi-e*.

CALLIGRAPHY (SUMI) BRUSHES

Calligraphy brushes are designed to be held perpendicular to the paper; the width of the brushstroke is varied by pushing the tip down into the paper or lifting it up while moving the brush parallel to the surface. This allows for the proper flow of ink or watercolor from the belly of the brush to the tip and helps the brush to maintain a proper point. If more than the first half of the brush—the tip to the mid-length of the hairs—is used, or if the brush is too dry, point and control are lost.

Any brush that is to be used with watercolor or ink should be wet before dipping it into the watercolor or ink. A large calligraphy brush should be prepared approximately fifteen minutes in advance by first thoroughly soaking it (hold the brush in water to soak—never allow the weight of a brush to be supported by the hairs) in room-temperature water to allow trapped air to escape. The excess water may be removed by gently squeezing the hairs together without pulling on them. The brush should then be placed upright in a jar to stand for the remaining length of time. Preparing the brush for this length of time gives the hairs a chance to soften and the scales to open and allow for the reduction of surface tension to increase absorbency.

When it is time to clean up, it is preferable to rinse the brush with warm water. If Oriental ink (sumi) has been used, it is recommended that some ink, 10 to 20 percent, be left in the brush to dry. This will cause a slight stiffness and protect the hairs until the brush's next use. (For more information about brush care, see pages 80 to 82.) After the brush has been rinsed, it should be squeezed dry, reshaped, and hung tip down to dry. If wet brushes, particularly large brushes, are left standing upright in a jar to dry, or stored away before they are thoroughly dry, the hairs will mildew, rot, and fall out.

Sheep or Goat Brushes are popular in China and Japan. Sheep or goat hair is long, at least 2 inches in length. It is very absorbent and can be shaped into a fine point when wet. Sheep hair has a natural inclination to stay together when wet and will, therefore, make it possible to maintain excellent control even when all the protective starch has been removed and the hairs have been fully loosened.

Few types of hair will hold up well or make good control possible when the direction of a brush stroke is changed 180 degrees without stopping, or without lifting the tip of the brush off the working surface. Sheep hair is very elastic and is one of the few hairs that will survive this type of treatment.

Horsehair Brushes are used primarily by the Japanese. Horsehair is popular because the length of the hair makes it possible to create extremely large brushes. Horsehair does not have any natural ability to stay together when wet, and is often left partially starched, or is covered with an outside layer of sheep hair. Calligraphy brushes made only of horsehair are loosened only one-half to two-thirds from the tip; the remainder of the brush is left permanently stiff, and only the first quarter to one-half is ever used.

Horsehair is not as elastic as sheep and will not hold up as well if dramatic changes in direction are not accompanied by the lifting of the brush from the working surface. White horsehair, however, is an exception to this rule.

Calligraphy (Sumi) *Brushes*

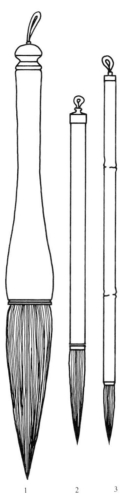

1. EXTRA-LARGE CALLIGRAPHY BRUSH, usually horse or sheep hair
2. LONG-HAIR CALLIGRAPHY BRUSH, usually sheep *(choho style)*
3. CHINESE-STYLE CALLIGRAPHY AND PAINTING BRUSH, usually sable and/or weasel

|||||
1 2 3

Weasel or Rabbit Brushes, or brushes made of a combination of weasel and rabbit hair, are popular in China for calligraphy. Brushes made of these hairs are for smaller calligraphy pieces and for everyday writing. They are preferred for their quick reponse and point. These brushes are used fully loosened.

Samba Brushes are highly prized among Japanese calligraphers because of the hair's great resiliency and point. They are used either partially or fully loosened. Samba brushes have become rare in the West and when found are often expensive. To the beginner, a samba hair brush often tends to feel uncontrollable, if not wild.

Badger Hair is used in Oriental brushes only in combination with other hairs. Badger hair adds resiliency to a brush.

WATERCOLOR (SUMI-E) BRUSHES

Since watercolor painting is more sensitive to the quality of the brush, greater care is often taken in selecting and assembling watercolor brushes than calligraphy brushes. It is not uncommon to use a watercolor brush for both watercolor and calligraphy, particularly in China.

The method of applying paint with a watercolor brush, although prescribed, is not as restrictive as is the application of ink with a calligraphy brush. Most brush strokes still involve a combination of up and down movements, onto and off the working surface, that are accompanied by parallel movements across the surface. The brush may be held at different angles, however, to give a greater variety of painterly effects. Skill at performing the various movements, coupled with knowledge of the way a particular style of brush will behave, allows the artist to create spontaneously artwork that is natural to the eye with a minimum of effort and great economy of form.

Watercolor brushes are used fully loosened, and the full length of the hair is commonly used. Those brushes that are made with combinations of the more resilient hairs are not designed for 180-degree changes in direction without first being lifted from the working surface.

Watercolor brushes can be divided into those that are used primarily for rendering and those used mainly for sketching or shading. Rendering brushes, which are the *menso* style, are used similarly to small Western watercolor brushes to produce detailed images through the use of multiple small brushstrokes and outlining. Sketching, or *chuho*-style, brushes and shading, or *tanpoh*-style, brushes are used for creating an image, often semi-abstract, with a minimum of brushstrokes. Sketching brushes are usually dipped into three values of ink to create shading in one stroke. The brush is first dipped fully into the lightest value, then it is dipped approximately one-half the length of the hair into the middle value, and, finally, the tip alone is dipped into the darkest value.

Weasel, cat, and rabbit hair are used primarily in brushes designed for rendering. Sheep hair, horsehair, deer hair from the inner arch, bamboo, and blends of natural hair and synthetic filaments are used in brushes that are designed for sketching or adding color.

Japanese Weasel Brushes are sharply pointed, narrow, and small. The length of the exposed hair is longer than a Western sable brush of the same diameter. This brush closely resembles a designer's quill. This type of brush is commonly called *menso* and is used for detail drawing, line drawing, and illustration. It can be used either partially loosened or fully loosened.

Chinese Weasel Brushes are sharply pointed and resemble Western watercolor brushes in shape and size. These brushes are used fully loosened. This style of brush is commonly bought in a set of three—small, medium, and large. The small is roughly equivalent to a size 7 Western watercolor brush and the large is comparable to a size 14. This style of brush behaves almost identically to that of a Western sable watercolor brush, and is one of the few Oriental brushes that can easily make the transition to Western watercolor technique.

Cat Hair Brushes are detail brushes that resemble Western spotting brushes in

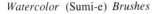

Watercolor (Sumi-e) *Brushes*

1. BAMBOO BRUSH,
 ANCIENT STYLE
2. BASIC PAINTING BRUSH,
 CHUHO STYLE
3. KUMADORI BRUSH
 (used for shading
 and round shapes),
 TANPOH STYLE
4. MENSO BRUSH
 (for details)
5. SAISHIKI BRUSH
 (for color),
 TANPOH STYLE
6. HAKE BRUSH

1 2 3 4 5 6

shape and size. Only the short, white cat hairs, or the tips of the longer hairs, are used in brush making. These brushes are used fully loosened to apply the finishing touches to a painting, or to apply a glaze to ceramics.

Rabbit Hair is used in China to add resiliency to a brush. It is rarely found in a brush by itself.

Sheep Hair is used in three types of brushes. The first is a flat wash brush, which is called *hake* in Japanese. There is a large variety of shapes and sizes of *hake* brushes. The best are those in which the hair is glued together and then sewn into a lacquered handle. All sheep brushes seem to shed some hair, especially when new. The better-quality brushes cease to lose hairs after several

washings. *Hake* brushes are used for the application of delicate watercolor washes, for the application of adhesives, and even as theatrical makeup brushes.

Small to medium-size, short, round brushes made primarily of sheep hair are commonly called *saishiki* and can be categorized as *tanpoh*-style brushes. These brushes are used to add color or shading to a painting and are used fully loosened. They can be classified as rendering or sketching brushes.

Sheep hair is often used as an outer layer of a brush to add absorbency and control, particularly when the core is composed of horsehair.

Horsehair Brushes used for watercolor, as opposed to horsehair calligraphy brushes, always contain some sheep hair. The sheep hair may be mixed in randomly with the horsehair, as is done in the less expensive brushes, or, better, it may be a separate outer layer. Since horsehair brushes for watercolor are used fully loosened, sheep hair is needed to help keep the horsehair together during use. The better-quality brushes are made from horsehair taken from the ear and belly of the animal.

This type of brush, which falls into the category of *chuho*, was developed in Japan, and is commonly sold in the West under either of two names, *choryu* or *seiryu*. This is the basic *sumi-e* brush, the workhorse of Japanese painting. It is common practice to dip this brush into three different shades of ink to produce an image that is shaded and sketched in the same stroke. There are rarely more than four available choices in size; these are designated small, medium, large, and extra-large. The Western equivalent for small is about a size 7 in an English watercolor brush, and extra-large would be near a size 14.

Deer Hair (Inner Arch) Brushes are made in several styles. Deer hair (taken from the inner arch) is used primarily by the Japanese in brush making. It is used to produce both *chuho*- and *tanpoh*-style brushes. There is one style called *kumadori,* a *tanpoh* brush, in which the better grades are made with 100 percent deer hair. The lesser grades are blends of sheep, badger, horse, and, sometimes deer. *Kumadori* brushes look like extra-large Western spotting brushes; the length of the hair is short and the shape resembles the tip of a bullet. A *kumadori* brush is used for shading and to sketch semicircular shapes, such as plum blossom petals. Shading is sometimes accomplished by loading this brush with plain water and running the tip of the wet brush along a painted edge, causing it to bleed. This style of brush is popular among ceramists for applying glazes in designs to the surface of pottery.

Deer is often used in combination with such hairs as weasel and horse to produce an all-purpose sketching brush that resembles in appearance the *choryu*, or *seiryu,* brush, but which has a different responsiveness. The feel of this style of brush is like that of a Western watercolor brush, and it is commonly called by the name of *gyokuran* or *maruyama.* This brush is used fully loosened.

Bamboo Brushes are made by leaving one end of a piece of bamboo to rot in the ground until it is soft. The individual fibers are then separated by mashing them with a mallet. This brush is used for both calligraphy and painting, when a distinct textured appearance is desired. Drawings or sketches with this brush will have an abstract quality.

Blends of Natural and Synthetic Hair in Oriental brushes would seem to contradict romantic notions about the purity of the tradition in Oriental artists' materials. Because of the substantial price increases in recent years, the temptation to use less costly ingredients for brush making is no longer being resisted. Because of the sensitivity of *sumi-e* to the lack of absorbency inherent in synthetic brushes, the proportion of natural hair to synthetic hair must be higher than would be found in Western brushes. If there is too little natural hair, the paint will collect at the tip of the brush rather than remain in the belly. The result will be too much paint deposited at the beginning of the brushstroke and not enough at the end.

Early efforts by the Yasutomo Company to strike an effective balance between synthetic fibers and natural hairs to produce a more affordable category of Oriental brushes have been moderately successful. Their first efforts are in the *choryu, menso,* and *hake* styles of brushes. These brushes are a reasonable alternative when cost is a serious concern.

Recommended Brush Assortments

THE FOLLOWING RECOMMENDATIONS are made without mention of quality, and are intended only as a guide.

WESTERN WATERCOLOR BRUSHES

Basic Assortment

One standard watercolor round, size 7 or larger.

One watercolor flat, ¾ inch or larger.

One watercolor mop, twice the size of the standard round or larger.

General Purpose Assortment

Two standard watercolor rounds, one between sizes 5 and 7, and one between sizes 10 and 12.

Two watercolor flats, ½ inch and 1 inch.

One squirrel round, between sizes 10 and 14.

One watercolor mop that is at least twice the size of the larger standard watercolor round brush.

For greater detail add:

One designers' round quill, English size between 4 and 8 (or between 2 and 2/0 in French sizing where 8 is the smallest and 6/0 the largest).

One spotting brush, between sizes 4 and 8.

For a softer look add:

One oval wash brush, ¾ inch.

One *hake* brush, between 2 and 3 inches.

One one-stroke lettering flat, between 1 and 1¼ inches.

OIL AND ACRYLIC BRUSHES

There are too many variables, such as the size of the intended painting and the painting style to be used, to give specific recommendations. As for general recommendations, bristle is best if a more textured or an impressionistic appearance

is desired. Sable or sablelike brushes are best if a smoother or a more detailed appearance is sought.

ORIENTAL CALLIGRAHY (SUMI) BRUSHES

There are countless styles in Oriental calligraphy, and brush selection would depend on which style one intends to follow. However, if you wish to begin without formal training and are interested in Japanese calligraphy, you may begin by selecting a round brush made with long sheep or goat hair. This brush is commonly recognized by a thin black stripe around the bamboo handle near where the hairs are inserted.

If a Chinese style of calligraphy is desired, select a Chinese weasel brush of a medium size.

ORIENTAL PAINTING (SUMI-E) BRUSHES

Oriental painting technique is derived from calligraphy and, like calligraphy, has many styles. Its nature is less esoteric for Westerners and specific recommendations are more easily made.

JAPANESE PAINTING BRUSHES

Basic Assortment

One basic painting brush like *choryu,* or *seiryu,* in a medium or large size.

One smaller and different-style basic painting brush such as *gyokuran,* or *maruyama,* in a small size.

One detail brush, such as *menso,* in a medium to large size.

One *hake* brush about 2 inches wide.

For a general-purpose assortment add:

One coloring brush like *saishiki* in a small or medium size.

One shading brush like *kumadori* in a small to medium size.

One extra-small detail brush like those made of cat hair in small to medium size.

CHINESE PAINTING BRUSHES

Basic Assortment

A set of three weasel brushes—small, medium, and large. If cost or availability is a problem, one large weasel brush will suffice.

One *hake* brush around 2 inches.

For a more general assortment add:

One rabbit hair brush in large to extra-large size. If not available you may substitute a brush like *gyokuran.*

One extra-long-hair brush made of sheep. You may substitute a long-hair sheep calligraphy brush.

Brush Care

THERE ARE four things that will end the life of a brush—wear, dried paint, mildew, and moths. Although there is little that can be done about wear, damage from dried paint, mildew, and moths can be easily avoided by proper cleaning, proper drying, and proper storage.

CLEANING

Thorough cleaning involves removing material that gets caught in the scales of the hairs or that builds up near the ferrule. Material trapped in these locations prevents the brush from returning to its ideal shape.

Watercolor Brushes, both Western and Oriental, and calligraphy brushes made with natural hair, are best cleaned by rinsing with room-temperature water—never use hot water on natural hair brushes—when watercolors or nonwaterproof inks have been used. This preserves the natural oils in the hairs that protect them from becoming dry and brittle. However, since dyes are sometimes used, which stain the hairs and tend to dry out the brush and affect successive uses of other colors, and because it is difficult to be patient for all necessary rinsings, a cleaning aid may be used.

Do not clean watercolor brushes with anything that you would not be willing to use on your own hair. You would not use liquid dishwashing detergent or paint thinner to wash your hair. Neither should these be used on expensive brushes that could last for decades if properly cared for. True soaps such as Ivory soap do far less damage than chemical detergents and are recommended for cleaning fine brushes. Some of the new cake brush cleaners (the Masters Brush Cleaner and Preserver by B & J Company and Brush Soap by Grumbacher) that have recently come on the market function like hair shampoos. They contain mild chemical detergents combined with such conditioners as natural oils like lanolin, which replace what is removed in cleaning. Some artists use their own shampoo and conditioner on their brushes. This would seem to be an acceptable alternative as long as the brush hairs are not made too oily from the conditioner, in which case they could lose their natural absorbency.

After a brush has been cleaned it should be reshaped and allowed to air dry thoroughly before being stored. The best way to allow a brush to dry, par-

ticularly a large brush, is to hang it with the tip down. This will help prevent moisture from being trapped in the ferrule, which would cause the brush to rot.

Acrylic Brushes, or those used with vinyl paints, must be periodically rinsed clean while you are working, because the paint that is trapped near the ferrule is drying while you are working with the tip. Small amounts of paint buildup in this area will not wash out once dry and will eventually render the brush useless. The only way to prevent this is to rinse the brush thoroughly every fifteen to twenty minutes with warm water. When finished, cleanup can be accomplished easily with soap and warm water, or with any of the new commercial brush cleaners.

If acrylic or vinyl paint has dried in a brush it can be removed with acetone. Acetone will, however, rob a brush of a great deal of its life, if not destroy it. (It should be noted that nylon brushes tend to dissolve in acetone.) Acetone is a hazardous substance, which can be absorbed through the skin, and frequent use may reduce your life expectancy as well. Manufacturers of the new artists' brush cleaners claim that they can remove some dried acrylic paint. There are also artists' brush conditioners, such as Silicoil, which can help recondition a brush with dry and brittle hair.

Oil Brushes can be cleaned easily without the use of such solvents as turpentine, petroleum distillate, or paint thinner. (Paint thinner should always be avoided for cleaning brushes.) Plain soap and water, or an artists' brush cleaner, work extremely well after the brush has been wiped free of excess paint. But this procedure is not workable when it's necessary to clean a brush quickly so that it can be loaded with a different color and continue to be used. In this case, the brush will have to be rinsed with thinner, but it should not be left sitting in thinner.

I recommend that a jar of solvent, such as turpentine, be set up with a coil in the bottom of the jar. This provides a nonabrasive surface to scrub the brush while rinsing it with thinner. The jar should have a cover to protect against evaporation when not in use. This will allow the rinsing of the brush between color changes as well as before final cleaning with soap and water. When it is time for cleanup, the brush is first wiped clean of excess paint, then quickly rinsed in the jar of solvent, and finally washed and allowed to air dry. Periodically, a brush conditioner may be used to restore performance. This method keeps the exposure to thinners at a minimum.

As for brushes with dried oil paint, if an artists' brush cleaner is not successful, it is time to consider a new brush and better work habits.

Synthetic Filament Brushes can easily stand repeated exposure to solvents such as turpentine, petroleum distillate, and most paint thinners. Solvents such as acetone, however, will dissolve nylon filaments. Synthetic brushes that have lost their shape, perhaps because the weight of the brush was left resting on the tip, may be restored by placing the brush in water that is hot, but just below the boiling point.

STORAGE

After a brush has been cleaned, reshaped, and air-dried, it has to be protected. All brushes, whether made from natural hair or synthetic filament, have to be protected against mechanical pressure. Never store a brush resting on the tip, or in a container so small that the tip is pushed against one of the sides. The hairs or filaments will take on a distorted shape that is difficult to undo. Natural hair brushes can sometimes be reshaped by giving them the equivalent of a shampoo and set. This involves rinsing the tip of the brush in warm water and attempting to reshape it. It may be necessary to repeat this effort several times. Sometimes it is helpful to dip the brush into a solution of gum arabic after the warm water treatment to aid in reshaping. Synthetic brushes may be reshaped with hot water.

Natural hair brushes, especially expensive watercolor brushes, have to be protected from moths, which may lay their eggs on the hairs, which will be food of the larvae when they hatch. Never place a brush in a plastic bag and put it in the dark. This may keep the moths off the brush, but you will be providing a fertile ground for mildew and rot.

I recommend using a Japanese brush holder for storage. This resembles a bamboo placemat with a string attached at one end. Brushes are simply rolled into the mat, which permits the circulation of air and protects the brushes from moths. If you are storing large brushes in a Japanese brush holder, it is a good precaution to wrap a cotton cloth around the holder to prevent insects from crawling into the partially open end. Moth balls, or flakes, provide extra protection and are particularly important when storing brushes in drawers.

These storage procedures are not necessary if the brushes are used every day; then they may simply be placed upright in a jar when entirely dry. Whenever they are not to be used for several days, however, it is best to store them away using one of the methods described.

Part Three

PAPER

TRUE PAPER has a long and rich history. It begins with Ts'ai Lun, who, in A.D. 105, requested the first patents for making paper. The actual inventor of paper is not known. Some of the earliest forms of paper were composed of tangled silk that had been collected as a byproduct of the processing of silk cocoons for silk threads. Ts'ai Lun's paper was said to be made from old rags, hemp, fish nets, and tree bark. The recipe for making paper was a highly guarded secret within the Orient until A.D. 751, when an Arab conquest resulted in the capture of some papermakers, who divulged their secrets. The Arabs, in Spain since A.D. 711, took the art there, and the first European paper mills were established around 1100.

By this time the process of papermaking was no longer very secret and had begun to spread rapidly through Europe. From Spain, its production moved to Italy. Fabriano established the first Italian paper mills in 1276, and is still making some of the world's finest papers. It was not until the nineteenth century, however, when papermaking machinery as well as a method for processing wood into wood pulp were invented, that paper became a common and inexpensive material. Prior to this time, papers were made primarily from rags and cotton, had great strength, and were relatively permanent. The conversion to ground wood as a raw material resulted in weaker papers that were impermanent. Much of the paper artwork, books, and numerous documents produced during the nineteenth century and the early part of the twentieth century are decaying rapidly and require conservation to preserve them. As the understanding of the causative agents for the breakdown of wood-pulp papers evolved, various paper refining techniques were developed and are continually being modified today.

The artists' paper that we know today started as a byproduct of the wallpaper industry. The first machine for making paper, invented around 1798 by Nicholas Louis Robert at the Essonne paper mills in France, enabled paper to be made in a continuous roll. Henry and Sealy Fourdrinier brought the invention to England and in 1807 developed it for commercial use in making wallpaper. Most artists' materials are derived from industrial products. It has only been since the middle of the twentieth century that significant research and development has been done on materials specifically for the artists' market.

The Chemistry of Paper

PAPER IS composed of cellulose fibers. Cellulose is a polymer of the sugar glucose and is used by plants to produce cell walls. Plant matter that has been processed to create a solution consisting of cellulose filaments suspended in water can be made into paper. A screen is passed through the solution so that the filaments can collect on it and thus form a layer. This layer of cellulose fibers is then pressed and dried to produce a usable sheet of paper. The source of the cellulose fibers, and the degree to which that source is refined, determine the nature and quality of the paper produced. The two most important factors that affect the quality of paper are the presence of impurities and an acidic pH. Finished papers may contain natural impurities, such as lignins that have not been removed during processing, unnatural impurities, such as residual chemicals, like sulfites, not washed out during final processing, or such chemicals as alum that have been added during final processing.

Lignins, which are the combined glues that hold plant cells together, are undesirable in a finished paper product. They age poorly, turn brown, become acidic over time, are waterproof, and resist the natural bonding of cellulose fibers to each other. If lignins are not removed and are left in contact with the surrounding cellulose fibers in paper, their acidity will break down the cellulose and the paper will become brittle.

Lignins comprise 20 to 30 percent of wood, but only 1 percent of cotton fibers. Because of the high concentration of lignins in wood, papers made from wood pulp discolor and eventually self-destruct. Although there are methods for the removal of most or all of the lignins, unless the residual chemicals used in these processes are also dealt with, embrittlement and acidification will only be postponed. For this reason, wood-pulp papers are generally avoided for permanent artwork. Because it is nearly lignin-free, paper made from 100 percent cotton is most desirable. The recently developed process for the removal of all lignins is being used at this time primarily to manufacture boards and storage containers used in archives, in conservation, and in museum-style framing.

Another major consideration in paper is its pH. The scientific symbol indicating the concentration of hydrogen ions in a liter of solution, pH describes the acidity, alkalinity, or neutrality of something. Water, which is composed of two

atoms of hydrogen that are attached to one atom of oxygen, is designated with the symbols H_2O or HOH. A very small number of water molecules, HOH, occasionally break up and reform. During the breakup, a positively charged H ion and a negatively charged OH ion are formed. The Hs are acidic and the OHs are alkaline. Since they are in equal amounts in water, water is said to be neutral—neither acidic nor alkaline. Water has been assigned a pH value of 7, which represents equal concentrations of acid and alkali. If the concentration of H ions becomes greater than the number of OH ions, then the result is said to be acidic, and a lower number is assigned. Each number represents a factor of 10— ten times more or less acidic than the number above or below it. A pH of 6, for example, is ten times more acidic than water, and a pH of 5 is ten times more acidic than 6, or one hundred times more acidic than water. If the concentration of H ions becomes less than the concentration OH ions, the result is said to be alkaline and is assigned a higher number, such as 8, which is ten times less acidic than water (or ten times more alkaline than water). The scale ranges from 1 to 14.

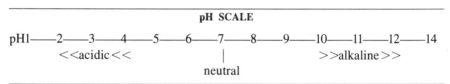

pH SCALE

pH1——2——3——4——5——6——7——8——9——10——11——12——14

 <<acidic<< | >>alkaline>>

 neutral

The more acidic a paper, the faster the cellulose will break down, resulting in a shorter lifespan. A number of factors can influence the pH of a paper. Residual acids from processing, rosin or alum sizing, fillers used to create bulk, oils used to make paper transparent, optical brighteners, atmospheric sulfur dioxide, and the presence of lignins can all result in a pH of 4.5 or lower. Recent study has shown that even the purest cotton papers will become slightly acidic, even though they left the mill at pH ranging between 6.5 and 7. This may be due to the nature of the paper itself, or because of exposure to air polluted with sulfur dioxide and oxides of nitrogen—common pollutants caused by the burning of fossil fuel—which turn water molecules into sulfuric acid and nitric acid.

To cope with the natural and unnatural acidification of paper, many manufacturers are resorting to buffering. Buffers are such chemicals as calcium or magnesium carbonate, which can absorb a significant amount of acid. Buffered papers are often slightly alkaline with a pH around 8.5. A pH moderately higher than 7 is not considered harmful in paper.

The two situations where pH information is vital is in the case of paper and boards used for archival storage and framing, and in watercolor papers. Materials used to help preserve artwork should have the highest standards. Although there is little reason for watercolor paper to meet all standards for archival use, it should be close to a neutral pH (neither acidic or alkaline) because many pigments used in watercolor are sensitive to significant change in pH. The whiteness of watercolor paper is another important factor because as paper acidifies it usually yellows.

Although virtually all paper products used for archival storage and framing are buffered to maintain a nonacidic pH, only a few artists' papers are buffered.

With the exception of watercolor papers, it is generally considered unnecessary in papers made with 100 percent cotton because most 100 percent cotton papers will acidify only slightly and stop. It is becoming more commonplace to buffer wood-pulp art papers and boards to slow down, not stop, the discoloration and embrittlement process. The problem of maintaining a nonacidic pH with even 100 percent cotton watercolor papers is the need to add a size to reduce absorbency. Although Aquapel is a neutral size, it has not yet replaced the traditional alum/gelatin size. (For more information about sizing, see page 93.) Alum is a combination of sulfates, which tend to acidify the paper, leaving it sometimes with a pH as low as 4.5.

Exactly how much damage to a paper will be caused by a specific amount of acidity is debatable. It is clear that wood-pulp papers are more sensitive than rag or cotton papers because pulp fibers are shorter and are weakened during refinement. Yet, recently, documents produced during the Salem witch trials on paper made from linen and rags were found in the basement of an old building. They were found to have a pH near 1 from centuries of rat urine, yet they were still flexible and readable despite considerable yellowing. The lesson here is that pH can affect permanency and quality but is not necessarily an indication of either.

How Paper
is Made

PAPERMAKING begins with the process of breaking down plant materials until individual cellulose fibers are obtained and are then suspended in water. A sheet of paper is formed by passing a screen through the suspension so that the individual fibers collect on the screen. The sheet of paper is then transferred to a mat where it is allowed to drain and dry. Pressure is often used to speed the process or to impart a particular finish.

The type of paper obtained can be influenced dramatically by such factors as the variety of plant material used, how the plant materials are broken down into fibers, how small the cellulose fibers are, the kind of screen used, how the screen is passed through the suspension, the kind of mat on which the sheet is placed, and whether the sheet is pressed. Other factors that influence paper variety are the use of chemicals, the addition of fillers or brighteners, the way in which the sheet is dried, and the polishing of the sheet's surface. All these variables make it possible to produce almost unlimited styles of paper. In the Orient, one can find more than a hundred varieties of paper made with the same plant material where the only differences in its manufacture are the way the screen is passed through the suspension and the average length of the fibers.

Handmade paper is often the least complicated method of papermaking. This method is so labor-intensive, however, that the cost of using the best plant sources often pales by comparison. Therefore cotton and rag fibers, which require little or no special treatment—chemical or mechanical—to reduce them to workable fibers, are commonly used. Today, sheets of cotton linters, made from the leftover short fibers collected from the cotton gin, are added to water and beaten in a machine similar to a blender. The level of concentration of fibers helps to determine the thickness of the paper. The suspension is transferred to a vat through which a flat, rectangular wire or bamboo screen can be passed to form the sheet. The fiber-laden screen is drained and the wet paper is often pressed before it is allowed to dry.

In mouldmade paper, the person holding the screen is replaced by a rotating screen cylinder, which forms a continuous sheet of paper. The individual sheets are produced by passing a stream of air or water through the wet sheet. Mouldmade paper is considered half handmade and half machine-made because

people are still used to create the suspension of fibers as well as in the pressing and drying of the individual sheets. The cost of materials becomes more significant and occasionally results in the use of cheaper raw materials. Such materials require refining before use, as well as chemical additives to improve their appearance, all of which complicates the papermaking process.

The production of machine-made paper involves little human contact until the paper is purchased. The materials are the most significant cost factor in this type of paper production. Elaborate chemical and mechanical processes are often used to change poor-quality raw materials into a useful piece of paper. First, impurities are removed; then the chemicals used to purify the raw materials must be removed or neutralized. Often such additives as sizing and optical brighteners are required. Then a rotating cylindrical screen pulls the fibers from the suspension to form a continuous sheet of paper. Finally, this sheet is pressed and dried by other steel rollers. For some types of paper like bristol, additional sizing is added before drying and the surface of the paper is polished after drying. The primary disadvantage of machine-made paper is that most varieties are of low quality. The advantages of machine-made paper include price, the availability of some varieties, such as hard-surfaced bristol and paper boards, which could not possibly be made by hand, as well as the ability to produce large quantities.

Characteristics of Paper

THERE ARE SEVERAL TERMS that are often misused in describing paper. Durability, for example, is often confused with permanence, formation with grain, and finish with surface. Understanding the applicable terms will greatly improve your chances of getting what you want when buying paper.

Acid-free is a term used to indicate that a paper or board, when it leaves the factory, has a pH of 6.5 or higher, which indicates that there is little or no acid that can accelerate aging or deterioration. However, "acid-free" does not mean that the paper or board is guaranteed to remain in this condition or that it is free of any other undesirable chemicals. It also does not mean that it is safe to use the paper or board for archival storage or framing. "Acid-free" is a label sometimes used in misleading ways by a few manufacturers to imply permanency when it does not exist.

Conservation is the repair, restoration, and preservation of documents, objects, and artwork with the intention of preserving them permanently.

Deckle refers to a wooden frame used in the papermaking process and to the irregular edge on the paper produced by the use of that frame. In papermaking, a screen or mould is passed through a suspension of pulp to form sheets of paper. A deckle is a separate wooden frame fitted over the papermaking mould to prevent excess pulp from spilling over the mould as it is lifted from the vat. A deckle edge is formed when a small amount of pulp seeps under this frame, producing an irregular edge on the paper. This deckle edge is often left untrimmed. Handmade papers have four deckle edges because each sheet is made individually and the water is allowed to drain from the mould in both directions. Mouldmade papers have two deckle edges and two torn edges because one continuous sheet is formed and the water is allowed to drain in one direction. The one long sheet is later torn into smaller sheets, which accounts for the two torn edges.

Durability is the ability of a paper to retain its original qualities under use. Most print papers, for example, do not have a durable surface and will be ruined by erasure, but bristol paper is very durable because it will maintain its surface qualities under repeated erasures. Durability does not necessarily indicate permanency. The American Society for Testing and Materials defines durability in their

publication ANSI/ASTM D-3290 as "the ability of a paper to resist the effects of wear and tear in performance situations. For example, paper currency should be made durable, but permanence is not a problem."

Fillers include such materials as kaolin (clay), calcium carbonate, and titanium dioxide, which are used to fill the pores on the surface of papers and boards to make a paper whiter and more opaque, as well as to give bulk. The more filler that is used, the less fiber there will be, and it is the fiber that maintains the strength of a paper or board. Today, it is becoming increasingly common for manufacturers to load up ground-wood boards with calcium carbonate to buffer them against the significant acidity that develops as the relatively unrefined pulp ages. Too much of this chalk will result in a great sensitivity to changes in humidity, which can cause severe warping. If such a board gets wet, the chalk dissolves and the board can easily fall apart.

Finish is the condition of the surface of a paper. The terms used to describe the finish of drawing papers and illustration boards are similar to those used to describe watercolor papers and boards, but refer to different finishes.

In the case of drawing papers and illustration boards, the terms "hot press," "plate," or "smooth" refer to a surface that is as slick as glass with virtually no tooth. This type of finish is produced by pressing the paper through hot rollers. The terms "cold press," "kid," "vellum," "regular," and "medium," refer to a surface that ranges from a barely detectable tooth to the feel of a medium-grade sandpaper. "Rough" refers either to an irregular bumpy texture of the surface, or to a laid surface that is characterized by lines caused by the way the screen was sewn to the mould, like an impression of Venetian blinds.

In watercolor papers, "hot press" or "smooth" refers to a surface like that of a "vellum" or "cold press" drawing paper. Hot-press watercolor paper is not formed by pressing with hot rollers, but by the using of a fine wire screen to collect the fibers. A cold-press watercolor paper is formed by pressing the still wet paper with a textured surface like a felt mat, giving the paper an irregular surface. This watercolor finish would be equivalent to a "rough" finish in a drawing paper. "Rough" in watercolor paper is an exaggeration of "cold press." A "laid" surface finish is determined by the pressure and the grain of a wire grid against the surface of the paper.

Formation is determined by the manner in which the fibers collect upon the screen during manufacture. For example, when "wove" paper is held up to the light, the formation of the fibers appears uniform. When the same is done to an inexpensive bond paper, the formation will appear mottled.

Grain is evident in machine-made and mouldmade paper. The fibers tend to align themselves in the one direction that the wire screen used in the machine process pulls them from the water. This gives the machine-made paper more strength in one direction than another. In handmade paper, the fibers are pulled more slowly and they are lifted up and out, without directional preference. Handmade papers, therefore, have no grain.

GRS/m² is a unit of measure for the weight of paper in the metric system. It is the weight of one square meter expressed in grams. A 140 lb. $22'' \times 30''$ watercolor paper is equivalent to 300GRS/m².

Handmade Papers are usually made of cotton or Oriental fibers. Strong chemicals are not used because these fibers do not have to be treated as wood does. The hand process of lifting the fibers from the water allows the fibers to align in all directions and interlock among themselves. This gives handmade papers great strength. When this type of paper gets wet, it will expand evenly in both directions with minimal buckling and warping.

Mouldmade Paper is halfway between handmade and machine-made paper. When making mouldmade papers, the individual screen used in handmade paper to pull the fibers from the water is replaced by a rotating screen. It slowly pulls the fibers from the water in a long continuous sheet. Individual sheets are made by passing a stream of water or air at intervals across the continuous sheet while it is still wet. This creates a weakness where each sheet can be gently torn free after drying.

Permanence refers to the length of time materials will maintain their original integrity. Materials that will not maintain their original integrity for a minimum of twenty-five years are not considered permanent. Materials that will maintain themselves for fifty to seventy-five years are considered relatively permanent if handled with care. A life expectancy from seventy-five to one hundred or more years is considered permanent. Materials that have shown little or no deterioration within seventy-five years will probably continue to remain in good condition for some time longer.

The permanency of paper can be reduced by the presence of wood fibers, alum or rosin sizing, residual chemicals from bleaching, traces of iron and copper from the water used in processing, exposure to sulfur dioxide or nitric oxide, and a pH of 5.5 or less.

Ply refers to one sheet of paper that is bonded to another of the same kind. For example, two-ply bristol is made of two one-ply sheets laminated together.

Sizing is the use of a glutinous material to fill up the pores in a paper's surface. Paper is composed primarily of cellulose. Cellulose possesses a great many "free radicals," a chemical term for atoms containing unpaired electrons. Free radicals love to attach themselves to water molecules. Therefore, when the cellulose of paper comes into contact with water, the water forms a temporary chemical bond causing the paper to swell to accommodate the increased volume. The purpose of a size is chemically to tie up a certain percentage of these free radicals and make them unavailable for water molecules. The more size, the less absorbent the paper will be, resulting in less buckling of the surface and less bleeding of color.

Animal gelatin or glues were early sizing agents. In the mid-seventeenth century, alum (potassium aluminum sulfate) was introduced to harden the gelatin sizing. Hardening the soft gelatin increases the surface tension and results in the

color staying more on, and spreading less over, the surface. This allows the painter to work more slowly and achieve greater detail. By the nineteenth century it became clear that the animal gelatin aged poorly, and that the alum acidified the paper. These deleterious effects led to the unpopularity of animal-source sizes. Rosin (a residue collected from the processing of pine trees) was then introduced as a possible substitute, but it proved to be even worse for the longevity of art paper. In the recent past, vegetable gelatins replaced the animal gelatin because of their better aging characteristics. Efforts to deal with the acidic alum-sized papers through the use of buffers proved unsuccessful; alum requires a slightly acidic pH to attach itself to paper.

Today, a synthetic size, Aquapel, manufactured by Hercules, Inc., is replacing the traditional sizing agents because it possesses all the ideal characteristics of a hardening size without the disadvantages. Chemically, Aquapel is an alkene ketene dimer. Dimers are chemicals with two chemically active parts and Aquapel has one area that is attracted to water and one that is attracted to oil. The part that is attracted to water attaches to the free radicals of the cellulose in paper and the other part repels water. The most important characteristic of this size is that it works without an acidic pH.

Most art papers are sized in one of two ways—tub or surface. Tub sizing is commonly used in handmade and mouldmade papers, where the whole sheet is dipped into a vat containing a size. This results in sizing equal on both sides. Surface sizing is done on machine-made papers, where the size is applied by roller to one side only; only the sized side is meant to be used.

Surface refers to the front and back, or top and bottom, of a piece of paper. The top of the sheet of paper is determined by the manufacturing. A piece of artwork is usually done on the top surface, that is, the side in which the most care has been taken, the surface to which the sizing has been applied. Some illustration boards and bristol paper are specially manufactured to have two identical working surfaces.

Tooth is a term that describes the arrangement of small peaks and valleys that the fibers form on the surface of the paper. The degree of difference between the peaks and valleys determines how the pencil or pastel will be caught and how the graphite or color will settle on the surface.

Weight describes one aspect of a paper's quality. The "basis weight" of a paper is based on the weight of 480 to 500 sheets (500 sheets equal one ream) of a paper in its standard size at a temperature of 75°F and a humidity of 50 percent. For example, 140 lb. watercolor paper—a typical artists' paper—indicates that approximately 500 sheets of this paper in its standard size, 22″×30″, would weight 140 pounds. The standard size used for most print paper basis weight is 24″×36″. It is particularly difficult to compare weights of art papers to commercial print papers because of the difference in standard sizes.

Types of
Fibers

IN THE WEST, paper is generally made from wood or cotton or a combination of both. The way the fibers are chemically treated during the manufacturing process affects the appearance and the durability of the paper. The most suitable papers for permanent artwork are those made from cotton. Though some people believe that a paper is safe if it is at least half cotton fiber, only paper made of 100 percent cotton fiber is recommended for artwork that is expected to last for decades. Papers derived primarily from wood pulp, even pulp that is treated or buffered, are best used only for printing, graphics, or student purposes.

In Oriental papers, three types of fiber are commonly used—kozo, mitsumata, and gampi. These three fibers, used alone or in combination with each other, are the basis for the largest variety of papers in the world today. When used without fillers, these fibers produce durable, permanent papers, often of great beauty.

GROUND WOOD

Wood that is ground into a pulp without any additional purification is called ground wood. All the impurities—lignin, resin, and hemicellulose—remain. Paper made from ground-wood pulp is the least durable and the least permanent, and has the poorest appearance of all papers. However, the paper is more opaque than most and absorbs printing inks well. Since paper of this type is also the least expensive, it is popular primarily among printers and schools. Newsprint, construction papers, oak tag, newsboard, chipboard, railroad board, and oatmeal paper are among the many ground-wood papers. It is my opinion that this type of paper should never be used as a primary ground for permanent artwork.

Chemically Treated Wood Pulp. In an attempt to improve the appearance, durability, and permanence of papers derived from wood, a variety of chemical treatments have evolved to make lignin soluble for easy removal and to separate the wood pulp into individual fibers. In 1851, a treatment using caustic soda (sodium hydroxide) was developed, which resulted in a pulp referred to as "soda pulp." This treatment increased bulk, but weakened the fibers. During the 1870s, a treatment that reduced the weakening of the fibers involved the use of sulfur dioxide and bisulfate, forming a "sulfite pulp." This method significantly

reduced the lignin content to between 2 to 5 percent, which could be further reduced through bleaching and thorough washing. This pulp was given the name "alpha-pulp." This type of treatment is used today to produce the better-quality wood-pulp artists' paper.

The sulfate process developed by Carl Dahl in 1884 is the process used today for the production of most paper products in general use. It is more efficient than the sulfite process, which did not remove or break down wood chips, so they had to be removed before processing. This is not necessary in the sulfate treatment; however, the resultant pulp is much higher in impurities that resist bleaching. The sulfate process produces a much stronger fiber and is often referred to as the Kraft process—the term "Kraft" is derived from the German word for strong. Although this process produces a stronger fiber, it is also much rougher and less suitable for use in the production of artists' papers.

Although sulfite, or alpha-pulp, papers are compared to cotton papers, they have neither the quality nor the permanence that only cotton papers have. The sulfite papers are a tremendous improvement, but, in most cases, the lignins are replaced with a lesser evil—the natural resins and chemical residues left over from processing. These are rarely dealt with, and must be before this pulp can be considered an equivalent to cotton. Ground-wood pulp papers have a lifespan of only a few years before embrittlement and yellowing take their toll. Sulfite papers are a vast improvement since it usually takes between one and three decades before the residual chemicals and the remaining natural resins produce significant yellowing and embrittlement.

A distinct advantage to sulfite is its moderate cost compared to cotton. A wide selection of papers are made from this pulp, including drawing, tracing, layout, bond, colored, decorative, and watercolor papers, and boards for illustration, mounting, and matting. This type of paper is fine for artwork that will be reproduced and the original may be sacrificed, but it should not be used for original artwork that will be considered an investment.

Chemically Treated and Buffered Wood Pulp is simply chemically treated wood pulp with the additional enhancement of a chemical buffer. The buffer keeps the paper made from this pulp looking better longer because yellowing will not occur until the buffers are exhausted. Buffering will also help to maintain the color quality of pH-sensitive inks, dyes, and certain watercolor pigments. Drawing and watercolor papers made from this type of pulp are being introduced by only a few companies, including Seth Cole, Rising, and Pentalic, but are nevertheless widely distributed.

Chemically Treated, Lignin-free, Buffered Wood Pulp is the result of a new process in which, it is claimed, all the undesirable natural residues and chemicals used in processing have been removed so that a pure cellulose pulp remains. This pulp is then buffered for extra safety. This is a costly process and if this pulp were used only to make a cotton paper substitute there would be little recognizable saving. In the case of museum boards, however, which are expensive partly because of the large amount of cotton fiber used, the savings

may be as high as 25 percent when substituting this type of pulp for cotton. Currently, this pulp is being used primarily to produce a less expensive board for use in archival storage and framing.

COTTON

Cotton is virtually pure cellulose fiber, which has a natural resistance to deterioration and to many forms of chemical attack. Cotton fibers range in length from ⅝ to 1½ inches. The longer fibers are separated by the cotton gin for use in the manufacture of textiles. The shorter fibers left in the gin, which are called cotton linters, are collected separately and used to make cotton papers and boards.

Papers made from 100 percent cotton are among the most permanent, most durable, and strongest. They possess all of the most desirable characteristics and all the best drawing, watercolor, charcoal, and tracing papers and the finest museum and illustration boards are made from 100 percent cotton fibers. Papers and boards made of 100 percent cotton fiber are among the most expensive. Keep in mind that many 100 percent cotton tracing and visualizing papers are impregnated with oil or chemicals, which can dramatically reduce their lifespan.

Rag and cotton are terms that today are virtually interchangeable. At one time, rag meant cotton taken exclusively from cotton textile remnants. Very few cotton papers are still made from rags, either entirely or partially. Fabriano's Roma paper, which is said to have been used by Michelangelo, is still, however, made of 100 percent rag. Strathmore's Artist Bristol is also still made of rag.

The difference between true rag papers and cotton papers made from linters is that the rags have the longer cotton fibers and the weaving seems to add strength. The symbol of quality is still a paper that is made from 100 percent cotton rags. That is probably why people prefer to call both cotton linter and cotton rag papers "rag."

COTTON AND WOOD

The larger the ratio of cotton to wood, the better the paper will handle and age. Most artists and conservators do not consider a paper with less than 50 percent cotton safe for permanent artwork. Owners of some paper mills of long standing, as well as some government guidelines, claim that paper made with at least 50 percent or more cotton fiber is safe. In Europe, most fine art papers have some refined pulp but the majority of the 100 percent cotton papers produced there are sent to the more extravagant Americans. I have yet to find an art restorer in this country, however, who will vouch for a paper that contains less than 100 percent cotton fiber.

KOZO, MITSUMATA, AND GAMPI

These are the most common fibers used in making Oriental papers. Only the inner bark, or bast fiber, of *Broussonetia kazinoki* for kozo, *Edgeworthia chrysantha* for mitsumata, and *Diplomorpha shikokiana* for gampi, is used to make paper. When these fibers are used without wood pulp or other fillers, they are as permanent as cotton and, in the case of gampi, even more permanent.

Kozo, known in North America as mulberry, makes the strongest and most durable of the Oriental papers. It has the longest fibers, will not shrink or expand when wet, and produces a paper with an uneven surface. This fiber is used alone to make paper and is added to other fibers to give them additional strength and durability.

Mitsumata is traditionally described by the Japanese in what they feel are female terms. They say it is the most beautiful, softest, most absorbent, and the weakest of the three fibers. It is often used to balance kozo fibers, which are described in male terms, to increase the absorbency, even the surface, and add beauty to a paper.

Gampi is described by the Japanese as having both male and female characteristics. Its fibers are long, thin, somewhat shiny, and very tough. The fibers are so durable that paper made of gampi is referred to as "paper cloth." Gampi paper is smooth, lustrous, and has its own natural chemical resistance to paper-eating insects. It is nonabsorbent, damp-resistant, and may well be the most permanent paper in the world. The best paper is made from uncultivated plants, but the plant is rare because it was overused to the point of near extinction. Most available gampi papers are made from a species of the plant found in the Philippine Islands and processed in Taiwan.

Many Oriental papers available in the West are made from one of these three fibers. They are called Japanese papers, or Japanese-style papers, even if they are made in another country.

Tan-hi is the Chinese version of kozo fiber and is the primary ingredient in such traditional Chinese papers as gasen. Today, tan-hi is more commonly referred to as tampi.

Types of Paper

MANY DIFFERENT KINDS of paper are created for a wide variety of applications, including painting, drawing, graphics, printmaking, and calligraphy. Papers are available in an extensive range of sizes, thicknesses, and finishes, as well as in differing degrees of quality, permanency, and durability.

A particular type of paper can often be used for another purpose. Print papers, for example, can be used with acrylics, and many graphics papers are ideal for drawing. Keep in mind, however, that certain papers have poor aging characteristics and should not be used for permanent fine artwork.

This section explains the various types of paper and their many uses.

WATERCOLOR PAPER

Oriental watercolors and watercolor papers have been around long before Ts'ai Lun patented papermaking in China in A.D. 105. Western watercolor papers, as we know them today, were developed during the second half of the eighteenth century and are, therefore, a relatively modern achievement. James Whatman paved the way for the development of watercolor paper when, under commission in the late 1750s, he replaced the traditional coarse laid wire screen of the papermaking mould with a wire screen so fine that it was called "wire cloth." This allowed for an even formation of the pulp fibers without any textural impressions left on the surface of the newly formed paper. This new style of paper was called "wove" paper and was primarily developed for printing. Whatman found that various textures could be imparted to this textureless paper. He discovered, for example, that when felt blotters of various textures were applied to the still-wet paper surface and pressed, impressions of those textures were imparted to the paper.

Whatman made paper available in three finishes—"hot press," "not" (which meant "not hot press," and has come to be called "cold press"), and "rough." During this time, watercolor papers were still classified as drawing papers. Whatman has been credited with the adaptation of the "hard size" (alum-gelatin sizing) for use in watercolor papers. Sizing is particularly important in these papers because it allows the color to stay on the surface as the water sinks in. This gives watercolors their brilliance, which would be lost if the color were to

sink below the surface with the water. An additional benefit is that the color can be reworked because of its accessiblity on the surface of the paper. Arches watercolor paper has retained its popularity because of its "hard size" as well as its double sizing, both of which permit erasure and repeated washes. The heavily sized paper gives excellent control of watercolors.

Several manufacturers have attempted to resolve the problem of acidity due to alum hardening by simply not using alum. This approach produces a watercolor paper that is not popular with artists using traditional watercolor techniques. Watercolorists who do abstract expressionist work, however, often prefer the softer look that colors have on the surface of this type of paper.

Strathmore's 100 percent cotton watercolor paper has the new synthetic sizing called Aquapel, which can be buffered. (Eventually all fine watercolor papers will convert to this kind of sizing.) Strathmore's paper has two deckled edges and two cut edges, which makes it less popular among watercolorists who like to use the whole sheet and prefer to show four deckle edges in framing.

Whatman, Saunders, and Strathmore papers, as well as Fabriano and the Royal Watercolor Society paper, are still among the world's finest. Today's watercolor papers come in many different sizes, weights, and packages, such as pads and blocks. There are still only three categories of finishes available, but each category varies from brand to brand, allowing somewhat more choice for the artist.

Hot press has a smooth vellum surface with a very fine tooth. This finish is excellent for soft drawing materials, pen and ink, brush linework, wash, and airbrush. This type of paper is not as popular for traditional watercolor techniques.

Cold press, or semirough, is the most popular finish and is especially good for beginners. Cold-press finish is excellent for traditional watercolor technique and, because of its moderate texture, will handle some detail. This finish is also excellent for charcoal, pastel, and paint sticks.

The purpose of the texture in watercolor paper is to create a sense of depth. One of the ways to accomplish this is by varying the ways that the finish receives the color. A wet wash will cover the peaks of the finish as well as penetrate the valleys. One color will tend to look like two because of the difference in the ways that the light strikes the peaks and the valleys. When a second, drier wash is applied, it will tend to cover the peaks without penetrating the valleys, and will also miss some of the peaks. A painter can rapidly develop many textural effects with a minimum of effort. How the individual artist develops this technique is what makes this simple medium so versatile. Some experimentation with styles of cold-press finish, such as irregular versus laid, should be done to determine what is best for you.

Rough finish has pronounced peaks and valleys; even wet washes tend to be speckled with some spots of white showing through. This finish is not for beginners, but unfortunately for them, most of the less expensive watercolor papers are available only in a rough finish. Many people give up watercolors only because they started with this finish. It takes advanced skills to handle rough finish successfully. The large peaks and deep valleys tend to produce errors that

are difficult to hide. When the finish is used by an experienced watercolorist, however, the results can be amazing. Rough finish can be used effectively with acrylics, paint sticks, and some pastels.

Watercolor paper is packaged in several forms: pads, rolls, sheets, and watercolor blocks. A watercolor block is a stack of watercolor paper, betwen 90 and 140 lb., that is gummed together at the edges, making it possible to do a painting without prewetting and stretching the paper, as is usually required for papers of weights under 200 lb. After the painting is completed on the watercolor block it is allowed to air dry, without the help of the sun or a blow drier. Air drying eliminates the risk of splitting the gummed binding that holds the paper together.

Arches watercolor paper is the brand most readily available in sheets, rolls, pads, and watercolor blocks. Arches paper is mouldmade in France only during certain times of the year because the water from the river used to wash the paper becomes muddy during the winter. This accounts for the slight variations in whiteness from batch to batch as the water begins to change. Arches comes in the largest variety of weights, sizes, and packaging of all the watercolor papers available in North America. The weights for $22'' \times 30''$ range from 90 lb to 400 lb. Sheet sizes range up to $40'' \times 60''$. Arches has recently introduced an excellent student-grade paper called Archette. It consists of 25 percent cotton fiber; the balance is alpha pulp, and is 270 GRS/m² or 127 lbs. in $22'' \times 30''$. At the present time, Archette is only available in cold press finish. This paper is significantly less expensive than Arches 100 percent rag version, yet its handling characteristics are almost identical.

Fabriano also makes a wide variety of watercolor papers. This company is particularly known for its Esportazione series, the finishes of which are quite rough. This paper is one of the few entirely handmade 100 percent rag watercolor papers available today. Fabriano also produces a watercolor paper named Artistico, which is a mouldmade paper of 100 percent rag and is more affordable than the Esportazione. The 300 lb. rough in the Artistico series is said to be produced on an especially slow-running papermaking machine, which allows the water to drain slowly. This process creates a paper with characteristics close to those of a handmade paper.

T. H. Saunders watercolor paper has undergone a number of changes in the company's attempt to make a more archival and better-quality paper. The current product is quite good and is certainly less likely than most to acidify with age. This may also be said of Strathmore watercolor paper. Canson Mi-teintes, which comes in thirty-five colors, was originally developed as a lightweight watercolor paper, but today is used more often as a pastel paper. It is currently only 66 percent rag, and buckles considerably when wet. Most of these companies make both mouldmade and machine-made papers, with different grades of pulp and qualities of finish.

PRINT PAPERS

Some print papers are used for drawing and painting. Like watercolor papers, print papers are available in a range of sizes, quality, and content. They are handmade, mouldmade or machine-made. The two important differences are that

print papers have a softer surface and contain little or no sizing. This makes them ideal for printmaking but, in most cases, undesirable for painting and drawing. Print papers in general are not as durable, thus the surface finish will not take erasure or hard drawing materials. The absence of sizing causes watercolors to sink in and bleed outward, resulting in a soft, dull look. These characteristics can, however, be used to advantage with such materials as soft colored pencils or acrylics, or for Oriental-style watercolor

Some of the most popular print papers are Rives BFK, Arches, Copperplate, and German Etching (75 percent rag). Arches and Rives come in a limited variety of shades. A category of print papers, called "proof papers," are usually wood pulp and have a harder and more durable surface.

DRAWING PAPERS

Any paper that has enough tooth to bite off sufficient particles from a drawing material, such as graphite, to form a visible mark could be called a drawing paper. However, to be considered good, a drawing paper must be durable enough to take repeated erasure without serious damage to the surface. It should also take ink without bleeding or excessive absorption.

In watercolor painting, the brush is the most important component; in oil painting, it is the paint; in drawing, it is the paper. Each artist should make his or her own experiments and comparisons among the varieties available in the major categories of drawing papers—bristol, charcoal/pastel, drawing/sketching, bond, and graphics papers. Even a simple pencil line will appear totally different on different brands of the same type of paper. This category is broken down into five basic groups: bristol, charcoal and pastel, drawing and sketching, bond, and graphics paper.

Bristol is the strongest, most durable, all-purpose drawing paper available. It has a very hard surface that is heavily sized, polished, and compressed. It comes in two finishes, plate and vellum, and in several thicknesses.

Plate finish is as smooth as glass, is especially good for pen and ink, and allows flat and even washes. Airbrushing on this surface gives a very crisp look, but the finish is too slick for colored pencil, charcoal, pastel, and very soft pencil. Vellum finish is excellent for all pencil, colored pencil, medium to hard charcoal, hard pastel, and oil pastel. It is also excellent for washes, gouache, pen and ink, and airbrush when a fine texture is desired. Some care must be taken with this surface to protect it from the natural oils from your hands, which can be transferred to the surface, affecting the absorbency and the bite of the tooth.

Bristol is usually made so that either side may be used, although there may be slight differences in the finish between the two sides. Strathmore's 100 percent rag Artist Bristol is considered the standard to which all others are compared. This bristol is still made only from 100 percent cotton cloth trimmings, which helps to give it its tremendous strength. But, because of the widespread use of cotton-synthetic blends in the garment industry, there is an increasing shortage of raw materials for production of this paper. Strathmore is currently developing a process to separate the synthetic from the natural fibers, rather than resorting to

the use of cotton linters. The sheet sizes are $23'' \times 29''$ and $30'' \times 40''$, and the paper is available in pads. Two-ply, nonrag bristol is the most common form of bristol to be found in pads.

One-ply bristol is thin enough to be translucent. The plate finish is thinner than the vellum because of the greater pressure applied in making; thus it is the easier of the two to see through for tracing. Because the one-ply is a bit thin, its hard surface is easily damaged if handled carelessly. It is easily subject to buckling from the moisture in the air and from the perspiration of your hand.

Two-ply bristol can be used for tracing with the aid of a light table. This thickness is less subject to humidity and damage by handling. Two- and three-ply are the most popular thicknesses. Three- through five-ply are chosen more for weight than for any qualitative difference in performance. Five-ply feels like a lightweight illustration board or a 300 lb. hot-press watercolor paper.

Charcoal and Pastel Papers are essentially interchangeable. The selection of the finish and the color of a charcoal or pastel paper is even more important than the selection of the drawing materials since the finish of the paper determines the appearance of the artwork. Pastelists, for example, study the color of a paper the way a painter studies a color chart.

There are two basic finishes—laid and irregular. Laid finish is the imprint of the regular pattern of the wire screen of the papermaker's mould. An irregular finish is the result of the felt mats on which the still-wet sheet of paper is pressed out, which produces a tight, irregular arrangement of small peaks and valleys on the surface. Both of these finishes can be found in different degrees of texture, from cold press to rough. The finishes of this type of paper serve the same purpose as the finishes of watercolor paper; the texture is worked the same way, except with charcoal and pastel instead of watercolor.

These papers are not as durable as bristol and will take only light erasing before the surface becomes seriously disrupted. They are lighter in weight, generally have little sizing, and are machine-made. "Ingres" usually refers to a laid finish paper of light to medium weight. Strathmore's 100 percent rag charcoal paper comes in twelve colors, two whites, and one black. It is lightweight with a laid finish and is one of the most popular papers of this type. Canson Mi-teintes, which, it is said, Degas used for some of his pastels, is made in thirty-five colors with an irregular finish and is of medium weight.

Drawing Papers, or papers marketed as "drawing," vary widely in quality from newsprint to the fine handmade Fabriano Roma papers said to have been used by Michelangelo. However, most of the available drawing papers are not even close to this quality. Today, drawing is more popular than ever before and large sheets of rag drawing paper are in great demand.

Drawing papers resemble bristol paper, but have not been compressed or as heavily sized; thus the surface is less durable with a coarse vellum finish and a rougher tooth. Bristol is considered a multimedia paper because it can take everything from markers to watercolor. This is not true of drawing papers— permanent markers will bleed and there is little control for traditional watercolor technique. Drawing papers are primarily for use with pencil, crayon, oil pastel,

paint sticks, charcoal, graphite sticks, carbon pencil, colored pencil, and some light pen and ink. Common sizes are $18'' \times 24''$ and $24'' \times 36''$ in sheets, $36'' \times 10$ to 20 yards, and $42'' \times 10$ to 20 yards in rolls. To meet the larger demands, companies such as Andrews Nelson & Whitehead are making available sheets of drawing paper up to $30'' \times 40''$ and rolls of $60'' \times 20$ yards. White and off-white are most common, but colors can be found. The overwhelming percentage of drawing pads are of the nonrag variety. Generally, if a pad is not labeled as rag, it is not rag.

Bond Papers are sometimes distinguished as ledger bond and layout bond. The finish of bond papers is more like bristol than drawing papers—ledger has more of a plate finish, and layout is a bit like vellum. Layout bonds are usually lightweight, 13 lb. to 20 lb., making these papers translucent, but not transparent like tracing paper. Ledger is usually heavier, 28 lb. to 32 lb., more opaque and less fragile. These papers have good durability and strength.

Both ledger and layout bond work well with a large variety of drawing materials. Watercolors and permanent markers can be used with some success. This type of paper is found almost exclusively in pads or rolls, and most are not rag. The rag bonds are now generally sold as "graphics paper."

VISUALIZING AND DRAFTING PAPERS

This group includes tracing papers, both rag and nonrag, and graphics papers. These papers are designed primarily to be transparent or translucent.

At this time there are no tracing or graphics papers, 100 percent rag or not, that are generally considered archival. The processes used, and the chemicals with which these papers are impregnated, tend to make them impermanent. They should not be used for permanent fine artwork unless they are specifically guaranteed by the manufacturer.

Tracing Paper is, basically, one of two kinds—rag and nonrag. Nonrag, or sulfite, is either inexpensive or expensive, and there seems to be little middle ground. Inexpensive tracing paper comes in pad weights of 11 lb., 13 lb., and 16 lb. and in rolls of 8 lb. and 11 lb. The lighter weights are sometimes referred to as "flimsy" or "sketch paper." This paper is for rough sketches, preliminary drawings, and overlays, and will work well with most drawing materials. The lesser-quality papers do not take erasure well and will "ghost," leaving a faint impression after repeated erasure. These papers are impregnated with a resin or an oil to make them transparent.

"Vellum" is a term used in drafting and engineering to refer to the expensive or better-quality tracing paper. These papers are made for final drawings where control and detail are most important. The standard for comparison is Canson Vidalson, which is manufactured in France. It is a sulfite paper that is made under tremendous pressure so that it becomes transparent. It is the hardest and most transparent, and has the most durable surface of any paper I have seen. Ink can be scraped off the paper with a razor blade without seriously disturbing the surface. This paper takes all drawing media well and is especially good for pen and ink. However, it does have some serious drawbacks—it is easily affected by

moisture and skin oils, it tears and cracks easily, and it has poor aging characteristics. The three most common weights in pads are the #70, #90, and #100, which are most often referred to in terms of pounds. These numbers actually refer to the metric equivalents of 18½ lb., 24 lb., and 29½ lb., respectively. Sheet and roll weights are most commonly found in #90 and #180 (the equivalent of 48 lb.).

Rag tracing papers are made transparent with oils or resins. They are not as transparent and do not have as durable a surface as the sulfite vellum, but the paper is less affected by moisture and does not tear or crack as easily. Like the nonrag vellum, however, it is easily affected by skin oils and ages poorly. Rag tracing papers, such as Clearprint, are made with a large variety of nonphoto blue graphs imprinted within. A nonphoto blue is a particular color that is not "seen" by most photocopying processes. This permits the use of the graph as a drawing guide without having the graph appear in the reproduction.

Graphics Papers are designed for final work by graphic artists. A number of years ago, 100 percent cotton or rag bond paper pads were labeled "bond paper good for graphic arts and markers." Today, most of the same bond papers are called graphics paper, marker paper, or something similar. There are some that have been especially improved to accept work with permanent markers, or to be particularly translucent, or to be opaque. All make exceptional drawing papers. One of the unique features of this paper is its translucency and its bright whiteness, which keeps it from looking like a tracing paper. Although these papers are designed for final work in the graphic arts, do not be confused by the 100 percent cotton or rag label. They cannot, as yet, be considered archival.

SPECIALTY PAPERS

There are hundreds, if not thousands, of specialty papers. Here are a few facts about them.

Interleaving, or Separation, Sheets are papers that are pH neutral and non-abrasive, and are not necessarily cotton or rag. They are used to isolate artwork on paper from its container, or to protect its surfaces in handling, or to separate pieces of artwork placed in stacks. The three most popular papers for this purpose are Strathmore slip sheets, such soft thin Oriental papers as troya, and glassine paper. Glassine, which recently has come into question for archival storage, is a glossy, transparent, coated paper particularly popular among photographers to protect negatives and photographs, and among painters who need to protect the surface of their paintings. Glassine paper does not leave little fibers stuck to a surface after being in contact with photo emulsions and painted surfaces. One peculiar exception is Cibachrome prints, which scratch very easily. Even glassine paper has been known to scratch this surface. One well-known printer of Cibachrome prints finds that only the softness of an Oriental paper like Troya gives real protection.

Transfer Papers, like graphite or carbon papers, are used to transfer a drawing to another surface. Carbon papers are greasy and do not erase well once applied,

but they will transfer onto such nonporous surfaces as metals better than graphite. Graphite is better for transfers to paper or board because it permits transfer of more detail, and it erases more easily. Saral Transfer Paper, made especially for this purpose, comes in several colors.

Stencil Papers are either waxed or oiled to resist the buckling that otherwise occurs if an untreated stencil is used repeatedly with water-based paints. The popularity of this paper has waned with the development of frisket and drafting polyester (Mylar). Frisket is made from a sheet of either paper or plastic with a low-tack adhesive applied to one side, and comes attached to a paper carrier to protect it until used. Frisket was primarily designed for airbrush stenciling on paper and board. Drafting polyester, which is a polyester with at least one side chemically treated to receive drawing materials, has become popular for making more durable stencils. It is not affected by moisture, it will lie flat even after being rolled up for a long time, and it will not tear.

Calligraphy Paper is any paper that will not easily bleed, feather, scratch, or wrinkle when used with pen and ink. There are a lot of papers treated to look like genuine parchment for use by calligraphers, but calligraphers should not feel limited to paper labeled "calligraphy." Experienced calligraphers often use Strathmore charcoal paper and Canson Mi-teintes. The most popular paper for practice is inexpensive tracing paper.

Coated Papers are used for bookbinding, printing, presentations, mock-ups, architectural models, and other graphic art purposes. There are metallic-coated papers, papers coated with colored inks, adhesive-backed colored papers such as Pantone, silk-screened colors such as Chromarama, and many more. None, however, are considered safe for permanent fine artwork.

Cover Paper is another large, nebulous group of papers that come primarily from the printing industry. These papers are of medium weight, 65 to 80 lb., and are used for covers for magazines, booklets, catalogues, and flapping paper. They include a high-grade construction paper. The better grades have good light-fastness, are quite durable, and make good drawing and calligraphy paper. Again, these papers are not for permanent artwork.

Decorative Paper is a category that includes printed papers, marbled papers, cockrells, and folk papers such as mingei and rakusui papers. Marbled papers are made by floating oil-based inks on the sized surface of water. The inks are swirled around and then a sheet of paper is placed over them. The inks are picked up and transferred to the paper's surface, resulting in a marbleized pattern. Cockrells are similar to marbled paper, but the inks are skillfully combed into precise traditional patterns before being transferred to the surface of the paper. This is done with such accuracy that two sheets, each individually made, can look remarkably alike. It can take thirty to forty years of apprenticeship to master the technique necessary to produce matching sheets. To tell the difference between the genuine article and a printed imitation, look at two of the four corners for the partial fingerprints of the maker. They are left when the paper is pulled from the water. Marbled paper and the English cockrells are traditional bookbinding end papers.

Mingei means "folk" in Japanese. Mingei paper is traditionally made from handmade mulberry paper, which is dyed or printed using a hand-cut stencil with patterns hundreds of years old. Some papers are even hand-colored. Yuzen is another paper that is a bit more modern in appearance and in method of manufacture. These papers are traditional bookbinding and gift papers. *Rakusui*, which means "rain paper," is made by taking the still-wet paper and placing it over a slightly raised patterned surface, which is then rained with droplets of water. A small number of the fibers are thus washed away, allowing a pattern to develop in the paper. These papers are sometimes referred to as lace papers because their regular transparent patterns resemble lace cloth.

ORIENTAL PAPERS

"A painting, a poem — how paper reveals a man's nature." This old saying reflects the style of Oriental papers. Because their absorbency, texture, and weight instantly show any lack of skill with the brush and hesitation in the mind of the artist, they can reveal the degree of mastery of one's body and mind. Most Westerners find this intimidating and prefer to use Oriental papers only as print paper, since printmaking places distance between the insecure hand and the final result. Perhaps an introduction to the aesthetics of Eastern art would make these materials more emotionally accessible to Western artists.

By Western standards, most Oriental papers are highly absorbent. This allows the artist, as the ink or watercolor is applied, to create shading or a multivalued edge as the brushstroke is made. The character of this edge is determined by the quickness of the stroke and how it is executed, and by the density of the ink in relation to the specific absorbency and texture of the paper. Success is based simply on developing skill, by experiencing how each particular paper will respond.

Oriental papers tend to be made thin for a number of interrelated reasons. Since the artwork is produced with a minimum of ink or watercolor, with little if any rendering, there is no need for thick papers to compensate for the buckling that occurs when using Western water-media techniques. The fibers in Oriental papers also have a natural resistance to swelling when exposed to water; therefore, they do not have to be thick to resist buckling. These papers are made thin for a practical reason, too. Eastern materials and techniques preclude easy correction of accidents and errors; thus a substantial amount of paper may be used before success is attained. It is less costly to practice on thinner paper than on thicker paper. After a successful painting is produced, it can be mounted to another heavier paper for handling and display. Even master calligraphers and painters do not get it right the first time every time!

My advice to those who would like widen their horizons by trying such papers as these is to start with a few sheets of the less absorbent papers and work to the most absorbent. When you find a style of paper that you feel you can work with, find the cheapest variety of it, buy a lot of it, and experiment. After you understand the paper's habits and characteristics, you can acquire a better quality. But you should always remember to do a few warm-up stokes on the cheaper version.

The artwork produced on Oriental papers has been traditionally protected first by mounting it on either a heavier paper or a piece of the same paper, and then by mounting it on silk. It was discovered that adhesives break down with time so, to minimize this problem, artwork is mounted with only enough adhesive barely to hold it to the backing. This allows easy removal for remounting at the first sign of deterioration. The purpose of the traditional presentation of artwork in the form of scrolls is to protect the artwork by storing it rolled, thus reducing its exposure to air and light. The artwork is unrolled for special presentations, for a short time, and then rerolled to be stored. In the West, a work of art is usually displayed continually, which is not safe for unprotected scrolls. When creating or collecting Oriental-style artwork, it is important to frame it in a Western manner if it is to be displayed continuously. (See *Framing and Storage,* pages 275 to 307).

The tradition of Oriental papermaking is more than eighteen hundred years old. Tragically, there are many traditional papers that will never be made again, because the information about how they were made was not transmitted and has been lost for all time. Nevertheless, there are still almost unimaginable varieties being made today, of which only a select few are available in the West. One of these, for example, called *hosho,* is made in almost one hundred varieties. I have selected eight distinct groups of papers that are available in the West. They are referred to by their most common names. Many importers and distributors make up their own names for these papers and it is not uncommon for the same paper to have several names. It is usually more practical to shop for these papers with a sample in hand than to ask for a paper by name.

The following papers are listed in descending order of their absorbency. The absorbency of a paper is determined by the arrangement of the fibers and the addition of sizing. Traditionally, the sizing used in Oriental papers is the natural vegetable adhesive mucilage, although the use of Western alum sizing has become prevalent. Many of these papers are available in handmade and machine-made varieties, but be aware that being handmade is no assurance of a paper's purity of fiber or neutrality of pH. As a result of diminishing sources of raw materials, more and more of these papers are being contaminated with such fillers as wood pulp, straw, and rice straw, while the price remains high. Some manufacturers have begun to use such traditionally Western sources of raw materials as pine trees. They claim to use the same methods of collecting and cleaning the inner bark, or bast fiber, of the tree that are used to collect kozo, mitsumata, and gampi fibers. The core of the tree, which contains the highest lignin content, is not used. They believe that time will prove that these papers will last as long as those made from traditional Eastern sources.

Since few Westerners have any expertise in determining the quality of Oriental art materials, the best guideline of quality, for the time being, is price.

Hosho first appeared around the fourteenth century in the Echizen Province of Japan. The best grades are still made primarily from kozo fibers. Occasionally, mitsumata may be added to improve the paper's elasticity. The lesser grades contain mostly sulfite pulp.

This paper is very absorbent. It is thick and fluffy, with a porous surface that is not durable for hard pencil or erasure. Its finishes range from vellum to cold press, and it has a uniform formation with moderate to heavy tooth. A fine-quality hosho is one of the most beautiful of white papers. It does not shrink, tear, or expand easily, and it is especially good for woodblock and linoleum printing. Because it is not sized, hosho is also good for soft, semiabstract watercolors, but it is not recommended for the beginner. Only an experienced hand is quick enough to prevent the uncontrolled spread of the ink into the paper. The handmade variety has four deckled edges. The most common size is approximately $18'' \times 24''$.

Kozo is similar to hosho, but it has a tighter arrangement of fibers, which results in slightly less tooth. It also has smaller pores, which means it has less absorbency. Made from 100 percent kozo fibers, it is the most common variety of paper, as well as the largest category of paper.

Kozo can be sized, making it less absorbent and slightly more durable. Its surface ranges from vellum to a coarse form of cold press. The formation of the fibers appears slightly mottled because of the way the long kozo fibers arrange themselves. Kozo is slightly thinner than hosho, and more versatile. The name "goyu" is sometimes used for the heavier variety of kozo, which is less absorbent and gives a drier, slightly mottled look with watercolors. A common size for kozo is $24'' \times 36''$. It is a paper that Westerners can be comfortable with for watercolors and printing.

Moriki could easily be placed in the kozo category because it is also made of kozo fibers, and some medium-quality grades are made of kozo and sulfite. This paper looks and feels very much like a thin kozo paper. It is, however, significantly less absorbent than kozo or hosho, and thus even more versatile for most Western techniques. Moriki has a delicate and translucent appearance, and a slightly shiny surface. It has a finer tooth that is more durable than other kozo papers and will hold some detail with watercolors. The formation is a mixture of evenly arranged fibers and longer mottled fibers, which can be easily distinguished because of the paper's translucency. Full sheets are about $23'' \times 34''$.

Mulberry paper is kozo paper. Mulberry is actually the Western name for the plant from which the kozo fibers are derived. Lesser varieties are made from kozo and sulfite pulp. However, there still are enough distinguishing characteristics to set it apart from the other kozo papers. Mulberry paper is very similar to moriki in appearance, but it is more opaque and somewhat less absorbent. Its surface is durable enough to take light drawing, but with very little erasure. It is the paper of choice for linoleum and woodblock printing. Mulberry is commonly used for stone rubbings, hinges in picture framing, and document repair, and is also the paper which is used to make the decorative mingei papers. Full sheets are about $24'' \times 36''$.

Troya is a paper made from kozo fiber, but it does not resemble any of the other kozo papers. This paper has a uniform formation, which, on close inspection, appears to have an open pattern like a fine mesh. Troya has the unusual char-

acteristic of being less absorbent and more porous than other Oriental papers. This means that when watercolor is used, it tends to go right through the paper, but does not spread (if the paint is not allowed to pool underneath). Troya is one of the thinner Oriental papers, and because it is porous, it appears to be very absorbent when in fact it is not. Working with this paper over a blotter will give rewarding results.

In the West, troya is rarely used for artwork, but rather for slip sheets to protect the surfaces of artwork. It is made in two weights; one is like tissue paper, the other like that of moriki. This paper is machine-made and does not have deckled edges. Its size is approximately 24″×36″. One of the major importers is no longer distributing this paper, so it has become difficult to find.

Gasen and Gasenshi. Gasen, which originated in China, is the oldest type of Oriental paper still used for artwork. Both the Chinese and Japanese traditionally prefer this paper for calligraphy and for Chinese-style painting. There are other Chinese papers, but since the Revolution, very few have the quality and permanence necessary for fine artwork. Gasen is one of the few Chinese papers exported to Japan and North America.

The name "Gasen" is derived from *ga*, which means "painting," and *sen*, which is a location in China. The Japanese added the *shi*, which means "paper," to the name "gasen" to make the translation more fluid, thus "gasenshi" means "painting paper from Sen." Although the Japanese tend to use the names "gasen" and "gasenshi" interchangeably, a paper called gasenshi often indicates that it is a gasen-style paper made in Japan. Gasen was originally made of 30 to 40 percent tampi and rice straw. Today, most gasen is made of either kozo or tampi mixed with straw and bamboo. Although the straw and bamboo considerably reduce the longevity, the traditional working qualities of this paper are considered more important than permanency.

This paper is thin, highly sized with a platelike finish, and remarkably strong. The surface is the most durable of all the papers discussed thus far, but it is still not classed as a drawing paper. Many Chinese paintings are done in great detail on this paper. Because it is very thin, it must be used with an absorbent surface underneath it to prevent the paint from pooling and spreading. The pattern of the bamboo mat that is used to pull the fibers from the pulp vat is left clearly imprinted, like a watermark, throughout the paper. This obvious laid pattern is one of the most identifiable characteristics of this paper. The most common size of gasen is 27″×54″, and gasenshi is usually found in 18″×27″. Both are without deckled edges, and are probably no longer handmade.

Torinoko means "child of the bird," or "egg," and its surface resembles an eggshell. It was introduced around the eighth century, and was made of pure gampi. Torinoko made from gampi is probably the most permanent paper made. The Treaty of Versailles was written and signed on this paper because it was believed to be the most permanent paper in the world.

The plant from which the gampi fibers are collected is now rare in Japan, and the plants from other Asian countries are not of the same quality. It is therefore difficult to find a torinoko paper today—even in Japan—that contains gampi, even in combination with mitsumata. With the one exception of a gampi

torinoko imported by Andrews Nelson & Whitehead, torinoko is made of kozo, or kozo with mitsumata. The method of manufacture and the addition of sizing have, however, helped to create a paper that looks and behaves like the original.

Torinoko is a nonabsorbent Oriental paper, which means it will take watercolor very much like a Western drawing or watercolor paper. The surface durability of this paper varies, depending on its method of manufacture and on what substitute for gampi was used. It is a thick, heavy, strong paper, with two workable sides—one a fine vellum and the other a nappy, cold-press finish. Machine-made torinoko comes $18'' \times 24''$ without a deckle; handmade torinoko is roughly $24'' \times 36''$ with a deckle.

Masa paper is the least absorbent of all the papers and the easiest for a Western watercolorist to work with. In overall appearance it greatly resembles torinoko, but today it is made primarily of sulfite pulp, and when it is soaked with water it tends to fall apart. Although this paper is not strong, it does allow the control that Western painters prefer, and it does have one additional advantage over the other Oriental papers—it is available in rolls of $42'' \times 10$ yards, as well as in sheets of roughly $18'' \times 24''$. Masa is machine-made and has no deckle.

Part Four

PAPER BOARDS

THE FIRST STEP in discussing any paper board is to define a board. A paper board is defined by its thickness. Any paper that is 0.012 inch or more, which is a little less than $1/64$ inch in thickness, can accurately be called a board. Tissue paper is approximately 0.001 inch thick, bond paper ranges from 0.003 to 0.004 inch, and one-ply museum board ranges from 0.0125 to 0.015 inch. The material most commonly used to store and protect fine art is four-ply museum board and its thickness ranges from 0.050 to 0.060 inch (0.060 inch is almost $1/16$ inch).

At one time there were several ways to define various boards by their thickness. A standard mat board was said to be fourteen-ply (roughly the equivalent of putting together fourteen sheets of bond paper) and double-weight mat board twenty-eight-ply. A standard museum board, which is approximately equal to a mat board in thickness, is called four-ply because each ply is much thicker than bond paper and it takes only four to reach the desired thickness. Today, most manufacturers of paper boards are shifting toward using a point system of measurement, which will make it easier to comprehend thickness and to compare various boards. In the point system, one point equals 0.001 inch. Therefore, if the average mat board or museum board is between 0.050 and 0.060 inch it would be between 50 pt. and 60 pt. in thickness.

There can often be as much as a four-point variance of thickness within a manufacturer's advertised thickness. Manufacturers of mat board have, for the most part, dropped their system of defining thickness by plys in favor of the point system. Some manufacturers who make both mat board and boards for illustration, as well as for graphic arts, refer to their 50 pt. to 60 pt. boards as single weight, and their 100 pt. to 120 pt. boards as double weight. Museum boards are still most commonly referred to in plys, although the point system is rapidly taking over.

The type of board is defined by its content, such as ground-wood boards, which, regardless of whether or not the surface is rag, are for graphic art use or other nonfine artwork. Boards that can be used in archives, such as museum board, are composed of rag, cotton, or purified cellulose. In the case of foam-centered boards, the center is composed of styrene. In the following entries there are explanations of the composition of the various boards and the reasons they are made the way they are, as well as indications of the circumstances under which they can be used with fine artwork.

Nonarchival Boards

A NONARCHIVAL BOARD is made of unrefined or partially refined wood pulp, or from recycled paper products where the residual lignin content is greater than in cotton (1 to 2 percent). The term "nonarchival boards" also includes any board that cannot maintain a neutral or slightly alkaline pH, as well as any board with significant levels of metals like iron and copper, which can oxidize and stain. Boards that have colorant that can bleed, or that have an alum sizing, are also nonarchival.

In general, nonarchival boards are not safe as a permanent support for fine artwork, although some painters have had limited success in preparing such boards for fine artwork by coating both sides with an acrylic polymer before painting.

CARDBOARDS OR GROUND-WOOD BOARDS

This group of boards, which includes cardboards, chipboards, and upson boards, is made primarily from recycled paper products and ground wood. These boards are highly acidic and contain metals and petroleum products. They should not be used in the production, or the storage, of fine artwork.

Corrugated Cardboard that is ⅛ inch, or single weight (called single wall in the cardboard trade), is composed of three sheets of a heavy, chemically treated, ground-wood pulp paper commonly called Kraft paper (named after the Kraft, or sulfate, pulp process). Two of the sheets are separated and the third, which is in the middle, is formed in a corrugated shape. This type of board has great strength in one direction. It is weak when bent along the corrugation, which can be compensated for by gluing two sheets of corrugated board together with the corrugation running in opposite directions. This results in an inexpensive and lightweight packing material.

Double-weight, or double-wall, corrugated board consists of five sheets of Kraft paper, two outside, one center, and two corrugated. Although the double weight is considerably stronger than single weight, it is still vulnerable to bending along the direction of the corrugation.

The strength of corrugated board depends on the thickness of the Kraft paper used to manufacture it. The type of corrugated board most commonly found in

art supply stores is the same used to make the average corrugated cardboard box. It is single weight and is $36'' \times 72''$.

Henri de Toulouse-Lautrec often used corrugated cardboard for his artwork, and today it is not uncommon for people to follow his example. However, the limited number of surviving pieces produced on this board have only endured because of extensive conservation and restoration, not because this is a viable support for artwork. This board should not be used in contact with fine artwork or in conservation framing.

Chipboard and Newsboard are names that are used interchangeably. This type of board is made primarily of recycled paper products and, consequently, contains a great variety of undesirable impurities from metal to petroleum products. This board is used as an inexpensive mounting and backing board in nonconservation framing. It is often oil-impregnated; mounting, therefore, can be difficult and is often impermanent.

The appearance of chipboard ranges from an uneven brown to a mottled gray. The single weight is 45 to 55 pt., and double and triple weights are commonly available in the size $32'' \times 40''$ and can be found in $40'' \times 60''$.

Stencil Board is also produced by the Kraft (sulfate) paper-pulp process and is impregnated with oil or wax to make it waterproof. This waterproof quality keeps the board from absorbing the water of a waterborne paint and buckling. It also prevents the paint from flowing under the edge of the stenciled image. This board is, however, totally unsuitable as a ground for fine artwork. Most stencil boards are just thick enough to qualify as boards (12 pt.). The sizes most commonly available are $18'' \times 24''$ and $24'' \times 36''$.

COATED, OR COVERED, GROUND-WOOD BOARDS

Mat boards, illustration boards, mounting boards, Upson board, and watercolor board are among the ground-wood, or recycled paper, boards that have a surface covering that is designed to meet specific needs. Some of these boards can be used interchangeably, such as mat boards and mounting boards, but none of them should be used in the production of fine artwork or its storage.

Upsonite®, which is commonly referred to as Upson board, is produced by Domatar Industries, Inc. Although Upsonite is made largely from the same materials as chipboard, it is lower in density and a bit lighter in weight. It is also available in a greater variety of thickness, size, and surface. It ranges from ⅛ to ⅜ inch in thickness (the point system is not used for this board because it is treated more as a building material for temporary displays than as an art material), and from $4' \times 8'$ to $4' \times 12'$ in size. Textured finishes are produced in pebble, smooth, and linen, as well as a waterproof variety for outdoor displays.

This board is used in the arts primarily for model buildings, such as sculptural or architectural models, and mounting photomurals. It is popular for theater sets, parade floats, and game boards.

Mounting Boards are chipboard covered with white paper. Inexpensive mounting boards are covered on both sides with a clay-coated paper and are intended

to be used only for mounting, such as for dry mounting photos and posters.

The better grades of mounting board are covered on one side with a bond paper, or inexpensive drawing paper, which is durable enough to handle pencil and paste-up. This type of mounting board is often referred to as mechanical, paste-up, or graphic arts board. It is designed to be an intermediate step in quality between boards that work well only in mounting, such as the clay-coated boards, and an illustration board, which is designed for multimedia. Graphic arts studios and newspaper publishers use this board for layouts, pasteups, and for the overall design of a project that will be reproduced by some printing process. Mechanical board is less expensive than illustration board, and its use can result in considerable savings, particularly when the board is used in large quantities. Conventional clay-coated boards do not work well with pen, marker, or pencil and will not stand up under the constant repositioning of material attached with rubber cement or wax.

Mechanical boards are widely available in single thickness, but double-thickness boards can also be found. Mounting boards are available in white and gray. Single weight is between 45 pt. and 55 pt., and double and triple weights are common. Common sizes are $30'' \times 40''$, $32'' \times 40''$, and $40'' \times 60''$, though sizes like $20'' \times 30''$ and $22'' \times 28''$ are available in some of the better grades.

Railroad Board is made from recycled paper and is clay-coated, or surfaced with white paper. This board is often made water resistant, to prevent buckling when waterborne paint is used or because of handling with wet hands. It is relatively thin as boards go, and its thickness is rated in terms of plys rather than points. The most common thickness, four-ply, is not standard, and it can range from 15 pt. to 20 pt. Also fairly common is six-ply, but virtually the only size it comes in is $22'' \times 28''$. The surface paper, which covers both sides of the recycled paper core, is only slightly refined. Railroad board is produced in white, black, and several lacklustre, dyed colors.

Poster Board is a thicker and slightly stiffer form of railroad board; six-ply and eight-ply are the common thicknesses. In addition to the $22'' \times 28''$ railroad size, poster board is available in $28'' \times 44''$. Poster board is covered only on one side with either white or colored paper. This board is used for show cards, picket signs, and display advertising.

Scratch Board is poster board covered with a white clay coating and a black-ink surface, which can be easily scraped away with a razor blade or a knife specially made for this purpose. When the surface coating is scraped away, the contrasting white clay layer is exposed. Art done on scratch board can resemble an etching or a woodblock print. This board is used primarily in the graphic arts to create images to be reproduced in various print media. Scratch board suffered in popularity in recent years and is no longer readily available.

Mat Boards are ground-wood boards with facings of decorative paper, metal foil, fabric, and simulated fabric, and as well as various textured finishes. The ground wood used in better-quality mat boards is from pulp where the tree bark and knots have been removed or at least avoided. Such impurities do not bleach

or readily break down during processing and can show up in the bevel when a picture mat is cut. The reddish-brown appearance of particles from the knots can be a stark contrast to the bleached ground-wood bevel, making the mat a total loss.

Mat boards are used for decorative and display purposes in and out of a picture frame. Mats were originally developed to keep paper artwork from coming in contact with the glass inside a picture frame. Later, mats were further developed to add a decorative border to paper artwork. Because of the high acidity of most mat board, paper artwork often develops a brown stain when in close or direct contact with these boards. A yellow stain can develop in as little as six months on some of the more absorbent print papers use in fine artwork. After several years of contact, it is often quite noticeable on the surface of artwork near the exposed bevel of the mat. Today, the Crescent Cardboard Company has begun to try to remedy the formation of this brown stain by adding chemical buffers, such as calcium carbonate, to their boards. Accelerated aging tests performed on their mat boards show that the boards still have a pH of 7.3 after a simulated one hundred years. It began with a pH of 7.7, so the increase in acidity would be considered negligible. Despite the good showing in pH this board should not be considered a substitute for museum board. It is only a much needed improvement of the standard ground-wood mat board. It is also likely that distributors of this board, as well as art supply stores and picture framers, will take several years to turn over their inventories for all the new boards. Using buffers is merely a temporary solution that will only delay the problem because the buffer will eventually be exhausted as the ground wood ages and as the boards absorb atmospheric pollutants.

The most common size of mat board is $32'' \times 40''$ with a thickness ranging from 55 to 60 pt. Selected colors are available in boards of $40'' \times 48''$.

Illustration Boards are made of ground wood and have drawing paper adhered to one side. If the paper is smooth, like a plate-finish bristol, it is called hot press; if it has some texture, it is called cold press. Watercolor boards are illustration boards that have either a rough drawing paper or a thin watercolor paper surface. Acrylic boards have a canvaslike textured paper. Linen texture and laid finish (a charcoal or pastel paper finish) are available with in white, gray, and colored surfaces.

These boards are designed to be used for production art where surface appearance and convenience are the only requirements. The rigidity of the board's backing keeps the paper surface flat during and after use so that artwork will photograph without distortion. In addition, this kind of artwork often passes through many hands and, if it were not on board, it could easily be damaged. Fine artists have often recognized this convenience and have been fooled by terms like "100 percent rag surface" into believing that such boards are safe for fine artwork, particularly since it is not unusual to find high-quality paper used for the surface of an illustration and watercolor board. However, with the one exception of the Strathmore 100 percent rag illustration board, this refers only to the surface. The ground-wood backing makes all such boards, no matter what their surface, unsafe for fine artwork.

The common sizes of illustration board are 15″×20″, 20″×30″, and 30″×40″. Boards of 40″×60″ are manufactured but are difficult to find. Single-weight illustration boards range from 50 pt. to 60 pt. Many of the different surfaces are found in double weight and a few in triple weight.

RAG ILLUSTRATION BOARDS

Rag, or cotton, illustration boards are on the borderline between nonarchival and archival. They do not fit the definition of archival because they are often highly sized with alum and are therefore acidic. A board that is 100 percent cotton, like the Strathmore 500 series illustration board, which is the industry standard, is not greatly affected by a slightly acidic pH, nor, for that matter, are most of the artists' materials that would be used on it. In any case, this board is designed for use in producing fine artwork as well as graphic artwork and not for storing documents in archives or in protecting art in museum-style picture framing.

The 100 percent cotton illustration boards manufactured by Strathmore have a very durable surface and resemble bristol paper in their finish and working qualities when using various drawing materials and waterborne paints. Their greatest asset is their ability to stay flat under almost all conditions.

Cotton illustration boards are available in two weights—heavyweight, approximately 65 pt., and lightweight, approximately 33 pt. The lightweight with regular (cold press finish) surface comes only in 22″×30″. The heavyweight in regular surface and high (hot-press finish) surface is available in 20″×30″ and 30″×40″.

Archival
Boards

AN ARCHIVE is a place to keep records. Archival refers to something used in storing and preserving such as archival boards, which are used for storing and keeping artwork and records. The qualities that make a board safe for storing artwork and valuable documents have been evolving since the mid 1970s. The most desirable board is one that does not age, remains at a pH of 7, is totally inert, is iron- and copper-free, is inedible to insects, remains free of mold and mildew, does not condense moisture, yet is absorbent. The development of such a board is unlikely for many years. A more reasonable expectation for an archival board would be that it is composed of either 100 percent purified cellulose from wood or 100 percent rag (or cotton) fiber and that it is at least 50 pt. thick. It should also be free of iron and be buffered to remain free of acid for seventy-five to one hundred years under normal framing and storage conditions.

The logic for this is that a board made from cotton, rag, or purified wood cellulose is relatively inert, does not readily condense moisture, and is practical in that it can easily be cut to size. The thickness is important because it provides both a mechanical and a chemical barrier. Thicknesses of less than 50 pt. may not be sufficient to keep a moderate-size piece of art ($26'' \times 36''$ or larger) away from the glass facing when it is framed. This is important because there is a natural tendency for artwork that is hinged to a mat, rather than glued to a backing, to curve toward the glass (see *Framing and Storage,* pages 275 to 307, for more information). Boards of less than 50 pt. are more easily subject, with changes in humidity and temperature, to developing buckles that can be transferred to the artwork that is being stored or framed. The same thickness is also needed to provide a chemical barrier from the acids present in polluted air and from such other storage materials as the backings used in framing or the wooden file drawers used for storage. Buffering of the board is mandatory, with the exception of boards made for the storage of albumin, dye transfer, and Cibachrome prints so that any acids from the storage environment and air pollution can be neutralized. Care must be taken by the manufacturer to be certain that there is no residual iron in the board that may accumulate in the washing of the fibers during processing.

Any board that can meet these requirements and show no detectable deterioration for seventy-five to one hundred years should be considered safe and proba-

bly would remain safe for several more generations. The type of museum board currently in use has not been around for one hundred years, and all claims to permanency are based on theory and accelerated aging tests. In other words, everyone is attempting to make the best decisions possible with whatever information is currently available. It can be expected that new definitions and minimum requirements will continue to evolve.

MUSEUM BOARDS

"Museum board" is the common name for 100 percent rag or cotton-fiber boards that meet the current minimum standards for archival use. Museums were among the first major users of this type of board for storing and framing artwork, hence the name. At one time, this board was also called rag board. Because there are several types of boards that contain rag or cotton that do not meet the minimum standards for archival use, the name has slowly been replaced. Despite the introduction of conservation boards composed of purified wood cellulose, museum boards are still overwhelmingly the board of choice for archival purposes, because rag or cotton fibers are longer than those of purified wood cellulose and are, therefore, stronger and more durable. Any picture framer knows that it is much harder to cut a mat from a museum board than a conservation board, and that cutting blades wear twice as fast when cutting a museum board.

Several manufacturers produce a limited selection of colored museum boards. The Strathmore Paper Company, for example, manufactures two grays, five colors, black, white, natural, and cream, all tested for bleed resistance, scuffing, rubbing, and abrasion to meet standards established by the United States Library of Congress. The thickness of its four-ply boards was originally between 50 and 55 pt.; however, Strathmore has increased it to 60 pt. to compete with the thicker boards now on the market. Museum board of a one-ply thickness— between 12.5 and 15 pt. and usually available only in white—is used primarily for temporary storage and as a separation sheet when stacking artwork. It is also occasionally used as a drawing paper. Museum board that is two-ply can often be found in the same range of size and color as that of four-ply, and is used for temporary storage for up to twenty-five years. It is too thin to be used in picture framing as either a mat or a backing. Both one-ply and two-ply are available in only 32″ × 40″.

Museum board that is four-ply is most commonly used for long-term storage and museum-style framing. It is available in various shades of white and gray, as well as a limited range of colors, in 32″ × 40″, and is also made in 40″ × 60″. A new, still larger size, 48″ × 84″, has begun to be distributed in some major cities. New and not readily available, six-ply and eight-ply are, in most cases, chosen more for aesthetic reasons in picture framing than for additional protection.

RAG MAT BOARD

Rag Mat is a 100 percent rag board with a buffered, fade-resistant, colored, sulfite-pulp paper facing. It is produced by the Crescent Cardboard Company. It

is currently manufactured in twenty-eight colors, and new colors are soon to be introduced. The boards are available only in $32'' \times 40''$.

The early versions of this board had a thickness of approximately 45 pt., which was considered by many people to be too thin to keep most medium-size paper artwork away from the glass in picture framing. These boards are, however, being replaced with ones that are 50 pt. Rag Mat "100" is similar to the Strathmore museum boards, which are now produced in a thickness of 60 pt. in four-ply.

CONSERVATION BOARDS

These boards are made neither from rags nor from cotton, but are composed of purified cellulose pulp from wood where the lignin has been removed and to which an alkaline buffer has been added. Conservation boards are made to meet the same requirements as those for museum boards, and are accepted by most institutions for use in archives. Some conservative conservators still question this type of board for long-term use because of the extensive chemical processing that the fibers undergo. They believe that the fibers are significantly weakened, affecting durability and possibly even permanency. Nonetheless, as rag and cotton fibers become increasingly rare and expensive, conservation will become more common.

A large percentage of conservation boards available at this time are produced by three companies—the Rising Paper Company produces Conservamat, Andrews Nelson & Whitehead offers pHase 7, and the Process Materials Corporation offers Archivart Conservation Board. With the exception of the white and cream produced by the Process Materials Corporation, these boards are all between 50 and 60 pt. in thickness and $32'' \times 40''$ in dimensions. Larger and thicker sizes are not generally available.

The color selection of conservation boards is much the same as the limited selection of museum boards, although black is not available. At one time, the gray pHase 7 boards used for framing changed significantly after a year or two, becoming lighter and developing a red tint. Today, primarily due to intense competition, most manufacturers apply stringent tests to avoid such problems as fading. These tests, however, are accelerated aging tests, which only simulate certain aspects of the aging process and therefore cannot be a substitute for actual conditions.

The leading conservation mat board, Alphamat, made by the Bainbridge Company, is the conservation board equivalent to Crescent Cardboard's Rag Mat. Alphamat is available with paper facings in sixty colors, which are pigmented to prevent fading. The board itself is a bright white. The bright white bevel, although eye-catching on white and off-white mats, is found by many people to be distracting on the darker and more strongly colored shades of mats. This board is designed for use in picture framing where the artwork is not touching the paper facing. Although several pastelists have used this board surface to draw on, it is not clear whether it is generally safe for fine artwork. The surface is a very thin paper adhered to an archival board and this combination would appear to be less hazardous than using a colored wood-pulp paper alone because,

over the years, as the paper facing loses its strength, it has the board for support. In addition to the sixty colors available in $32'' \times 40''$, nine are produced in $40'' \times 60''$, but are not readily available. The boards are 55 pt. thick.

ARCHIVAL NONBUFFERED BOARDS

Albumen photographs, which were made through an early method of producing black-and-white prints with animal protein, and dye transfer prints, produced by a more modern and lightfast method of producing color prints, are both adversely affected by an alkaline pH, or a pH of more than 7.5. Dyed natural fibers, like silk and wool, are also sensitive to alkalinity because the dyes used in their production are usually acid dyes. It is therefore best to avoid buffered museum and conservation boards when framing albumen photographs, dye transfer prints, and work made of natural fibers.

Nonbuffered archival boards are very specialized, and are not readily available. The Light Impressions Corporation, however—a mail order house that sells a large variety of archival supplies to the public as well as to the trade—offers a 50 pt., four-ply, 100 percent rag board that is not buffered, in sizes from $8'' \times 10''$ to $32'' \times 40''$. The company's address is: 439 Monroe Avenue, Rochester, New York 14607.

ARCHIVAL CORRUGATED CARDBOARD

The Process Materials Corporation produces a buffered corrugated board that appears identical to ordinary corrugated board, except that it is blue-gray or bright white rather than brown. It is called Archivart Multi-Use Board, and is available in both single weight (single wall), ⅛-inch, and double weight (double wall), ¼-inch in sizes of $32'' \times 48''$, $40'' \times 60''$, and $48'' \times 96''$.

Archival corrugated cardboard is used as a backing board in museum-style framing and storage, as well as an artists' material. Although the purity of the wood pulp used to make this board is questionable, as is the quality of the adhesive used to hold the various layers together, the manufacturer claims it meets archival requirements. For additional security when using the board as an art material, I have had good results in creating rigid, and safe, painting surfaces by mounting 100 percent rag to this board.

Foam, or Foam-Center, Boards

FOAM BOARDS were originally developed for use in the graphic arts, but have now found their way into the world of fine art. Foam-center boards are lightweight boards made of a rigid plastic foam with a paper or plastic facing. They resist warping, are more dimensionally stable than boards made from wood pulp, and are far less acidic. Despite the many advantages of this type of board over most paper boards, it cannot be considered archival because the core is polystyrene, or some variant of polystyrene, and this material naturally decomposes over a long period of time and is said to give off acid vapors. This aging process is greatly accelerated when exposed to ultraviolet light (some of the newer boards have UV stabilizers) and air pollution. Some manufacturers have begun to buffer the surface paper to help maintain an acid-free surface. In museum-style picture framing, where foam board is used as a backing material, it is not exposed to ultraviolet light and the elements. This would make its use in framing quite safe as long as it is not in direct contact with the artwork. Unfortunately, some artists think this material is safe to use as a painting or sculpture material for fine artwork when they learn it is used in museum-style framing. Unless foam board is thoroughly covered—particularly the exposed foam edges—with enough paint to seal the surface from air and to prevent ultraviolet light exposure, it will deteriorate too rapidly for fine art.

FOAMCORE BOARDS

Foamcore boards are made with a polystyrene core and either a white clay-coated or brown Kraft paper facing. The original white foamcore board was produced for the graphic arts industry by Monsanto and was named Fome-Cor. Today there are several other competitors, as well as a generic version. The way the polystyrene bubbles are formed during manufacture allows the edges to stay sealed, or at least crimped, during die cutting. This creates a characteristic pillow effect. It also means that any accidental impressions or dents can permanently damage the board. The foam center is not affected by moisture, but the surface paper is, and outdoor use as well as wet mounting can be a problem. The surface will readily accept oil paints and acrylic paints, but the foam is sensitive to some solvents, particularly those in lacquers and shellacs. Fome-Cor

cuts easily with a razor blade, if the blade is sharp and without defects; if it is not, it can tear the foam instead of cutting it. My experience with this particular board is that it behaves as if it had a grain and tends to cut well in only one direction. This board is commonly used in dry mounting and vacuum mounting, as well as in wet mounting when counter mounting is done (see *Framing and Storage* pages 287 to 295).

There are three types of Fome-Cor:—original, acid-free, and super thick. The original is made in two thicknesses, ⅛ and $^3/_{16}$ inch, and four sizes, 20″×40″, 32″×40″, 40″×60″, and 48″×96″, of which the first two are most common. In the $^3/_{16}$-inch thickness, there is a greater variety of available sizes, but only the first three are readily found. The surface pH is slightly acidic, 5.5 to 6.5, and it is for this reason Monsanto produces an acid-free Fome-Cor where the surface paper is buffered to a pH of 7.5 to 8.5. The printed literature for this board suggests that it is archival and may be used as a substitute for museum board. This seems questionable because, for example, the surface of this board is made from a Kraft paper and not a purified cellulose, or cotton fiber. It is uncertain how much alkaline reserve the buffer can provide in neutralizing air pollutants and the natural formation of acid during the aging of Kraft paper. There are also questions about the permanency of polystyrene itself. This board is obviously an improvement on the original; nevertheless I have reservations about its archival qualities. The acid-free foam core is produced in thicknesses of ⅛ and $^3/_{16}$-inch, and sizes of 32″×40″ and 40″×60″. The super thick variety, called Fome-Cor ST, is identical to the original board but is ⅜-thick instead of $^3/_{16}$-inch. The available sizes are 30″×40″, 32″×40″, and 40″ × 60″.

PRIME-FOAM-X® BOARD

Prime-Foam-X is produced by Primex Plastics Corporation. With all its similarities to Fome-Cor, it has some significant differences. The outer paper facing is thicker, whiter, and glossier. The formation of the foam bubbles and their higher density in this board allow for better retention of shape and minimize damage. This board is said to have "memory" because slight indentations tend to heal themselves. Consequently, in die-cutting the edges do not crimp or seal as they do with Fome-Cor. I have found that Prime-Foam-X does not have any directional cutting resistance and cuts well in all directions. It is manufactured in the same sizes as Fome-Cor and is also available in an acid-free version. This board is now produced with a UV inhibitor to reduce the possibility of ultraviolet light breaking down the foam. There are two thicknesses—0.125 inch, or ⅛ inch, and 0.210 inch, which is almost ¼-inch thick and is thus often referred to as ¼-inch nominal. Primex prefers to use thousandths of an inch rather than fractions in referring to thickness. The surface pH is between 6.5 and 7.0 for the regular surface and 7.5 for the acid-free surface. Prime-Foam-X is a little more expensive than Fome-Cor.

GATORFOAM® BOARD

Gatorfoam has a foam center of Dow styrofoam polystyrene with a Luxcell veneer. The veneer is a multilayered, resin-impregnated, Kraft paper surface. Styrofoam is a much harder form of polystyrene foam and is much more durable, but does not have any better aging properties. The hardness of the core combined with the Luxcell veneer results in a board that can only be cut with a table saw, which significantly reduces its ease for use in picture framing and storage. The major advantage of Gatorfoam is its thickness, which ranges from $3/16$ to $1\frac{1}{2}$ inches. The $3/16$, $\frac{1}{2}$, and $\frac{3}{4}$-inch thicknesses are made in $30'' \times 40''$ and $40'' \times 60''$. One inch and $1\frac{1}{2}$ inches are available in $48'' \times 96''$ as well.

Gatorfoam is manufactured with two surfaces, one white, the other brown. The brown Kraft is better for receiving paint and for mounting. There are also two grades: Gatorfoam I is the standard, Gatorfoam II is a less expensive version with an expanded polystyrene foam center. This board is primarily used in model building and as a lightweight substitute for plywood.

GILMAN BOARD

Gilman board is like Gatorfoam II in that it has an expanded polystyrene core, which is also known as block foam. The outer sheeting, however, is a clay-coated, white sulfate paper. This paper allows the board to be hand cut by first scoring with a mat knife and then bending, which makes it more practical for picture framing. Gilman board is produced in thicknesses like Gatorfoam—from $3/16$ to 1 inch, but only in $4' \times 8'$ sheets.

ARTCORE

Artcore, manufactured by the Amoco Company, is not a paper, or a paper surface foam board. It is entirely plastic. It is polystyrene foam covered with a white styrene sheet. Since it is all plastic, it is also waterproof. The surface sheet is treated with a UV inhibitor to reduce deterioration from sunlight and fluorescent light. The nonabsorbency of the styrene facing can, however, make mounting difficult. I have had areas of several photographs separate from the surface after vacuum mounting. In fact, after experimenting with this board I have found it has no advantages for framing and storage over the paper-faced foam board. It would seem more practical for making displays, models, and signs. Its surface pH is 6.0 to 6.5, and it is manufactured in thicknesses of $1/16$, $\frac{1}{8}$, and $3/16$ inch. The available sizes are comparable to other foam boards.

Part Five

PAINT
SURFA

TODAY IT IS RARE to find artists making their own brushes or paints; however, the reverse is true when it comes to preparing a surface or support to paint on. An artist's involvement in preparing a painting surface may range from purchasing raw canvas, stretching it, sizing it, applying a ground, and priming it, to simply applying a second coat over preprimed stretched canvas.

Preparing your own surfaces to paint on provides the opportunity for you to create a working surface that meets your own requirements. Manufacturing it yourself also saves money. Too often, however, an artist's impatience, lack of money, and incomplete understanding of the role of a properly prepared painting surface results in a painting that eventually requires major conservation or simply self-destructs. The unfortunate reality is that the preparation of a proper painting surface is too often the last consideration that a painter makes.

There are some basic guidelines for the preparation of a painting surface that have developed over the last seven hundred years. If these guidelines are violated, disaster will result. This does not mean that only traditional surfaces may be used, but rather that the principles of these guidelines must be understood so that new, as well as old, surfaces can be properly prepared so that artwork will have a reasonable chance of survival through time.

Definition
of Terms

THE FOLLOWING are basic terms used in discussing painting surfaces.

Auxiliary Support. An auxiliary support is a device used to hold the support. Stretcher bars, for example, are the auxiliary support for the canvas, which is the support for the painting.

Support. A support is what physically holds the painting, or paint film, such as canvas, plywood, compressed-wood fiberboards, metal, paper, and boards. The ground is applied to the support.

Size or Sizing. Sizing is the material applied to the support to temper it and to protect it from any deleterious effects of the ground or paint. Hide glue, gelatin, or acrylic polymer are used for sizing the support.

Ground. A ground is the surface coating or film, such as acrylic gesso, which is applied to a support, such as stretched canvas, to receive the paint. All grounds, with the exception of frescoes, are composed of gypsum and an adhesive or binder. It is the gypsum that provides the necessary absorbency to receive the paint.

Priming. Priming is often confused with ground. It is the layer between the ground and the paint film. For example, the ground may be too absorbent, in which case the absorbency may be reduced by priming the ground with a medium or diluted varnish.

Portable Supports

THERE ARE TWO TYPES of portable supports—stretched and unstretched. A stretched support is a material, such as canvas, stretched over a frame or panel. Unstretched supports are plywood, fiberboard, particle board, metal, paper, board, and even canvas without a frame. The purpose of having a portable support is to be able to move it easily from place to place. Therefore a support's most important characteristics are that it be lightweight, stable, and durable. Often these factors must be balanced among one another. For example, if the support is too lightweight it is often not stable. And, if it is made to be very durable it is often too heavy. Each situation is unique and requires its own balancing act.

AUXILIARY SUPPORTS

The purpose of an auxiliary support is to give structure and support to the support itself. An auxiliary support may be either stretcher bars, a frame, or a panel. A panel is a uniform structure with at least one solid, flat, unbroken surface. The first panels were made of wood planks butted against each other, the surface of which was used to paint on. Today, lightweight panels are used as auxiliary supports as well as supports. A frame consists of a set of bars that are fixed together and cannot be expanded. Frames were first seen in the seventeeth-century Dutch school of painting. Their introduction was a major advance in reducing the weight and increasing the portability of paintings. Stretcher bars are bars designed to produce a frame that can expand slightly to tighten further a stretched canvas. The first stretcher bars with mitered corners and keys (little wedges used to force open the corners of a stretcher bar frame to tighten a stretched canvas) appeared in the early nineteenth century.

Frame Supports are the simplest and the oldest auxiliary support for stretching canvas. They are the easiest to make, but they have no provision for tightening sagging canvas. They consist of four pieces of wood in small sizes, which are simply glued and nailed together. Cross braces are added for larger sizes. Today, frame supports are made from kiln-dried pine or mahogany, which has less tendency to warp. The bars are usually made from $1'' \times 2''$ lumber that has had one of

Tongue and Groove Bars

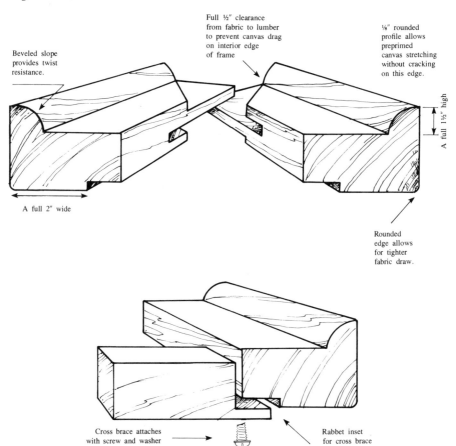

Full ½″ clearance
from fabric to lumber
to prevent canvas drag
on interior edge
of frame

⅛″ rounded
profile allows
preprimed
canvas stretching
without cracking
on this edge.

Beveled slope
provides twist
resistance.

A full 1½″ high

A full 2″ wide

Rounded
edge allows
for tighter
fabric draw.

Cross brace attaches
with screw and washer
through slot in crosspiece.

Rabbet inset
for cross brace
fits flush.

BEST KEY™

The Best Moulding Best Key™ corner system screws into
any existing stretcher bar unit. It replaces the standard wooden
key with a rust-resistant metal "double hinge" that collapses
when its screw is tightened, thereby expanding the corner and
tightening the fabric. Loosen the screw and the fabric will relax
to its original size. The Best Key™ allows the artist superior
tolerance when tightening the fabric with a key.

Illustration courtesy of Best Moulding Company

the 1-inch sides milled at an approximately 30-degree angle to produce a ridged edge. The ridge allows the canvas to be stretched with only one edge of the bar touching it, rather than a whole side, which could leave an unsightly impression on the front of the canvas.

The corners and cross braces are often reinforced with triangles, made of ⅛- to ¼-inch plywood, nailed and glued to the back. All wood should be seasoned, cured, or kiln-dried and should be free of knots. Cross bracing is most often done every 18 inches. With heavy bars made from $2'' \times 4''$ wood, cross bracing is done every 36 to 48 inches.

A Framed Panel Support is a piece of lightweight mahogany veneer plywood with a frame attached to the back to give additional reinforcement to prevent warping. Panels such as these are used to stretch canvas over. The panel is made from plywood ⅛-inch thick, or ¼-inch thick for larger sizes. The frame is made of $1'' \times 2''$ (milled $1'' \times 2''$ is actually $¾'' \times 1¾''$) mahogany strips with cross bracing every 16 inches. The panel is glued to the frame and sealed with a wood sealer. The advantages of this type of auxiliary support for stretched canvas is that it is strong, yet lightweight, and it allows for the easy sanding of a gessoed surface to achieve a smooth finish. It also provides support for drawing and for egg tempera paintings. The problem with this kind of rigid support is that the canvas cannot be tightened without restretching. In addition, care must be taken not to glue the canvas accidentally to the surface of the panel when sizing it or when preparing a ground.

Stretcher Bars are designed so they can be assembled without being fixed in place, and the corners can be expanded after the canvas has been stretched. They should always have a raised lip at the outer edge to keep the canvas from touching the inside edge of the stretcher bars and leaving an impression. The main purpose of stretcher bars is to remove any sagging of the canvas—a recurrent problem with linen—which can occur during stretching and sizing, as well as during the application of the ground. Expanding the corners of a painted picture is not wise because small cracks can develop, which will eventually become larger, especially in older paintings. The general rule is that if a sagging painting cannot be corrected with minor adjustments, leave it alone or get help from a professional restorer.

There are several types of corner designs—tongue and groove, Lebron, Muleski, and Starofix. The tongue and groove system is the style most commonly used for commercially made pine stretcher bars. They range from ⅝ to $^{11}/_{16}$ inch in depth and 1½ to 1⅝ inches in width, and lengths from 6 to 72 inches with increments of one inch. One end of each bar is cut so that it will slide into the groove cut into the end of the other bar. The cutting remnants, which are in the shape of little triangles, are used to expand the corners by wedging them into the gaps in the inside of the joined corner after the canvas has been stretched over the bars. A heavy-duty version of these bars can sometimes be found in art supply stores or can be ordered through them. One of the best I have seen is manufactured by the Best Moulding Company and is illustrated opposite.

Muleski Stretcher Bars

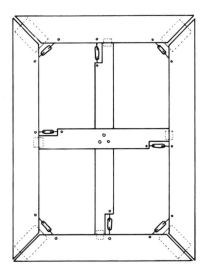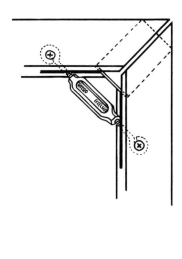

Two types of hardware are used to expand the corners of stretcher bars. The first type is a turnbuckle, which involves a metal link that holds together a screw on each end. The screw has an eyelet at the end so that it may be fastened to a surface. The screws have opposite threading so that when the link is turned the screws are pulled together. The Muleski stretcher bar corners, named after the designer Thomas Muleski, employ turnbuckles.

The corners have a large groove in which a small aluminum plate is inserted and the eyelet turnbuckles are fastened to the inside of the corner groove. The link is exposed in the inside of the corner and when turned the corner expands along the aluminum plate.

The Lebron stretcher bar system, named for the designer James Lebron, uses a Tite-Joint Fastener, which consists of a locking sleeve on one edge of a draw bolt and a tightening nut assembly on the other end.

The nut assembly and the locking sleeve are embedded into each side of the corner. Dowels are placed on each side of the draw bolt, parallel to it. The corner is expanded by turning the round nut with a pin or nail, which fits into small holes made for this purpose. As the corner expands the dowel maintains the alignment of the corner.

A new development in stretcher bars is the use of extruded aluminum strips with outside edges made of wood. A company called Starofix has developed what it calls a "continuous tension stretcher." A type of adjustable spring clip is used in the inside corners to keep the canvas stretched taut. They are light-weight, and so strong that cross braces are not required for lengths less than 72 inches. They are ideal for conservation work and for very large canvas works.

Title Joint Fastener

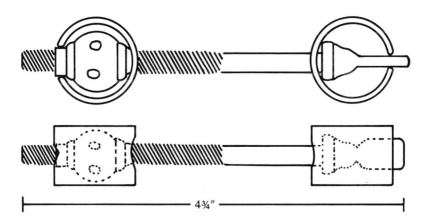

4¾"

Lebron Stretcher Bars

Starofix Continuous Tension Stretcher Bars

CROSS SECTION SHOWING CORNER PLATES

CROSS SECTION
SHOWING STRUCTURE
OF BARS

1. WOOD SECTION OF BARS
2. ALUMINUM SECTION OF BARS
3. CORNER PLATE
4. BLOCK
5. SPRING
6. ADJUSTMENT SCREW
7. WRENCH FOR SCREW

However, they are expensive and their high price puts them out of reach for most painters. In addition, they are not readily available outside New York City.

STRETCHED SUPPORTS

By the Renaissance, fabric was widely used as a support for painting and had almost replaced the wooden panel. Panels are heavy and the paintings on them are easily damaged. A bumped panel can send ripples through the surface, weakening the bond between the ground and the support. Fabric stretched over a frame resolved the two major problems of weight and elasticity.

The time-tested practical approach to painting on a fabric support, such as canvas, is to stretch it across a frame, stretcher bars, or a panel. Paintings—particularly oils—that are completed on unstretched fabrics and later stretched, form tiny, almost invisible, cracks in the paint film, which eventually become larger. Therefore, unstretched artwork should remain unstretched and stretched work is best left alone.

Of all the possible fabric supports, canvas is the best choice because of its long history of durability. The term "canvas" is derived from *canabis*, also known as hemp, which, with flax, was the first fiber used to produce sailcloth. "Canvas" now includes jute, which is used to make burlap, and cotton. Of these three, cotton and flax, or linen, are the most popular.

There are several ways to classify canvas. For the artist, the most important information involves the ounces per square yard and the thread count. This information, however, is sometimes difficult to obtain. Ounces per square yard will tell how heavy the canvas is. Threads per square inch will tell how dense the canvas is. Canvas that is less than seven ounces per square yard with a thread count of less than fifty threads per square inch is too lightweight for use as a support for painting. It will not be sufficiently strong to resist tearing and the spaces between the threads will be too large to fill adequately during sizing. As long as the canvas is heavier than seven ounces with a tighter weave than fifty threads, your choice can be based more on appearance and feel than technical specifications.

Linen has been found in Stone Age remains and in the tombs of ancient Egypt and has proven its durability. The linen wrappings from Egyptian mummies are still flexible today. The source of linen fibers is the flax plant, whose fibers are stronger than any other natural fiber and range in length from 10 to 36 inches. Linen fibers are round, not flat like cotton, which gives linen fabrics their irregular texture. Chemically, the fibers are 70 to 80 percent cellulose and contain the same oil that is found in the plant's seeds and that is used in linseed oil. The natural content of linseed oil preserves the fibers and keeps them flexible. On the other hand, it was long ago discovered that paintings using linseed oil on unsized linen rotted quickly, because the fibers can stand only so much linseed oil. When linseed oil dries it becomes acidic and will attack the cellulose. Today, the problem of acidity is greater, because of the acidic air pollutants, which can also attack the cellulose of linen. Bleached linens should not be used as a support for painting because the bleaching process severely weakens the fibers.

The ropelike quality of the linen fibers produces an irregular texture which is especially ideal for figurative painting because of the sense of depth it gives to the surface. Unfortunately, linen is more difficult to stretch than cotton canvas, for it has a tendency to sag after the first attempt, thus requiring tightening. In addition, linen is often two to three times more expensive than cotton and is difficult to obtain in weights greater than seven ounces with thread counts greater than fifty. Although a thin linen canvas is stronger than a thin cotton canvas, artists should nevertheless use linen heavier than seven ounces per yard and denser than fifty threads per inch, with as few knots as possible. Today, the best grades of linen are produced in Belgium. Yet, few artists can afford an eight- to ten-ounce, tight-weave Belgian linen in widths larger than 54 inches, let alone find it. At the present time, most of the affordable linen is imported from Southeast Asia. The quality and consistency is not as good, but it is adequate.

Cotton, like wood and linen, has been in use since prehistoric times, particularly in the Orient. The best cotton comes from the east coast of the United States; the second best is from Egypt. Cotton fiber is almost pure cellulose and is easily affected by acid and bleach. Therefore only unbleached cotton fabrics should be used as supports for paintings, and they should be sized before oil painting to protect against acidity.

There are several negative aspects of using cotton as a support for painting. For figurative painting, cotton has a less interesting texture than linen. It is also less strong than linen, for its fibers are shorter, ranging from $5/16$ to about $1½$ inches in length. Cotton fabrics derive their strength more from the process of twisting the yarn during manufacturing than from the weight or thickness. A well-twisted yarn can be stronger than two yarns of the same thickness that are not twisted. But, it is very difficult for most people to perceive this quality by casual inspection. What you can look for to give you an indication of the quality is the "trash" content. Trash is the waste recovered from the processing of the cotton bolls and, to cut expense, a small amount is often added back into the cotton as a filler. If too much trash is used, the strength of the fabric will suffer. An indication of the amount of trash in a fabric is the brown specks, called moats, which come from the seeds and husks of the cotton boll. The fewer moats you see, the less trash and the better the quality of the canvas. Lack of strength in a cotton canvas can be overcome by selecting a heavier weight and a tighter weave. Eight ounces per square yard should be a minimum. Most professional painters use a ten- to twelve-ounce canvas with a weave so tight that few if any holes can be seen when the fabric is held up to the light.

Cotton is not as permanent as linen because it lacks linen's natural oil content. Cotton fabrics are basically unprotected cellulose, which is easily attacked by acidity. The exposure to the acidity from air pollution and ultraviolet light over several decades will substantially weaken a cotton canvas. This can be somewhat compensated for through proper sizing with acrylic mediums.

Commercially Prepared Canvas is an alternative for those painters who do not wish to prepare a painting support themselves. Preparing a traditional glue-sized,

lead-primed, linen canvas requires skill as well as effort, and a prepared canvas is often the only sane option.

Manufacturers of prepared canvas refer to their products as "primed" canvas because they are ready for use without further preparation. This is not an accurate use of the term "primed," but it has been adopted because of convenience. It is simply easier to say "double-primed linen," for example, than "linen with a hide-glue size and a lead white, oil ground." Unfortunately, this use of the term "prime" has carried over to common artists' vocabulary, occasionally leading to incoherent discussions of various products and methods used in the preparation of canvas for painting. In this discussion of prepared canvas, the commercial descriptions of products are used, but please do not confuse them with the proper use of the term "primed."

There are four basic varieties of prepared canvas available in most artists' materials stores. They are acrylic-gesso-primed cotton, acrylic-gesso-primed linen, glue-sized single-primed linen, and glue-sized double-primed linen. All of them can be used as supports for oil paintings. Acrylic or vinyl paints, however, may only be used on the acrylic-gesso-primed canvases, which conforms to the rule of not using a water-based paint over an oil-based surface. "Single-primed" and "double-primed" refer to the number of coats of lead paint that have been applied. The more coats, the smoother the surface, the stiffer the canvas, and the greater difficulty in stretching it. "Double-primed" is less flexible than "single," which makes its permanency more questionable.

Commerically prepared primed canvas comes in several forms: rolls, panels, pads, and stretched. The rolls are generally of 6-yard lengths with widths ranging from 45 to 84 inches. Most are made from eight-ounce canvases, although different weights and weaves are common. There are differences in quality, but they are, in most cases, not related to permanency, and choice should therefore be based mainly on cost and personal taste. The only caution to be taken in your selection is the weight, or strength, of the canvas. Remember that the larger the painting, the heavier the canvas should be.

Preprimed and stretched canvases are often of a quality too poor for professional work, and are normally reserved for studies or experimentation. The better grades are considered by many to be minimally acceptable in sizes up to 24″×30″. Beyond this size, substantial reenforcement is often required. Canvas pads and canvas panels are not suitable for truly professional work.

STRETCHING CANVAS

Fabrics like canvas are stretched to the maximum during the manufacturing process and this tension has to be maintained, if not increased. If this is not done the fabric will attempt to return to a more relaxed state as the humidity changes or if water-based paints are applied to it. The result can be buckling, sagging, or distortions of the painted surface. It is therefore best to fasten a canvas securely before painting.

Fredrix Artist Canvas, Inc. offers instructions for stretching canvas; this is a simplified version of its recommendations, with some modifications.

Check the squareness of the auxiliary support, and verify that it is adequately reinforced. It can then be placed over the canvas, aligning the vertical and horizontal weave. There should be at least three inches of excess material on all sides so that the canvas can be held and wrapped around the edge of the auxiliary support.

Wrap the canvas around at the center of one of the longer sides of the auxiliary support and then tack or staple it to the back of the support. The opposite side of the canvas should be pulled (canvas pliers are often helpful at this point) and tacked down in the same fashion. Repeat the procedure for the centers of the adjacent sides. At this point, there should be a diamond-shaped wrinkle.

Return to the center of the long side. Choose a point one or two inches to one side of the point where the canvas is already tacked, and pull the canvas and secure it as before. Working outward toward the corners, tack down the opposing side, followed by the adjacent sides. The diamond wrinkle should disappear as the corners are reached. About two inches from the corner, tuck, fold, and tack the canvas in place.

If you are using stretcher bars as an auxiliary support for raw canvas and there are minor wrinkles, the corner may now be expanded to remove them. If the canvas is fixed over a frame or panel, all or part of the canvas must be restretched to remove wrinkles. With raw canvas, dampening and drying will remove most minor wrinkles, but they may return when the canvas is prepared for painting.

Wrinkles in prepared canvas should not be removed by expanding the corners or by dampening, both of which can cause cracking and weakening of the bond between the support and the ground. Care should also be taken not to stretch lead-primed canvas too tightly because fine cracks can develop.

UNSTRETCHED SUPPORTS

Wood is the oldest unstretched support, and examples of its use date back to 2900 B.C. in Egypt. During the Renaissance, oak was the wood of choice, followed in popularity by pine and then poplar. Wooden supports were panels made from boards joined together at the edges. Today, even if you chose to duplicate these panels and had the carpentry skills and knowledge of woods necessary to produce them, you would have great difficulty finding properly cured hardwood milled in the correct manner. Panels that are built up from boards joined side to side have the drawbacks of being heavy and having a tendency to develop a washboard effect on the surface of improperly prepared panels. Today's unstretched supports include canvas, paper, plywood, fiberboard, particle board, and metal.

Plywood is available in two types. One has a solid wood core and a wood veneer on both sides. The other, which is most often used as a support for painting because of its availability and lower cost, consists of several veneers of wood glued with the grain at right angles to each other. The veneers of wood are produced by rotary cutting; a whole log is cut on a giant lathe by rotating it against a blade, shaving off layers. In all veneer plywood the inner layers are of

a cheaper grade and are thicker than the veneer. The outer veneer can range from a construction grade to that of a fine-quality hardwood. A hardwood-surface veneer plywood with one good side that is at least ¾-inch thick is sufficiently warp-resistant for use as a support. Plywood is actually stronger than its equivalent in wooden planks and less subject to shrinkage and warpage.

The problem with using plywood as a support for artwork is that the glue that bonds the plies can fail. In addition, a washboard effect can develop in a painting because the veneer is cut in a rotary fashion and then flattened and joined edge to edge to cover the large surface. In general, wood does not expand or shrink equally in all directions and, because of this, not only can this washboard effect appear but the entire board, no matter how thick, can warp. Gluing 1″×2″ strips of wood to the back of the plywood and sealing both sides with a wood sealer can help to prevent this.

Sealing plywood also helps to reduce the tendency of the grain (the correct term for what most people call grain is actually "figure") to swell when such waterborne materials as acrylic gesso are applied. Most commercial wood sealers are oil-based so that they themselves will not swell the grain (figure) of the wood during application. Yet this does not present a problem for the subsequent application of acrylic emulsion paints or grounds because sealers work by soaking into the wood rather than sitting on top of it; they do not prevent paint or ground from also soaking in and establishing a firm mechanical bond. This appears to be one of the few exceptions to the rule of never applying a waterborne paint over an oil-based material. The surface should be lightly sanded after the sealer has dried and before the application of the size or ground. This increases the surface tooth for better adhesion.

Fiberboard, commonly called by its trade name, Masonite, is made of ground wood chips, which include bark, that have been broken into fibers with the aid of steam and pressure. The fibers are glued together and formed into a sheet using the lignin content of the wood (lignin is the natural adhesive that holds a tree together) and some synthetic resin adhesive. Wax, rosin, paraffin, and a preservative are often used as additives to control moisture content and to resist attack from mildew and rot. A hardwood fiberboard, commonly referred to as tempered fiberboard, is produced by treating fiberboard with heat and impregnating it with oil. Tempered fiberboard is dark brown and has two smooth sides. Untempered fiberboard is chestnut brown and has only one smooth side. Fiberboard is dense, hard, durable, and does not warp or bend easily. Its thickness ranges from ⅛ to ½ inch; ¼-inch is most commonly used as a support. Sheet sizes can be found up to 4′×16′.

Only untempered fiberboard should be used as a support. Tempered fiberboard is unsuitable because the oil impregnation does not allow for a secure ground. Fiberboard supports of 24″×36″ and larger should be reinforced by gluing a framework of 1″×2″ wood strips, made of either basswood or mahogany, to the back, as would be done for a framed panel.

Particle Board, which is made from byproducts of milled lumber, began to be manufactured during the 1940s after synthetic resin glues were developed. Parti-

cle board, an inexpensive alternative to plywood, is formed by mixing wood chips and sawdust with a water repellant and a preservative and then gluing them together. Particle board looks like a wooden version of meatloaf, and when it is made wet it develops a similar texture because the wood chips swell and rise above the surface. Consequently, it is necessary to seal particle board with a wood sealer prior to preparation for painting. It also has no internal structure and tends to sag, particularly when it is exposed to moisture, unless it is sealed and reinforced with wood strips on the back. Particle board comes in the same sizes and thicknesses as plywood. A minimum thickness of ¾ inch is best for use as a support for painting.

Particle board is heavy, however, and the edges tend to crumble, which does not make it the best choice for a support. It has also been found to give off hazardous formaldehyde vapors. The only reason particle board still remains in use is because it is inexpensive.

Metal was not used as a support for large paintings until the 1970s. In ancient times, metals were rare and too expensive to be used as a support for painting, except in the case of miniatures. Since metal is heavy, only thin metal sheets could be used and they were often too flexible. Copper was commonly used for minatures until the development of aluminum, which was first used commercially in 1886. It was not a practical alternative until the introduction, in the 1970s, of aluminum honeycomb support panels, which were originally used by conservators for relining canvases. Frank Stella was the first major contemporary artist to use this material to produce sculptural paintings. Aluminum honeycomb

Aluminum Honeycomb Panel

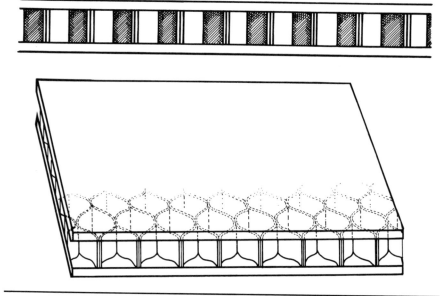

support panels have a honeycomb aluminum core with a cell size of ⅜ inch and thickness of ⁹/₁₆ inch covered on both sides with a skin of aluminum alloy that is 0.025-inch thick. The skin and honeycomb are bonded together with heat and pressure-cured epoxy. Some manufacturers, such as the Process Materials Corporation, supply the panels with a redwood edge. The overall thickness is ⅝ inch. There is no standard size because the panels are custom made. They are extremely expensive; a 40″×60″ panel costs several hundred dollars.

The main advantage of this material is that it does not warp, is very strong and lightweight, and resists sagging. Unlike copper, which reacts with the linseed oil in oil paint and turns green, aluminum is relatively inert. However, an aluminum surface that is polished is not as good a support as a surface that is sanded or slightly oxidized. Although all metal supports can be painted on without sizing or ground, the surface of aluminum must be completely covered with paint or protected with a varnish. If this is not done, the moisture in the air will react with the aluminum and will result in corrosion.

Unstretched Canvas has been successfully used as a support, but it has never quite caught on. Ed Moses, the founder of nonrigid, unstretched artwork, developed a means of impregnating paper or fabric art with an acrylic polymer medium to give it strength and durability. This process basically involves coating both sides of the material with a pure acrylic polymer (made by the Rohm and Haas Company), or any other acrylic polymer medium. The wet, coated material is then spread out on a sheet of glass to dry. When it is dry it can be carefully peeled off the glass. Collages can be made by adding coated dry material to the coated wet material on glass and, when dry, can be removed as one piece. The surface, although slick, will accept thin layers of acrylic or oil paint.

Unstretched canvas can also be primed with acrylic gesso and then painted over with acrylic paints. However, uneven surfaces, shrinkage, and how to hang, display, and store unstretched artworks make this type of support problematic. A traditional hide-glue sizing and lead white priming should not be attempted on unstretched supports because of the potential for cracking.

Paper painting supports should, in general, be heavyweight and have a high cotton content, like 300 lb., 100 percent cotton watercolor paper or 100 percent cotton museum board, both of which are durable and sufficiently absorbent to be adequately sized and primed for oil or acrylic painting. Wood-pulp papers or boards can be used if they are first thoroughly coated with an acrylic polymer medium on both sides. However, these are still not considered as safe for fine artwork as cotton papers and boards. Lightweight papers as well as print papers can be used, but they are best avoided until after experimentation with heavy paper and board. With rare exceptions, when using paper or board as a support the finished painting must still be framed behind glass, like any other paper artwork for proper protection.

SIZING

Sizing is the application of a substance, such as hide glue or acrylic polymer, to a support to reduce the absorbency of the support and to keep the paint from

coming in direct contact with the fibers that make up the support. The oil in oil paint will cause unprotected natural fibers to rot and become brittle. Polymer emulsion paints will not adversely affect natural fibers and can actually help preserve them. Although sizing is not needed to protect a support from acrylic or vinyl emulsion paints, it is often used to reduce the absorbency of the support because, if too much of the paint sinks into the support, the color loses its intensity and develops a dull appearance.

The sizing used by the manufacturer of paper and board to produce a specific working surface should not be confused with the sizing needed for paintings with oil or acrylics. Watercolor paper, for example, is sized to help keep the color on the surface, not to protect it from the paint or to make it more permanent. All such sizing incorporated in paper and boards during the manufacturing process is not adequate for the preparation of supports for oil, or polymer emulsion, paints.

Sizing Paper. The technology that makes it possible to use paper as a support is relatively new and is still considered experimental when compared to other traditional supports. When producing fine artwork, it is safe to use polymer emulsion paints directly on unsized paper or board, although better results are often obtained when sizing is used. Using oil paint directly on unsized paper or board will result in self-destruct artwork because the acid from linoleic acid of linseed oil in oil paint breaks down the cellulose of the paper, and the combination of the two provides an ideal environment for the growth of mold. To prevent this kind of damage to the paper fibers, they must be coated with a size.

The easiest way to size a paper support is to apply two coats of undiluted polymer emulsion medium (only the working side needs to be sized, but less buckling will result if both sides are coated). This produces a "plastic"-looking surface and tends to make thin paper translucent. There are several ways, discussed below, to reduce this plastic effect to a minimum if the natural surface appearance of the paper is desired. These methods are still considered experimental, despite the current positive results. Paper will tolerate only limited contact with oil, including linseed oil. The inks used in fine art printing contain oils. However, during the printing process only a small amount of ink and oil is actually left on the paper surface. Some deterioration does take place, but in most cases after decades of use it has not been considered significant. There is obviously some room for error, but only time will tell how much.

Diluted polymer media can be used effectively as a size for paper supports with less change in the natural surface appearance. When applied in dilute mixtures, both gloss and matte polymer media will appear matte on most paper surfaces, and since the gloss version dries clearer it is best to use it whenever possible. Adding more than 50 percent water to acrylic media should not be done if a colored support is used because the overthinning can result in a milky, or cloudy, appearance. It also lessens the ability of the acrylic polymer to form a strong paint film. When used as a size for white paper or raw canvas, however, the cloudiness cannot be seen and a strong paint film is not desired. A mixture of one part acrylic medium to four parts distilled water applied in two thin coats to both sides of a paper support appears to give good results. The mixture is easily applied with a wide squirrel-hair brush or with an inexpensive foam brush.

The wet paper should be laid out smooth on a clean sheet of glass to dry. When dry it may be easily peeled off the glass.

Gelatin is a refined glue. It is considerably more expensive than other types of size because of its unique manufacturing process. When used as a size for a painting support, gelatin should be hardened with either formaldehyde or alum. Expense and inconvenience have kept painters away from using gelatin as a size. Gelatin is used primarily as a size for such papers as watercolor paper where only a dilute solution is needed and the quality of the size is important. Nevertheless, if you wish to use a gelatin size, Winsor & Newton offers prepared size in two-ounce bottles. It shoud be heated gently until liquid and applied directly with a soft brush. Two coats should give adequate protection without seriously altering the paper's natural appearance.

Animal hide glues, such as rabbit-skin glue, are among the oldest and most reliable substances used for sizing paper and canvas; the preparation of and application to both supports are very similar. (For more information about sizing canvas, see below.) The only difference is that for paper a 3 percent solution (one part glue to thirty parts water) is used and two thin coats are applied. Recent investigation has shown that hide glues seem to be adversely affected by such air pollutants as sulfur dioxide; exposure has greatly accelerated the aging process so that the glue becomes brittle and tends to crystallize. This has caused a great unresolved debate about whether to continue using such natural sizing agents as hide glues, which have a track record of several hundred years, or to turn to synthetic polymers, which have only been used for about forty years. At the present time, acrylic polymers appear to be relatively inert to most pollutants; however, contrary to most beliefs, they are porous and do not actually seal the support as hide glues do. Therefore, acrylic polymers do not necessarily protect the support from pollutants and chemicals. What they seem to do is simply provide mechanical dimensional stability to hold a support together despite what reactions take place. At this time, the common wisdom seems to be to use the acrylic polymers for sizing and grounds and then to use an oil-based protective varnish over the completed painting regardless of whether it has been painted with acrylics or oils.

Sizing Canvas. Canvas, like paper, has to be protected with a size from the acidity and rotting effects of linseed oil. Acrylics are inert and can be applied directly to canvas without sizing; however, sizing would contribute to better control during subsequent application of grounds or paint. A mixture of half water and half acrylic polymer emulsion, gloss or matte, applied in two thin coats will act as a size for both oil and polymer emulsion grounds.

The traditional method of sizing a canvas for oil paintings involves the use of a hide glue, such as rabbit-skin glue. A hide glue can be prepared by making a 10 percent solution (one part glue to ten parts water). The glue is soaked in room-temperature water for twelve hours or until the crystals swell, at which point the mixture is heated in a double boiler to about 175°F (80°C). If the glue is heated too quickly or brought to a boil, it will become an unusable gelatinous mass. After the glue has liquified, filter it through cheesecloth. Allow the glue to cool to about 140°F (60°C), then apply it with either a brush, spatula, or painting

knife. Be sure to work the glue into the canvas. This will fill any pin holes.

The purpose of the sizing is to seal the fibers of the canvas, not to provide a continuous, solid paint film. If too much glue is applied, cracking will result. In addition, the ground will bond more to the glue than to the support, and as the humidity changes the glue will expand and contract more than either the ground or the support, which can cause the ground to detach from the support. A ground will adhere better if the sized support is rubbed with a pumice stone or lightly sanded. Rabbit-skin glue is still available from the Fredrix Artist Canvas Company and the Holbein Company.

Sizing Panels. Wood, or wood-product panels, such as plywood, particle board, and fiberboard, should be sealed with a wood sealer. Modern wood sealers reduce the wood's absorbency and help to preserve and protect it—desirable qualities of a size. Consequently, a wood sealer can be used as a size for panel supports. In the past, hide glue was used for wood just as it is for paper. When a waterborne size, such as hide glue or polymer emulsion, is used the figure of the wood will swell and rise, requiring sanding to make the surface smooth again.

Panels made of metals, such as the aluminum honeycomb panels, are not absorbent and do not have to be protected from the paint, hence sizing is not necessary.

THE GROUND

A ground is a stable, absorbent surface to which the paint can permanently adhere. All grounds are composed of gypsum (chalk) and adhesive. A good ground must have durability and a resistance to cracking.

The permanence of the finished artwork depends on the structural integrity of the support as well as the ground, both of which bear the same relationship to a painting as that of a foundation to the house built on it. No one would buy a house without having the foundation inspected, yet most artwork is collected solely on surface appearance. Many painters will take great pains to select the highest-quality paints and media to create the best possible surface appearance, yet are incredibly careless in the selection of a proper ground or support. Many artists assume, for example, that acrylic gesso can be applied to anything to make it safe to paint on. Acrylic gesso, however, should not be applied to tempered fiberboard, because the fiberboard is oil-impregnated and prevents proper bonding of the ground, leading the ground to detach itself as the board ages. Just as much care needs to be taken for what is below the surface as for what is applied on top of it.

In the past, grounds were tinted with lampblack, umber, or green earth to hide the yellowing effect of the linseed oil as it aged. The Holbein Company produces several tinted foundation whites for those who wish to duplicate the look of older painting styles.

Grounds for Paper. Acrylic gesso, which makes an excellent ground for paper, is often too thick to be easily applied directly to a paper support, yet thinning it only with water can result in a brittle ground. Acrylic gesso is made with as little binder as possible so that it will be an absorbent ground to receive paint. If

it is further diluted and then placed on a highly absorbent support, such as an unsized paper, there may not be enough binder remaining in the ground to keep it flexible. Therefore, it is best to dilute the gesso with a mixture of half an acrylic polymer medium and half water, and apply two or more coats. Using the fifty-fifty mixture will replace what binder may be absorbed or washed away. It is not necessary, but it is helpful, to size the paper support before applying a ground.

If a glue-sized paper with a lead white ground is desired it may be applied as it is for canvas.

Grounds for Canvas. Lead carbonate ground into linseed oil is the oldest substance still in use as a ground for oil painting. It is traditionally applied to a hide-glue-sized support, but it can just as well be placed over a support sized with polymer emulsion. Lead grounds are highly reflective and have been nicknamed silver white. They are also durable and very elastic. To maintain its flexibility, an oil ground must contain only linseed oil as its vehicle and it therefore has the disadvantage of tending to yellow.

Great care should be taken when handling a lead ground because of its toxicity. Another caution about using lead white is that air pollutants can react with unprotected lead white pigment and blackening can occur. A final protective varnish over the painting will prevent this. Nevertheless, if correctly used, lead carbonate is still one of the best options for a ground.

Today, many whites are ground only for mixing with colors and contain such oil vehicles as safflower oil, because they do not yellow as much as linseed oil. These mixing whites are not nearly as flexible and therefore not as safe for use as grounds. The term "foundation white" is often used by manufacturers to indicate that it is made to be used as a ground for painting.

The first coat of an oil ground should be applied thinly with a palette knife and worked into the surface texture. The second coat should cover the surface. Lead oil paint dries quickly, but a minimum of ten days should be allowed for the lead paints to cure before painting begins. The Fredrix Artist Canvas Company states that it ages its lead ground canvas several weeks before shipping or applying a second coat. To accommodate the impatient artist, fast-drying alkyd primers, consisting of titanium white in an alkyd resin, have recently been developed. A second coat can often be applied within three hours and will be ready for painting in twenty-four hours. Many traditionalists favor lead grounds and feel that there is little difference between alkyd primers and the use of acrylic gesso. They argue that a lead white ground supplies more than just a white surface to paint on; it also provides a naturalness to the eye that cannot be synthesized.

Gesso—which means "chalk" or "gypsum" in Italian—traditionally refers to recipes of chalk and glue for ground on rigid supports. Today, acrylic polymer emulsion gesso is so commonly used as the painting ground that it has taken the term "gesso" for itself and the original gesso is now usually referred to as powdered, or dry, gesso. Acrylic polymer emulsion gesso has not so much replaced the traditional gesso formula used on a rigid support as the hide glue and lead white ground combination used on canvas. Since the polymer of the

acrylic polymer emulsion gesso can size a support as well as form a painting ground, it can be applied directly to canvas without any additional preparation. However, most painters find acrylic polymer gesso too thick to apply easily and choose to dilute it first. A very smooth surface can be achieved by first applying two coats and then sanding, and then repeating this several times until the surface is as smooth as vellum tracing paper.

Grounds for Wood or Wood Particle Panels. Only a few fastidious painters still use the traditional gesso ground of chalk (gypsum) and hide glue to size rigid supports. Polymer emulsion gesso is now the ground of choice, although the original gesso grounds are superior in absorbency and in their ability to be polished. Polymer gessos can also be polished, but not to the same degree. Modern ready-mixed commercial versions of traditional gesso often have titanium white added to increase coverage and add brilliance. This kind of gesso is supposed to be used only on rigid supports, but there is one notable exception to this rule. Over the centuries, Tibetan scroll painters have developed a technique to use this normally brittle ground on a flexible support. A thin layer of a white chalk and glue is applied to a stretched, glue-sized linen that is similar in weight to a bed sheet. The gesso surface is polished under compression first with a damp smooth rock, about the size of a small potato, and then with a small, very smooth, dry stone. This otherwise brittle ground is made flexible by the thinness of the glue and gesso layers, the application of the minimum amount of glue and size needed to create a safe ground, and the compression of the ground during polishing. This process has permitted scroll painters to create works that can be carefully, but safely, rolled and unrolled for centuries.

Whether a traditional gesso formulation or a modern polymer gesso is used to produce a ground on a wood support, it should first be sealed with a wood sealer to preserve the wood and protect the ground from any tree sap. After that, the methods of applying a polymer gesso ground to a wood support are the same as those for canvas. The preparation of a traditional gesso ground involves the same recipe for making a hide-glue size for canvas, except gypsum is added along with the glue before it is cooked (for a hide-glue recipe, see page 143). For every part of glue added to the water, two parts of gypsum are also added. After it is cooked and applied, the surface may be sanded and polished with a smooth stone or a silk cloth. Liquitex offers a convenient ready-mix called Gesso Ground Dry Mixture, which has detailed instructions for its use and how to mix it with a 10 percent hide-glue solution.

Traditional gessoed panels are often far more absorbent than those produced with a polymer gesso, and the surface often has to be primed before painting is begun.

Grounds for Metal. Metal is nonabsorbent and is a difficult surface to apply paint to. Only oil-based paints will bond permanently to the surface. Metal does not require a ground to receive paint, but it is often best to prime the surface first. This will help to keep the paint from sliding over the surface when it is being applied.

PRIMING

Priming is done to regulate surface absorbency. Traditional gesso panels, for example, are often too absorbent and metal supports are too nonabsorbent. The challenge is to regulate the absorbency to your needs. There are various ways to accomplish this, but one rule must be observed: never apply a waterborne paint over an oil-primed surface. Do not be fooled by appearances. It is not difficult to get waterborne paints to go on an oil-primed surface, but you cannot make them stay there over the years.

Waterborne priming to reduce absorbency can be accomplished easily using diluted polymer medium (half water to half medium) brushed on in thin coats or, better still, airbrushed. The Winsor & Newton Prepared Size can be heated, diluted with water, and applied in thin coats until the desired absorbency is obtained. Dilute solutions of gum arabic or a hide glue can accomplish the same effect.

Oil-based priming to reduce absorbency is most often done with a retouch varnish (see *Oil Media, Solvents, and Varnishes*, pages 269 to 273), which can be brushed on, airbrushed on, or applied with a commercial spray can. Dilute solutions of damar varnish or shellac are also used.

Metal support surfaces are made more porous by the application of several thin coats of a lead white paint (foundation white). Lead paints should not be airbrushed or sanded. Almost any foundation white paint, commercial metal primer, or lacquer primer (not synthetic lacquers) will do the job.

Fixed Supports
(Walls)

THE SCOPE of this book is limited to painting and drawing materials used to produce portable, and, as much as possible, permanent artwork. Mural painting is, with rare exception, neither portable nor particularly permanent. Although most of us like to think of the walls of our homes and buildings as permanent, weather, sun, heat, cold, acid, alkali, air pollution, earthquakes, wars, fires, bulldozers, and interior decorators have all contributed to their impermanence as well as to the impermanence of any artwork applied to them. In fact, today's muralist counts himself or herself lucky if an outdoor painting survives for ten years. Examples of indoor murals that have lasted for centuries are due to extraordinary care and protection, and have often undergone conservation and restoration several times. It has recently been discovered that many murals currently under restoration have been so poorly "restored" several times in the past that some repainted areas bear no resemblance to the original painting.

Murals become a fixed part of the environment and, for the most part, cannot be protected. Paper artwork is framed and protected from the environment. Oil or acrylic paintings are executed on grounds and supports chosen for their permanence and portability. They are also varnished to protect the surface and are kept away from the surface of the wall when hung. Murals are attacked from both the front and the back by the environment.

To produce a mural that will last several decades outdoors, and several more indoors without extensive protection and care, requires an extensive knowledge in several areas, some of them well beyond that of artists' materials. Assuming the artist knows which pigments have the highest lightfastness rating and are alkali-proof (modern walls tend to be highly alkaline), extensive knowledge of building materials and their chemistry is also required. For example, it is not uncommon for an inexperienced muralist to find a painting on a new concrete wall peeling off after several months. This is because the form oil (used to prevent the wood moulds from being cemented to the concrete after it has set) had not been removed before painting. This oil can stay in the wall for several years and must be removed (usually by sandblasting) before painting begins. It is knowledge such as this that cannot be left to trial and error. Anyone who wishes to do serious mural work should apprentice with an experienced muralist.

Part Six

IN THE SEVERAL thousands of years of art history there are three major technological advances that have changed painting and drawing for all time. The first major technological development occurred when metal tools were developed during the latter part of the Bronze Age (1500 to 1000 B.C.) and minerals in rock form could for the first time be easily processed into pigments. Before this time an artist's palette consisted of several shades of brown and brownish yellows, as well as black and white. The Bronze Age brought with it a deep red (cinnabar), a bright orange-red (realgar), a brilliant yellow (orpiment), a deep blue (lapis lazuli), a pale blue (azurite), and a green (malachite). The transition in painting must have been like the later transition from black-and-white to color photography.

The next major development did not occur until the age of industrialization in the nineteenth century, when the technology to synthesize mineral salts was developed. Almost all of the mineral pigments used today were developed between 1800 and 1910. Aureolin, chrome yellow, lemon yellow, zinc yellow, cadmium orange, cadmium yellow, cadmium red, alizarin crimson, chrome red, chrome green, chromium oxide green, cobalt green, emerald green, viridian, cobalt blue, synthetic ultramarine, and cobalt violet were all introduced during this period. These new pigments allowed the creation of paintings that could never before have been produced. Without the development of these pigments it would be safe to assume that the Impressionist, Luminist, or Expressionist movements could not have occurred.

The last major transition is happening right now with the development of new synthetic organic pigments, which have broadened the artist's palette beyond most painters' abilities to cope. There are so many potential new colors that most manufacturers are unable to make them all available. For every phthalocyanine, azo, anthraquinone, quinacridone, indanthrone, and dioxazine pigment now in use as an artists' pigment, there are at least five others that could be.

This vast spectrum has taken issues like the nature and use of color, as well as the nature of perception, from academic speculations to practical concerns.

Painters tend to see pigments as colors rather than as chemicals. Pigments are, however, chemicals that possess many characteristics in addition to their ability to absorb light and reflect a particular color of the spectrum. The painter must take these chemical characteristics into consideration to avoid such disastrous results as the cracking of paint films, the fading of colors, and serious injury to his or her health. This section includes all the latest information available on more than one hundred of today's most significant colors, their pigment composition, and their chemical properties, with emphasis on practical information, including pigment compatibility, permanence, and toxicity.

A pigment by itself is of little use. Dry pigments have no inherent adhesive quality. To be kept in place, pigments must be mixed with some type of binder. Attempts have been made to rub dry pigments into textured surfaces, but the results are often of poor quality and cannot be considered durable. Although this might seem fairly obvious, many established artists have attempted to sprinkle pigment on surfaces, or to use a water-soaked brush to apply dry pigments.

Over the centuries, several successful methods of mixing a binder with a pigment have been developed. The pastel is an example of a dry mixture. To produce a soft pastel, pigments are mixed with water and a gum binder and then dried. Because there is so little binder, soft pastels are not durable and have to be used on textured surfaces. Soft pastel drawings are delicate and easily disturbed; therefore, they require extensive protection and must be stored and framed in specific ways. (See *Framing and Storage,* pages 275 to 307.) Oil pastels and colored pencils are more durable and can be applied to smoother surfaces because their binder is wax. The most popular method of making a pliable mixture of pigment and binder is the making of paint. Paint is produced by grinding or mixing a pigment with a medium such as linseed oil for oil paints, or a water solution of gum resins for watercolor.

When a binder and pigment are mixed together, this is called a medium. For example, if linseed oil were used as the binder, the medium would be oil paint; if an egg binder were used, the medium would be egg tempera. Pigments take on various characteristics depending on the particular binder.

Characteristics
of Pigments

ALL OF US see the labeling on our packaged foods. Some of us actually read the labels, but how many of us know what any of it means or how to translate it into useful information? The same is true of artists' materials. This section explains the essential nature of pigments and provides a working knowledge of their characteristics to help you to distinguish one pigment from another so that you may use them to your best advantage.

NAMES OF PIGMENTS

The names used for various pigments often make about as little sense as the names that automobiles are assigned by their manufacturers, and frequently convey even less information. This is because several methods are used to name pigments and, even after several thousand years, one is no less confusing or more efficient than another.

Pigments used before the nineteenth century were most often named after their discoverer, the location of their source, their appearance, or just poetically. Due to advances in technology at the turn of the nineteenth century, new synthetic mineral pigments were being rapidly discovered. Many of these pigments were given names that included part of their chemical names—cobalt blue and cadmium yellow, for example. New pigments, whose exact chemical nature was not known, continued to be referred to by the names that had been used in the past.

As confusing as the names were at this time, they did relate to a specific pigment or group of pigments. This did not last for long and things got much worse. With the development of new pigments from the end of the nineteenth century until today, it has been found that many of these new pigments have characteristics that allow them to be used as substitutes for older, less permanent, or more costly pigments. Many manufacturers simply substituted the newer pigment for the old one, and kept the old name. Since this was not a coordinated effort among manufacturers, not everyone made the same substitutions. Therefore, today, it is easily possible for a pigment to have several names, or a color to have several pigments. If the name on the container is not what is inside, then information about such characteristics as permanency, compatibility, and transparency cannot be relied upon.

Some manufacturers are attempting to clarify this confusion by adding the names and numbers assigned to specific pigments by the Society of Dyers and Colourists of London to the common name on the label. (The same information is available from the American Association of Textile Chemists and Colorists, P.O. Box 12215, Research Triangle Park, NC 27709.)

In the Table of Pigments and Colors (pages 166 to 199), I have included these Colour Index (C. I.) names and numbers. It is important, however, to understand what the C. I. names and numbers do not indicate—such characteristics as purity, quality, and concentration—nor do they distinguish among the shades that may exist within a specific pigment. Phthalocyanine blue, for example, has several shades that range from a reddish-blue to a greenish-blue, although all shades have the same C. I. name and number. Phthalocyanine blue is, with rare exception, contaminated with the carcinogen PCB and is always mixed with an extender when used as a paint, yet none of this information would be reflected by the names and numbers.

C. I. names and numbers can be helpful, occasionally, in comparing the quality of different brands of paint. Cadmium red paint, for example, can be made from either chemically pure (C. P.) or chemically concentrated (C. C.) cadmium sulfo-selenide. C. P. cadmium sulfo-selenide is assigned the C. I. name of Pigment Red 108 and the C. I. number of 77196, and C. C. cadmium sulfo-selenide, which is extended with barium sulfate up to a concentration of 15 percent, is assigned the same C. I. name, but a different C. I. number, 77202. Cadmium sulfo-selenide is among the most costly of pigments and is therefore often the first to be compromised in the manufacture of paint. The finest paints are made with the purer and more costly Pigment Red 108, C. I. 77196.

PERMANENCE

Permanence is defined as continued existence. All existence is conditional or relative. Nothing is truly permanent. A substance may only be considered permanent because it has a longer continuity of existence than another substance. The only thing that does seem to be permanent is impermanence. A common metaphor for permanence is, "It's set in concrete," but even concrete has been recently found to be good for only a hundred years before it becomes brittle and begins to crumble.

It is commonly believed that the finest quality of pigment is synonymous with the highest degree of permanence. This is not the case. In fact, the oldest and most reputable companies attempt to offer the widest possible range of colors, which includes those that are both modern and traditional. Consequently, there will be a wide range of permanency in a given manufacturer's selection of colors.

There are many factors that influence the permanence of pigments. These include weather, ozone, visible light, ultraviolet light, acid, alkali, water, oil, solvents, detergents, humidity, air pollutants, temperature, the type of medium used, the ground on which the pigment is applied, and whether it is mixed with other pigments. Despite all the technical advances and fancy equipment for the testing of permanency, the method is still basically the same—trial and error and

the examination of past artwork. Technical advances have only developed the limited accelerated-aging testing procedures.

Accelerated aging tests are heavily based on theory and speculation. In addition, there is no standardization of testing procedures among manufacturers of pigments and paints. Tests can range from the very harsh, involving exposure of pigments, or paints, to direct sunlight outdoors, or a more moderate testing procedure proposed by the American Society for Testing and Materials (ASTM) in D 4303-83, *Standard Test Methods for Lightfastness of Pigments Used in Artists' Paints*. The ASTM guidelines are for lightfastness testing only. They recommend using one of three types of light—sunlight, daylight fluorescent light, or xenon-arc light that is filtered through glass indoors.

Permanency ratings for pigments that have been in use for seventy-five years or more can be safely relied upon because they have been proven under actual conditions. Ratings on pigments in use for less than seventy-five years, and especially for less than twenty-five years, have to be viewed with some suspicion. Pigments tested through accelerated aging rarely include more than three variables and cannot duplicate actual conditions. Although such testing has often proven reliable, there have been exceptions. The vast number of variables involved in the natural aging process makes it impossible to guarantee the relative permanency of a pigment. Consequently, any rating given should be considered only as a summation of the best available data and not as a warranty.

When a pigment or paint is exposed to light and a change is measured, the change is then translated in a scale. The Wool Scale is a common international method of rating the lightfastness of a color or a pigment. With the help of some manufacturers I have attempted further to translate this scale, which ranges from 10 to 1, into practical terms for the painter.

10: Theoretically, absolutely lightfast

9: Has shown in practice, or theoretically will show, no observable change for two thousand years

8: No visible change for two hundred years in its pure form under normal museum conditions

7: No visible change for seventy-five years in its pure form under normal museum conditions

6: No visible change for twenty-five years in its pure form under normal museum conditions

Less than 6 is not considered acceptable for fine or professional artwork and is classed as fugitive

The ASTM has proposed the following rating system, which is based on their suggested testing procedures for the determination of the lightfastness of pigments in oil or acrylic. Manufacturers and researchers who have conformed to these guidelines have assigned each color in question to one of three categories:

Category I: Excellent lightfastness. Very slight to no color change after the equivalent of one hundred years of indoor museum exposure.

Category II: Very good lightfastness. Less permanent than Category I, but satisfactory for most indoor painting.

Category III: Borderline. Use with caution.

Manufacturers of paint who are not using the ASTM guidelines have condensed scales like the Wool Scale down to four or five categories and then assigned each category a symbol such as a letter or an asterisk. Most manufacturers have been reluctant to make public the correlation of their categories to actual time, such as years, under museum conditions. Since there are so many variables involved with longevity, no manufacturer could possibly supply a warranty, and it was feared that making such a correlation would imply such a warranty. Talens was the first company I could persuade to break the ice for the benefit of all painters.

Although the actual boundaries drawn between the different permanency groups, due to the variations in testing procedures, can vary significantly from manufacturer to manufacturer, the highest rating given to a paint by manufacturers is most often equivalent to 8 on the Wool Scale. The lowest rating, other than fugitive, is equivalent to 6 on the Wool Scale. In other words, if a manufacturer's highest rating is *** or AA, the color should show no visible change in its pure state under normal museum conditions for at least two hundred years. A color assigned the lowest rating, such as * or B, should show no visible change for at least twenty-five years in its pure state under normal museum conditions. (This rating is considered the minimal acceptable limit for an artists' material.) Colors labeled as "fugitive" or that have no rating, will show a visible change within twenty-five years. Although the Talens Company said that its middle category ** is roughly equivalent to seventy-five years under normal museum conditions, there is too much variation among manufacturers to generalize about the ratings used between the highest and lowest.

This information applies only to artists' paints and not to any other materials such as graphic arts materials, industrial paints, or house paints, for which the term "permanency" means fifteen to twenty-five years, or one generation.

Despite the enormous spectrum of available artists' colors, a number of painters have experimented with pigments that do not meet minimum permanency standards (at least 6 on a Wool Scale), such as fluorescents, enamels, even vegetable juices. Artwork produced with these materials must be considered "self-destruct" artwork. As long as the customer who collects such a piece of artwork understands its nature, it seems reasonable to produce and sell it. However, there have been several situations where an artist did not do his or her homework and unknowingly produced and sold a piece of "self-destruct" artwork. Most of these situations have been resolved by the artist exchanging the artwork for another. It would be wise for any professional artist to consider that there have been successful legal actions taken against the artists and galleries in such cases.

COMPATIBILITY OF PIGMENTS

Pigments, which are chemicals, can react with one another to form new chemicals. When this occurs in artwork the results, such as changes in a painting's appearance, are often undesirable. Chemical reactions can be avoided by not

using incompatible pigments or by treating the pigments so that they can be mixed together without reacting. The only proven treatment that will prevent most incompatible pigments from reacting with one another is to grind them into a drying oil, such as linseed oil, which will coat each pigment particle. If all the pigment particles are coated they will not be able to come into contact with one another and react. This is the reason that the greatest variety of pigments and colors is found among oil paints.

LeFranc & Bourgeois has supplied additional permanency information on its oil paint tubes in regard to compatibility. Paints that can be mixed without significant reduction in permanency have a large red M painted on the front of the tube.

Compatibility of pigments within oil paints is of little concern if the protective oil coating is not stripped away. However, if an oil paint is mixed with only a thinner instead of a medium, the thinner will wash away the protective coating. (For the proper method of thinning oil paints, see page 259.) Since most of the chemical reactions in this case are slow, it may be several years before the effects of this misuse become obvious. Unfortunately, the excessive use of thinners has become a common method of painting.

In watercolors, acrylics, and soft pastels, the binder does not isolate and prevent potentially incompatible pigments from coming into direct contact and reacting with one another. Consequently, such pigments are, in many cases, left out of the manufacturers' range of colors when producing these media. This cannot be totally relied upon, and some basic knowledge of the most common incompatible mixtures is necessary.

The incompatibility of unprotected pigments containing sulfur and unprotected pigments containing lead is well known. For example, lead white, chrome red, chrome green, and Naples yellow should never be mixed with cadmium red, cadmium yellow, cadmium orange, cadmium green, vermilion, or ultramarine blue. When unprotected, these mixtures will tend to blacken. Another less common example is the incompatibility between unprotected pigments containing sulfur and some unprotected pigments containing copper, such as emerald green, malachite, verdigris, and azurite. Since only emerald green is still available as an artists' pigment, there is little concern here.

There is another type of incompatibility that is not well understood. It has been known for some time that the mixing of any color, particularly organic dye-pigments (for example, alizarin crimson and cadmium red hue), with white can result in either a bleaching effect to the color or a staining effect to the white. This gave little cause for concern in the past because there were so few organic dye-pigments available. Today, more than half of the commercially available dyes and pigments are organic dye-pigments, and as more of these dye-pigments have been added to artists' color lines so has there been an increase in reports of bleaching and staining. Until more is known, it might be wise to be conservative about using mixtures of organic dye-pigments and white.

Although it is rare, dilute watercolors and very dilute acrylics can suffer from incompatibility due to electrochemical properties. Cobalt blue, for example, when mixed with burnt sienna will form aggregates that settle to the bottom resulting in a gritty paint mixture.

TOXICITY

Indiscriminate application of powdered pigments to artwork or the manufacture of homemade paint without proper protection is simply suicidal. All pigments, particularly in their dry, powdered form, should be regarded as hazardous or potentially hazardous. Most of us would not live near a factory that produces many of the chemicals used as pigments, or a dump where these were disposed of, yet we take these same chemicals into our studios or, worse, our homes, with few or no safeguards.

The degree to which a pigment is toxic varies with the type of exposure. A pigment may be relatively nontoxic when exposed to the skin, moderately toxic when ingested, and highly toxic when inhaled. Virtually all pigments have their highest toxicity rating when either ingested and/or inhaled. The use of such solvents as turpentine, which can be absorbed through the skin, can carry pigments through the skin that would not otherwise pass. In the Table of Pigments and Colors (pages 166 to 199), the highest toxicity rating given to a pigment has been used, regardless of the type of exposure. The toxicity rating also attempts to take into account the contamination of a pigment by hazardous material. Many pigments have forms in which they are less easily absorbed by the body and are, consequently, less hazardous, but it is unwise to rely on the possibility that the pigment in use is of the safer variety. It is wise to treat all pigments as hazardous or potentially hazardous. The following guidelines, which are used in the Table of Pigments and Colors, are for single exposures and are relative to the sensitivity of the individual. Carcinogens are labeled separately and allergies are not covered.

Highly toxic means that serious injury or death will result from absorption of a small amount, such as a mouthful, by a healthy adult.

Moderately toxic means that temporary to permanent minor injury will result from absorption of a small to moderate amount by a healthy adult.

Slightly toxic means that temporary minor injury will result from absorption of a small to moderate amount by a healthy adult. Larger quantities could cause greater damage.

Nontoxic means that no detectable injury will occur from absorption of small to moderate amounts by a healthy adult. Nontoxic does not mean safe or nonhazardous.

More comprehensive information on the subject of toxicity can be found in *Hazards,* pages 309 to 323.

PURITY

The purity of a pigment can vary greatly. The average level of purity is the industrial grade, which is not chemically pure. The next grade is the "chemically pure" pigments, in which some trace levels of contaminates up to approximately 1 percent can still be found. The next level of purity is the grade used by the cosmetic and pharmaceutical industries. Most of the pigment that is readily available in bulk is of the industrial grade. For most industrial purposes, how-

ever, and for most amateur-grade paints, this grade would be considered adequately pure. In making the finest grades of artists' paint, chemically pure pigments are preferred. Levels of purity above this in artists' paint is unwarranted in all concerns, except where toxicity is involved.

Only the experienced can differentiate between these levels of purity. If you make small-scale paintings that will be viewed from close up, or use watercolors or egg tempera, or are involved with restoration, purity may be important. If you work very large or on murals, small impurities will not be as noticeable if you have to stand back twenty to thirty feet to see the whole artwork.

Types of Pigments

THE OLDER, more traditional pigments were derived mostly from substances that existed naturally in the environment. Even when some of them were later synthesized, they were not chemically altered. These older pigments produce colors that can be seen in nature and tend to convey a sense of naturalness, even when used for abstract works.

The new, synthetic pigments are still derived from such natural substances as petroleum, but they have been chemically modified to create a new substance that is unnatural to the environment and, to many, has an unnatural appearance. Many of these colors, because of their industrial applications, are now part of our cities' visual environment, our synthetic environment.

In this comparison between modern and traditional pigments there is no suggestion that the natural pigments are better than the synthetic ones. The characteristics of both types of pigments can be exploited to a painter's advantage to accomplish a particular effect.

I have grouped pigments in regard to whether they are inorganic or organic, and whether they have been synthesized. Organic pigments are either composed of carbon or are part of, or produced by, a living organism, such as ivory black (carbon). Natural extracts from animal or plant matter, or synthesized material originating from organic matter, such as petroleum products, have been the source of many organic pigments.

Inorganic pigments are pigments that do not have hydrocarbons (a molecular arrangement of carbon and water), such as cadmium sulfide (cadmium red), but include oxides and sulfides of carbon, like copper carbonate (malachite green, genuine). Inorganic pigments are either natural salts and minerals extracted directly from the earth or rocks or are synthesized from salts and minerals.

NATURAL INORGANIC PIGMENTS

Natural inorganic pigments are found in nature as minerals or earth and are then ground, sifted, washed, and sometimes cooked (calcinated). The term "natural mineral pigment" is used to describe natural inorganic pigments that are found as naturally occurring metallic salts, such as basic copper carbonate (azurite and malachite). The terms "earth color" and "earth pigment" are used to describe

natural inorganic pigments that, in addition to being naturally occurring metallic salts, have significant quantities of clay and/or silica naturally mixed into them, such as hydrated ferric oxide and silica (raw sienna).

SYNTHETIC INORGANIC PIGMENTS

Almost all of the inorganic mineral pigments used today are manufactured, or synthetic. A synthetic version of a pigment may be chemically identical to the natural form, but it is produced artificially rather than naturally. It may also be an entirely new pigment created from minerals.

An example of a naturally occurring inorganic mineral pigment would be genuine ultramarine blue, which is derived from the gemstone lapis lazuli. Synthetic ultramarine blue, on the other hand, is made by a modern process that combines silica, alumina, soda, and sulfur, the basic elements of the naturally occurring lapis lazuli. Although, chemically, they are almost identical, lapis has a crystalline structure, which gives greater depth and beauty than the synthetic pigment.

One example of an entirely new synthetic mineral pigment is cadmium yellow, which was invented in 1817. Cadmium was mined from the earth and then extracted by turning it into a man-made salt that could then be used as a pigment.

Glass pigments are synthetic inorganic pigments in an unusual package. The pigment Egyptian blue, in use from 1500 B.C. to 500 A.D., was made from small glass particles called frit, which were ground to make the pigment. The exact color made from this pigment depended upon the size of the particles of glass. When the glass frit was ground to a small particle, it was a pale blue. A coarser grind produced a bright blue. This method of making color is still used in Japan and the name given to these pigments is "new earth." The Japanese have elaborated on this method of using the size of the glass particles to help determine a color and have taken ten to fifteen base colors and ground them into ten to fifteen different sizes, resulting in a palette of more than one hundred colors.

SYNTHETIC ORGANIC PIGMENTS

There are currently about seven thousand organic dyes synthesized from coal tar and petrochemicals, to which approximately two hundred more are added each year. A dye, as opposed to a pigment, is soluble in the medium in which it is applied, thus making it impractical to make paint directly from a dye. For example, if a dye is mixed directly into linseed oil it would readily dissolve into it. However, when this mixture is mixed with other paints, applied to a painting ground, or used with a brush, it would dissolve into them just as readily, staining and bleeding uncontrollably. To regain control it is necessary to convert a dye into a pigment, which is insoluble in the medium. This is done chemically by attaching the dye to an insoluble, inert substrate, such as aluminum hydrate. (This is like dyeing cotton threads before weaving them into a fabric.) The result is called a dye-pigment, also known as a lake. After the dye is attached to something solid and insoluble, it can be formed into a paint just like any other pigment. (However, just as dyed fabric is tested to be colorfast, so must a dye-

pigment be found to be bleed-resistant). The synthetic organic pigments used in paints are "dye-pigments."

Because many of these new pigments were less costly, and because there have been dramatic improvements on the range of available colors, many of them were made available before rigorous testing for bleeding was performed. For those painters for whom bleeding of one color into another, no matter how slight, is a problem, a simple, but not conclusive, bleed test can be performed.

A watercolor or gouache can be tested by first applying a dilute watercolor to a hot-press watercolor paper and left to dry. Then, using either a sponge or a large, soft, wash brush, attempt to wash away the watercolor. Most nonbleeding pigments will be almost totally removed. Pigments that tend to bleed will leave a significant stain.

Oil colors can be tested by applying a thin coat of white paint over a semidry and a dry layer of the test color. Fast bleeders will tint the white overpaint whether wet or dry, within one day. Slow bleeders will show color in the white with the semidry test color.

There are three major groups of synthetic organic pigments used in artists' paints—anthraquinone, azo, and phthalocyanine. The first, anthraquinone, was 1,2-dihydroxyanthraquinone (alizarin crimson) developed in 1868 in an attempt to understand the coloring properties of madder root. This discovery led to the development of several indanthrones, of which one has come into use among artists as indanthrone blue.

The second group, azo, refers to a particular molecular arrangement among nitrogen-containing organic molecules. Although azo dyes were developed as early as 1880, it was the development of naphthol AS (naphthol red) in 1912 that heralded the birth of stable dye-pigments, which today include arylides (used to make hansa yellow, cadmium yellow hue), perinones (perinone orange), and naphthols (naphthol red, naphthol crimson, and cadmium red hue).

The third major group is the phthalocyanine dyes (phthalocyanine blue and green). Phthalocyanine was first discovered in 1907. It was rediscovered several times after that until the 1930s, when it was developed for artists' use. Out of this group came the quinacridones, of which gamma-quinacridone (quinacridone magenta) and quinacridone violet b (quinacridone violet) have become relatively commonplace.

NATURAL ORGANIC PIGMENTS

Natural organic pigments include dyes that were converted into dye-pigments (lakes) and pigments made from either animal or plant sources. All plant-source pigments, such as madder, indigo, and gamboge, are dye-pigments. Animal or plant-source pigments are all dye-pigments with the one exception of carbon from bone. Examples of animal dye-pigments are sepia and Indian yellow.

Pigments
and Colors

VARIOUS CHARACTERISTICS of pigments and colors are explained in the table that follows. Below is a definition of terms as they apply to this table.

Common Name

The common name is the name most commonly used to describe a particular color or pigment. The Colour Index Name and the Colour Index Number are used in conjunction with the common name to be as specific as possible in naming pigments. The Colour Index Names and Numbers do not in any way indicate purity, quality, or concentration, or distinguish between the shades that may exist within a specific pigment. Phthalocyanine blue, for example, has several shades that range from a reddish-blue to a greenish-blue, yet all shades have the same Colour Index Name and Number. Phthalocynine blue is, with rare exception, contaminated with the carcinogen PCB and is always mixed with an extender when used as a paint; yet none of this information is reflected by the names and numbers. Another example is cadmium red (cadmium sulfo-selenide), which, with the exception of a few of the finest paint manufacturers, is mixed with the extender barium sulfate; however, the Colour Index Name and Number do not change until the percentage of barium sulfate exceeds 15 percent.

Alternate Name

Alternate names include some of the more common European names for the pigment, as well as distinctions made for the various shades, such as light, middle, and deep. Not only can one pigment have several names, but that one name is often used for more than one pigment.

General Appearance

The word "general" cannot be emphasized too strongly. A pigment's appearance can vary greatly because of its chemical derivation, its method of manufacture, or the refining process.

Date Introduced

The dates given are those that best reflect the first general use, or introduction, of a pigment. The use of the term "recently" means that the pigment has come into use within the last twenty to thirty years and is still in the process of becoming established.

Compatibility with Other Pigments

Some pigments can react chemically with other pigments and their permanency is thereby affected.

Compatible Media

All media means oil, watercolor, acrylic, and egg tempera. Pigments that significantly speed up or slow down the drying times of oil media are indicated, as are pigments that add to the flexibility or brittleness of oil paint films.

Source of Pigment

All pigments that are man-made, whether they are of mineral or organic nature, are referred to as synthetic.

Chemical Composition

The exact chemical composition of the pure or the traditional form of a pigment is given whenever possible; exceptions are trade secrets or cases where the exact chemical composition is simply unknown.

Relative Toxicity

The degree to which a pigment is toxic varies with the type of exposure. A pigment may be relatively nontoxic when exposed to the skin, moderately toxic when ingested, and highly toxic when inhaled. Virtually all pigments have their highest toxicity rating when either ingested or inhaled, or both. The chart uses the highest rating given to a pigment regardless of the type of exposure. The toxicity rating also attempts to take into account the contamination of a pigment with hazardous material. Many pigments have forms in which they are less easily absorbed by the body and are therefore less hazardous; however, relying on the possibility that the pigment in use is of the safer variety is unwise. It is wise to treat all pigments as hazardous or potentially hazardous. The following guidelines are for single exposures and are relative to the sensitivity of the individual. Carcinogens are labeled separately and allergies are not covered.

Highly toxic means that serious injury or death will result from absorption of a small amount, such as a mouthful, by a healthy adult.

Moderately toxic means that temporary to permanent minor injury will result from absorption of a small to moderate amount by a healthy adult.

Slightly toxic means that temporary minor injury will result from absorption of a small to moderate amount by a healthy adult. Larger quantities could cause greater damage.

Nontoxic means that no detectable injury will occur from absorption of small to moderate amounts by a healthy adult. Nontoxic does *not* mean safe or nonhazardous.

Permanence

There are many factors that influence the permanence of pigments. These include weather, ozone, visible light, ultraviolet light, acid, alkali, water, oil, solvents, detergents, humidity, air pollutants, temperature, the type of medium used, the ground on which the pigment is applied, and whether a pigment is mixed with other pigments. Testing of permanency is still based heavily on theory and speculation. Only recently have serious attempts been made to use a scientific

approach. Permanency ratings for pigments that have been in use for seventy-five to one hundred years can be safely relied upon because they have proven their ratings under actual conditions. Ratings on pigments in use less than seventy-five years, and especially less than twenty-five years, have to be viewed with some suspicion. Such pigments are tested through accelerated aging tests, which rarely include more than three variables and cannot duplicate actual conditions. Although such testing has often proven reliable, there have been notable exceptions. The vast number of variables prohibits any guarantee as to the relative permanency of a pigment, and therefore the information supplied in this category is a summation of the best available data and is *not* intended as a warranty.

Although this category occasionally refers to some other variables, it is primarily concerned with lightfastness (the pigment's ability to retain its original color). The Wool Scale, a common international method of rating the lightfastness of a color or a pigment, is given on page 155.

The American Society for Testing and Materials (ASTM) has proposed new testing procedures for the purpose of rating the lightfastness of pigments in oil and acrylic. Manufacturers and researchers who have followed these guidelines have assigned the ratings that appear in the chart. Three categories are used.

Category I: Excellent lightfastness. Very slight to no color change after the equivalent of one hundred years of indoor museum exposure.

Category II: Very good lightfastness. Less permanent than Category I, but satisfactory for most indoor painting.

Category III: Borderline—use with caution.

Transparency
The degree of transparency or opacity of a pigment can vary with the medium that is used with the pigment. When a commercial paint is made, fillers are often added, which can greatly alter the transparency depending on the type of filler. The difference between napthol crimson, for example, and one variety of cadmium red hue is the filler mixed with napthol carbamide to make it opaque like the cadmiums.

Tinting Strength
Tinting strength depends on the quality and purity of the pigment, and may vary accordingly.

I. TABLE OF PIGMENTS AND COLORS

Common Name	Alternate Names	General Appearance	Date Introduced
WHITES			
Barium White Pigment White 21 C.I. 77120	Barium Sulfate, Permanent White, Blanc Fixe	Bright white in dry form and yellow in oil	Natural—unknown; synthetic introduced 1830
Lead White PW 1 C.I. 77597	Flake White, Silver White, Cremnitz White	Pure white	4 B.C.
Titanium White PW 6 C.I. 77891	Permanent White, Titanium Dioxide	Strongest of the whites	Pure grades not until 1919
Zinc White PW4 C.I. 77947	Chinese White, Zinc Oxide, Permanent White	Pure white	1782
BLACKS			
Charcoal Black Pigment Black 8 C.I. 77268	Peach Black	Black with warm cast, which varies in tint with source of charcoal	Before 2000 B.C.
Davy's Gray PBK 19 C.I. 77017	Mineral Black	Gray	Unknown
Ivory Black PB 9 C.I. 77267	Bone Black	Black with brown cast	Before 2000 B.C.
Lamp Black PBK 6 C.I. 77266	Carbon Black, Vegetable Black	Velvet Black	Before 2000 B.C.; oldest known pigment
Mars Black PBK 11 C.I. 77499	Iron Black, Iron Oxide Black	Black	Circa 1920
Payne's Gray PB 27, 77510; PBK 6, 77266; PR 83, 58000; & PB 29, 77007		A grayish-black with a tinge of blue	Recent
YELLOWS			
Aureolin Pigment Yellow 40 C.I. 77357	Cobalt Yellow	Golden yellow	1852
Cadmium Yellow PY 37 C.I. 77199	Cadmium Yellow Light, Cadmium Yellow Medium, Cadmium Yellow Deep, Cadmium Yellow Lemon	Pale cool yellow to orange-yellow	Circa 1830s

Common Name	Alternate Names	General Appearance	Date Introduced
Cadmium-Barium Yellow PY37:1 C.I. 77199:1	Cadmium Yellow, Cadmium Yellow Medium, Cadmium Yellow Deep	Same as Cadmium Yellow	1927
Cadmium Yellow Hue PY1, C.I. 11690 and/or PY 3, C.I. 11710	Cadmium Yellow, Lemon Yellow, Japanese Yellow Senegal Yellow, Azo Yellow	Similar to Cadmium Yellow; however, as the hue approaches orange, intensity and brilliance lost	Circa 1900s
Chrome Yellow PY 34 C.I. 77600	Chrome Lemon Yellow, Chrome Yellow Deep, Chrome Orange	Same as Cadmium Yellow	1818
Gamboge Natural Yellow 24 C.I. not assigned		A pale yellow with a slight brownish tinge	Circa 1600s
Hansa Yellow Light PY 3, C.I. 11710 Hansa Yellow Medium PY 1, C.I. 11680	Lemon Yellow, trade names like Winsor Lemon (PY 3), Arylide Yellow, Azo Yellow	Pale cool yellow to a bright yellow	1900
Indian Yellow		A rich golden yellow	Circa 1850; today it is used in the Orient
Lemon Yellow PY 3 C.I. 77103	Barium Yellow, Permanent Yellow, Baryta Yellow	Pale cool yellow	Circa 1800s
Litharge PY 46 C.I. 77577	Lead Oxide, Massicot	Pale yellow	Before 2000 B.C.
Mars Yellow PY 42 C.I. 77492	Yellow Oxide, Ochre	Paler and more uniform than Yellow Ochre	Approx. 1950s
Naples Yellow PY 41 C.I. 77589	Antimony Yellow	Pale yellow with reddish tint	500 B.C. (in ceramics)
Nickel-Titanium Yellow PY 53 C.I. 77788	Nickel Yellow, Nickel Titanate Yellow	A pale cool yellow	Circa 1960s
Orpiment PY 39 C.I. 77086	Arsenic Yellow, Kings Yellow	Similiar to Cadmium Yellow	Circa 1500 B.C., today used only in the Orient
Yellow Ochre PY 43 C.I. 77492	Ochre, Roman Ochre	Ranges from orange to light brown	Before 2000 B.C.
Zinc Yellow PY 35 C.I. 77955	Citron Yellow, Zinc Chromate	Cool deep yellow	Circa 1800

Common Name	Alternate Names	General Appearance	Date Introduced
ORANGES			
Cadmium Orange Pigment Orange 20 C.I. 77202		A warm orange	Circa 1830s
Cadmium-Barium Orange PO 20:1 77202:1	Cadmium Orange	Same as Cadmium Orange	Circa 1930s
Perinone Orange PO 43 71105	Perinone, Orange Azo, Indo Orange Red	Orange-red	1924
Mars Orange PY 42 C.I. 77992		A brownish-orange	Circa 1950s
REDS			
Alizarin Crimson Pigment Red 83 C.I. 5800	Alizarin Carmine, Alizarin Madder Lake, Crimson Lake, Rose Madder Alizarin	Similar to Carmine and Madder	1868
Cadmium Red (C.P.) PR 108 C.I. 77196	Cadmium Red, Cadmium Red Light or Deep, Cadmium Red Scarlet, Cadmium Vermilion	Ranges from bright yellowish-red to a deep purple-red	1910
Cadmium Red (C.C.) PR 108 C.I. 77202	Cadmium Red Light, Cadmium Red Scarlet, Cadmium Red Deep	Ranges from bright yellowish-red to a deep purple-red	1910
Cadmium-Barium Red PR 108:1 C.I. 77202:1	Cadmium Red	Same as Cadmium Red	Circa 1910
Cadmium Red Hue PR 7(12420); PR 9 (12460); PR 170 (12475); PR 188 (12467); or PR 48 (15865)	Azo Red, Vermilion Hue, Scarlet Lake, Helio Red, Cadmium Red, Japanese Red, Peony Red, Geranium Lake, or brand names like Winsor Red and Grumbacher Red	Similar to Cadmium Red and Vermilion	Circa 1950
Carmine Natural Red 4 C.I. 75470	Crimson Lake	A deep red with a tinge of blue	Circa 1500
Chrome Red PR 104 C.I. 77605	Persian Red	Similar to Vermilion	Circa 1800
Light Red PR 102 C.I. 77492	Burnt Ochre	A pale reddish-brown	Before 2000 B.C.

Common Name	Alternate Names	General Appearance	Date Introduced
Madder NR 9 C.I. 75330	Rose Madder, Madder Lake	Similar to Carmine	Circa 1300
Mars Red PR 101 C.I. 77491	Red Oxide, Violet Iron Oxide	Varying shades of red-brown, some with purple tints	Circa 1700
Naphthol Crimson PR 170 C.I. 12475	Naphthol Carbamide	A deep red with a bluish tinge	Circa 1940s
Naphthol Red Light PR 9 C.I. 12460	Naphthol AS-OL	A warm red	1912
Quinacridone Magenta PR 122 C.I. 73915	Quinacridone, Acra Violet (Registered), Rose Violet, Rose, Alps Red	A purplish-red	1958
Realgar PY 39 C.I. 77085	Red Orpiment, Red Arsenic Sulfide	Orange-red to vermilion	Circa 1500 B.C.; today used only in the Orient
Red Ochre PR 101 C.I. 77491	Indian Red, English Red, Red Bole, Gulf Red, Red Pozzuoli, Venetian Red	Varying shades of red-brown	Among the oldest known pigments, before 2000 B.C.
Red Lead PR 105 C.I. 77578	Minium, Mineral Orange, Mineral Red, Lead Oxide Red	A bright red with a tinge of orange	One of the oldest synthetic pigments; today used only in the Orient, found before 1 B.C.
Vermilion PR 106 C.I. 77766	Chinese Vermilion, English Vermilion, Scarlet Vermilion	Red with a yellow tinge, occasionally red with a purple tinge	Circa 1500 B.C.

BROWNS

Asphaltum Natural Black 6 C.I. Not assigned	Asphalt, Bitumen	A dark brownish-black	Before 2000 B.C.
Burnt Sienna Pigment Brown 7 C.I. 77492, or PB 7 C.I. 77491	Caledonian Brown, Indian Red, Terra Rosa, Venetian Red	Brown with yellow tinge, occasionally with a red tinge	Before 2000 B.C.
Burnt Umber PBR 7 C.I. 77492, or PB 7 C.I. 77491	Umber	A medium to dark brown often with a tinge of yellow	Before 2000 B.C.
Mummy Natural Brown 11 C.I. Not assigned		Similar to Asphaltum	1800s; use discontinued during the 1920s

Common Name	Alternate Names	General Appearance	Date Introduced
Raw Sienna PB 7 C.I. 77492 or PY 43, C.I. 77492	Sienna, Raw Siena	Transparent golden yellow	Before 2000 B.C.
Raw Umber PBR 7 C.I. 77492, or PBR 7 C.I. 77491	Umber	A medium brown often with a tinge of olive green	Before 2000 B.C.
Sepia Natural Brown 9 C.I. Not assigned		A blackish brown with a tinge of red	Circa 1780s
Vandyke Brown Natural Brown 8 No C.I. number, or PBR 8 C.I. 77727	Van Dyck Brown, Cassel Earth	A deep dark brown	Circa 1600s

GREENS

Common Name	Alternate Names	General Appearance	Date Introduced
Cadmium Green PY 37, C.I. 77199 PG 18, C.I. 77289	Cadmium Green Light, Cadmium Green Deep	Varies from light yellow green to bluish-green, depending on the mixture	Circa 1925
Chrome Green PY 34, C.I. 77600 & PB 27, C.I. 77510	Cinnabar Green, Prussian Green	Varies greatly depending on the ratios of the two pigments used	Circa 1818
Chromium Oxide Green PG 17 C.I. 77288	Oxide of Chromium, Chromium Oxide, Chrome Oxide (not the same as Chrome Green)	A cool olive-green	1862
Cobalt Green PG 19 C.I. 77335	Cobalt Green Light, Cobalt Green Deep	Bluish-green	1835
Emerald Green PG 21 C.I. 77410	Venonese Green, Paul Vero Green, Paris Green	A light slightly yellow green	1814; today most paint manufacturers have discontinued use of this poisonous pigment
Green Earth PG 23 C.I. 77009	Terre Verte, Bohemian Green, Verona Green	Gray-green	Before 2000 B.C.
Hooker's Green Natural Pigment Yellow 24, No C.I. Number & PB 27, C.I. 77510	Hooker's Green Light, Hooker's Green Deep	A deep transparent green which varies due to the mixture	Unknown
Hooker's Green Hue PG 8, C.I. 10006 or PB 15, C.I. 74160 & PY 1, C.I. 11680	Hooker's Green Light, Hooker's Green Deep	Similar to Hooker's Green	Recently

Common Name	Alternate Names	General Appearance	Date Introduced
Malachite PB 30 C.I. 77420	Mineral Green, Malachite Green, Bremen Green	Ranges from a pale green to a deep blue-green	Circa 1500 B.C.; today used only in the Orient.
Permanent Green PG 18, C.I. 77289 & PY 37, C.I. 77199 or PY 36, C.I. 77955	Permanent Green Deep, Permanent Green Light	Lighter versions of Viridian	Circa 1860
Phthalocyanine Green PG 7 C.I. 74260	Monastral Green, Phthalo Green, Thalo Green(R), and trade names like Winsor Green	Similar to Viridian, but deeper and with a slight bluish tinge	1938
Sap Green Natural Green 2 C.I. 75440, 75650 or 75695		A light olive-green with a tinge of yellow	Original used from 1100 to 1700
Sap Green Hue PG 8, C.I. 10006 & PG 7, C.I. 74260 &/or PG 36, C.I. 74265	Sap Green	Similar to Sap Green	Recently
Verdigris PG 20 C.I. 77408		A deep green with a tinge of blue	Before 1 B.C.
Viridian PG 18 C.I. 77289	Transparent Oxide of Chromium, Green Oxide of Chromium	A cool deep green	Circa 1860

BLUES

Common Name	Alternate Names	General Appearance	Date Introduced
Azurite Pigment Blue 30 C.I. 77420	Bremen Blue	A pale blue	Circa 1500 B.C.; today used only in the Orient
Cerulean PB 35 C.I. 77368	Coeruleum, Cerulean Blue	A bright pale blue with greenish tinge	Known since 1805, but first introduced 1821; reintroduced in 1860
Cerulean Blue Hue PW 4(77947) & PB 15 (74160) &/or PB 29 (77007) or PG 7(74260)	Cerulean Blue	Similar to Cerulean Blue	Recently
Cobalt Blue PB 28 C.I. 77346	Cobalt Blue Light, Cobalt Blue Deep	A bright blue, sometimes with a slight reddish tinge	1820
Cobalt Blue Hue PB 15, C.I. 74160 &/or PB 29, C.I. 77007 & PW 4, C.I. 77947	Cobalt Blue	Similar to Cobalt Blue	Recently
Cobalt Turquoise PB 36 C.I. 77343	Chromium Cerulean Blue	A bright greenish-blue	Recently

Common Name	Alternate Names	General Appearance	Date Introduced
Egyptian Blue PB 31 C.I. 77437	Blue Frit	Ranges from a pale blue to a deep blue depending on the size of the pigment particles	In use from circa 1500 B.C. to A.D. 500; today used only in the Orient
Indanthrone Blue PB 60 C.I. 69800	Indanthrone, Indanthrone Blue R, Indian Blue	Resembles Prussian Blue	1901; however it has only recently come into use as an artist pigment
Indigo Natural Blue 1 C.I. 75780 and/or C.I. 75790		A deep violet-blue	Before 1 B.C.; today found in the Orient or in products imported from the Orient
Manganese Blue PB 33 C.I. 77112		A bright, cold, pale blue	Available since 1907; significant use did not occur until after 1950
Phthalocyanine Blue PB 15 C.I. 74160	Monastral Blue, Thalo Blue(R), trade names like Winsor Blue, Hoggar Blue, Hortensia Blue, Touareg Blue	Ranges from a dark reddish blue to a deep slightly greenish-blue	1907; rediscovered several times after; finally caught on in the 1930s
Prussian Blue PB 27 C.I. 77510	Turnbull's Blue, Antwerp Blue, Milori Blue	A deep blackish-blue	1724
Ultramarine, Natural PB 29 C.I. 77007	Lapis lazuli, Lazurite	A deep blue, sometimes blue-violet or greenish-blue	Before 2000 B.C.; today used primarily in the Orient.
Ultramarine, Synthetic PB 29 C.I. 77007	French Ultramarine, New Blue, Permanent Blue, Ultramarine Blue	Made to resemble Lapis lazuli; however, reddish tints are also made	1828

VIOLETS

Cobalt Violet PV 14 C.I. 77360	Cobalt Violet Deep	A deep violet with a reddish tinge	1859
Cobalt Violet Pale PV 14 C.I. 77350	Cobalt Violet	Bright pale violet	Circa 1800
Dioxazine Purple PV 23 C.I. 51319	Transparent Violet, Dioxazine Violet	A dark blue violet	1952
Manganese Violet PV 16 C.I. 77742	Permanent Violet, Mineral Violet	Pale reddish violet	Has been around since 1868; but has only recently come into use
Quinacridone Violet PV 19 C.I.46500	Permanent Rose, Permanent Magenta, Alps Red, Garnet Red, Thalo Red Rose(R)	Reddish-violet	1958

II. TABLE OF PIGMENTS AND COLORS

Common Name	Compatibility with Other Pigments	Compatible Media	Precautions
WHITES			
Barium White	Compatible with all	All media; slows drying in oil	Becomes transparent in oil
Lead White	Incompatible with sulfur-based pigments except when ground in oil	Oil or egg tempera; forms a tough and flexible paint film in oil, and speeds drying	Tends to yellow in oil, or blacken on direct exposure to city air
Titanium White	Compatible with all	All media; slow drying in oil	None
Zinc White	Compatible with all	Oil, egg tempera, and watercolor; slow drying in oil	Forms brittle paint film; should not be used in underpainting in oil
BLACKS			
Charcoal Black	Compatible with all	All media; slow drying in oil and can form brittle paint films in oil when used by itself	Very slow to dry in oil—do not use in underpainting by itself
Davy's Gray	Compatible with all	All media	
Ivory Black	Compatible with all	All media; slow drying in oil and can form brittle paint films in oil when used by itself	Very slow to dry in oil—do not use in underpainting by itself
Lamp Black	Compatible with all	Oil or egg tempera; slow drying in oil and can form brittle paint films in oil when used by itself	Very slow to dry in oil—do not use in underpainting by itself
Mars Black	Compatible with all	All media; forms a tough and flexible paint film in oil	
Payne's Gray	Varies due to mixture; for example, if ultramarine is used, see this category under ultramarine	All media	Mixed colors have reduced permanency
YELLOWS			
Aureolin	Compatible with all	All media; speeds drying in oil	Sensitive to acid/alkali
Cadmium Yellow	Incompatible with Emerald Green, Azurite, as well as lead-based pigments not in oil	All media; slow drying in oil	Do not use with acidic media

Common Name	Compatibility with Other Pigments	Compatible Media	Precautions
Cadmium-Barium Yellow	Incompatible with Emerald Green, Azurite, as well as lead-based pigments not in oil	All media; slow drying in oil	This is a diluted version of Cadmium Yellow, and does not perform as well in tinting and glazes
Cadmium Yellow Hue	Compatible with all	All media	Some azo pigments have recently been found to bleed into other colors and paint films
Chrome Yellow	Compatible with all	All media (see precautions); forms a tough and flexible oil paint film and speeds drying in oil	Not permanent in watercolor because the lead can react with air pollutants and darken
Gamboge	Not available	Watercolor and egg tempera	Not lightfast and therefore not safe for professional use
Hansa Yellow	Compatible with all	All media; slows drying in oil	There is some evidence that pigment dyes bleed over time
Indian Yellow	Compatible with all	All media (except fresco)	All commercially available Indian Yellow paint is an imitation
Lemon Yellow	Incompatible with Naples Yellow	All water-based media	Do not use with acidic media
Litharge	Incompatible with sulfur-based pigments	Oil; speeds drying in oil	Highly toxic
Mars Yellow	Compatible with all	All media; forms a tough and flexible oil paint film	
Naples Yellow	Incompatible with Barium Yellow (Lemon Yellow)	Compatible with all; forms a tough and flexible oil paint film; speeds drying in oil	Do not use with acidic media
Nickel-Titanium Yellow	Compatible with all	All media	
Orpiment	Same as Cadmium Yellow	All media	Extremely hazardous to health, particularly in dry form
Yellow Ochre	Compatible with all	All media; forms a tough and flexible oil paint film	
Zinc Yellow	Compatible with all	Oil, slightly soluble in water	Tends to develop a greenish tint on aging

Common Name	Compatibility with Other Pigments	Compatible Media	Precautions
ORANGES			
Cadmium Orange	Same as Cadmium Yellow	All media; slows drying in oil	Same as Cadmium Yellow
Cadmium-Barium Orange	Same as Cadmium Yellow	All media; slows drying in oil	This is a diluted version of Cadmium Orange, and does not perform as well in tinting and glazes
Perinone Orange	Compatible with all	All media	Lightfastness might be significantly reduced when mixed with large amounts of white
Mars Orange	Compatible with all	All media	
REDS			
Alizarin Crimson	Compatible with all	Oil and watercolor; slows drying in oil	Although more lightfast than Madder, thin glazes should be avoided
Cadmium Red (C.P.)	Incompatible with copper-based pigments (except copper phthalocyanine)	All media; forms a tough and flexibile oil paint film, and slows drying in oil	Do not paint on surfaces that will be heated—hazardous vapors can form
Cadmium Red (C.C.)	Incompatible with copper-based pigments (except copper phthalocyanine)	All media; forms a tough and flexible oil paint film, and slows drying in oil	Do not paint on surfaces that will be heated—hazardous vapors can form
Cadmium-Barium Red	Incompatible with copper-based pigments (except copper phthalocyanine)	All media; forms a tough and flexible oil paint film, and slows drying in oil	This is a diulted version of Cadmium Red and does not perform as well in tinting and glazing
Cadmium Red Hue	Compatible with all	All media	Some varieties bleed, also permanency is often significantly reduced when mixed with white
Carmine	Compatible with all	Oil and watercolor	Sensitive to alkali
Chrome Red	Compatible with all	All media	Not permanent in watercolor because the lead can react with air pollutants and darken
Light Red	Compatible with all	All media; speeds drying in oil	

Common Name	Compatibility with Other Pigments	Compatible Media	Precautions
Madder	Compatible with all	Oil and watercolor; slows drying in oil	Madder is often the cut-off point for minimum acceptable lightfastness for artist pigments
Mars Red	Compatible with all	All media; forms a tough and flexible oil paint film	
Naphthol Crimson	Compatible with all	All media	As with all dye-pigments, bleeding may occur
Naphthol Red Light	Compatible with all	All media	As with all dye-pigments, bleeding may occur
Quinacridone Magenta	Compatible with all	All media; forms a tough and flexible paint film in oil	As with all dye-pigments, bleeding may occur
Realgar	Incompatible with copper-based pigments	Oil, watercolor, and egg tempera	
Red Ochre	Compatible with all	All media	
Red Lead	Incompatible with sulfur-based pigments and lithopone, except in oil	Turns brown in oil; in watercolor it will blacken when exposed to air	Do not use; poisonous and unstable
Vermilion	Compatible with all pigments in oil, incompatible with lead-based pigments in water-based paints	All media; slows drying in oil	Do not paint on surface that will be heated—hazardous vapors can form

BROWNS

Common Name	Compatibility with Other Pigments	Compatible Media	Precautions
Asphaltum	Not compatible with any; it tends to bleed into and stain other colors	Oil-based media; does not fully dry, and can cause cracking in oil	Should not be used
Burnt Sienna	Compatible with all; however it tends to make cobalt pigments settle out of mixtures in watercolor	All media; forms a tough and flexible oil paint film	Do not mix with cobalt pigments in watercolor washes
Burnt Umber	Compatible with all	All media; forms a tough and flexible oil paint film and speeds drying in oil	Said to darken in oil
Mummy	Same as Asphaltum	Oil-based media; does not fully dry, and causes cracking of oil paint films	Should not be used—fugitive; disrespectful to the dead

Common Name	Compatibility with Other Pigments	Compatible Media	Precautions
Raw Sienna	Compatible with all	All media	
Raw Umber	Compatible with all	All media; forms a tough and flexible oil paint film and speeds drying in oil	Said to darken in oil
Sepia	Unknown	Watercolor, ink	Should not be used
Vandyke Brown	Compatible with all	Oil and watercolor; does not fully dry, and can cause cracking of oil paint films	Said to bleed in oil; too fugitive for professional work

GREENS

Common Name	Compatibility with Other Pigments	Compatible Media	Precautions
Cadmium Green	Incompatible with copper-based pigments, except phthalocyanine pigments	All media; slows drying in oil	
Chrome Green	Compatible with all	Oil and watercolor; speeds drying in oil	Should not be used in watercolor, can react with air pollutants and darken
Chromium Oxide Green	Compatible with all	All media	
Cobalt Green	Compatible with all	Watercolor and oil; speeds drying in oil	
Emerald Green	Incompatible with sulfur-based pigments like Cadmium Yellow	All media; slows drying in oil	Do not use
Green Earth	Compatible with all	All media; slows drying in oil	
Hooker's Green	Compatible with all	Traditionally used only in water-based paints	
Hooker's Green Hue	Compatible with all	Not used in oil-based paints	This mixed color is only slightly better than the original and should still be used with caution
Malachite	Incompatible with sulfur-based pigments	Watercolor only	Malachite is expensive and is hard to grind into a pigment; also it is a poor mixing color
Permanent Green	Varies with mixture	All media	Zinc Yellow is sometimes used instead of barium sulfate, raising opacity and lowering tinting strength
Phthalocyanine Green	Compatible with all	All media	

Common Name	Compatibility with Other Pigments	Compatible Media	Precautions
Sap Green	Compatible with all	Today's mixture is compatible with all media	
Sap Green Hue	Compatible with all	Mixtures for oil do not use ferric-nitroso-betanaphthol; a color most common in watercolor	This mixed color is only slightly better than the original and should still be used with caution
Verdigris	Incompatible with sulfur-based pigments, and lead-based pigments	Oil media	Should not be used—too many compatibility problems
Viridian	Compatible with all	All media	

BLUES

Azurite	Incompatible with sulfur-based pigments	Water-based only	Do not use
Cerulean	Compatible with all	All media	
Cerulean Blue Hue	Varies due to specific pigments used	All media	This mixture simulates only the surface color of Cerulean, not its qualities
Cobalt Blue	Compatible with all	All media; forms a tough and flexible oil paint film, and speeds drying in oil	
Cobalt Blue Hue	Varies due to specific pigments used	All media	This mixed color simulates only the surface color of Cobalt Blue, not its qualities
Cobalt Turquoise	Compatible with all	All media	
Egyptian Blue	Compatible with all	All media	
Indanthrone Blue	Compatible with all	All media	Sensitive to chlorine
Indigo	Compatible with all	All media	Not recommended for permanent artwork
Manganese Blue	Compatible with all	All media; speeds drying in oil	
Phthalocyanine Blue	Compatible with all	All media; speeds drying in oil	
Prussian Blue	Compatible with all	Oil, watercolor and egg tempera; speeds drying in oil	

Common Name	Compatibility with Other Pigments	Compatible Media	Precautions
Ultramarine, Natural	Incompatible with copper- and lead-based pigments, except for Phthalocyanine and pure white lead.	All media; slows drying in oil	When available, it is extremely expensive
Ultramarine, Synthetic	Same as the natural pigment	All media; slows drying in oil	

VIOLETS

Cobalt Violet	Compatible with all	All media; speeds drying in oil	One of the most expensive pigments, many substitutes are available but are not adequate
Cobalt Violet Pale	Compatible with all	All media; speeds drying in oil	Beautiful, but extremely poisonous
Dioxazine Purple	Compatible with all	All media	Bleeding may occur with any dye-pigment
Manganese Violet	Compatible with all	Oil; forms a tough and flexible oil paint film, and speeds drying in oil	Sensitive to acid preservatives in water media
Quinacridone Violet	Compatible with all	All media	Bleeding may occur with any dye-pigment

III. TABLE OF PIGMENTS AND COLORS

Common Name	Source of Pigment	Chemical Composition	Relative Toxicity
WHITES			
Barium White	Natural or synthetic mineral pigment	Barium sulfate	Nontoxic
Lead White	Synthetic mineral pigment	Basic lead carbonate	Highly toxic
Titanium White	Synthetic mineral pigment	Titanium dioxide	Nontoxic
Zinc White	Synthetic mineral pigment	Pure zinc oxide	Nontoxic
BLACKS			
Charcoal Black	Incomplete combustion of plant matter	Carbon contaminated with natural resins	Suspected carcinogen
Davy's Gray	Earth; black slate	Aluminum silicate with carbon	Suspected carcinogen
Ivory Black	Carbonization of bone; in the past, ivory was used	Carbon contaminated with calcium phosphate	Suspected carcinogen
Lamp Black	Incomplete combustion of vegetable or mineral oil; at one time from soot in lamps	Pure carbon with slight oil contamination	Suspected carcinogen
Mars Black	Synthetic mineral pigment	Ferro-ferric oxide	Nontoxic
Payne's Gray	Mixed color	A mixed color whose ingredients vary from manufacturer to manufacturer	Varies due to mixture
YELLOWS			
Aureolin	Synthetic mineral pigment	Potassium cobaltinitrite	Slightly to moderately toxic
Cadmium Yellow	Synthetic mineral pigment	Cadmium sulfide	Highly toxic, and a suspected carcinogen
Cadmium-Barium Yellow	Synthetic mineral pigment	Cadmium sulfide and barium sulfate	Highly toxic, and a suspected carcinogen
Cadmium Yellow Hue	Synthetic organic dye pigment from coal tars	Arylide yellow G and/ or 10 G, mixed with barium sulfate to simulate the opacity of the cadmiums	Unknown
Chrome Yellow	Synthetic mineral pigment	Lead chromate-sulfate	Highly toxic
Gamboge	Natural vegetable pigment that includes its own binder	Resin, gambogic acid, and gum	Highly toxic

Common Name	Source of Pigment	Chemical Composition	Relative Toxicity
Hansa Yellow	Coal-tars	An arylide pigment	Unknown
Indian Yellow	An organic pigment extracted from cow urine after the cow is fed mango leaves and then deprived of drinking water	Magnesium euxanthate	Nontoxic
Lemon Yellow	Synthetic mineral pigment	Barium chromate	Moderately toxic
Litharge	Synthetic mineral pigment	Lead monoxide	Highly toxic
Mars Yellow	Synthetic mineral pigment	Pure hydrated ferric oxide	Non toxic
Naples Yellow	Synthetic mineral pigment	Lead antimonate	Highly toxic
Nickel-Titanium Yellow	Synthetic mineral pigment	Nickel titanate	Moderately toxic, and a suspected carcinogen
Orpiment	Natural mineral pigment	Arsenic trisulfide	Highly toxic
Yellow Ochre	Earth	Hydrated ferric oxide and clay	Itself is nontoxic, however it can be contaminated with toxic manganese
Zinc Yellow	Synthetic mineral pigment	Zinc chromate	Highly toxic, and a suspected carcinogen

ORANGES

Common Name	Source of Pigment	Chemical Composition	Relative Toxicity
Cadmium Orange	Synthetic mineral pigment	Cadmium sulfo-selenide	Same as Cadmium Yellow
Cadmium-Barium Orange	Synthetic mineral pigment	Cadmium sulfo-selenide and barium sulfate	Same as Cadmium Yellow
Perinone Orange	Synthetic organic dye-pigment from coal-tar	Perinone	Unknown
Mars Orange	Synthetic mineral pigment	Ferric oxide	Nontoxic

REDS

Common Name	Source of Pigment	Chemical Composition	Relative Toxicity
Alizarin Crimson	Synthetic organic pigment	1,2-dihydroxyanthraquinone (Alizarin)	Slightly toxic
Cadmium Red (C.P.)	Synthetic mineral pigment	Chemically Pure (C.P.) cadmium sulfo-selenide (crystals of cadmium sulfide and cadmium selenide)	Highly toxic and a suspected carcinogen

Common Name	Source of Pigment	Chemical Composition	Relative Toxicity
Cadmium Red (C.C.)	A Chemically Concentrated (C.C.) synthetic mineral pigment	Cadmium sulfo-selenide (crystals of cadmium sulfide and cadmium selenide) mixed with less than 15% barium sulfate	Highly toxic, and a suspected carcinogen
Cadmium-Barium Red	Synthetic mineral pigments	Cadmium sulfo-selenide diluted with more than 15% barium sulfate	Highly toxic, and a suspected carcinogen
Cadmium Red Hue	Synthetic organic dye-pigment from coal tar	Any of several naphthol red pigments mixed with barium sulfate to resemble cadmium's opacity	Unknown
Carmine	Natural organic dye from the female cochineal insects	Carminic acid attached to an alumina substrate	Nontoxic
Chrome Red	Synthetic mineral pigment	Basic lead chromate	Highly toxic
Light Red	Calcinated earth	Dehydrated ferric oxide with clay and silica	Nontoxic
Madder	The roots of the *Rubia tinctorum* or *Rubia peregrine*	Several varieties of natural oxyanthraquinone dyes	Slightly toxic
Mars Red	Synthetic mineral pigment	Ferric oxide	Nontoxic
Naphthol Crimson	Synthetic organic dye-pigment from coal tar	Naphthol carbamide	Unkown
Naphthol Red Light	Synthetic organic dye-pigment from coal-tar	Naphthol AS-OL	Unknown
Quinacridone Magenta	Synthetic organic dye-pigment from coal-tar	Gamma-quinacridone	Unknown
Realgar	Natural mineral	Arsenic disulfide	Highly toxic
Red Ochre	Earth pigments, and/or synthetic mineral pigments	Ferric oxide mixed with varying amounts of clay and silica	Nontoxic
Red Lead	Synthetic mineral pigment	Lead tetroxide	Highly toxic
Vermillion	Natural or synthetic mineral pigment	Mercuric sulfide	Highly toxic

BROWNS

Asphaltum	Natural organic dye from the residue of oil or coal tar	Tar (mixture of decomposed organic matter)	Unknown

Common Name	Source of Pigment	Chemical Composition	Relative Toxicity
Burnt Sienna	Calcinated earth	Dehydrated ferric oxide with silica	Nontoxic
Burnt Umber	Calcinated natural earth pigment	Dehydrated ferric oxide, dehydrated manganese oxide, silica and/or clay	Highly toxic (due to the manganese)
Mummy	Natural organic dye from the asphaltum in mummies	Asphaltum	Unknown
Raw Sienna	Earth	Hydrated ferric oxide and silica	Nontoxic
Raw Umber	Natural earth pigment	Hydrated ferric oxide, hydrated manganese oxide, and silica and/or clay	Highly toxic (due to the manganese)
Sepia	A natural organic dye from the cuttlefish	78% melanin, the remainder is miscellaneous salts	Unknown
Vandyke Brown	Coal-tar, bituminous lignite or brown coal	Bituminous earth containing iron and manganese	Highly toxic (due to the manganese)

GREENS

Common Name	Source of Pigment	Chemical Composition	Relative Toxicity
Cadmium Green	A mixture of two synthetic mineral pigments	A mixture of hydrated chromium sesquioxide and cadmium sulfide	Highly toxic and a suspected carcinogen
Chrome Green	A mixture of two synthetic mineral pigments	Lead chromate (Chrome Yellow) and ferric ferrocyanide (Prussian Blue)	Highly toxic
Chromium Oxide Green	Synthetic mineral pigment	Chromic oxide (the dehydrated version of the pigment used to make Viridian)	Moderately toxic and a suspected carcinogen
Cobalt Green	Synthetic mineral pigment	Cobalt zincate	Moderately toxic
Emerald Green	Synthetic mineral pigment	Copper aceto-arsenite	Highly toxic
Green Earth	Natural earth pigment	Ferrous silicate and clay	Slightly toxic
Hooker's Green	A mixture of synthetic organic and synthetic mineral pigments	Once Gamboge and Prussian Blue, today Phthalocyanine Blue and a yellow azo pigment	Today's mixture is a suspected carcinogen

Common Name	Source of Pigment	Chemical Composition	Relative Toxicity
Hooker's Green Hue	A mixture of synthetic organic dye-pigments	Ferric-nitroso-betanaphthol or Phthalocyanine Blue and arylide	Suspected carcinogen
Malachite	Natural mineral pigment	Basic copper carbonate	Highly toxic
Permanent Green	Synthetic mineral pigment mixed with the extender barium sulfate	Hydrated chromium sesquioxide & barium sulfate or cadmium sulfate or zinc chromate	Moderately toxic and a suspected carcinogen
Phthalocyanine Green	A synthetic organic dye-pigment	Copper Phthalocyanine Green (C.I. pigment green 7)	With rare exception, this nontoxic pigment is contaminated with a known carcinogen
Sap Green	A mixture of synthetic organic and synthetic mineral pigments	Once made from vegetable dyes like those from unripe buckthorn berries; today like Hooker's green	Today's mixture is a suspected carcinogen
Sap Green Hue	A mixture of synthetic organic dye-pigments	Ferric-nitroso-betanaphthol and Phthalocyanine Green	Suspected carcinogen
Verdigris	Synthetic mineral pigment	Basic copper acetate	Highly toxic
Viridian	Synthetic mineral pigment	Hydrated chromium sesquioxide	Moderately toxic and a suspected carcinogen

BLUES

Common Name	Source of Pigment	Chemical Composition	Relative Toxicity
Azurite	May be a natural or synthetic mineral pigment	Basic copper carbonate	Highly toxic
Cerulean	Synthetic mineral pigment	Cobaltous stannate	Moderately toxic
Cerulean Blue Hue	Synthetic organic dye-pigments and synthetic mineral pigments	Zinc White and Phthalocyanine Blue and/or Ultramarine Blue or Phthalocyanine Green	Varies due to the composition of the pigments used to make this color
Cobalt Blue	Synthetic mineral pigment	Cobalt aluminate	Slightly to moderately toxic; however, arsenic is a common contaminate
Cobalt Blue Hue	Synthetic organic dye-pigments and synthetic mineral pigments	A mixture of Phthalocyanine Blue and/or Ultramarine Blue which is mixed with Zinc White	Varies due to the composition of the pigments used to make this color

Common Name	Source of Pigment	Chemical Composition	Relative Toxicity
Cobalt Turquoise	Synthetic mineral pigment	Cobalt-chromium aluminate	Moderately to highly toxic
Egyptian Blue	Synthetic mineral pigment	Calcium-copper silicate	Nontoxic, but very abrasive due to ground-glass composition
Indanthrone Blue	Synthetic organic dye-pigment	A anthraquinone pigment	Unknown
Indigo	Natural or synthetic plant dye-pigment	Indigotin	Not available
Manganese Blue	Synthetic mineral pigment	A mixture of barium sulfate and barium permanganate	Highly toxic
Phthalocyanine Blue	Synthetic organic pigment	Copper phthalocyanine	With rare exception, nontoxic pigment is contaminated with a known carcinogen
Prussian Blue	Synthetic mineral pigment	Ferric ferrocynanide	Slightly toxic; can produce cyanide gas if heated or mixed with acid
Ultramarine, Natural	A natural mineral pigment	The gem stone Lapis lazuli	Nontoxic
Ultramarine, Synthetic	A synthetic mineral pigment	Sodium aluminum silicate-polysufide	Nontoxic

VIOLETS

Common Name	Source of Pigment	Chemical Composition	Relative Toxicity
Cobalt Violet	Synthetic mineral pigment	Cobalt phosphate, occasionally mixed with cobalt arsenate	Moderately toxic unless arsenic present, then highly toxic
Cobalt Violet Pale	Synthetic mineral pigment	Cobalt arsenate	Highly toxic
Dioxazine Purple	Synthetic organic dye-pigment	Carbazole dioxazine	Unknown
Manganese Violet	Synthetic mineral pigment	Manganese ammonium pyrophosphate	Highly toxic
Quinacridone Violet	Synthetic organic dye-pigment	Quinacridone Violet b	Unknown

IV. TABLE OF PIGMENTS AND COLORS

Common Name	Permanence	Transparency	Tinting Strength
WHITES			
Barium White	Lightfast; alkali/acid-proof; Wool Scale grade 8	Opaque unless ground in oil	High, except in oil
Lead White	Lightfast; Wool Scale grade 8; ASTM Category I in oil, I in acrylic	Opaque	Good
Titanium White	Lightfast; alkali/acid-proof; Wool Scale grade 10; ASTM Category I in oil; I in acrylic	Highly opaque	Very high
Zinc White	Lightfast; Wool Scale grade 8; ASTM Category I in oil, I in acrylic	Opaque	Good
BLACKS			
Charcoal Black	Lightfast; Wool Scale grade 8	Opaque	High
Davy's Gray	Lightfast; Wool Scale grade 8	Semiopaque	Low
Ivory Black	Lightfast; alkali/acid-proof; Wool Scale grade 8; ASTM Category I in oil, I in acrylic	Opaque	High
Lamp Black	Lightfast; alkali/acid-proof; Wool Scale grade 10; ASTM Category I in oil, I in acrylic	Opaque	High
Mars Black	Lightfast; alkali-proof; Wool Scale grade 9; ASTM Category I in oil, I in acrylic	Opaque	High
Payne's Gray	Poor lightfastness if PR 83, C.I. 5800 is used, possibly 7 on the Wool Scale	Semitransparent to semiopaque	Good
YELLOWS			
Aureolin	Lightfast; Wool Scale grade 8; ASTM Category II in oil, not used in acrylic	Transparent	High
Cadmium Yellow	Lightfast; Wool Scale grade 8; ASTM Category I in oil, I in acrylic	Opaque	Good

Common Name	Permanence	Transparency	Tinting Strength
Cadmium-Barium Yellow	Lightfast; Wool Scale grade 8; ASTM Category I in oil, I in acrylic	Less opaque than Cadmium Yellow	Good, but less than Cadmium Yellow
Cadmium Yellow Hue	Lightfast; Wool Scale grade 7-8; ASTM Category II in oil, II in acrylic	Most azo pigments are mixed with barium sulfate to resemble the opacity of the cadmiums	Good to excellent
Chrome Yellow	Lightfast; Wool Scale grade 8	Opaque	Excellent
Gamboge	Fugitive; Wool Scale grade less than 6	Very transparent	Very good
Hansa Yellow	Lightfast; acid/alkali-proof; Wool Scale grade 7-8; ASTM Category II in oil, II in acrylic	Transparent to semi-transparent	Excellent
Indian Yellow	Lightfast; Wool Scale grade 8	Transparent	Excellent
Lemon Yellow	Very good lightfastness; alkali-proof; Wool Scale grade 7-8	Semitransparent	Low
Litharge	Fugitive; Wool Scale grade less than 6	Not available	Low
Mars Yellow	Lightfast; alkali/acid-proof; Wool Scale grade 8; ASTM Category I in oil, I in acrylic	Semiopaque	Good
Naples Yellow	Lightfast; alkali-proof; Wool Scale grade 8; ASTM Category I in oil, not used in acrylic	Opaque	Good
Nickel-Titanium Yellow	Lightfast; acid/alkali-proof; Wool Scale grade 8; ASTM Category I in oil, I in acrylic	Semiopaque	Good
Orpiment	Lightfast; Wool Scale grade estimated at 8	Opaque	Good
Yellow Ochre	Lightfast; alkali/acid-proof; Wool Scale grade 8; ASTM Category I in oil, I in acrylic	Semiopaque	Varies
Zinc Yellow	Lightfast; Wool Scale grade 8; ASTM not tested	Semitransparent	Moderate

Common Name	Permanence	Transparency	Tinting Strength
ORANGES			
Cadmium Orange	Lightfast; Wool Scale grade 8; ASTM Category I in oil, I in acrylic	Opaque	Good
Cadmium-Barium Orange	Lightfast; Wool Scale grade 8; ASTM Category I in oil, I in acrylic	Less opaque than Cadmium Orange	Good but less than Cadmium Orange
Perinone Orange	Lightfast; Wool Scale grade 7-8; ASTM Category I in oil, I in acrylic	Transparent	Very good to excellent
Mars Orange	Lightfast; Wool Scale grade 9; ASTM Category I in oil, I in acrylic	Semiopaque	Good
REDS			
Alizarin Crimson	Poor lightfastness; Wool Scale grade 7; ASTM Category III in oil, not lightfast in acrylic	Very transparent but not as much as Madder	Very good
Cadmium Red (C.P.)	Lightfast; alkali-proof; Wool Scale grade 8	Opaque	High
Cadmium Red (C.C.)	Lightfast; alkali-proof; Wool Scale grade 8; ASTM Category I in oil, I in acrylic	Opaque	High
Cadmium-Barium Red	Lightfast; alkali-proof; Wool Scale grade 8; ASTM Category I in oil, I in acrylic	Less opaque than Cadmium Red	Similar to, but less than, Cadmium Red
Cadmium Red Hue	Lightfast; often alkali-proof; Wool Scale grade 7 to 8; Most are ASTM Category II in oil, I in acrylic	Most azo pigments are mixed with barium sulfate to resemble the opacity of cadmium	Good to excellent
Carmine	Poor lightfastness; Wool Scale grade 6; purple when alkaline, becomes yellow when acidic	Very transparent	Very good
Chrome Red	Lightfast: alkali-proof; Wool Scale grade 8	Opaque	Good
Light Red	Lightfast; alkali-proof; Wool Scale grade 8; ASTM Category I in oil, I in acrylic	Semitransparent	Varies with clay and silica content
Madder	Poor lightfastness; Wool Scale grade 6	Very transparent	Good to very good

Common Name	Permanence	Transparency	Tinting Strength
Mars Red	Lightfast; Wool Scale grade 9; ASTM Category I in oil, I in acrylic	Semiopaque	Good
Naphthol Crimson	Lightfast; Wool Scale grade 7-8; ASTM Category II in oil, II in acrylic	Transparent	High
Naphthol Red Light	Lightfast; Wool Scale grade 7-8; ASTM Category II in oil, I in acrylic	Transparent	High
Quinacridone Magenta	Lightfast; Wool Scale grade 8; ASTM Category I in oil, I in acrylic	Transparent	High
Realgar	Not available	Not available	Not available
Red Ochre	Lightfast; Wool Scale grade 9; ASTM Category I in oil, I in acrylic	Semiopaque	Varies with clay and silica content
Red Lead	Lightfast, but not durable	Opaque	Very good
Vermilion	Lightfast; Wool Scale grade 7-8; ASTM Category I in oil, I in acrylic	Opaque	Good

BROWNS

Common Name	Permanence	Transparency	Tinting Strength
Asphaltum	Fugitive; Wool Scale grade less than 6	Semitransparent	Good
Burnt Sienna	Lightfast; alkali-proof; Wool Scale grade 8; ASTM Category I in oil, I in acrylic	Semitransparent	Varies with silica content
Burnt Umber	Lightfast; alkali-proof; Wool Scale grade 8; ASTM Category I in oil, I in acrylic	Semiopaque	Good
Mummy	Fugitive; Wood Scale grade less than 6	Semitransparent	Good
Raw Sienna	Lightfast; Wool Scale grade 8; ASTM Category I in oil, I in acrylic	Transparent	Low
Raw Umber	Lightfast; alkali-proof; Wool Scale grade 8; ASTM Category I in oil, I in acrylic	Semiopaque	Good
Sepia	Highly fugitive	Transparent	Varies
Vandyke Brown	Fugitive; Wool Scale grade less than 6	Transparent	Weak

Common Name	Permanence	Transparency	Tinting Strength
GREENS			
Cadmium Green	Lightfast; alkali-proof Wool Scale grade 8	Opaque	Very good
Chrome Green	Lightfast; Wool Scale grade 8	Opaque	Very good
Chromium Oxide Green	Lightfast; alkali-proof; Wool Scale grade 9; ASTM Category I in oil, I in acrylic	Opaque	Excellent
Cobalt Green	Lightfast; Wool Scale grade 8; ASTM Category I in oil, I in acrylic	Opaque	Moderate
Emerald Green	Lightfast; Wool Scale grade 8	Opaque	Good
Green Earth	Lightfast; alkali-proof; Wool Scale grade 8; ASTM Category I in oil, I in acrylic	Semitransparent	Poor
Hooker's Green	In the past, fugitive; today's formula has poor lightfastness; ASTM Category III in acrylic/fugitive in oil	Highly transparent	Very good
Hooker's Green Hue	Most mixtures have only slightly better lightfastness than the original	Transparent	Very good
Malachite	Lightfast; alkali-proof; Wool Scale grade 8	Transparent	Poor
Permanent Green	Lightfast; alkali-proof; Wool Scale grade 9; ASTM Category I in oil, not used in acrylic	Semitransparent	Very good
Phthalocyanine Green	Lightfast; alkali-proof; Wool Scale grade 8-9; ASTM Category I in oil, I in acrylic	Extremely transparent	The tinting strength is so high that it requires the use of extenders for workability
Sap Green	In the past highly fugitive; today's lightfastness depends on the mixture of substitute pigments	Transparent	Very good
Sap Green Hue	Most mixtures have only slightly better lightfastness than the original	Transparent	High
Verdigris	Lightfast; alkali-proof; Wool Scale grade 8	Transparent	Should not be used to tint other colors

Common Name	Permanence	Transparency	Tinting Strength
Viridian	Lightfast; alkali-proof; Wool Scale grade 9; ASTM Category I in oil, not used in acrylic	Transparent	Excellent

BLUES

Common Name	Permanence	Transparency	Tinting Strength
Azurite	Good lightfastness; Wool Scale grade 7; not durable, easily affected by media and atmosphere	Semiopaque	Poor
Cerulean	Lightfast; alkali/acid-proof; Wool Scale grade 8; ASTM Category I in oil, I in acrylic	Semitransparent	Moderate
Cerulean Blue Hue	This is a mixed color whose permanency depends on the weaknesses of the colors used	Opaque	Poor
Cobalt Blue	Lightfast; alkali/acid-proof; Wool Scale grade 8-9; ASTM Category I in oil, I in acrylic	Semitransparent	Moderate
Cobalt Blue Hue	This is a mixed color whose permanency depends on the weaknesses of the colors used	Semiopaque to opaque	Moderate to poor
Cobalt Turquoise	Lightfast; Wool Scale grade 8; ASTM Category I in oil, I in acrylic	Semiopaque	Moderate
Egyptian Blue	Lightfast; alkali-proof; Wool Scale grade 8	Very transparent	Poor
Indanthrone Blue	Lightfast; Wool Scale grade 8; ASTM Category I in oil, I in acrylic	Very transparent	High
Indigo	Fugitive; Wool Scale grade less than 6	Semitransparent	Moderate
Manganese Blue	Lightfast; alkali-proof; Wool Scale grade 7-8; ASTM Category I in oil, I in acrylic	Semiopaque	High
Phthalocyanine Blue	Lightfast; alkali/acid-proof; Wool Scale grade 8-9; ASTM Category I in oil, I in acrylic	Transparent	Tinting strength is so strong extenders are required to make this color workable

Common Name	Permanence	Transparency	Tinting Strength
Prussian Blue	Lightfast; Wool Scale grade 8; ASTM Category I in oil, not rated in acrylic	Transparent	Extremely high
Ultramarine, Natural	Lightfast; alkali-proof; Wool Scale grade 8-9; ASTM Category I in oil, I in acrylic	Semitransparent	Poor
Ultramarine, Synthetic	Lightfast; alkali-proof; Wool Scale grade 8; ASTM Category I in oil, I in acrylic	Transparent to semi-transparent	High

VIOLETS

Cobalt Violet	Lightfast; Wool Scale grade 8; ASTM Category I in oil, not tested in acrylic	Semiopaque	Moderate
Cobalt Violet Pale	Lightfast; Wool Scale grade 8 in watercolor, less than 6 in oil	Semiopaque	Poor
Dioxazine Purple	Lightfast; Wool Scale grade 8; ASTM Category I in oil, II in acrylic	Transparent	High
Manganese Violet	Lightfast; Wool Scale grade 8; ASTM Category I in oil, not stable in alkali media like acrylic	Semitransparent	Moderate
Quinacridone Violet	Lightfast; Wool Scale grade 8; ASTM Category I in oil, I in acrylic	Very transparent	High

V. TABLE OF PIGMENTS AND COLORS

Common Name	Recommendations	Additional Comments
WHITES		
Barium White	Used as a filler or extender in oil paint	
Lead White	The most flexible oil color—best for oil grounds; speeds drying of oils; good for tints	Cremnitz White, Genuine is no longer made using traditional method of corroding lead plates with acetic acid in clay pots. This method produced a very dense, yet workable paint. Today the name is applied to thick and pure forms of lead white.
Titanium White	The most reflective white paint	Yellowing was found in early version of this pigment. Today its pure form is one of the least yellowing pigments of all. This is commonly used as a food colorant.
Zinc White	Most transparent of the whites and best for tints; also a nontoxic substitute for lead	Many manufacturers as well as painters mix Zinc White with Lead White to make the Zinc White more flexible and to improve the consistency and transparency of Lead White.
BLACKS		
Charcoal Black	Do not use by itself in underpainting in oil	Made from burning plant matter such as peach pits, grape vines, and various woods to give a particular cast to the black. Each manufacturer offers a cast according to its own tastes.
Davy's Gray		
Ivory Black	Do not use in underpainting in oil	Originally made from burning ivory, hence the name Ivory Black; today it is made from bone. The slight brown cast is primarily due to the calcium phosphate residue from the bone.
Lamp Black	Do not use in underpainting in oil; not used in watercolor due to oily consistency	Made from the soot of burning oils. A purer black than Ivory Black because of the absence of the calcium residue. However, there is a greasy residue from the incomplete combustion of the oil.
Mars Black	Excellent for mural painting	Ideal all-purpose black
Payne's Gray	One of the few mixed colors that is difficult to mix and match consistently	
YELLOWS		
Aureolin	Transparent alternative to Cadmium Yellow	Still popular in spite of the expense, because it dries much faster than the cadmiums and its transparency makes it ideal for glazing.

Common Name	Recommendations	Additional Comments
Cadmium Yellow		The best grades are barium-free. However, current labeling guidelines permit up to 15% barium sulfate contamination for Cadmium Yellow. Cadmium Yellow is still used as a treatment for some skin diseases.
Cadmium-Barium Yellow	In pure state it is visually indistinguishable from Cadmium Yellow and is less expensive.	Cadmium Yellow containing any barium sulfate should be named Cadmium-Barium Yellow. However, this rarely occurs, even when 15% or more barium sulfate ASTM guideline is exceeded.
Cadmium Yellow Hue	An inexpensive substitute for Cadmium; also provides a larger range of yellows to select from	
Chrome Yellow		Crocoite and phoenicohroite are the names for the naturally occuring mineral. However, today it is synthesized. This pigment is commonly used in painting porcelain and in traffic paints.
Gamboge	Do not use	Derived from the sap of the tree *Garcinia hanburyi* which is found in southern China, Cambodia, and Thailand; used in lacquers as well as artist's watercolors
Hansa Yellow	Inexpensive alternate to some Cadmiums; however, more transparent	
Indian Yellow		Unavailable in the West since the 1930s; today this pigment can be obtained synthetically instead of by torturing cows. However, no manufacturer has found it worthwhile to produce it.
Lemon Yellow		More in demand in the electronics industry for its properties as an electro-chemical anticorrosive than as an artist's pigment
Litharge	Use sparingly as an additive to drying oils to speed drying	Although rarely used, it is used in a medium for oil painting to speed the drying time.
Mars Yellow		
Naples Yellow		
Nickel-Titanium Yellow	A very durable and permanent pigment	
Orpiment	Do not use	Commonly found near silver mines and hot springs
Yellow Ochre		

Common Name	Recommendations	Additional Comments
Zinc Yellow	This color has been mostly replaced by the paler hues of Cadmium Yellow.	

ORANGES

Cadmium Orange		See Cadmium Yellow in regard to barium sulfate contamination. The high demand for Cadmium in the manufacture of semiconductors and fireworks has kept the price of cadmium pigments high.
Cadmium-Barium Orange	In pure state it is visually indistinguishable from Cadmium Orange and is less expensive.	See Cadmium-Barium Yellow in regard to the barium sulfate content
Perinone Orange	Inexpensive	Once hailed as the leading edge of the new synthetic organic pigments, it is now infrequently used.
Mars Orange		

REDS

Alizarin Crimson	The improved permanency makes this a good substitute for Madder.	
Cadmium Red (C.P.)	Modern replacement for Vermilion	Use of a C.P. cadmium pigment by a manufacturer is an indication of concern for the highest quality.
Cadmium Red (C.C.)	Modern replacement for Vermilion	Use of C.C. rather than C.P. cadmium pigments by a manufacturer indicates slightly less concern for quality, yet paints made from this pigment are still of high quality.
Cadmium-Barium Red	In its pure state it is indistinguishable from Cadmium Red and is less expensive.	The difference between this pigment and other purer forms of cadmium pigments can only be seen by mixing with other colors or when used in glazing.
Cadmium Red Hue	Inexpensive replacement for Cadmium Red and Vermilion	Imitation Cadmium Reds have greatest limitations when mixed with yellow, where the colors obtained are often far duller than can be had with genuine Cadmiums
Carmine	Its great beauty keeps it in use in spite of its weak lightfastness.	Used in the past for dyeing silks and wools, and as a food dye. Carmine is dye that is made into a pigment "lake" by adhering it to an inert substrate like aluminum hydrate.
Chrome Red	Effectively replaced by the less hazardous Cadmium Red	

Common Name	Recommendations	Additional Comments
Light Red		
Madder	This color has all but been replaced by synthetic coal-tar derivatives.	C.I. Natural Red 8 is the dye from the madder plant. C.I. Natural Red 9 is the dye made into a pigment "lake" using alum as the substrate.
Mars Red		
Naphthol Crimson		Popular as an inexpensive pigment for acrylics where bleeding is less likely to occur than in oils
Naphthol Red Light		Popular as an inexpensive pigment for acrylics where bleeding is less likely to occur and where lightfastness is greater than in oils
Quinacridone Magenta	Can produce intense violet glazes	
Realgar	Do not use	This pigment is found in silver mines and around mineral springs.
Red Ochre		
Red Lead	This color has been replaced by Cadmium Red.	
Vermilion	Many alternatives to this pigment have been developed, yet many claim it cannot truly be replaced.	Cinnabar is the natural form of this pigment, which is now synthetically produced. Today it is in greater demand for making batteries than paint.
BROWNS		
Asphaltum	This fugitive dye has been mostly replaced with mixtures of more stable dyes and pigments.	
Burnt Sienna		A natural earth pigment like this with its clay or silica content is ideal for glazing and less effective for tinting.
Burnt Umber		See Burnt Sienna
Mummy	Of historical interest only	Yes, they actually ground up mummies to obtain this pigment. It fell out of use primarily because some epidemics of cholera were traced back to the people who handled this pigment.
Raw Sienna		See Burnt Sienna
Raw Umber		See Burnt Sienna

Common Name	Recommendations	Additional Comments
Sepia	This fugitive dye has been replaced with mixtures of more stable pigments.	Sepia is made from the dried ink bags of the cuttlefish. Melanin is the primary colorant and is commonly found in the hairs and skins of animals, as well as in some vegetables.
Vandyke Brown	Do not use	

GREENS

Common Name	Recommendations	Additional Comments
Cadmium Green	Can be mixed easily	
Chromium Oxide Green	Excellent for murals	Also used in coloring glass and in the inks for printing money
Chrome Green	Most manufacturers have switched to safer mixtures like Azo Yellow and Phthalocyanine Blue.	
Cobalt Green	This expensive color can be adequately replaced by less expensive mixtures.	
Emerald Green	Although this bright green is not easily replaced, it should be.	
Green Earth	Often replaced with other pigments or mixtures possessing higher tinting strengths	Celadonite is the name for the natural mineral deposit of green mica high in iron content, which is the main color ingredient of this pigment. It also makes it semi-transparent.
Hooker's Green		
Hooker's Green Hue	Can be mixed	
Malachite	In the West, this pigment has been replaced with synthetic organic pigments.	
Permanent Green	The extender is added to improve control as well as price.	
Phthalocyanine Green	Superb mixing color	
Sap Green		Originally from the fermentation of the ripe berries of *Rhamnus catharitca* (buckthorn)
Sap Green Hue		
Verdigris	Has been replaced by the safer Viridian	
Viridian	Excellent tinting and glazing color	

Common Name	Recommendations	Additional Comments
BLUES		
Azurite	Synthetic versions are adequate replacements	Azurite and Malachite are found in the same deposits and rock formations
Cerulean	Tends to be expensive, but hard to find substitute	
Cerulean Blue Hue	Less expensive, however it is also easily mixed	
Cobalt Blue	Expensive, but there is no other transparent bright blue like it	The price for this pigment has been driven up by its classification as a "strategic" mineral, due to its use in jet engine parts and weapons.
Cobalt Blue Hue	Less expensive, however it is also easily mixed	
Cobalt Turquoise	Since its recent introduction it has rapidly grown popular in spite of its high cost.	See Cobalt Blue
Egyptian Blue	Glass pigments are called "new earth" in the Orient. Replaced by synthetics in the West.	This pigment is ground blue glass
Indanthrone Blue	A more permanent and stable replacement for Prussian Blue	
Indigo	This pigment has basically been replaced with mixtures of more stable pigments.	This pigment is from the fermented leaves of the *Indigofera*
Manganese Blue	A truly remarkable color only recently coming into its own	
Phthalocyanine Blue	Excellent mixing color	
Prussian Blue		Commonly used for carbon papers and typewriter ribbons as well as artists' paints
Ultramarine, Natural	Essentially replaced by synthetic ultramarine	The crystalline nature of this mineral is said to give its color depth and luminosity.
Ultramarine, Synthetic	The replacement for the glue stone Lapis lazuli	

Common Name	Recommendations	Additional Comments

VIOLETS

Cobalt Violet	Known for its great brilliance and beauty	This pigment is made solely for use in the manufacture of artists' paint.
Cobalt Violet Pale		See Cobalt Violet
Dioxazine Purple	Very good mixing color like Phthalocyanine Blue	
Manganese Violet		
Quinacridone Violet		

Part Seven

WATER
MEDIA

A WATERBORNE MEDIUM is a colorant mixed with a binder suspended in water. The type of binder used defines the type of waterborne medium, or waterborne paint. Tempera, for example, is a waterborne paint whose binder is egg. Ink is a waterborne medium for a pigment or dye with a shellac binder. Acrylics and vinyls are waterborne paints that have a polymer binder. Watercolor is a waterborne paint with a gum binder. The common element is that after the water evaporates, the binder holds the colorant to the applied surface. The primary advantage of waterborne paints and media is the immediacy of the results. In most cases, a finished drawing or painting can be had within minutes. The major drawback is that most artwork produced with waterborne paints or media is less durable and has to be protected from such hazardous atmospheric conditions as humidity and pollution, and from physical damage caused by handling and storage.

The History and Manufacture of Watercolor

ALTHOUGH THE USE of watercolors dates back to prehistoric times, it was not until about A.D. 500 that watercolor painting came to be considered a fine art, when Chinese poet-painters helped it evolve from being primarily a decorative craft. In the West, Albrecht Dürer (1471-1528) has been credited with upgrading the level of watercolors. Primarily a printmaker, he was looking for a way to color areas of his prints and ended up using a combination of transparent and opaque (gouache) watercolors to produce colored drawings. Chalk was often added to a watercolor to give a stronger and fuller quality. This explains the flat and linear appearance of his watercolors, since opaque watercolors do not readily lend themselves to shading.

J. M. W. Turner (1775-1851) was a technical innovator who took full advantage of the newly developed synthetic mineral pigments that were beginning to find their way into the artist's palette. He applied these new transparent and opaque watercolors with sponges, rags, and knives, as well as with brushes. Despite his use of opaque color and even pastel on his watercolor paintings, he is still considered part of the original English (transparent) watercolor school. The French Impressionists who followed the English school developed an even more dramatic look by taking advantage of the now numerous synthetic mineral pigments, and by often applying them unmixed.

Today, watercolor is still heavily dominated by the principles of the English watercolor school. Consequently, the term "watercolor" has come to mean transparent watercolor and opaque watercolor is now called "gouache."

Modern watercolors are manufactured by first preparing a mill-base, which is a mixture of raw pigment in gum arabic and wetting agent, as well as a plasticizer, such as glycerin, to help keep the color from drying out too rapidly. Gum arabic is a thick resin obtained from the acacia tree. It comes in small pieces which are tied in cheesecloth and soaked overnight in water to produce a gum solution. It is important that the pigment in the mill-base be uniformly dispersed, or the next step of grinding will be adversely affected.

A base-paint will be produced by grinding the mill-base with additional medium (gum arabic) in a series of rollers, which may be made of iron, stone, or ceramic, or some combination of these three. It is said that too much grinding

reduces the brilliance of a color, but too little grinding can produce a gritty consistency. Each pigment has different grinding requirements, and how well a manufacturer accommodates these requirements plays a large role in determining the quality of the final product. Most manufacturers use primarily iron rollers, reserving stone grinding for the most delicate pigments. The Schmincke Company is the only major paint manufacturer to use the extra-hard Diabas stone mills for all its colors, which is an expensive method of production. Holbein effectively uses a combination of iron, stone, and ceramic rollers to get the best from both the Old World technique and modern technology.

The mill-base is first ground by iron rollers, then stone, then ceramic, which gives an increasingly finer dispersion. The specific number of revolutions and the pressure required for each pigment are considered trade secrets.

At this point, the base-paint may need some adjustments so that the color matches previously established standards. This is done during the last stages of grinding when the paint is ground an additional two to three times to mix in antiseptic and antifungal agents. The paint is then inspected and aged before packaging.

Watercolor pencils and crayons, which have long been in use among illustrators and graphic artists, have recently become popular among fine artists. Fortunately there are several brands that claim lightfastness, such as those produced by Derwent and by Caran D'Ache of Switzerland. They qualify as waterborne media since they can be drawn with and then reworked with a brush and water, applied to a wet surface, or mixed with water and then applied. (For more information about crayons and colored pencils, see pages 30 to 31.)

Pigments In Watercolor

A WATERCOLORIST should not only have an understanding of the quality of his or her paints but should also have a working knowledge of the compatibility of the pigments used and the effect air pollution may have on their stability. The pigments in watercolor do not possess a protective coating as oil paints do; therefore some pigments can react chemically with one another, as well as with air pollutants. This lack of a coating means that dye-pigments, which by their nature tend to bleed and stain the painted surface, are a greater problem with watercolors because they can stain not only the paper but the brush and palette. All these factors make it imperative that you understand the working characteristics of colors that you wish in your palette. (See the Table of Pigments and Colors, pages 166 to 199.) You should consider avoiding chrome colors in watercolor because they contain lead, which can react with the air pollutant sulfur dioxide and blacken. And, if you are going to rework painted areas frequently, you may wish to avoid dye-pigments, which can stain permanently, and select primarily mineral pigments, which will not.

Grades of
Watercolor

As with oil paint, there are three grades of watercolor—artist, amateur, and student. Since watercolors are used in smaller quantities and bought in smaller volumes than oil paints or acrylic emulsion paints, the overall expense of setting up and maintaining a palette of colors is often considerably less than with other media. Most professional watercolorists purchase primarily artist-grade materials, and students purchase artist and amateur grades as funds permit. Thus the average watercolorist often has higher-quality paints than do painters who work in other media. It is important, however, to see watercolor paints in perspective.

In watercolors, the quality of the paint is not as important as the quality of the brush or the paper. Each medium has its own set of priorities. With oil paints, the paint comes first. In drawing, paper has the highest priority. Without a good brush and paper in watercolor painting, the only thing that will be expressed in the finished product will be the artist's inability to do watercolor paintings. Because a quality brush is usually more expensive than an entire palette of watercolors, it is often the first item to be compromised when setting up for watercolors. If funds are still short after the brush has been compromised, the paper, which is used up quickly, is next to be short-changed. Over the years, I have seen many painters set up for watercolors in this way only to become discouraged when nothing seemed to work until they changed their priorities.

Transparent
Watercolor

IT IS THE COMBINATION of technique with the relative transparency of the paint that gives watercolor its great range, from the subtle to the dramatic. The English watercolor style is a good example of this. Those who paint in this style use transparent washes of color, which allow the background to shine through as if it were another color. The use of textured paper (see *Paper,* pages 99 to 101) allows flecks of the white surface or previously applied color to show through, giving depth and contrast to subsequently applied colors.

William Reeves, the English color manufacturer, is credited with inventing the dry cake form of transparent watercolor around 1780. These colors were made from dry pigments, gum arabic, and sugar (which kept them moist) and were then fitted into small pans which were set into paintboxes. Although they were considered to be an improvement over the colors then in use (which were sold in sea shells), they still tended to be too dry and hard, with a tendency to crumble. A moister cake was created by the French, who substituted honey for the sugar in the original formula. In 1830, the English replaced honey with glycerin, which is still in the formula used today. The first watercolors in tubes were introduced in 1846 by Winsor & Newton, who now makes more than eighty colors in tubes.

WATERCOLOR DYES

Watercolor dyes, such as those produced under the names Dr. Martin's or Lumacolor, are somewhere between a watercolor and an ink. They are made primarily from dyes rather than from pigments or dye-pigments. They are designed primarily for the graphic artist, whose needs are convenience and intense color, even at the sacrifice of permanency. With the exception of a few colors, watercolor dyes are highly fugitive and are not for use in fine art. Colors that are fade-resistant are marked as lightfast. However, changes in acidity and alkalinity can significantly alter the appearance of virtually any watercolor dye, lightfast or not.

Opaque Watercolor, or Gouache

THE FIRST watercolors were opaque and were referred to as "body color." Exactly how body color took on the French name "gouache" has been a matter of speculation for some two hundred years. The LeFranc & Bourgeois Company says, "The word 'gouache' comes from the Italian *guazzo*, which means the mixing of water, glue, and pigments."

Today, opaque watercolor is known as gouache, poster paint, designers' colors, and tempera. The terms "tempera" and "poster paint" are used for the lesser qualities of opaque watercolor, which are not acceptable for fine artwork. Gouache and designers' colors are acceptable for fine artwork with certain reservations. Almost all the commercially available gouache is made more for use by illustrators and designers, for whom having a particular color sometimes outweighs permanency. It is not unusual to find a considerable number of fugitive colors offered in lines of gouache, and these must be avoided by the fine artist. Gouache also has other drawbacks. If, for example, it is applied too thickly, as is done in acrylic or oil painting, it will tend to crack. The use of a rigid support will improve, but not correct, the problem. Bleeding and staining of colors are more common in gouache because of the greater percentage of dye-pigments used in its manufacture.

Gouache is made in much the same way as transparent watercolor. However, it is rarely ground as finely and has a much lower concentration of pigment because of the addition of white and other additives, which are designed to improve leveling properties and slow the rate of drying. Gouache is made this way to allow the artist to apply a flat, opaque field of color with a minimum of dilution or mixing and to achieve a look very different from watercolor.

There seem to be three types of gouache on today's market. The first places emphasis on opacity, even to the extent of limiting the color range. Winsor & Newton's Designers Gouache is an example of this. There are some seventy colors, with several grays, blacks, whites, and a gold and a silver, most of which are quite opaque.

LeFranc & Bourgeois's Designers' Gouache is an example of the second type, where the emphasis is on color range rather than opacity. It manufactures fifty-

four more colors than Winsor & Newton, in addition to the several whites and blacks, but the paints are, on the average, slightly less opaque.

In the last type, quality dominates both color range and opacity. The German company H. Schmincke, recently reintroduced in the United States after a long absence, makes a line of double stone-ground gouache of the same quality as its extra-fine artists' watercolors. This paint is very finely ground and is more like the original gouache formulations intended for fine art. The information in Schmincke's color chart indicates that only the most permanent pigments available are used. This gouache is so fine that it is rated to be used in a 0.3mm airbrush without clogging (recent tests show that it works just as well in a 0.1mm airbrush).

Media for Watercolor

WATERCOLOR DEPENDS on the absorbency of the working surface and on the binder to remain where it is applied. If the surface is not absorbent, like glass or plastic, watercolor will crawl (an art term for the beading of water on nonabsorbent surfaces), rub, or flake off the surface. If very dilute watercolor is applied to a semiabsorbent surface, like a plate-surface bristol paper, there could be so little binder that the watercolor might dust off the way a pastel drawing might. If an absorbent paper, like a print paper, is used, the watercolor often spreads uncontrollably or sinks below the surface. The purpose of watercolor media is to regulate watercolors so that they can be controlled within a particular working situation, as well as to create special effects.

GUM ARABIC

Gum arabic is the binder for watercolor. It is also frequently used as a medium to help keep diluted watercolors from sinking below absorbent surfaces, to give a crisp appearance to the edges in a watercolor, to increase transparency, and to provide a varnishlike surface.

Gum arabic is a natural gum, which is collected in the form of an exudate from branches of an African tree of the species *acacia*. The best gum arabic is collected from commercial plantations in the Sudan. The quality of gum arabic can be simply tested by dissolving some of the dry form in water, which should leave very little or no residue. The addition of a drop of iodine will indicate any added sugar (used as filler) by leaving a purplish color.

A gum arabic medium can be prepared by adding one part dry gum arabic to two parts water and then slowly boiling until the gum is dissolved. A small amount of camphor (moth flakes) added to the medium will help to preserve it. Commercially prepared gum arabic media often have an emulsifier and glycerin added to improve handling. A thicker watercolor medium—a gel—can be made by the addition of silica.

GUM WATER

Gum water is the name given to a diluted gum arabic medium that has a wetting agent. This medium allows for the addition of smaller amounts of gum for

improving the transparency without decreasing the watercolor's ability to flow on the working surface. It is the wetting agent that prevents crawling, or beading, on less absorbent surfaces.

AUXILIARY PRODUCTS FOR WATERCOLOR

The following products are used to change, or control, the handling characteristics of watercolor.

Ox Gall that has been clarified is a natural wetting agent for watercolors. It is used to reduce the surface tension between a watercolor and a less absorbent surface. However, only small amounts should be used and some caution is needed when using ox gall with colors that are made from pigments such as ultramarine blue, which are sensitive to acidity. (See the Table of Pigments and Colors, pages 166 to 199.)

Prepared Size is a product of Winsor & Newton Company. It is made from gelatin, water, and a preservative. The manufacturer describes it as "a soft gel which reduces the absorbency of paper, boards, and lightweight textiles. The gel becomes liquid on warming. Thinning is not normally required." This preparation achieves the opposite effect of that obtained with ox gall.

Wetting Agents for Nonabsorbent Surfaces are commercially prepared and include Flex-opaque and No-Crawl, which are used primarily to allow the application of gouache on such nonabsorbent surfaces as clear polyesters and acetate. A small amount—a drop or two—added to a watercolor mixture will improve flexibility and help prevent flaking. However, if too much is added, the paint becomes tacky and will not dry properly.

Masking Fluids, or Liquid Friskets, are like pigmented rubber cement. They can be painted on an area in which you wish to block the application of a watercolor. After the masking fluid is applied and has dried it will protect the surface, and when it is no longer needed it can be rubbed off easily. Luma Mask, Art Maskoid, Art Masking Fluid, and Miskit are some of the brand names for this pigmented rubber latex solution. These products should not be thinned or applied to a wet surface.

Egg Tempera

THE TERM "tempera" comes from temper or tempering, which means to bring something to a desired, or usable, consistency. In this case, the something is a pigment. Egg tempera is one of the oldest, most versatile, and most durable methods of painting. Said to date back to prehistoric times, it is generally unaffected by humidity and temperature changes. Tempera emulsions form their own protective surface film and do not darken with age as oil paint films do. They dry rapidly and become water-resistant, which means one application of paint can be rapidly followed with another without the two layers mixing. This unique property is a distinct advantage over ordinary watercolor in that a wash of a different color may be applied over the original color without the two colors mixing to form a third. This allows you to see one color through the other. In egg tempera, a red wash may, for example, be applied over a blue wash, and the result will be a blue-red or violet, whereas the result of this procedure in watercolor will tend to appear as a muddy brown.

Tempera colors can be scraped off easily and reworked. When applied in thin layers the results are more transparent than transparent watercolor; when applied more thickly the results are opaque like gouache. After the tempera painting is completed, it can be burnished (polished) with an agate to add depth and brilliance and to increase transparency, or it can be varnished to look like an oil painting.

The first recorded recipes for egg tempera called for only the egg whites and were used for illuminating manuscripts on paper and parchment. Because this mixture is brittle, it was eventually replaced by a recipe that required only the egg yolk, which contains semidrying oils and produces a tougher, more flexible paint film. This recipe was prevalent with the Byzantine artists of the thirteenth and fourteenth centuries. In the fifteenth century, with the development of oil painting, egg-oil emulsions came into use. Soon after, egg tempera took second place to oil paints and became just a convenient medium for underpainting before the application of oil paints. Many of the old masters used a green earth tempera color underpainting in their oil paintings to create more realistic flesh tones.

Egg tempera paints are made by mixing powdered pigments with egg yolk in roughly equal parts. The pigment is first made into a paste with a small amount of water. (Some pigments, such as alizarin crimson, Prussian blue, and some blacks do not mix readily into a water paste and so a small amount of alcohol must be added as a wetting agent.) A fresh hen's egg (eggs sold in most markets are often several weeks old) and distilled water are used for the binder. To prepare the binding medium, an egg is cracked and the yolk is separated from the white. The yolk is dried by rolling it in the hand or by placing it on a sheet of absorbent paper. The yolk is then cut with a knife and the liquid allowed to run into a glass jar. Distilled water is added to bring the egg to the consistency of thin cream. The pigment paste is now mixed with the egg yolk binder and the paint is ready for use.

Tempera made with only an egg yolk is not as workable a painting medium as an egg-oil emulsion. The addition of a small amount of stand oil improves the handling properties and increases the resistance to cracking so that the paint film can be made thicker. Egg-oil emulsions can be used on flexible supports such as canvas, heavy watercolor paper, and thick bristol paper, if applied in thin layers. Thicker layers, like those used in the application of gouache, are quite safe if they are built up slowly in thin layers. Egg-oil emulsions produce a glossier finish than pure egg tempera and dry harder. Like egg tempera, an egg-oil emulsion dries very rapidly, in seconds in thin washes, and can be painted over almost immediately.

Egg-oil emulsion temperas are now being offered in tubes by the Rowney Company and the Sennelier Company. After thinning with a little distilled water, the paint can be used straight from the tube, saving the artist the inconvenience of having to prepare the color from the raw materials before each painting session.

You can prepare your own egg-oil emulsions according to the following instructions. But you should take extreme caution when using dry pigments.

Egg Yolk and Linseed Oil are combined to create an egg-oil emulsion with an oil paint consistency. Mix one teaspoonful of oil with a single egg yolk. Too much oil slows the rate of drying significantly and tends to leave a tacky surface. One part of this emulsion can then be mixed with one part of water-dampened pigment.

Egg Yolk, Stand Oil, and Damar Varnish make a durable and flexible egg-oil emulsion. Mix one egg yolk and one level teaspoonful of a mixture of half stand oil and half Damar varnish. Pigment can then be added one part to one part. As with all egg or egg-oil temperas the surface can be polished with a silk pad when dry. The disadvantage of this egg-oil emulsion is that it very much resembles oil paint with its inherent yellowing; thus it has little advantage over oil paint. Venice turpentine can, however, be used as a substitute for stand oil, to reduce future yellowing and to improve the clarity of the paint film.

Whole Egg and Linseed Oil is the lazy person's egg tempera. The egg, oil, and pigment are mixed in equal portions. This egg-oil emulsion dries relatively quickly, producing a hard, but slightly cloudy, surface.

Casein

CASEIN is a milk protein which was commonly used by painters in the past as a binder to make a paint with characteristics similar to egg tempera. At one time, casein was a common glue used in cabinetmaking and was know for its great strength. A powdered form of casein is made by drying the curd of soured skim milk (the milk fats from whole milk are nondrying oils and must be removed). Today, casein is prepared commercially by heating and acidifying skim milk and then drying it to produce a powder, which is only soluble in water if made alkaline. One way to prepare a casein solution is to soak the powder in water and then add calcium hydroxide, which can be purchased from a chemical supply company. Fortunately, most casein powder, when it can be found, is in a form that will mix readily with water.

The use of casein is said to date back to the Egyptians. It was also used as an alternative to rabbit-skin glue for sizing canvas because it could be applied cold. The first commercially produced casein was marketed in the nineteenth century. The Pelikan Company of Germany produces casein paint called Plaka, which can be found in most artists' material stores. Its consistency allows for application by either brush or palette knife. It adheres well to paper, paperboards, wood, plaster, plastic, glass, and metal. It dries matte with a velvetlike finish and becomes waterproof in twenty-four hours. Outdoor use requires a final, protective varnish.

Casein paint has some drawbacks; although it is highly water-resistant, it is not truly waterproof, and it is brittle and becomes more so as it ages. Therefore, the thicker the paint film, the more rigid the support should be. In general, thick applications of casein paint should be avoided. Adding a little drying oil, such as linseed oil, to casein paint will reduce potential cracking, but will slow the drying time and add some yellowing properties. Casein paints dry very quickly and look like oil paint except that they have a matte finish.

The popularity of casein waned with the introduction of polymer emulsion paints, which have almost all the advantages of casein paint with none of the drawbacks.

Ink

AN INK is a watercolor that is already diluted for convenience and whose colorant tends to remain in solution. An ink is composed of a pigment or dye that is suspended and stabilized in water. Glue, gum arabic, gelatin, shellac with borax, and soap are some of the more common ingredients used to maintain a suspension and provide a binding agent.

The most common form of ink, dating from about 250 B.C. to approximately 1100, was a carbon black ink with a glue or gum binder. At this time, it was found that the mixing of a natural iron salt—ferrous sulfate—with an extract from nutgalls, which are high in tannic acid, resulted in a chemical reaction that produced a blue-black ink. This method of ink production was considered an improvement; however, it was not lightfast and the particles that remained in the ink from the chemical reaction did nothing to improve flow characteristics. It was the development of synthetic dyes, during the nineteenth century, that paved the way for the fountain pen. Inks could now be made from true solutions, with no particles to clog a writing instrument.

INDIA INK

The term "India ink," or "China ink," originally referred to a lampblack (carbon) ink in stick form produced in either China or Japan. Today, "India ink" refers to any ink made of carbon that is also waterproof. Some manufacturers of India ink still use carbon from Oriental ink sticks. Shellac is commonly used as the binder for this ink and makes it waterproof. India ink should not contain any dye.

There are two methods of testing an ink to see if it is a dye composite. A drop of ink placed on a piece of absorbent paper will spread out and feather at the edge. An ink that is a dye composite will produce a two-colored edge, such as a blue-black and maroon, within a few hours, and a carbon black ink will not. The second method is to place some of this ink on paper in direct sunlight for one day. If there is any evidence of fading, it is not a carbon ink.

Nonwaterproof India inks are available—they are made primarily for use in fountain pens. The absence of shellac reduces the possibility of clogging. Nonwaterproof India inks always state on the label either "nonwaterproof" or

"fount." Only such inks should be used in a fountain pen. However, the use of any India ink, waterproof or not, will void most fountain pen warranties.

It would seem that the centuries of continuous use of India ink in both writing and drawing can be attributed to the simplicity of its use and its great permanence.

DRAWING INKS

The term "drawing ink" refers to both India ink and colored waterproof inks. Until recently, colored drawing inks were known for being highly fugitive. Today, there are several transparent dye composites, and several semiopaque pigmented inks that are labeled lightfast. These—and only these—may be considered for fine artwork, but remember that lightfastness of such products often meets only the minimum standards.

FOUNTAIN PEN INK

Conventional fountain pen inks are dyes dissolved in water, or water-alcohol mixtures, with a nonwaterproof binder. This allows the ink to flow freely without clogging the pen. Until recently, almost all fountain pen inks were highly fugitive and could only be preserved by protection from exposure to light. The recent resurgence of interest in calligraphy, combined with the manufacture of calligraphy fountan pens, generated a demand for fountain pen inks, expecially colored inks, that did not fade when the finished product was framed and displayed. Today, there are several companies producing a limited range of both waterproof and nonwaterproof and pigmented and dye-composite inks that can be used in fountain pens. However, they are new and should be used with caution, and only after reading any restrictions described on the label.

INKS FOR TECHNICAL PENS

Permanence, opacity, and being waterproof are high priorities in a technical pen ink. Technical pens, which are used in drafting and illustration, are designed to be used with permanent, opaque waterproof ink that would ruin any other fountain pen. (Technical pens do require some maintenance or they, too, will be rendered useless by such inks.) Inks made for technical pens often meet minimum lightfastness standards for fine artwork, and may be used for such, if they are labeled "lightfast."

As the use of technical pens has widened, so has the selection of inks for use in them. Today, transparent and opaque and matte and gloss inks are available. There are also inks that work on plastic surfaces, such as acetate and drafting film. The flow, or working characteristics, of ink are often very different from brand to brand. Some inks, like those produced by Koh-i-noor Rapidiograph, seem to be made with density foremost in mind, and are not as free flowing. This quality is ideal for drafting, where exacting reproduction of drawings is required. For fine artwork, however, flow is often more important than density, and many other companies produce thinner inks that flow more easily. It is wise to sample several brands to see which is best for you. Whatever ink you select, it should never be used in a fountain pen.

Oriental Inks
and Watercolors

ALL THE RESEARCH on inks and watercolors leads back, again and again, to China and Japan. Calligraphy itself is the oldest form of abstract art, and watercolor painting developed from it. It would seem almost impossible to master waterborne media without some appreciation for the source of it all. And to appreciate the art of the East is to appreciate the nature of its materials, for they are inseparable. It would also help to understand that the selection of Oriental materials is more subjective than objective. It is possible, for example, to choose from as many as fifty different shades of black, ranging from warm blacks to cold blacks, all of the same level of quality. In such a case, how could a choice be anything but subjective—how can one shade be said to be better than another unless it meets your own particular needs or desires?

The best guidelines for the novice are price and previous exposure. With Oriental materials, price is a good indicator of quality because, in general, if it costs more, it's usually better. Another guideline is not to overbuy. If, for example, you have never before been exposed to ink sticks and ink stones, it is unlikely that you will be able to experience the subtle differences between their levels of quality and you would be wise to buy conservatively.

INK STICKS

In the Orient, ink is found in the traditional form of a solid stick. Liquid ink is made by rubbing the ink stick against the wet surface of a particular type of stone. Ink sticks are made by burning either vegetable oils (such as sesame oil, rapeseed oil, and paulownia oil), or pine wood and pine resin and collecting the soot, or lampblack, which is then combined with animal hide or bone glue, spices, and minerals. The mixture is compressed and dried into a stick.

Ink sticks made from vegetable oils tend to produce a warm black ink, with a hint of brown or purple. Calligraphy inks are made primarily from oils and their exact shade is often regulated by the addition of various plant matter, as well as the source of the glue (what type of animal and whether the shin or other bones were used). The plant matter and glue are added to the soot before the stick is molded. A shine is considered a desirable characteristic in a calligraphy ink and an undesirable characteristic in an ink for painting. The shine is regulated by the particle size of the soot as well as through the addition of plant matter.

Inks made for painting do not contain any additional plant matter and the particle size is selected to give a matte appearance, so that the subtlety of the painting can be seen without distraction. Painting inks are made from either vegetable oils or pine. Those made from pine soot produce a cool, bluish-black ink, which has a lighter appearance than those made from oil. Pine-soot inks are used for washes as well as for the overall background of a painting. The darker inks made from oil are used for the final details and for contrast.

When starting or testing a new ink stick, never use the first grind because ink sticks often have a coating that is best removed before use. One method of testing an ink is to dilute the freshly ground ink so that it can be used as a wash. Then make a brush stroke where, at some point, you reverse the direction, going over a part of the area previously painted. If the area or edge of the previously painted area maintains its integrity, it is a good sign. The more it dissolves, the less desirable the ink is. Some inks look better while they are still damp on the paper and become dead when dry, while others look better after drying than while in use; you should therefore wait until inks are dry to inspect them.

Oriental ink sticks are like wines; their quality is determined as much by the aging process as by method of preparation. An ink stick should be aged for at least one year (two to three years is preferable) before use, and, indeed, some of the very best sticks are more than four hundred years old. The aging process involves the natural oxidation of the protein that makes up the glue. According to Boku-undo U.S.A., Inc., only ink sticks that are handmade truly benefit from this aging process, and for this reason it distributes only handmade ink sticks that have been aged for a minimum of five years. Prices for Oriental ink sticks range from $1.50 to several thousand dollars for the highest-quality sticks that are several centuries old.

Chinese Ink Sticks are made primarily from pine trees that are high in resin and therefore characteristically produce a bluish-black ink. However, there are always exceptions because the addition of minerals and spices may change the hue. The Chinese make ink sticks throughout the year without regard to changes in weather. This, unfortunately, can result in an ink stick cracking when it is later shipped to parts of the world that have dramatically different temperatures and humidity. Broken ink sticks can sometimes be repaired by wetting the two broken ends and holding them together until they dry. Producing ink sticks year round also results in some inconsistencies in quality. The Chinese grade their ink sticks using a series of three-digit numbers.

101—The best professional quality commercially available

102—Very good, professional quality

103—Good, professional quality

104—Amateur

105 or higher—Student

Japanese Ink Sticks are usually made from vegetable oils and therefore tend to produce warmer blacks. But, because so much of Japanese history involves Chinese influence, blue-black ink sticks made from pine in Japan are commonly

available. Many Japanese ink sticks have camphor added, which gives a silvery black appearance to the ink when it is used full strength. The illusion of silver flecks can be seen when the image is held to the light at an angle.

The Japanese make ink at only one time during the year (in the autumn), to reduce the possibility of cracking and to improve consistency. Buying Chinese ink is always a gamble even when purchasing a second stick made by the same family in China. It could be among the world's best or the world's worst. The Japanese go for consistency, so you may not get the world's best, but you also will not get the world's worst. They have good, constant quality so the second purchase will be like the first.

The Japanese utilize a series of dots to classify the quality of their inks. Five dots on the end of the stock indicate the finest quality, while fewer dots signify a lesser quality. Unfortunately, certain Japanese manufacturers sometimes take advantage of the beginner's limited knowledge in this area by putting five dots on their lowest-quality sticks and, in some cases, adding blue dye to ink sticks made from vegetable oils. Price should be some indication of quality.

BOTTLED ORIENTAL INK

In China and Japan, the use of bottled ink is frowned upon and generally considered to be a concession to barbarians. There are, however, several brands of Oriental ink from China and Japan that come ready for use in bottles. The best is not as good as the ink that comes in stick form, but it is usually superior to Western bottled ink.

Many manufacturers have switched from using animal glues to using acrylic polymers as a binder for the ink. These acrylic inks have a longer shelf life of seven to ten years, as opposed to the two to three years of inks that have animal-glue binders. Acrylic inks also tend to be waterproof, rather than water-resistant. Consequently, it is more difficult to shade an area properly after an acrylic has dried. An acrylic ink can also ruin a brush that is left to dry in it, while animal-glue inks can almost always be redissolved. The better grades of bottled ink are still made with animal glue.

Ink paste, which is a concentrated form of liquid ink, is also manufactured in as large a variety as bottled ink. Few stores, however, carry an equal variety.

INK STONES

Natural ink stones are made from slate, and imitation ink stones are ceramic. The ink stone, with water, is used to grind the ink stick into tiny particles to form liquid ink. The better the stone, the smaller and more consistent the particles will be and the denser the ink. A good stone will make a poor ink stick perform slightly better than a good ink stick ground on a poor stone. It is best to have a stone that at least matches or slightly exceeds the quality of the ink stick.

The older the stone that is used to make an ink stone, the better it will perform. Because the geological formations in China are much older than those in Japan, the best stones come from China. Both the Japanese and Chinese make their best products out of the oldest stone that can be found in China. The Japanese term for the best grades of slate used in the manufacture of ink stones

is *tankai*. There are several grades of *tankai* just as there are grades of diamonds. The very best *tankai* was found under rivers. Today it can only be found in private collections and in museums. Since China has a long history, all the stones of this quality have already been found. Today's *tankai* is collected from caves and these lesser grades of *tankai* can be found even in the West, but they are expensive. Japanese ink stones that are more moderately priced are made primarily from more recent lava formations. The least expensive ink stones are made from ceramic rather than from natural stone. (For colored ink sticks, multiple ceramic stones are used because of the expense and to keep the better stone from being contaminated with residual colors.)

Japanese ink stones are made into a rectangular shape with a well, or deeper impression, on one side to hold the water separate from the grinding surface and to collect the ink. The better natural stones are often characterized by a natural irregular shape, or are encased in a wooden box.

Chinese ink stones are usually round in shape with either a concave or a flat grinding surface. It is also common to find a lid, which covers the stone, made of wood or of the same stone. The moderately priced stones are made of slate. Better quality is sometimes indicated by the irregular shape, a wooden encasement, and the purplish hue of the stone. Some Chinese ink stones have an oil or wax on them to help protect them until purchase. This material should be washed away before use.

Inspecting an Ink Stone involves looking for any hairline cracks that may result in the stone coming apart easily, and checking to see if it is a ceramic stone or a natural stone. If there are any natural imperfections such as streaks that appear to run with the tooth, or grain, of the stone, they are not necessarily to be avoided and are, in fact, sometimes sought after for the character that they give.

Testing an Ink Stone involves three steps of inspecting the grinding surface. The finer the surface, the finer and more consistent the quality of the ink will be. The surface of an ink stone is similar to a saw's teeth, in that there are tiny peaks tilted in one direction that can grind off small particles of the ink stick when rubbed against it. The first step is to test the tooth of the stone's grinding surface. This can be done by rubbing the surface of the ink stone with the top edge of a fingernail in a direction away from the well. The better the stone, the more distinct and uniform the mark will be.

The next test involves the use of water. If the tooth is fine and pointed in one direction, a small amount of water placed on the (clean) grinding surface will appear to sink immediately just below the surface, but will not appear dry. The teeth will break the water tension and the water will be trapped beneath the tips of the teeth. If the surface where the water has been applied dries out quickly, then the stone is too absorbent and of lesser quality. If the grain is irregular or has imperfections, the absorption will also be irregular.

The final test is to check the flatness and smoothness of the grinding surface. Visual inspection and touching the surface with the fingers or tongue should show a very smooth and flat surface.

Ink stones range in price from three dollars to eighty thousand dollars,

depending on quality. A stone of adequate quality can easily be had for between ten and thirty dollars.

A complete inspection should be reserved for the more expensive ink stones. Performing an inspection this thoroughly on an ink stone that is priced at less than ten dollars, is like using a jeweler's eyepiece to inspect jewelry at the corner drugstore.

ORIENTAL WATER COLORS

The major difference between Western watercolors and Oriental watercolors is that in the Oriental system some colors are by tradition opaque, and others are transparent. They are sold in the form of a dry cake in a ceramic dish, or in a powdered form where the liquid binder is mixed in with water to make watercolor, or in colored ink sticks. (Although none of these materials should be considered nontoxic, traditional vermilion ink sticks, because they are made from mercuric sulfide, are highly poisonous and should be used with caution.)

The best Chinese watercolors come in a very limted number of colors and are in the form of little chips that are dissolved in water to make the color. With the exception of these chips, most of the Oriental colors available in this country are not of the first quality. Today, most instructors of Chinese and Tibetan painting who live in the West recommend the use of the finest tube Western watercolors and gouache over the lesser-quality Oriental watercolors.

"NEW EARTH COLORS"

These colors are artificial mineral pigments made of glass frits. They are similar to Egyptian blue in that their color depends on how finely ground the particles of pigment are. The main ingredient is lead borate glass, which is fused into such color-producing agents as metallic cobalt and chrome, and then ground. The ground glass particles are then separated according to size, which also determines the color. Holbein makes a line of these pigments, which have been used in Oriental watercolors and are currently being tested for possible application in Western artists' materials. By employing this method of manufacture, they are able to make as many as two hundred different shades from a few basic colors.

SEAL INK

Although seal ink is not a watercolor, it is used to sign a piece of calligraphy or an Oriental-style painting. A chop, which is like a rubber stamp made of wood or bone, has the artist's name or symbols carved on the face. The face of the chop is pressed gently into the surface of the seal ink (sometimes it is necessary to touch the seal ink several times to collect enough ink on the chop's surface). In some traditions, the seal is placed so that it just touches the edge of the still damp ink, or watercolor, because the slight mixing that occurs is impossible to forge, and the original can be proved.

The seal ink container usually has a loose-fitting cover to allow for a thin piece of silk to be placed over the ink surface. This piece of material serves to keep the surface moist so it can be reshaped through the silk.

The best seal ink is made from genuine vermilion from China, which is composed of mercuric sulfide and is extremely poisonous.

Polymer Emulsion Paints and Media

AN EMULSION is the suspension of tiny solids in a liquid. Milk is an example of an emulsion, and most solids, if made small enough, will tend to remain in suspension. A polymer is a larger molecule made of smaller and simpler chemical units most often arranged in a chainlike formation. A polymer emulsion is the suspension of polymers in a liquid. As the liquid evaporates, the suspended polymer solids come closer together until they touch and combine to form larger chains and eventually a film. A paint can be made by pigmenting a polymer emulsion. The type of polymer used determines the type of paint or medium— acrylic polymers for acrylic paints and vinyl polymers for vinyl paints.

Polymer emulsion paints, by comparison with oil paints and watercolors, have a short history, which began in late 1948 with the development of polyvinyl acetate emulsion (PVA), commonly known as white glue. However, PVA was too sensitive to water and heat, and the paints made from it were not durable. The acrylic polymer emulsions now used in artists' paints are a byproduct of the attempt to develop a new type of house paint during the early 1950s. (Today, however, the amount of actual acrylic binder in house paint is often quite low. In some states it can be as low as 20 percent and still be called acrylic paint. This would be too low to use in fine artwork.) The first artists' acrylic polymer paint became readily available in North America around 1963 and in Europe about two years later.

THE MANUFACTURE OF POLYMER EMULSION PAINT

The manufacture of polymer emulsion paints is a balancing act. Mixing dry pigment directly into a polymer emulsion rarely creates a usable paint. Several additives are needed to produce a workable paint. The polymer solids must be coated with emulsifiers to prevent them from binding together before the liquid evaporates. Dispersants are necessary to keep the pigments that are added from clumping together and/or settling out of the liquid. Antifoaming agents are needed to prevent foaming during the application of a paint so that the dried paint film does not have a craterlike surface. Wet-edge agents, such as ethylene glycol (very poisonous) or propylene glycol (less effective, but nontoxic), are used to regulate the drying time, allowing sufficient time for mixing and apply-

ing the paint. Thickeners are used to transform the milky quality into a paintlike consistency. And last but not least important, a preservative is added.

The type of paint film that is formed depends on the specific polymer formulation used. For example, the Rohm and Haas Company, the supplier of acrylic emulsion to all paint manufacturers in North America and many parts of the world, offers several varieties of 100 percent acrylic emulsion (of which 44 and 47 percent of the emulsion is composed of resin solids). Rhoplex is the name it has given to its acrylic emulsion and each formulation is assigned its own number. The most commonly used emulsions that are dispersed in water are AC-22, AC-33, AC-34, AC-35, and AC-235. (There are also acrylic solutions— such as Acryloid F-10, which is 40 percent resin solids in mineral thinner— which are used in the manufacture of paint varnishes and acrylic paints that can be thinned with mineral spirits.) AC-22 has good flow and leveling properties, but is less durable than the other formulas. AC-33 was the first formula used in the arts and is still commonly used. AC-34 was designed for outdoor use on wood, but tends to be slightly more brittle. AC-235, the improved version of AC-35, is used to give paint a thicker quality and would be used in impasto painting.

Since each of these formulas has desirable qualities as well as undesirable qualities, most paint manufacturers blend the various polymers like chefs to obtain, what is in their opinions, the best working characteristics. A blend of more than one polymer is referred to as co-polymers; virtually all artist acrylic and vinyl paints are co-polymers.

The physical process of making acrylics resembles the process one would more expect to see in a pastry shop than in a paint mill. Some manufacturers do not use rollers to grind the paint mixture as would be done with oil paints, but simply mix the ingredients together. Mixed paints are less desirable for airbrushing and for watercolors where fine dispersion is important.

CHARACTERISTICS OF POLYMER FILMS AND PAINTS

After the liquid of a polymer emulsion evaporates, such as with an acrylic polymer, a tough waterproof film forms. Although the chains formed by polymers are broken by ultraviolet light, there is such an overwhelming number of these chains that little or no visible damage occurs from exposure to indoor lighting. Visible damage can occur, however, when the emulsion is exposed to large amounts of direct sunlight outdoors, or when the emulsion has been thinned excessively before application and then exposed to direct sunlight. If a polymer emulsion is applied to a nonoily, absorbent surface, it will remain permanently attached. Although polymer films are quite flexible, there are situations where they can crack. Cracking can occur when a polymer emulsion is overloaded with particulate matter, such as additional pigment or sand, or when a significant amount of polymer is washed out of a paint mixture during the painting process. And an extremely absorbent painting ground can draw out enough polymer from a polymer paint to cause cracking.

The color range of polymer paints is limited for two reasons. The first concerns pH. Alkaline-sensitive pigments cannot be used in the manufacture of

acrylics because acrylic emulsions are alkaline. Acid-sensitive pigments cannot be used in vinyl paints because vinyl emulsions are acidic. The second reason is that in polymer emulsions, subtle differences between similarly colored pigments often cannot be seen and are therefore pointless to manufacture.

ACRYLIC POLYMER EMULSION PAINTS

Liquitex, made by the Binney and Smith Company, and Atelier, a lesser-known acrylic paint made by Chroma Acrylics, are examples of the differing formulations of acrylic paints in the marketplace today. Two different formulations are used for Liquitex, one type for the paint that comes in tubes, and the other for the paint that is available in jars. The paint in tubes is designed to have a thicker consistency and to leave brushstrokes the way oil paint can. The paint that comes in jars is designed to behave more the way an enamel paint would; the paint film tends to level out and the brushstrokes tend to disappear. Most other manufacturers' jars of acrylic paint are made with the same formulation as their tubes. Thinning tube paints will rarely achieve the same effect as Liquitex that comes in jars, and you usually end up with a thinned paint that still leaves brushstrokes.

Atelier is an example of a new type of acrylic for which updated formulations are used. It is designed to appeal to the impasto painter, who desires texture, thickness, and that heavier oil paint appearance. No matter how a manufacturer decides to formulate the consistency of the colors, additives or media are always supplied to alter the consistency to suit the artist's wishes.

ACRYLIC POLYMER SOLUTION PAINTS

There are certain formulations of acrylic polymer, such as Acryloid B-72 manufactured by Rohm and Haas, that form a solution, rather than a emulsion, in mineral spirits. Magna Color, made by Bocour Company, is an example of a paint made with this solution as the binder. Its consistency and general working characteristics are like oil paint, but it dries like acrylic. However, this type of paint has never attained even half the popularity that acrylic emulsion paints have.

VINYL EMULSION PAINTS

Vinyl emulsions are basically the same as acrylic emulsions. The acrylic polymer has one hydrogen atom replaced by a chloride atom, which results in some slightly different handling properties. Paints made from vinyl emulsions dry very matte and evenly. Acrylic emulsion paints tend to dry spottily with shiny and matte areas, even when a medium is added in an attempt to regulate this effect. Painted surfaces that have variations in surface shine produce the visual illusion of multiple tones of color within one color. This is often a desirable trait for figurative artwork, but is undesirable for most abstract artwork.

It is the matte quality that has made the vinyl emulsion paint Flashe, manufactured by the LeFranc & Bourgeois Company, popular among abstract artists. However, vinyl is said to break down more easily than acrylic when exposed to ultraviolet light and is therefore not recommended for murals where there may be exposure to direct sunlight.

Vinyl and acrylic paints can, in theory, be mixed together. If they are incompatible, the mixture should react immediately, resulting in a "cottage cheese" look, and the mixture will not spread when used. Liquitex colors have, for example, been successfully mixed when Flashe colors, with the one exception of the Flashe black vinyl paint, which will curdle when mixed with an acrylic.

POLYMER EMULSION MEDIUMS

When water is added to a polymer paint it is not only thinned but swollen, and the color appears thick and rich. When the water evaporates, however, the paint shrinks to a thin, dull, and sometimes opaque appearance. A thicker, more transparent, and deeper final appearance can be achieved by thinning the paint with a polymer medium, or with a mixture of water and polymer medium. As the water evaporates, the medium remains to give some bulk to the paint film. The more medium used, however, the more the pigment particles are dispersed and the more transparent the paint film.

Glazes are best produced by mixing a small amount of color in an undiluted medium. A general-purpose medium for thinning colors is a mixture of half water to half medium. Whenever polymer paints are to be thinned greatly with water, some medium should be used because if too much of the paint polymer emulsion is washed away or absorbed by the painting surface during the painting process, the paint film can develop cracks.

Both gloss and matte polymer mediums are available to alter the surface reflection to the desired appearance. Matte mediums are produced by the additive silica, or calcium carbonate, and tend to give a milky appearance to a paint film if used in large amounts. A gloss medium often doubles as a gloss varnish, but this is not true of a matte medium. A hardener must be added to create a matte varnish that will approximate the durability of a gloss varnish.

AUXILIARY PRODUCTS FOR ACRYLIC PAINTING

A number of auxiliary products are available for use in acrylic painting. They are designed to prepare a surface for painting, to slow the drying time of the paints, or to enable the artist to create texture on a surface.

Polymer Gel is a thickening agent that may be added to a polymer medium. For example, sodium polyacrylate can be added to acrylic polymer emulsions. Gels allow for an impasto style of painting with polymer paints. The more gel used, the more transparent the paint film. Gels are resistant to cracking and are excellent as adhesives for collage.

An Acrylic Retarder is either a gel or an additive that evaporates without a trace. It is designed to slow the drying time of acrylic polymer emulsion paints. The recommended amount of retarder to be used varies from manufacturer to manufacturer and if specified amounts are exceeded, the paint film will not form properly. Most retarders, when mixed properly with a color, will slow the drying time to approximately three hours. This allows areas of a painting to be blended or reworked in much the same way as can be done with oil paint.

Acrylic Modeling Paste is a unique product. It is a waterborne, puttylike substance that dries matte and opaque. It is an acrylic polymer medium mixed with marble dust and titanium dioxide. This product is used to build up textured surfaces and sculptured reliefs on absorbent surfaces. If it is to be applied to a flexible surface it must be mixed half and half with gel medium or cracking may result. When this paste is dry it may be carved, sanded, and painted with either waterborne or oil paints. Acrylic polymer paints may be mixed directly into it.

Acrylic Polymer Gesso is not the same as the traditional gesso formulation of white pigment and chalk mixed with hide glue. Although both are designed to create a primed surface for painting, the traditional gesso can only be used on a rigid support, such as a wood panel, since it is not the least bit flexible and will crack if applied to anything that moves or bends. Acrylic polymer gesso is a combination of gypsum, or chalk, titanium dioxide, and just enough acrylic polymer medium to keep the undiluted mixture from cracking on a flexible support, such as canvas.

Acrylic polymer gesso can be used to prepare any absorbent surface to receive either polymer emulsion paints or oil paints. Recent investigation seems to indicate that acrylic gesso may be more resistant to chemical attack by the pollution in city air than traditional gesso for rigid supports or the traditional combination of rabbit-skin glue and lead white for canvas supports. Today, acrylic polymer gesso has all but replaced all traditional gessos.

Although acrylic polymer gesso can be applied without thinning, it is much easier to work with if it is thinned. Because it has a minimum of acrylic polymer to provide a very absorbent painting surface, it can crack if diluted only with water and applied to a flexible and highly absorbent surface. It is therefore wise to add some acrylic polymer medium whenever water is added. Excellent results can be obtained using a mixture of 25 percent polymer medium, 25 percent water, and 50 percent acrylic polymer gesso for priming canvas. (For more information about priming and sizing supports, see pages 141 to 147.)

Artists have reported that some brands of less expensive acrylic gesso may be more subject to cracking. The problem occurs when the gesso is not properly formulated—when it contains too much particulate matter (pigment and filler) in relation to the acrylic emulsion. As the gesso dries, the overloading of pigment prevents the acrylic resin particles from forming a complete paint film, and the resulting paint film is weak and brittle. Problems such as these teach two important lessons—read the instructions on the jar, and combine acrylic polymer gesso and acrylic polymer paint made only by the same manufacturer.

ACRYLIC VARNISH, GLOSS AND MATTE

Unprotected polymer paint films are not very durable because they are relatively soft compared to oil paint films and can be marred easily as the result of abrasion. They are also more porous and the pigments and paint film can be affected by air pollution. A varnish can, however, provide the necessary protection. A varnish can also be used to control the surface appearance in terms of matte and gloss.

Acrylic polymer solution varnishes, which are dissolved in mineral spirits, are the best protection for acrylic paint films. They are more durable, forming a harder protective film than acrylic emulsion varnishes, which are waterborne. Acrylic polymer solution varnishes also provide better protection against air pollutants because they seal the painting's surface more thoroughly. (See *Oil Media, Solvents and Varnishes,* page 271, for more information about synthetic varnishes.)

An acrylic polymer emulsion varnish is the same as an acrylic polymer emulsion used as medium, except that the varnish contains a hardener. Unless specified by the manufacturer, an acrylic varnish should not be used as a painting medium. Most manufacturers discourage the thinning of acrylic varnishes, and if diluted with more than 50 percent water, the clarity of the dry varnish film can be seriously affected.

The application of a varnish should be smooth and consistent, and areas that might require more varnish should not be reworked. Reapplying a varnish to a partially dry area can result in streaking, evident brush strokes, and a milky appearance. It is best to wait the hour or two until the varnish dries, and then apply a second coat. Matte varnishes are particularly susceptible to this problem.

The painting surface shine can be regulated not only by choosing a matte or gloss varnish, but also by using a mixture of the two. A matte varnish, despite the hardeners added to it, is not as durable as a gloss varnish. And the matte surface can be rubbed or polished to a shine.

PERMANENCY OF ACRYLIC EMULSION PAINTS

Oil paint has been used for several hundred years, and its range of permanency is well established. Although oil paint is subject to some yellowing and cracking over the centuries, it is still a highly durable medium. Acrylic polymer paint, on the other hand, has been in use only for several decades. Its range of permanency is not established, but is instead implied through accelerated aging tests. Although aging tests have often proven to be quite accurate, they can never take into account all the variables. For example, acrylic and vinyl polymers seem to be more vulnerable to weakening from exposure to ultraviolet light (clear acrylic sheeting used in displays and picture framing does yellow in time from the ultraviolet light in sunlight and fluorescent light) and sulfur air pollutants than previously thought. This is not to say that such paints are unsafe, but rather that all the data are not yet in and there is still some uncertainty as to the actual long-term stability.

As an example of this uncertainty, Binny and Smith rate its most permanent colors in Liquitex, artists' acrylic emulsion paints, as having slight or no color changes after the equivalent of one hundred years of indoor museum exposure. Many of these same colors in oil paint often carry a rating that is equivalent to two hundred or more years before any visible changes occur. Oil paint with ratings of seventy five to one hundred years are often classed only as durable. Again, the point here is not that acrylics will not last as long as oil paint, but rather that no one can yet say, even with accelerated aging tests.

OIL PAINT AND ACRYLIC PAINT

There is a longstanding debate over whether it is safe to use oil paint over acrylics because they are made with different paint vehicles. New research seems to indicate that these two types of paint film do adhere quite well to each other, but only more complete testing will tell if the original optimism about the ability of oil paint to bind to acrylic emulsions is justified. Acrylic paint, however, should never be applied over oil paint.

Many people have noticed that oil paint seems to look "richer" than acrylic paint. This is partly due to the fact that oil paint vehicles can hold more pigment than can acrylic emulsions. Also, due to cost, most companies that manufacture acrylic paints use less pure grades of pigment when making colors such as cadmium red and cadmium yellow. (At present, Liquitex's cadmium colors, for example, are made with cadmium-barium pigment instead of pure cadmium. The manufacturer claims that a switch will be made to pure cadmium in the near future.) One company, Winsor & Newton, is now marketing a line of acrylic colors that are made from chemically pure pigments. It uses pure cadmium instead of the cadmium-barium pigment that most other companies use. Whether it makes a great deal of difference if pure pigments are used in acrylic paints seems to be a matter of personal taste. For instance, different types of black pigment such as Mars black and ivory black, which are easily distinguished from one another in an oil paint vehicle, look similar when ground into an acrylic emulsion because of differing refractive properties of oil and acrylic media.

HAZARDS OF ACRYLIC POLYMER EMULSIONS

The health hazards of the pigments used in acrylic polymer paints are discussed in *Pigments,* page 227, and *Hazards,* pages 309 to 323. The polymer emulsion itself has hazards of its own that must be considered. Although most major manufacturers have replaced the highly toxic ethylene glycol (wet-edge agent) and toxic preservatives with less hazardous ones in their polymer emulsions, they cannot be considered safe. Some of the polymers evaporate with the water and can be inhaled. Although the amounts are not significant in most painting situations, there are many painters who still do stain painting and color field painting, which involve the use of large amounts of acrylics, and the artist stands directly over the drying paint without any protection.

There are painters and small manufacturers making polymer paints who are not aware of the hazards involved in the manufacturing process and how they can be passed along to other users of their paints. For example, the raw acrylic polymer emulsion used in the manufacture of paint contains significant levels of highly toxic and volatile monomers that must be reduced or eliminated for safe use before handling. Not only can the vapors be hazardous, but mural painters should know about the experience of a well-known mural painter who was hospitalized for acrylic and heavy metal poisoning. She was working outdoors on a mural for the Olympics. The heat of the day apparently opened the pores of her skin, allowing a significant amount of acrylic polymer and pigment to be absorbed. Although polymer paints are not especially dangerous, they are not as safe as the prevailing opinion, and appropriate precautions are necessary.

Part Eight

IT HAS BEEN more than eight hundred years since the introduction of oil into the technology of painting, and there have been four major factors that have contributed to the development of oil paint and oil painting as they are known today. The first was in 1390 when it was discovered that zinc and lead pigments added to the oil paint sped drying time. This made oil painting feasible in damp or humid climates, such as in Italy and the Netherlands, where oil painting as a viable medium was first introduced.

In the sixteenth century, such natural resins as damar and mastic were introduced to the oil, allowing for the later development of the thicker *alla prima* style of painting. This oil-resin paint produced a paint film of great durability and was preferred by many of the Old Masters for use in glazing with successive layers of paint, but most of their specific recipes for making resin-oils and information regarding drying times are now lost. Many artists have since tried to duplicate the technology wherein glazes interlock to give that unsurpassed beauty and clarity so evident in the Masters' work, but, alas, have failed.

The period of industrialization during the nineteenth century brought with it not only a great new spectrum of pigments for artistic use, but also the collapsible tin tube, without which the Impressionist and Luminist painting movements could not have happened.

Pigments such as cobalt blue, chromium oxide green, cadmium yellow, chrome yellow, barium yellow, zinc yellow, cerulean blue, ultramarine blue (synthetic), zinc white, viridian, and cobalt violet were all introduced to oil painting for the first time in the nineteenth century. Such brilliant blues, yellows, and greens had not, and could not have, been seen in painting until this time, but it was the invention of the collapsible tin tube in 1841 that made it practical for the artist to leave the confines of the studio to paint outdoors. Before the development of the tin tube, colors had to be ground fresh or, where available,

bought fresh in either perishable animal-skin bladders or expensive metal syringes from colormen, as the first manufacturers of artists' paints were called.

The development of prepackaged oil paints was a great advance, though not without some sacrifices in quality, which might seem minor by comparison to the convenience but are nevertheless significant and noteworthy. Resin-oil paints were far more brilliant than resin-free oil paints, and each color could be formulated to dry at a similar rate to allow for proper interlocking of paint films. But, because of packaging and shelf life, resin-oil paint had to give way to resin-free oil paint. Resin-free oil paints have a high oil content with irregular drying times and poorer aging characteristics.

Attempts are still being made to deal with the problems of handling characteristics, packaging, and shelf life. Some manufacturers are experimenting with different methods of grinding and aging paint and are trying new drying oils or synthetic resins like alkyds, or are even attempting to reconstruct the old resin-oil paint with modern technology.

Oil paint, despite even the advent of acrylic, is still the most versatile, rich-looking, and time-tested painting medium of all time.

The Manufacture of Oil Paints

WITH THE EXCEPTION of a few pigments that are too delicate to be made other than by hand, oil paints are generally made by machine. The machine process is far more effective than the techniques used in making paints by hand, and the range of available colors is much greater.

MACHINE-MADE PAINTS

Most commercial artist-grade oil paints are made with some variation, or abbreviation, of the following description supplied by the Holbein Company.

The first stage is the preparation of a mill-base, a mixture of pigment, oil, and resins in ratios prescribed by the natural characteristics of each pigment, which is then placed in an agitator to disperse the ingredients evenly. Some pigments require a vacuum agitator to remove water and gas. If the mill-base is not properly prepared, the next stage of grinding will not be effective.

Additional medium and pigment are mixed with the mill-base and fed into the first series of rollers to grind the mixture and produce a base-paint. The purpose of grinding is to coat each particle of pigment completely with the medium, or vehicle. This isolates and protects the pigment from reacting chemically with other uncoated pigments, and is what gives oil paint its brilliant quality. That quality is determined during this stage of processing. The rollers that grind the paint are made from iron, stone, and ceramic, and are used individually or in combination with varying ratios of revolutions depending on the nature of the pigment (most pigments at this stage are ground three or four times starting with the iron, then the stone, and finally the ceramic rollers to make an artist-grade paint). If there is too much grinding, the pigment will be pulverized and its brilliance lost, and if there is too little grinding, the paint will be oily and gritty.

The third stage is the adjustment process where the base-paint is mixed with an antiseptic, an antifungal agent, driers (if needed), and stabilizers (such as wax, if needed), and is ground two to three times more. At this time, the color is also adjusted to match a previous company standard. The finished product is then tested for tinting strength, covering power, handling properties, resistance to putrefaction, and stability under exposure to light and variations in temperature. After quality control standards have been met, the mixture is aged. This

allows any excess oil to separate naturally from the pigment so that it can be removed before the final process of filling the tubes.

The manufacturing process described here is for an extra-fine quality, or artist-grade paint. Lesser grades are manufactured with substantially less grinding and quality control, as well as less expensive ingredients.

HANDMADE PAINTS

With the exception of a few delicate pigments such as genuine carmine, madder, and lapis lazuli (genuine ultramarine), the unromantic truth is that handmade oil paint is rarely as good as the best machine-made paint. The main reason is that machine grinding, or ball grinding, coats the individual particles more thoroughly with far less oil (less oil means a lower risk of yellowing and cracking) than could possibly be done by hand. Other drawbacks to hand grinding your own paint are storage problems, spoilage, and considerable health hazards, also assuming you know the proper ratios of vehicle to pigment and how to combine them and that you possess the proper tools. As for saving money by making your own paint, most people who have tried it have found that, for the average painter, it is not worth it.

The only reasons for an artist to make his or her own paint, in spite of all the obstacles, is either for the learning experience or to make a paint that cannot be bought, such as a resin-oil paint or restoration paint; however, even these types of paint are becoming commercially available in the United States.

Blockx paint is the last commercially available, extra-fine, handmade paint. Because it is handmade, it is not only very expensive, but the range of colors is small by comparision to other lines of extra-fine paints and the supply of those colors is extremely limited.

Characteristics
of Oil Paint

THE MOST IMPORTANT and unique characteristic of oil paint is the thin coating of oil on each particle of pigment. This coating usually consists of a "drying" oil such as linseed or poppy oil. The oil dries through oxidation, a chemical reaction between the oxygen in the air and the oil, and not through evaporation. This oxidation process creates a remarkably durable and flexible paint film. Since each particle is separated by a clear film, light can pass between some of the particles of pigment, as well reflect off others. It is these characteristics that give this painting medium its great depth and luminosity, when used correctly.

The two most common errors in oil painting are caused by varnishing a painting before complete oxidation has occurred (a painting may appear dry to the touch in several weeks, but it is often a year before the process is complete enough for a final varnish), and by using too much thinner, which strips off the protective oil coating, often resulting in unpredictable, and sometimes even disastrous effects. Painters will often buy the finest oil paints and then saturate them, using no medium, with the cheapest paint thinner, only to complain about how bad the paint looks and handles.

Without a thorough understanding of the role of drying oils, solvents, varnishes, and pigments, no painter is equipped to take advantage of what oil paints can do.

DURABILITY
Over a long period of time, oil paintings will tend to darken, yellow, and develop fine cracks in the surface. Yet the overall beauty and richness has survived centuries, a testament to the durability of oil painting.

PURITY AND LABELING
The term "pure" has been as overemployed in reference to paint as it has in reference to food. It is difficult to derive any practical information from the use of the term. For example, in the making of the finest artist-grade oil paint, only C.P., or chemically pure, cadmium sulfo-selenide (PR 108, C.I. 77196) is used to make a cadmium red color. Yet roughly half the contents of the paint tube consists of oil, with a small percentage of wax stabilizers, and usually a touch of

drier. Consequently, it is difficult to understand what the resulting chemical purity is or means after a pigment has been blended with stabilizers and driers, and in lesser grades of paint, fillers are added, too.

There have been attempts in the recent past to establish some form of standardization in the United States. These efforts have resulted in *Commercial Standard CS98-62,* published by the United States Department of Commerce (a copy can be had by writing to the Superintendent of Documents, Washington D.C., 20025). It is a voluntary standard allowing those who conform to it to say so in their labeling. The standard seems to have been written with a manufacturer's bias, rather than a consumer's bias, as well as a bias toward middle quality, and would seem to eliminate those manufacturers who produce the worst paint and those manufacturers that produce some of the best paint (primarily in the area of resin-oil) from using the approved label. Few manufacturers ever fully comply with this standard.

Another important outgrowth of the standardization efforts is the use of color indexing for artists' paints. Color indexing is a fairly specific method of identifying a pigment and establishing purity. (For information about this seven-volume index, write to the American Association of Textile Chemists and Colorists, P. O. Box 12215, Research Triangle Park, NC 27709. A reference copy can often be found in a university chemistry library or a public library that has a science reference section.) This information is particularly important to restorers, decorators, and paint manufacturers. The indexing numbers can be helpful to artists when these numbers are accompanied by the traditional names and chemical names for the pigments and, in cases where more than one pigment is used, their ratios. At this time, no manufacturer is supplying such ratios when more than one pigment is used. Some have even eliminated the traditional name in favor of only the index number, which is most discouraging because it makes valuable information inaccessible to all but the most scientific of painters.

A set of voluntary standards is now being established by the American Society for Testing and Materials (ASTM). This will be an improvement on the *Commercial Standard CS98-62,* as well as on labeling. Voluntary standards concerning health hazards and the labeling of hazardous materials are set down in ASTM D 4236, *Standard Practice for Art Materials for Chronic Health Hazards.* ASTM D 4302, *Standard Specifications for Artists' Oil and Acrylic Emulsion Paints,* deals with improved labeling, while ASTM D 4303, *Test Methods for Relative Lightfastness of Pigments Used in Artists' Paints,* attempts to standardize lightfastness test procedures. A copy of each of these documents is available, for $8.00 each, from ASTM Sales Services Dept., 1916 Race Street, Philadelphia, PA 19103. Manufacturers that conform to these standards will be permitted to say that their product "Conforms to ASTM D 4302." The ASTM recommends guidelines for proper testing and labeling, but does no testing. The supplying of accurate and meaningful labeling, as well as supplemental product information, is still almost entirely up to the good will of the manufacturers of artists' materials. Compliance with these guidelines should be higher than it has been with *Commercial Standard CS98-62.*

Winsor & Newton makes a point of advertising the compliance of its London

Oil Colour and London Alkyd Colour with these new standards. (These two lines of Winsor & Newton paint are, however, its lesser grade; it has, curiously, not involved its artist-grade oils.) It boldly labels its compliance on these paint tubes. But this information is no more meaningful to the average consumer of artists' materials than was the *Commercial Standard CS98-62*. The company has added such information as the chemical name of the pigment used, a permanency rating, a lightfastness rating, and the vehicle used. At first glance this would appear to be a vast improvement, yet most of this information has been commonly supplied on paint labels by most manufacturers for several years. The remaining information, as with virtually all current labeling, is in a form that, recurrently, is not truly meaningful.

Complete labeling, backed up with easily accessible, in-depth technical information, is needed. The labeling on artists' paints should be at least as good as what we have now come to expect on the food we buy. This is easier said than done, especially in an industry with such a variety of products. It is obvious that new labeling is continually developing, and it would be a great service to the artist if labels supplied meaningful information. The subject of purity and standards is already controversial, but it is nevertheless necessary to point out how little practical information, especailly in regard to purity, is accessible to the average painter, who is often left with little alternative but to accept the reputation of the manufacturer. (For information about labeling in relation to levels of quality, see pages 241 to 242.)

PERMANENCE

Permanence, in regard to the lightfastness and compatibility of the pigments, is discussed extensively in the chapter on pigments, pages 154 to 156. It is important to understand, however, that the general permanence of colors in oil paint is dependent on the protective coating that each particle of pigment possesses. Although the protective coating allows the use of many pigments that might otherwise interact chemically if combined in their dry unprotected form, it also reduces the permanency of the color that is produced by the pigment. As the protective coating ages, it tends to darken and yellow, particularly if that coating is comprised primarily of linseed oil, which changes the color.

The permanence of oil paint is also affected by atmospheric pollution, such as the sulfur dioxide and hydrogen sulfide present in city air. Unprotected (unvarnished) metal-based paints like the chrome colors, such as chrome yellow, and chrome green, white lead, cremnitz white, cinnabar green, as well as colors like ultramarine blue and permanent blue, can discolor when they come in contact with these pollutants.

Such colors as alizarin crimson, brown madder alizarin, indigo, permanent green, and purple madder alizarin are not as permanent when used in thin glazes. Scarlet lake (BON arylamide) and Winsor orange (BON arylamide and arylamide yellow) oil colors by Winsor & Newton are particularly sensitive to pale tints with white. Mixing white, or any color of greater permanency, with colors of lesser permanency does not improve the permanency of the latter and often reduces it.

TINTING STRENGTH

The ability of an oil color to maintain its strength when mixed with white is known as tinting strength. This is a common test for pigment concentration and a valid method of comparison between brands of paint if the pigment used by each is the same. The name of the color on the tube does not necessarily indicate what is in the tube. For example, a well-advertised tinting test shows two different brands of raw sienna. The advertiser's brand show greater strength of color. However, the pigments tested are similar, but not the same. The weaker-appearing brand of raw sienna is said to contain iron oxide mined from the traditional sites in Italy, which is high in silica and produces a more transparent color. The advertiser's brand is said to be a manufactured iron oxide, which contains no silica and thereby produces a stronger tinting strength. The point is not which is the more desirable characteristic and thereby which is the better paint, but rather that this is not a fair comparison.

Tinting tests can be made fair and can be performed by anyone once two identical pigments from two different brands have been identified. Within two brands of paint, about 25 percent will cross match using the same single pigment for a particular color. It is important to avoid testing colors that contain several pigments, even if they are identical, because the proportions for each pigment may be different. You can make a test mixing half zinc white with half color, and then take half of that mixture and mix it with half zinc white again, and repeat this procedure several times for each brand. This will give you a serial dilution, which can then be compared.

Small differences between brands in tinting strength are best ignored because the most concentrated use of a pigment to make a color is not always desirable. Some pigments become literally unworkable above certain concentrations. Paints made with too high a concentration of metal pigments such as cadmium or lead become so thick and cakey that they cannot be easily expelled from the tube or manipulated on the palette. Paints made with some of the newer synthetic pigments, such as phthalocyanine, have such high tinting strength that if they were used in high concentrations, they would totally overpower any color mixed with them. Because of these factors, manufacturers balance the level of concentration with the working consistency. Any home-done tint test comparison needs to be judged against your preferences for the particular paint consistency that a manufacturer offers.

TRANSPARENCY OR OPACITY

In oil paint each pigment, by its own chemical nature, will tend to be either transparent, semitransparent, or opaque. Most blacks, blues, violets, and purples are transparent, as are colors where the pigment is a like a dye-pigment, such as alizarin crimson and madder. Earth colors range from semitransparent to opaque, depending on their source. All cadmium and chrome colors, all whites, or colors that are made with white (such as Naples yellow and flesh tint), and genuine vermilion are opaque.

Of all the whites, zinc white is most transparent, followed by lead white and then titanium white, the most opaque. You can make a transparent color semitransparent or opaque by the addition of white. Many colors will take up to 10

percent white without any appreciable change in the surface appearance. Opaque colors can often be made semitransparent by thinning them with a painting medium and applying in thin glazes.

Virtually all manufacturers' color charts are encoded with information regarding the transparency and opacity of the colors in their unmixed state. Some companies, such as Schmincke, even label their paint tubes. It is important to note that in lesser grades of paint, it is more common to have expensive colors replaced with blends of other less costly colors, which in turn can affect the transparency and opacity. A mixture of white and phthalocyanine blue, for example, is sometimes sold as cobalt blue, or cobalt blue hue. This blend is opaque and does not produce the same kinds of tints when mixed with other colors. Genuine cobalt blue is prized for its transparency as well the delicate tints it can produce. Another example is cadmium red, the better grades of which are made from C.P. cadmium sulfo-selenide, and which is prized for its opacity and brilliance. It is sometimes replaced with lesser grades, which are often mixed with barium sulfate, and are therefore less opaque and not as brilliant.

It used to be common practice simply to paint over undesirable areas with opaque colors until it was discovered, after many years of aging, that areas which were hidden began to show through the increasingly transparent surface. This phenomenon is called pentimento. Therefore, if an area needs to be repainted, the area should first be prepared with a new ground of white paint.

To an artist who paints very large, these differences may seem insignificant for, if one has to stand twenty to thirty feet back from the surface of the painting to see it, it is unlikely that small details will be noticed. However, if you are a master at the craft of painting, or paint in a style where details must and will be seen, these differences are very important.

BINDERS

The nature of oil paint is such that particles of pigment are coated and suspended in a liquid, which, in turn, will bind those particles together when exposed to air. That liquid may be a drying oil, a resin-oil blend, or an oil-modified alkyd resin.

Drying Oils. These oils are used in grinding pigment to form an oil paint, as well as to make media for oil painting. It is the linolenic and linoleic acids present in a drying oil (commonly linseed oil) that, when in contact with air, oxidize to form a film that binds the particles of pigments together.

Some manufacturers substitute a refined poppy oil or safflower oil for linseed oil in preparing certain pale oil colors and whites. These drying oils have little or no linolenic acid, a binder that gives a yellow tint to oil paint. The only binder in these oils is the linoleic acid, which is not only less yellow, but also yellows less over time. However, linoleic acid by itself is a weaker binder and should not be used as a replacement for linseed oil in all cases.

Using a "pure oil" system of making paint is the least costly method and, unless driers and wax stabilizers are added to certain colors, there will be wide variations in consistency and drying times between many colors. This type of paint is referred to as "fat" paint because of the high oil content. The fatter the

paint, the more yellowing and the greater the possibility for future cracking.

Some manufacturers have attempted to reduce the "fat" either by an elaborate grinding system, such as that used by the Holbein Company, or by aging the paint before packaging, a method employed by Grumbacher.

Resin-Oil. The Schmincke Company has developed the use of a resin-oil binder, which is stable in tube paints and similar to that used by the Old Masters. Its line of oil paint has been named Mussini in honor of Cesare Mussini, a nineteenth-century painter and teacher who was one of the few remaining repositories of some of the Old Masters' paint-making recipes, and who passed this knowledge on to the colormen of Schmincke. Mussini oil paint is made with such drying oils as cold-pressed and refined linseed oils, poppy oil, and sunflower oil, which are blended with natural resins like damar and mastic, as well as with polycyclohexanone, a modern nonyellowing damarlike resin.

This elaborate formulation allows for four important effects: more even drying of paint films, which reduces the possibilities of future cracking; greater clarity and less yellowing because of the lower oil content; narrowing the range of drying times between different pigments; and smooth and even consistency with little or no separation of oil and pigments.

The mixing of such ingredients as mastic and damar into a paint after it has been ground with only linseed oil, will help to improve the paint's performance. However, it is not the same as when the pigment is ground into the same combination of ingredients to start with, where less oil and more resin can be used. When the ingredients are added later to a high-oil-content paint, the original oil in the tube is only diluted, not replaced, and the increase in performance is not as dramatic.

Oil-Modified Alkyd Resin. Alkyd resin is the category of resins that are made from mixtures of dibasic acids and polyhydric alcohols. One particular alkyd resin (kept a trade secret) is chemically combined with a nonyellowing oil, such as safflower oil, to produce a workable, fast-drying binder for oil paints. Driers are often included to speed drying and silica is occasionally added to give extra body.

Alkyd resins often exhibit a thixotropic effect. Thixotropy is an unusual phenomenon in which a gel, or paste, suddenly loses its plasticity when disturbed or moved mechanically, resulting in a liquid. The opposite may also occur where a liquid, left undisturbed, forms into a gel. There is a certain advantage to this thixotropic property in the glazing technique, for a glaze will resist running down the canvas after it has been applied and left undisturbed. However, the tendency of alkyds to liquify rapidly would be a disadvantage in the impasto technique.

Alkyd resins, originally developed for use in making industrial paints, have been applied to make a variety of fast-drying media for artists' paints. Winsor & Newton has produced two lines of paint (an artist-grade and an amateur-grade) where the pigments have been ground into an oil-modified alkyd resin. The range of colors is limited to its "selected list" (SL), which consists of colors that may be mixed with one another without loss of permanence. At this time it is

not clear if pigments other than those currently used in nonalkyd paint are safe to be stored in tubes after being ground into this acidic resin. It does seem to be all right, however, to intermix nonalkyd paint with alkyd paint, and nonalkyd medium with alkyd medium for immediate use.

Alkyd paints and alkyd media should not be overthinned. No more than 25 percent by volume of thinner to paint or medium is recommended; more than this will break down the consistency and quality of the paint or medium.

DRYING RATES

Each pigment affects the drying rate of its oil vehicle differently. Some speed the oxidation process, some slow it down, and some have no effect at all. To compensate for this, most manufacturers add a small amount of drier, such as cobalt or manganese, to the slowest-drying colors. This narrows the range of drying times within a line of paint, but, even with these driers, some colors' drying times may differ from others by several days to several weeks.

Natural and synthetic resins are also used to narrow the range of drying times further. Winsor & Newton has accomplished this in its alkyd paints by using an oil-modified alkyd in which it grinds its pigments. The Schmincke Company has narrowed the range of drying times by using a resin-oil formulation specific for each pigment in its Mussini paint. However, these two paints are unique. Most other brands of oil paint have a large gap in drying time between certain colors and caution in their combined use may be necessary.

In general, a faster-drying paint should never be applied over a slower-drying paint; otherwise cracking may result. Some of the slowest-drying colors not recommended for underpainting are all carbon-based blacks (ivory, lamp, carbon, and charcoal black), all cadmium-based paints (cadmium red, cadmium yellow, cadmium green), vermilion, alizarin crimson, zinc white, and Vandyke brown. These colors, unless modified by the artist or the manufacturer, can take between three and five days in a thin paint film to dry.

Among the faster-drying colors are the cobalt-based colors (such as cobalt yellow, cobalt blue, and aureolin), manganese-based colors (manganese blue, manganese violet, and manganese black), raw and burnt umber (both contain large amounts of manganese), prussian blue, and lead-based whites and colors (including flake white, cremnitz white, Naples yellow, chrome red, and chrome yellow). Some colors, such as the manganese-based colors, have a strong catalytic effect upon drying oils and are often ground into poppy oil in order to slow the drying time.

Each manufacturer does or does not adjust the drying rates of its colors according to its own idiosyncrasies, and most do not supply information about the drying times or the film characteristic of their colors. Because of the variations, generalization will often not be discovered until after use. An understanding of the nature of pigments, combined with knowledge of the pigments used by a manufacturer to produce a particular color, will help you to infer a drying rate. In addition to modifying drying times through the use of media, a painter can accomplish the same goal by mixing slow-drying colors with fast-drying colors.

FILM CHARACTERISTICS

In addition to varying drying times among pigments, there are also varying film characteristics, which can range from tough and flexible to hard and brittle. It is the brittle film characteristics that are of greatest concern, particularly when used in underpainting. If a brittle paint is used underneath, it may cause the over-painting to crack.

Zinc-based paints, such as zinc white, are the most brittle and are not recommended for use in underpainting. Cobalt-based colors, barium yellow, strontium yellow, and red oxides, although not as brittle as zinc paints, are also not recommended for use in underpainting. Lead-based paints, raw umber, and burnt umber are among the most flexible paints and are perfect not only for underpainting, but also for mixing with more brittle paints to stabilize them.

STABILIZERS

Ideally, little or no stabilizer should be used in an artist-grade paint. There are certain pigments, when ground into linseed or poppy oil, that could either have a stringy consistency or a tendency to separate from the oil. Such stabilizers as waxes (beeswax or aluminum stearate), water, and alumina hydrate (added to give bulk) are currently utilized to regulate consistency. Although there are definitely cases where it is more helpful than harmful to have these additives, the use of these materials has been abused. Consistency is often mistaken for quality, and it is certainly more profitable for a manufacturer to use stabilizers rather than pigment to meet the artist's expectations.

Stabilizers easily cross over into use as fillers. It is considered acceptable by most manufacturers to use, for example, as much as 1 to 2 percent aluminum stearate, by weight, to improve the consistency of some colors. However, aluminum stearate weighs very little compared to the volume it can occupy. Aluminum stearate does to oil paint what goose down does to a comforter; it is easily possible for this wax to take two to four times its weight in volume. If an "average" tube oil paint consists of 50 percent oil to 50 percent pigment by volume, the adding of 2 percent aluminum stearate, by weight, could reduce the amount of pigment by volume by 8 percent to 42 percent. Although certainly significant, this is not serious. It becomes serious when more than 2 percent by weight is used, not only because it replaces more pigment, but because it becomes necessary to increase the proportion of oil to offset the increased effects of the aluminum stearate. If 5 percent aluminum stearate, by weight, is used, it is quite possible to end up with volumes of 70 percent oil, 20 percent aluminum stearate, and only 10 percent pigment.

It is rare to see this kind of abuse in artist-grade paints because most of the cost of making these paints is for labor and not for materials. Most manufacturers of such paints find it pointless to scrimp on raw materials. In lesser grades, however, where competitive pricing is so important, the quantity and quality of labor and raw materials are reduced and one of the most effective ways to accomplish both is to increase the use of a stabilizer like aluminum stearate. The artist can sometimes detect the excessive use of stabilizers by doing a tinting strength test. (See page 236.)

OIL SEPARATION FROM PIGMENT

The separation of oil and pigment in an artist-grade paint does not necessarily indicate poor quality; it often means that little or no stabilizer was used. However, it can also indicate the lack of aging, lack of resin (natural or synthetic), or lack of modern grinding techniques, none of which would necessarily be serious drawbacks.

Separation commonly occurs in pigments containing cobalt, manganese, cadmium, and lead and appears to be due to an aging process whereby the surface tension of certain pigments is reduced with age, which results in a lesser amount of oil being needed to coat a particle. The excess oil is naturally expressed and causes the apparent separation. It is not uncommon to find an "old time" painter looking for old tubes of paint, rather than "fresh" tubes, because the aging process improves the quality of oil paint (as long as the container is closed). Some of the finer quality paints are aged up to six months to allow this separation to occur before packaging.

The separation of oil and pigment in lesser quality oil paints often indicates that too much oil was used in the manufacture. This would be especially true of paints in which stabilizers are commonly used to compensate for excessive oil.

DIFFERENT GRADES OF PAINTS

Three grades of paint seem to have developed in the United States: artist (finest, extra-fine, super-fine), amateur (fine, professional), and student. The European products that are available in the United States are often of two grades: artist and student. Many of the European student-grade paints are equivalent in quality to American amateur-grade paint.

In general, artist-grade paints are supposed to be made with only the purest, highest-quality ingredients, without regard to cost. The paint is manufactured according to the tradition that each company has established for itself and upon which it rests its reputation. Amateur-grade paints are made from the best ingredients that can be found at a reasonable price. The level of craftsmanship, although not as fine as in artist-grade paint, is sufficient to produce a consistently good-quality paint that is still safe for professional use. Student-grade paint made in the United States is designed to be used for studies or learning exercises that will most likely be discarded. Therefore, this paint is made with the least costly raw materials and with the most cost-effective methods. Within each of these grades there are also varying levels of quality.

To complicate matters, some companies have recently begun to call their amateur grade "Professional," a term that seems to imply some equivalence with artist-grade paint. The best way to avoid being confused by all this is to learn about the pigments that are used to make paint. For example, the finest cadmium red paint is made only from the purest cadmium sulfo-selenide (PR 108, C.I. 77196), and not from such cadmium-barium sulfo-selenide mixtures as PR 108, C.I. 77202, which contains less than 15 percent barium sulfate, or PR 108:1, C.I. 77202, which contains more than 15 percent barium sulfate. Such cadmium-barium mixtures fit into the amateur grade because they tend to be weaker in intensity and the paint is more transparent depending on the amount of barium

sulfate filler. Cadmium red hue, which is mostly found in student-grade, and occasionally in amateur-grade, paints is made with azo red pigments. It is a less expensive alternative to the cadmium pigments, but has a slightly unnatural appearance and, when mixed with azo yellow pigments, produces a dull orange. When you have this information, you can make an educated choice. You may even choose the azo-pigmented color over the cadmium-barium color for a esthetic reasons. Price may be a factor in making your decision as well, because the finest cadmium red paint is expensive. If you paint large pictures, which have to be viewed twenty to thirty feet away, the difference in the quality of the paint you select may not be seen.

In amateur and student grades of paint, the hue of expensive pigments may be imitated by using mixtures of less costly pigments. Cobalt blue, for example, is often simulated using mixtures of phthalocyanine blue and white. This kind of mixture looks similar in surface hue to the actual pigment, but it is opaque and duller than genuine cobalt blue. When mixed with other colors, the imitation tends to muddy the appearance.

Student-grade paints are not, and should not be, used for professional work. Making a choice between amateur-grade and artist-grade can simply be based on whether you can or cannot see the difference. The difference in quality is most obvious in such colors as manganese blue, cobalt violet, cadmium red, and Van-dyke brown. A comparison of one or more of these colors can be made by spreading some of each color on a sheet of glass with your fingertips. (Wash your hands thoroughly afterward.) If you cannot see, feel, or care about the difference, then it is pointless to buy the more expensive paint.

LARGE TUBES AND CANS OF OIL PAINTS

The renewal of interest in oil painting, particularly large oil paintings, has fostered interest in larger and more economical volumes of paint. A few companies have offered larger volumes of paint for some time. LeFranc & Bourgeois, for example, markets 250 ml tubes of the more popular colors of its 104 series (its second-grade, or amateur-grade, paint). In the past few years, small manufacturers have begun to produce cans or jars of oil paint. Recently, larger manufacturers, including Grumbacher, Martin/Weber, Maimeri, and Winsor & Newton, have entered this market, too.

The range in quality from brand to brand is great, and the lure of large volumes and low prices has led many artists to buy paints for expediency without checking the label or comparing quality. Most major oil paint manufacturers produce several grades of paint to cover the potential marketplace. At this time, no company is packaging its finest paints in large volume because even with the savings such paints in large quantities would still not be affordable for the average artist. What is being offered is either a second grade, also called professional grade, or the manufacturer's student grade. In some cases, a new, even lower quality than student grade is made to fill these large tubes.

These new large tubes, jars, and cans have to be looked at and tested carefully. Some of these paints are labeled Cadmium Red (Hue) when actually three separate pigments are used to make a simulated color, none of them cadmium and one of them white. Even if you ignore the potential permanency of tertiary

colors such as these, the mixing properties would be absurd. I particularly recommend that any paint that is a student grade or less should not be used professionally. Student-grade paints are for exercises and experiments where the final work is not sold. There is good quality, large-volume paint available at a substantial savings, but you must become an educated consumer to find it.

MIXING BRANDS AND GRADES
There are no precautions necessary when mixing different brands or levels of the same quality of oil paint. However, mixing an artist-grade paint with a student-grade paint does not give birth to an amateur-grade paint. In fact, few painters mix levels of quality. It is most common to underpaint with an amateur-grade paint and save the more expensive, better-quality, artist-grade paint for the final stages. This is a safe method of economizing.

The mixing of different brands of paint within the same level of quality, although perfectly safe, is not as common as might be imagined. Most painters develop a brand loyalty, and behave as if they were cheating on a lover when an interesting or unusual color is found in another brand. To put such attitudes in perspective it would be helpful to understand that although there are definite distinctions among brands, such distinctions are not so great that they should inhibit selections.

COLOR RANGE
In an artist-grade paint it is not uncommon to find as many as a hundred and fifty different colors. Approximately one-third of the colors is made using individual pigments in their natural state. Another one-third of the colors is the same pigments chemically or mechanically (grinding) modified to change the color. The remaining one-third is colors produced through mixing two or more pigments together. In lesser grades of oil paint, the color range often consists of only thirty-five to fifty colors, which rely heavily on mixtures of pigments to obtain much of the range.

It is a common misunderstanding among inexperienced painters that most of these colors can be duplicated with the use of a "good red, yellow, and blue." Although the final one-third of a color line can often be duplicated easily with a palette of colors consisting of one warm and one cool of each of blue, red, yellow, and violet with some additional help of white and black, the qualities of the other colors cannot be duplicated by mixing. Surface color, or hue, can often be made similar to the other two-thirds of a color line, but depth and brilliance cannot. Secondary (two colors mixed) and tertiary (three colors mixed) colors do not function well as tinting colors, often muddying the appearance of other colors. One example of this is cobalt blue hue, manufactured by some paint companies to simulate the more expensive cobalt blue. While the hue resembles the real thing in surface appearance, it is duller and is opaque, not transparent.

Experienced painters usually try to buy a needed color rather than mix it, and they try to use it in its purest form whenever possible. Consequently, large color lines exist primarily because of the demands of the painter rather than because the manufacturers are looking for something else to sell.

WHITES

In most painting techniques one-half the amount of paint used is white. The type of white, or the combination of whites, used plays a large role in determining the appearance of a work. There are three basic kinds of white—lead, zinc, and titanium.

Flake White is lead carbonate that has been ground into poppy or safflower oil (to slow the drying time and reduce yellowing) and to which a small amount of zinc is often added to improve consistency. Flake white has the greatest durability and is the most flexible of all the whites. It is not as white as zinc white nor as opaque as titanium, but is excellent for making tints of cooler colors, and can safely be used in underpainting. It is poisonous if ingested or if the powdered form is inhaled, but not through skin contact. Flake white can blacken if it is left unprotected against hydrogen sulfide, an atmospheric pollutant, so varnishing is a must.

Cremnitz White is the same as flake white but without the zinc additive. Its consistency is a bit drier and stiffer, and it is preferred by purists. Cremnitz white and flake white used to be known for yellowing because of linseed oil, but linseed oil is rarely used in making this paint today.

Foundation White, which is produced by a few manufacturers, is also lead carbonate, but this is ground into linseed rather than poppy or safflower oil. The paint films formed by poppy and safflower oils are not as strong or flexible as the film formed by linseed oil, and would not be as safe to use as a painting ground. Foundation white is specifically designed as a painting ground.

Zinc White, which was originally developed as a nonpoisonous alternative to lead carbonate, is effective but not as versatile. Zinc white is zinc oxide ground into poppy or safflower oil. It is the least opaque of all the whites and is ideal for tinting and glazing. It is not darkened by hydrogen sulfide. The major drawback of zinc white is its brittleness and, because of this, it cannot be used as a ground or in underpainting.

Titanium White is titanium dioxide ground into poppy or safflower oil (sometimes a portion of linseed oil is used). It is the most opaque and the whitest of the whites and, in its pure state, it can reflect more than 97 percent of all light. It is also the newest and now the most popular of all whites. The permanency rating is among the highest given to a pigment.

Blends of Whites are produced by several manufacturers. The most popular is a blend of zinc and titanium. Permalba white, produced by the Weber Company, is among the most popular of the available blends.

OIL PAINTS VERSUS OTHER PAINTING MEDIA

It is easier to learn how to paint with oils than with most other media. At the same time, it is the most difficult of media to master, primarily because it is so versatile. There are so many styles of painting, formulas for media, pigments, and tools in oil painting that many find they do not have the patience necessary

to master this medium. There are many quicker, less complicated media of expression, but, with the exception of egg tempera, none is as rich or as time-tested as oils.

Oils are most often compared with acrylics. Although acrylics were developed for artist use only forty years ago, this medium has taken over a large share of the artists' materials market. Many painters have begun in, or switched to, acry-lic because of the lower costs, availability in larger volumes, fast drying, easy clean-up, absence of hazardous thinners, and nonyellowing characteristics. Nevertheless, I have yet to hear anyone say that he or she uses acrylics rather than oils because they look better. In general, acrylics are primarily used as an alternative to oil.

The nature of acrylics prevents them from being as concentrated with pigments as oil paints, or as brilliant in appearance. Some pigments traditionally used in oil paint are not used in acrylics because their unique qualities cannot be seen in a polymer medium. The available color range of acrylics is narrower because many pigments cannot survive the alkalinity or cannot stay in suspension. Acry-lics have only a narrow range of available media, and are therefore less ver-satile. They also dry with a much darker appearance than the wet color, which can be deceiving for the beginner. If acrylics were compared to the classification of grade levels used for oils, they would fit the amateur grade.

The only other medium that has often been compared with oil painting is egg tempera. When used properly, it can be more brilliant, luminous, nonyellowing, and permanent than oils. However, the techniques for egg tempera are even more difficult to master, and it is a more fragile medium.

OIL PAINTS AND OTHER PAINTING MEDIA

Although water-based paints, such as acrylics and vinyls, should not be painted over any oil-based paint, oil-based paints can safely be painted over water-based polymer emulsion paints. This has been verified by manufacturers of both types of paint. Because of reasons involving economy and drying time, it has become common to underpaint with acrylic and finish with oil paint.

The use of wax in encaustic painting is a long-established, safe painting method. However, there have been some problems in the use of encaustic paints and oil paints within the same painting. Paintings in which oil paint has been applied over areas consisting of high proportions of wax have cracked and some-times the paint has fallen off the surface. Wax appears to dry quickly, but, in reality, it only sets up quickly, for it takes years to cure, certainly far longer than the oil paint applied over it. This would violate the rule of never applying a faster-drying paint over a slower-drying paint. The use of encaustic should not be a start-and-stop operation. Once wax is used, it is safer to finish with wax and not with oil.

The mixing of such drawing materials as pastels, paint sticks, and crayons with oil painting has become popular. Materials such as these should be reserved for the final stages of a painting. Oil pastels, crayons, and paint sticks are made of wax and pigment and should be treated as an encaustic paint. There is one paint stick made by Edding Company that is an acrylic, lacquer-based paint stick

that behaves more like a paint than a wax. This quality would make it safer to use in underpainting. Soft pastels are more difficult to use safely because of their chalky nature, which can give unpredictable results. However, charcoal has traditionally been used for preliminary, light sketching on the canvas before the painting is started, and can be used safely in moderation if the charcoal is fixed before the application of oil paint.

Although the use of mixed media can be a powerful method of expression, many an art conservator has had to repair works in which materials were thrown together carelessly.

THE ROLE OF MEDIA IN OIL PAINTING

A medium is a recipe that includes, in specific proportions, two or more of: drying oil(s), resin(s), drier(s), wax(es), and thinner(s). A medium, in addition to regulating the consistency of the paint, thinning or thickening it, will also regulate the drying time, transparency, gloss, and leveling characteristics, as well as improve the overall aesthetic appearance.

If you are glazing without a thickener, such as Venice turpentine, for example, the thinned paint will simply run down the canvas. If the various drying times between differing pigments are a problem, this can often be resolved with the use of a medium formulated to narrow the drying time. Sometimes the impressions left by brushstrokes are undesirable, and can be made to disappear by substituting stand oil for refined linseed oil. Depth, brilliance, and subtlety are all controlled by such resins as damar, mastic, and venice turpentine. More than one medium may be used in the course of a painting's development, and each would be used at different stages. (This is discussed further in *Media, Solvents, and Varnishes,* pages 251 to 273.)

Oil painting without media, or with only linseed oil and turpentine, is like placing an order at a French restaurant for boiled duck, no sauce, no salt, and no butter. An appropriate medium does for oils what a French chef does to an otherwise bland and greasy dead bird, and the results, like Duck à l'Orange, are exquisite.

HAZARDS

Although hazards are discussed in depth in the chapter on hazards (pages 309 to 323), it is important to stress here that the primary danger in working with oil paints lies with the use of thinners and the seemingly miraculous ways that painters seem to ingest and inhale paint without "eating" it.

Turpentine, until recently, had been thought to be one of the safer thinners that an artist could use, but now it has been rediscovered that turpentine can enter the body not only by inhalation, but through the skin. I say rediscovered because during the nineteenth century turpentine was used as liniment to carry herb and other remedies into and through the skin. Today, it seems to be a big surprise to everyone in the artists' materials trade that turpentine can pass through the skin. There have been reports of kidney damage and changes in the bone marrow in a very small percentage of painters who were said to be using this thinner as any average painter would. Even worse is the physical damage to

painters who use industrial thinners, which often contain far more hazardous chemicals.

It has been common to see painters having lunch, smoking, and biting their nails, with paint on their hands, in the folds of their skin, and caught under their nails. There are also artists who airbrush in their living space or in their studio without adequate ventilation, protective clothing, or breathing apparatus. An all-too-common response to the hazards of oil paints, from many of these same individuals, is "I'm not stupid, I don't eat my paints!"

Common sense, good work habits, and some basic knowledge about the hazards concerning the materials you use could save your life or, at least, the quality of your life.

Palettes

Technological and chemical advances over the past few centuries have enabled the manufacture of an increasing variety of colors in oil paints. The following lists give some indication of how the spectrum of colors has expanded, and also suggest a basic selection for the contemporary artist.

COLORS AVAILABLE DURING REMBRANDT'S LIFETIME

Vermilion

Red Lead (replaced by Cadmium Red)

Madder

Umber (although available, it was more often mixed)

Sienna

Ochre

Green Earth

Realgar (an arsenic orange, not used since the Renaissance)

Orpiment (an arsenic yellow, not used since the Renaissance)

Malachite Green (fell into disuse after the eighteenth century)

Ultramarine

Azurite (replaced by Cobalt Blue in the eighteenth century)

Indigo

Ivory Black

Lead White

COLORS AVAILABLE TO THE IMPRESSIONISTS

Alizarin Crimson

Vermilion

Chrome Red

Madder and Rose Madder

Indian Red

Cadmium Yellow
(pale, middle, and deep)

Chrome Yellow

Yellow Ochre

Naples Yellow

Barium Yellow

Zinc Yellow

Aureolin (Cobalt Yellow)

Sienna, Burnt and Raw

Umber, Burnt and Raw

Vandyck Brown

Green Earth

Malachite Green

Viridian

Permanent Green Deep

Chromium Oxide Green

Cobalt Green

Emerald Green

Chrome Green

Artificial Ultramarine

Cobalt Blue

Cerulean

Prussian Blue

Cobalt Violet

Ivory Black

Lead White

Zinc White

A SUGGESTED CONTEMPORARY PALETTE

Lemon Yellow

Cadmium Yellow Light

Cadmium Yellow

Alizarin Crimson

Cadmium Red Light

Cadmium Red

Cobalt Violet

Cobalt Blue

Ultramarine Blue

Phthalocyanine Blue

Phthalocyanine Green

Viridian

Chromium Oxide Green

Yellow Ochre

Indian Red

Burnt Sienna

Burnt Umber

Mars Black

Ivory Black

Lead White

Titanium White

A SUGGESTED BEGINNER'S, OR ABBREVIATED, PALETTE

Lemon Yellow

Cadmium Yellow

Alizarin Crimson

Cadmium Red

Cobalt Blue

Ultramarine Blue

Viridian

Yellow Ochre

Burnt Sienna

Burnt Umber

Ivory Black

Titanium White

Part Nine

DRYING OILS are fatty oils of vegetable matter that can react chemically with the oxygen in the air eventually to solidify and become dry to the touch. Nondrying oils are mineral oils and vegetable oils, such as peanut oil and cottonseed oil, that resemble animal fats and, because they do not oxidize naturally and harden, are unsuitable as a binder for paint.

Resins are either natural or synthetic organic chemicals that are solids or viscous (thick) liquids. They are used to make media for painting (they are often too brittle when used alone) to alter the working characteristic of the paint film. Resins, in a liquid form, differ from drying oils because they solidify by the evaporation of their solvent rather than through oxidation. Drying oils thicken and harden into a paint film over a two- to five-day period, while most dissolved resins thicken and harden within hours.

Paint that is taken directly from the tube usually needs to be "let down," or thinned to a workable consistency. No artists' paint should ever be let down with only a thinner such as turpentine. This washes away the drying oil that coats each particle of pigment and protects a pigment from interacting chemically with

other pigments. The drying oil also holds the pigments together as a paint film; therefore, the less you have, the weaker the paint film. Most of the cost in making an oil paint is in the meticulous care taken in coating each particle of pigment.

As early as A.D. 1100, Theophilus, a German monk, wrote about the use of a drying oil as a medium for painting. The slow drying rate of the oils prevented their immediate acceptance, but after it was discovered that the addition of zinc and lead to the oil reduced the drying time, painting with oil became widespread. The practice of using oils, which imparted smoothness to a painted surface, was introduced around 1390 in Italy and the Netherlands. With the beginning of the age of industrialization (from the eighteenth through the nineteenth centuries), knowledge of earlier materials and methods fell into a dark age. This was not because of deliberate secrecy, but because of disuse and the demise of the apprenticeship system, in which a student worked directly with a master to learn the craft. Much vital information about specific drying times of oil media and their use in causing paint films to interlock for durability has been lost.

Drying
Oils

DRYING OIL is both the binder and the vehicle for the pigments that are used in oil painting. Each particle of pigment must be thoroughly coated with oil to protect it from reacting chemically with other pigment particles, to allow proper dispersion of pigment particles for luminosity, and to provide a workable and durable paint film. It is important to understand that drying oils do not dry through evaporation, but through oxidation, which is a chemical reaction with the oxygen in the air. Painters often ask, "Why must I wait six months to a year to varnish paintings when they seem dry to the touch?" The answer is that if oxidation is not complete below as well as on the surface of the paint film and the surface is sealed off from its supply of oxygen, the still-wet paint is trapped underneath and proper drying is prevented.

LINSEED OIL

Linseed oil is made from flax seeds, which contain 30 to 40 percent oil. It dries to the touch quickly, between three and ten days, but it takes years before it dries completely. It tends to yellow with age because of the linolenic acid, which is one of its binding agents (the other is linoleic acid). A refinement process is commonly used during the manufacture of linseed oil to remove particulate matter and mucilage and to bleach out some of the yellow color.

Raw Commercial Linseed Oil is extracted from flax seeds today by crushing and steaming procedures developed in the nineteenth century. The better commercial grades are warmed and aged to remove the grossest particles. Raw linseed oil is the least desirable for use in any artists' paints or even commercial paint products because it contains the greatest amount of mucilage and impurities. It is perfectly acceptable for finishing raw wood furniture.

Refined Linseed Oil is most commonly made by steaming the crushed flax seeds and chemically bleaching the oil. The bleaching has only a temporary effect and the oil usually reverts to its original yellow color. There are many grades of linseed oil; the artist grade is often further treated with alkali to improve clarity and color, producing a pure oil that is pale, clear, and thin. Paint is produced by grinding raw pigment in the oil. Additional refined linseed oil is often added to prepared paint to thin the paint, and to add gloss and transparency. It is also used to slow the drying time of the paint film. If the oil is used sparingly, the

paint film dries in approximately three days. Drying can take ten or more days if the oil is used more generously.

Cold-Pressed Linseed Oil is the best of the linseed oils. It is produced from the first pressing of ripe linseeds. It is the least efficient method of producing large amounts of linseed oil, but it gives rise to the purest form. Because of its high cost, it is rarely used in making paints. It is expensive because it is produced solely for artists' use by the least efficient method. This oil resists embrittlement, has excellent flow characteristics, and adds gloss and transparency to a paint. It is used to thin paint and it allows brush strokes to level out of a paint film. Cold-pressed linseed oil is a slower drying oil than refined linseed oil.

Stand Oil was widely used in the Dutch school of painting during the seventeenth century. This oil is so called because of the old practice of letting the oil stand for long periods of time to allow the impurities to settle out. Today, stand oil is linseed oil that has been heated without air at a temperature between 525 and 575°F. This polymerizes the oil, making it viscous and thereby excellent for glazing and leveling brush strokes. Because it is a fatter oil, it is not recommended for underpainting, but rather for the top paint layers. It makes a paint film that is not only tougher, but also yellows less than regular linseed oil. The drying time for stand oil is slower than that of linseed oil.

Sun-Thickened Linseed Oil is made by placing partially covered linseed oil in the sun. This bleaches, slightly polymerizes, and partially oxidizes the oil, producing an oil that has characteristics somewhere between refined linseed oil and stand oil. It dries a little faster than both (between two and nine days, depending on the thickness applied). It dries more quickly than refined linseed oil because the oxidation process has already begun. This could, however, result in a less durable paint film.

POPPY OIL

Extracted from poppy seeds, poppy oil is slower drying—usually five days—than linseed oil. (Some companies, including Winsor & Newton, add cobalt driers to accelerate the drying time.) This oil, which is less yellow in appearance than other oils because it does not contain linolenic acid (one of the two binding agents in oil paint films, and the one that yellows more), is used in making or mixing the pale oil colors. But because it does not contain linolenic acid, there is a greater risk of cracking with paint films composed primarily of poppy oil. Consequently, it should not be the primary ingredient in a painting medium recipe.

SAFFLOWER OIL AND SUNFLOWER OIL

Safflower oil and sunflower oil have come into use only recently. They are presently used by some manufacturers as substitutes for linseed oil when making some of the paler colors. They are also used in the manufacture of alkyd resins. Although at this time it appears that both sunflower and safflower oil can be safely used in the manufacture of some colors, they are not recommended for use in media and are not expected to replace linseed oil.

Driers, or Siccatives

DRIERS, or siccatives, are usually metallic salts that are combined with oils or resins and then mixed into the paint and/or medium and/or varnish to accelerate the drying time by speeding the rate of oxidation and polymerization. But it is important to remember that driers diminish the life of the paint or varnish. With good judgment and experience, however, they can be used safely. The following guidelines may prove helpful.

1. Use a drier only in glazes or in thinly painted pictures.

2. Never use more than 3 percent concentrate to media consisting primarily of a drying oil, and 6 percent to oil-resin media combinations.

3. Never apply a faster-drying paint film over a wet, slower-drying paint film.

4. Test a drier before use on something other than your final picture.

Cobalt drier, siccative de Courtrai (primarily lead linoleate), and siccative de Haarlem (primarily damar resin) are among the more common driers. Cobalt and damar are the least harmful because they work primarily while the paint is in a liquid state, their action becoming progressively less as the paint film hardens. This is not the case with lead driers, which can continue to act even after the paint film hardens. Siccative de Haarlem is safer than siccative de Courtrai because of its lower lead content and proportionately larger amount of damar resin. Similar drying effects can be obtained by mixing small amounts of faster-drying colors into slower-drying colors, for example, mixing cobalt, manganese, viridian, and lead-containing colors with slower-drying colors such as phthalo blue or lamp black.

RESINS

Resins are added to painting media primarily for three reasons. First, a mixture of drying oil and resin will offer a paint film that can be worked over within hours or, at maximum, the next day because when the solvent evaporates, which happens within several hours, the resin hardens, holding the drying oil in place until it can oxidize and solidify. Second, a resin may be used to dilute a paint for glazing without overthinning it. If a glaze is too watery, it will run uncontrollably over the painting surface. Finally, resins dry with greater clarity than drying oils and they will add brilliance to paint films.

Resins are also the primary material used for varnishing paintings. (For more information about varnishes, see pages 269 to 273.) Today, the five most commonly used resins are copal, damar, mastic, Venice turpentine, and alkyd.

COPAL

Copal is a hard resin. Originally, the copal used in painting media was the fossil resin amber. Now that amber is considered a semiprecious stone and has become virtually unavailable to the artist, the copal available for artists' use is unspecified tree-root resins. There are many grades available on the world market and the best are rarely used for making media. In addition to thickening a paint medium, adding leveling properties to the paint film, and increasing gloss, this resin also exhibits a thixotropic effect (see page 257), which is particularly helpful in glazing.

Copal is a hard resin which can only be liquified through heating with a solvent and so, when it dries, it is difficult to dissolve unless it is reheated. This is a desirable characteristic because if a protective varnish such as damar has to be removed to clean or restore a painting, this can easily be done without great risk of dissolving underlying paint films which contain the copal resin. This insolubility at room temperature also means that a copal varnish makes an excellent isolating varnish (see page 269) when applying successive glazes.

The disadvantage of copal is that it darkens with age. Although the actual reason for this darkening is not known, it is speculated that it is due to changes that occur during the heating necessary to dissolve the resin. Copal is brittle and is best used conservatively with a flexible drying oil like stand oil. The difference between a "copal medium" and a "copal varnish" is that the varnish often contains driers, which add to the risk of cracking, and therefore the varnish is not best used in making a painting medium. Today, many of the commercially made copal media have no copal at all and are composed of synthetic substitutes or alkyd resins. These substitutes are safer to use as a medium, being less brittle, but they should not be used to replace copal varnish.

DAMAR

Damar is collected from the fir tree genus *Shorea* or from *Hopea* trees of Southeast Asia. Damar is a soft resin and is readily dissolved in turpentine (not in mineral spirits, because it is then partially insoluble) at room temperature and is the most popular additive to a painting medium as well as the most commonly used resin for varnishing. Damar when used in painting media helps paint films to set up quickly so that they may be worked over within a day. It is possible to interlock paint layers by taking advantage of the two types of drying that occur with a damar-drying oil combination. Several hours after using this combination, the damar has hardened and the drying oil has begun to polymerize through oxidation. If, in one and a half to two days, when the drying oil is roughly half dry, a second paint layer containing the same medium is applied, the two layers will interlock. The turpentine of the medium when applied will redissolve part of the resin and soften the drying oil of the paint film underneath, and the two should lock together. This process can be used to produce beautiful and subtle effects. Damar also adds gloss and brilliance to a painting.

MASTIC

Mastic is an exudate from the Mediterranean mastic shrub *Pistazia lentiscus*, also known as the pistachia tree. Like damar, it is a soft resin totally soluble in turpentine and only partially soluble in mineral spirits. The use of mastic resin in painting dates back to the time of Rembrandt and the Dutch Masters and is responsible for Rembrandt's blue backgrounds now appearing green. This is due to the yellowing of the mastic he used in the application of five or six coats of varnish. Mastic is still popular today primarily as an ingredient for media (see page 264) rather than as a varnish. The yellowing effect of mastic is less pronounced when it is used in a medium and many painters feel its advantages outweigh this drawback. One of the advantages is that a mastic solution dries faster than all the resin solutions—one hour in its pure form. It also dries clearer and with more gloss than damar. Many people who use mastic use it in combination with damar, fifty/fifty in a recipe calling for one or the other. This ratio reduces the yellowing of the mastic and helps to speed the drying of the damar.

VENICE TURPENTINE

Genuine Venice turpentine is collected from larch trees. It is a viscous liquid resin; such resins exude from certain trees and are often referred to as balsams. Venice turpentine has been used in painting for centuries and has excellent handling and aging characteristics. It should not be confused with the thinners gum turpentine or rectified turpentine. Venice turpentine is used as an additive to thicken other media. This resin is popular because it gives body to the paint film while maintaining gloss and brilliance, and it yellows very little over time. Genuine Venice turpentine is not easily found and some companies are using a substitute resin called Canada balsam. Canada balsam has two advantages over Venice turpentine—it dries more clearly and it takes only one or two hours to dry, as opposed to three days for Venice turpentine. However, Canada balsam has a distinct disadvantage in that it is more fluid than Venice turpentine.

OIL-MODIFIED ALKYD RESIN

Alkyd resin is the category of resins that are made from mixtures of dibasic acids and polyhydric alcohols. There are many alkyd resins and each manufacturer picks a favorite and keeps it a secret. The quality and concentration of an alkyd resin or medium can vary a great deal from manufacturer to manufacturer. The selected resin is chemically combined with a nonyellowing oil, such as safflower oil, producing a workable, fast-drying medium. Most manufacturers add driers to speed up the drying time and silica to give extra body.

Alkyd resins can exhibit a thixotropic effect. Thixotropy is an unusual phenomenon where a gel or paste suddenly loses its plasticity when disturbed or moved mechanically, resulting in a liquid. The opposite may also occur where a liquid, left undisturbed, forms into a gel. This effect can be used to advantage during glazing by helping to prevent the glaze from spreading uncontrollably over the painted surface. However, this characteristic is undesirable with impasto techniques. Alkyd resins should not be overthinned, so add no more than 25 percent thinner to resin.

Waxes

WAX WAS USED as a base for a painting medium since the first century B.C. and remained popular until about A.D. 700. Today, there has been a resurgence in the use of various waxes in painting. These include fossil waxes, paraffin waxes, and beeswax. The use of such waxes in painting is called encaustics, or encaustic painting. The term "encaustic" is derived from the Greek, meaning "burnt in," which occurs after the painting is completed. This process involves heating the surface to remove all brush or knife marks and to fuse the painting into one solid paint film. Tradition not withstanding, this final burning process is rarely used today. The best surviving examples of early encaustic are the mummy portraits from the Egyptian district of al-Fayyum from the first century B.C. A recent use of encaustic in painting is the *Target and Flag* paintings by Jasper Johns (*c.*1955). In these paintings, the pigmented beeswax was applied in translucent layers over strips of newspaper clippings.

The primary advantage of using beeswax, which must be kept warm during application, is that the surface can be worked over as soon as the beeswax-pigment mixture cools to room temperature. Since the wax can be softened and dissolved in turpentine or mineral spirits, an encaustic painting can be reworked with a brush and thinner.

Fossil waxes are actually far more commonly used today than the more expensive beeswax. The great advantage to fossil waxes is that they do not require heat to make them pliable. Dorlands Wax Medium is made commercially of fossil wax, which can be mixed directly with oil paint. It is ready to use with or without heat and is relatively inexpensive. It hardens as the solvent evaporates, which takes several times longer than cooling beeswax. Beeswax, despite its great expense, the difficulty of finding it in a pure and bleached state, and its need to be heated, is still preferred for heavy impasto technique.

Wax media set up quickly, drying to the touch within thirty minutes, although final curing is quite slow. A wax-medium paint film will dry with a matte sheen. If desired, a semigloss appearance can be created by polishing the heated and cooled surface with a silk cloth. Surface quality has become an important consideration for many contemporary artists, who feel that surface reflection detracts from the direct experience of their work. The major disadvantage in the use of wax is the danger of melting when it is exposed to high temperatures. If you wish to retain the matte quality, remember that this can easily be lost if the surface is polished by improper handling.

Media

WHENEVER A PAINT is thinned it should always be thinned with a medium, of which the simplest form is a combination of thinner and drying oil. The amount of thinner used should be less than 50 percent of the recipe because there will always be sufficient drying oil replacing whatever might be washed away by the thinner.

A medium is chosen not just to thin a paint, but also to alter its working characteristics, drying time, and final appearance. Resins, waxes, and driers are used as additives to basic thinner-drying oil media to make these changes. No matter what formula is used to create a medium, the principle of fat over lean should never be violated in its application. ("Fat" means a medium rich in oil and "lean" refers to a medium rich in thinner. A lean medium or paint mixture should never be applied over a fat one.)

Most of the following recipes have been offered by artists who have had success using them. Some are from previously published literature to which I have made small changes, primarily to update them for currently available materials. I would like to thank all those who laid the groundwork for these recipes by their courageous experimentation with different materials on their own work.

SIMPLE MEDIA

The following diagram describes two distinctly different media. The drying oil-turpentine medium is for thinning paint mixtures and the wax-turpentine medium is for thickening paint mixtures.

DIAGRAM OF SIMPLE MEDIA

Drying Oil or Wax
(linseed oil, poppy oil, stand oil, or wax)
|
Thinner
(turpentine, petroleum distillate)

A few drops of drier may be added to speed
the drying time if wax is not used.

Drying Oil-Turpentine Medium. A drying oil-turpentine medium is the most common type of medium used. It is the simplest to make and many paint manufacturers sell it premixed. It consists of 60 percent drying oil, usually linseed oil or stand oil, and 40 percent turpentine. The percentage of turpentine should be reduced as layers of paint are built up over one another.

The disadvantage of this method is the increased drying time as the thinner is reduced and the oil is increased in the fat over lean process. Turpentine-drying oil media also have no body and tend to run down the canvas, especially in glazes. (A glaze is a paint that has been thinned greatly with a medium to disperse the pigments in the paint. This makes the paint transparent and allows the application of a thin veil of color over another.) The drying time of this type of medium is slow, from two to five days, unless mixed with driers or a fast-drying color like manganese blue.

Wax-Turpentine Medium. A wax-turpentine medium may be heated and used with oil paint or mixed with dry pigment. It is ideal for impasto technique. The wax should be warmed in a double boiler reserved for just this purpose and dry pigment may be added directly. (Keep in mind that dry pigment is difficult to handle safely and can be extremely dangerous.)

WAX-TURPENTINE MEDIUM

1 part wax (preferably beeswax)

3 parts rectified turpentine

Warm in a double boiler and stir until the wax is dissolved.
Pour into a wide-mouth container.
May be worked over in 30 minutes.

INTERMEDIATE MEDIA

The following recipes are easy to prepare and provide greater versatility than simple media.

DIAGRAM OF INTERMEDIATE MEDIA

Drying Oil
|
Thinner
(If natural resin is involved use only genuine turpentine.)
|
Resin or Wax
(damar solution, damar varnish, Venice turpentine, or wax)

A few drops of drier may be added.

Copal-Drying Oil Medium. Copal media are ideal for producing very hard and durable, although brittle, paint films that can be applied without softening or redissolving previous paint layers. This allows for an egg-temperalike effect where one color can be painted over another after it has dried without the two colors mixing.

A TYPICAL RECIPE FOR A COPAL-OIL MEDIUM

1 part copal varnish (see Copal Varnish, page 270)

1 part genuine turpentine

1 part linseed oil (Stand oil may be substituted. The drying oil reduces the brittleness of the copal resin.)

The drying rate is approximately two hours if the copal varnish used contains driers; if it does not contain driers, the drying time will be approximately 1½ days. (Please note that this means workably dry, not totally dry.)

Damar-Drying Oil Medium. The difference between this medium and that of the copal-drying oil medium is that the damar will soften and partially redissolve when successive layers of paint mixed with this medium are applied. This allows the two paint films to interlock and to appear less isolated from each other. Damar also yellows and darkens much less than copal. It is also less brittle. Damar is not as hard a resin as copal and is therefore less durable, but not sufficiently so to cause concern. The following recipe also has better leveling properties than a copal medium.

DAMAR-DRYING OIL MEDIUM

1 part damar varnish (Damar heavy gum solution may be substituted for extra thick body.)

1 part stand oil

1 to 5 parts rectified turpentine
(This proportion may also be varied for desired fat or lean quality.)

15 drops of cobalt drier may be added to every 8 ounces of medium to speed drying.

The drying time is between 2 and 3 days (without the drier).

Stand Oil-Venice Turpentine Medium. The combination of stand oil and Venice turpentine will give a thick, resinous medium with enamellike leveling properties. Glazes with this medium will be exceptionally clear and brilliant.

STAND OIL-VENICE TURPENTINE MEDIUM

1 part stand oil

3 parts Venice turpentine

0 to 3 parts turpentine
(Vary turpentine according to fat over lean principles.)

It is necessary to warm the stand oil and Venice
turpentine first to make mixing them easier.

Paint films using the formula can often be worked over
in 1 to 2 days.

Greater brilliance as well as a shorter time between
application of paint films can be had by adding some
damar heavy gum solution (this is a concentrated form,
which can be bought or made).

COMPLEX MEDIA

The following media are significantly more difficult to prepare, yet are among the most versatile.

DIAGRAM OF COMPLEX MEDIA

Drying Oil
|
Thinner
(If natural resins are involved use only genuine turpentine.)
|
Resin A
(i.e., damar varnish)
|
Resin B
(mastic solution, Venice turpentine, or wax)

A few drops of drier may be used.

Damar-Oil-Venice Turpentine Medium. This is ideal as an all-purpose painting medium. If you use less turpentine, it is excellent for glazing. Both the damar and Venice turpentine allow for the interlocking of successive layers of paint.

DAMAR-OIL-VENICE TURPENTINE MEDIUM

9 parts damar varnish (to add gloss, increase brilliance, and speed drying)

4 parts stand oil (to aid leveling and to give body)

2 parts Venice turpentine (This is a resin and its purpose is to thicken the medium and add brilliance.)

4 to 9 parts rectified turpentine (To comply with fat over lean, the amount of turpentine should be reduced to 4 parts in successive layers. Do not substitute another thinner.)

Without the addition of a drier, this medium will often be ready to work over in 24 hours. A small amount of drier can speed this up.

Linseed Oil-Mastic Media. The combination of linseed oil and mastic, called megilp, was popular in the eighteenth and nineteenth centuries as a painting medium, although it is now blamed for many of the disastrous effects seen in paintings of this period. At first, the mastic resin was thought responsible for the cracking, blistering, and browning that occurred. It is now thought, however, that these undesirable affects were caused primarily by the extended heating of the mastic resin called for in the recipe and by the excessive use of driers in combination with impure turpentine. Megilp was so popular because it appeared to dry, in some cases, in only fifteen minutes, and in several hours in heavier applications. It reportedly had a wide range of handling properties and was excellent for impasto and glazing. There has been a resurgence of interest in linseed oil-mastic combinations, and various "improved" formulas have evolved. The resurgence started in the 1930s; however, fifty years is not enough time to make an unequivocable recommendation one way or the other. Time is the only known test for such media as these. There are many variations of megilp recipes, none of which I feel sufficiently confident about to offer at this time.

Flemish medium is an example of an all-purpose painting medium made with mastic and oil that has been handed down through time. It has excellent handling characteristics, and the mastic creates a brilliantly clear paint film. The following recipe is used today with excellent results. The ingredients are similar to those used to make the infamous megilp; however, there are several important differences regarding heat, turpentine, and the use of driers—the mastic is not added until the end of heating, only rectified turpentine is used, and the amount of drier is small.

FLEMISH MEDIUM

20 parts linseed oil (cold-pressed preferable)

14 parts rectified turpentine

7 parts mastic tears, or crystals

1 part litharge (lead monoxide—This is *highly poisonous* and is not sold in art supply stores; it must be obtained through chemical supply houses. If pale drying oil, which is made with litharge, is used instead of linseed oil, then this ingredient is unnecessary.)

Mix the poisonous litharge in a small amount of oil, using a palette knife, until a paste is formed. (This will prevent the litharge from settling to the bottom of the cooking pot when it is later added.) The remaining oil should be heated outdoors or with proper ventilation over a low flame in a covered enamel cooking pan. The pan should hold twice the volume of the ingredients. An asbestos mat placed between the flame and the pan will reduce the possibility of scorching.

When the mixture is warm, approximately 320°F, or 160°C, add the litharge. Gradually increase the temperature, over 2½ hours, with the last 30 minutes at exactly 482°F, or 250°C. Stir occasionally with a wooden spoon.

Allow the medium to cool to 392°F, or 200°C, by placing the pan on a stack of old newspapers and then stirring and fanning.

Now add the mastic in small amounts, stirring constantly. The medium will foam up as you add the mastic; if stirring is constant the foam will rapidly dissipate.

Next, very slowly add the cold turpentine. The medium will again foam up; this will dissipate if stirred and fanned.

Pour the warm medium, approximately 284°F, or 140°C, into a wide-mouth container and allow it to cool before covering.

Beeswax and Oil. This combination was used by Rubens because of its extreme versatility. It could be effective in impasto or as a glaze, but the disadvantage is that it is a dark medium and tends to discolor all colors. The following is a traditional recipe which has been updated.

BEESWAX AND OIL MEDIUM

10 parts linseed oil (cold-pressed preferable)

2 parts beeswax

1/8 part litharge (lead monoxide—This is *highly poisonous* and must be obtained from a chemical supply house. However, this ingredient can be omitted if pale drying oil is substituted for the linseed oil.)

Mix the poisonous litharge in a small amount of oil, using a palette knife, until a paste is formed. (This will prevent the litharge from settling to the bottom of the cooking pan when added later.) The remaining oil should be heated outdoors or with proper ventilation, over a low flame in a covered enamel cooking pan. The pan should hold twice the volume of the ingredients. An asbestos mat placed between the flame and the pan will reduce the possibility of scorching. When the mixture is warm, approximately 320°F, or 160°C, add the litharge and broken pieces of beeswax. Gradually increase the temperature over 2½ hours, with the last 30 minutes at exactly 482°F, or 250°C. Stir occasionally with a wooden spoon.

When the mixture appears black with brown fumes rising, it is ready. Allow the medium to cool; do not refrigerate or place the hot pan on a cold surface (a stack of old newspapers works well). Pour the cooled medium, approximately 284°F, or 140°C, into a wide-mouth container and allow it to cool before covering.

COMMERCIALLY PREPARED MEDIA

Commercially prepared media have a narrow range. They are primarily simple media, although occasionally intermediate and complex media can be found. Among the most commonly offered commercial painting media is a mixture of stand oil and turpentine, which usually carries a brand name. That such media as these continue to sell, and sell in quantity, testifies to either incredible laziness or a profound lack of understanding of these materials. With the exception of these media, many of the other painting media offered by manufacturers can be a justifiable convenience. In fact, most other commercial media consist either of all or part of some version of an oil-modified alkyd resin, which would be impossible to prepare at home. The use of alkyd as well as other synthetic resins has become so widespread that they have all but replaced many of the traditional ingredients used in commercially prepared media.

Prepared media such as Liquin by Winsor & Newton, Zec by Grumbacher, and Res-n-gel by the Weber Company, are some examples of primarily oil-modified-alkyd resins. The pastelike quality found in some of these media is often due to the addition of silica. Grumbacher's Gel is designed to give body to a paint mixture necessarily speeding the drying time. Liquin behaves similarly to a copal-drying oil medium and, in fact, similar formulations have been successfully offered by other manufacturers as a substitute for this medium. LeFranc & Bourgeois offers a ready-made Flemish Medium, based upon mastic and thickened oil with oxides, which has the consistency of a gel and which is sold in tubes. It also produces a medium it calls Venetian Medium, which is a ready-made wax-oil medium prepared similarly to its Flemish Medium, except that a hard wax is used rather than mastic. This medium could be a viable alternative to preparing the beeswax and oil medium previously described.

The only serious caution I would add about thinning prepared media that contain alkyd resins is that these resins are sensitive to overthinning and can break down chemically. I recommend that you use no more than 25 percent thinner to prepared media. So far, over the past ten years, these new prepared media have demonstrated great flexibility and durability whether applied thickly or thinly.

Diluents, or Solvents

SOLVENTS ARE USED in painting primarily to thin the paint or medium, and should then evaporate from the paint film without leaving a trace. The next most important function of thinners such as turpentine is to clean tools and brushes. Keep these two principles in mind as you read the following descriptions of the various solvents.

Many thinners and solvents can be hazardous to health. They are not only inhaled and ingested, but are absorbed directly through the skin.

Gum Turpentine is made from distilling the resinous gum from pine trees. Gum turpentine usually contains a small amount of sticky residue, which can be imparted to a painting if this kind of turpentine is used in large quantities. It may remain in the layers of paint, inhibiting proper drying and, in time, causing discoloration. Unless cost is a serious consideration, I do not recommend using gum turpentine with artist-grade paints and media. It is, however, perfectly acceptable for cleaning tools and brushes.

Rectified, or Artist-Grade, Turpentine is double distilled to remove the last bit of residue from the pine-tree gum. This thinner is ideal for oil paints and media because it does the job and then evaporates from the paint film without a trace. Artists often buy the finest paints and media and then use the cheapest thinners. This is like buying a Rolls Royce and putting kerosene in the gas tank. There are areas where compromises can be made, but they should be made with common sense.

Venice Turpentine is a resin used as a thickening agent in the preparation of media. (For more information about media, see pages 259 to 266.)

Petroleum Distillate, Mineral Spirits, and White Spirits are byproducts from the manufacture and refinement of petroleum. Although they are all basically the same type of product, the actual chemical composition may differ vastly from brand to brand. This is of little concern when purchasing a product made for artists' paint such as a turpentine substitute. There can be a serious problem, however, if this solvent is used with house paints or if house paint mineral spirit thinners are used with artists' materials. Always test a solvent with a particular paint no matter what the label says.

The advantage of using petroleum distillates that are produced for artistic use is that they are less expensive than turpentine, have a longer shelf life, leave no sticky residue, and according to government standards, are less hazardous than turpentine. They are also recommended for painters who are allergic to turpentine. There are, however, two drawbacks. The first is that demar and mastic are partially insoluble in these solvents. The other is that they have a decidedly oily smell, which some people may find offensive.

Odorless Paint Thinners are essentially the same as petroleum distillate or mineral spirits except that the unpleasant odor has been removed or masked. All are fine turpentine substitutes if you avoid using them with damar or mastic.

Remember, however, that the paint thinner that is sold in hardware stores is not the same, and may contain other solvents that can destroy an artist-grade paint, ruin brushes, substantially increase health risks, or cause other dangerous or unpredictable results. One artist reports that she was using a paint thinner purchased at a hardware store, when all of a sudden the hairs were falling out of her brushes in clumps. She had been using hardware-store paint thinner without serious problems until this incident. After investigation, it was discovered that many of the solvents packaged for hardware stores under the name "paint thinner" may be changed by the manufacturer without notice. These changes may be perfectly satisfactory for hardware use, but in this case the last batch of paint thinner the artist purchased was, unfortunately, particularly good at dissolving the glues used to hold her brushes together.

Oil Spike of Lavender is one of the oldest known turpentine substitutes. It is the essential oil from the lavender plant and possesses a most wonderful scent. It evaporates more slowly than turpentine, is nonflammable, and is primarily used as a turpentine substitute by those who are allergic to turpentine. Since it is slower drying than turpentine, it is occasionally used to slow the drying time of oil paint. Its disadvantages are its extremely high cost and limited availability. Currently, the only sources of this product are Winsor & Newton, Sennelier, and Schmincke.

Varnishes

VARNISH IS RESIN dissolved in turpentine or in a mixture of turpentine and a drying oil such as linseed oil. There are several resins available with which to make a varnish, and the selection of a resin is guided by use.

Picture Varnish is used as a final coating for a painting to protect the picture and unify the appearance of the surface. It can, for example, make the surface appear either matte or shiny, or protect the paint film from chemical reactions with the atmosphere and from mechanical abrasion.

Retouch Varnish is used to give a full and wet look to the surface of the unfinished painting before work is resumed. This prevents the eye from being fooled by the unevenness of the light reflected from parts of the painting's surface.

Mixing Varnish is used as an additive to the painting medium to accelerate the drying time, to add gloss, and to give body to a glaze.

Isolating Varnish is a resin that is insoluble in turpentine or mineral spirits. When this varnish is applied to a paint film, it will protect it from being affected by the turpentine or mineral spirits in the next layer of paint to be applied.

TYPES OF VARNISHES

The following are descriptions of various types of varnishes and their uses. Commercially prepared varnishes are readily available, or varnish can be made from recipes given in this section.

Damar Varnish is the most popular of all varnishes and is used as a retouch, a mixing, and a picture varnish. It does not bloom (develop a chalky appearance) and it yellows less than most natural resins. Damar varnish can be readily purchased already prepared or you can prepare it according to the following recipe.

DAMAR VARNISH

1 part crushed damar resin wrapped in muslin

4 parts rectified turpentine

Leave wrapped resin to soak in the rectified turpentine for 1 or 2 days, or until the resin has dissolved.
Filter if necessary.

Dries in approximately 1 hour.

Mastic Varnish is clearer than damar and can be applied more easily. However, it does tend to bloom (develop a chalky surface) in humid climates, as well as yellow more than damar. Mastic and mastic varnishes are much more expensive and harder to come by than damar. Today, mastic is usually used as a mixing varnish and rarely as a picture varnish. A mastic solution (concentrate) for painting as well as a varnish can be prepared from the following recipe.

MASTIC SOLUTION
(from which the varnish is made)

1 part mastic tears (The better mastic comes in the form
of tears, or little round balls.)

3 parts rectified turpentine (The best turpentine should be used, especially if the varnish will be used in painting.)

The preparation of mastic solution is sensitive to impurities and heat. The mastic tears should not be crushed to speed the process. The tears should be suspended in a gauze bag or nylon stocking and allowed to dissolve without use of heat. This takes 1 or 2 days.

Mastic has a more stable shelf life as a solution (heavy gum solution is best) than as a varnish. Therefore, you may wish to consider diluting a mastic solution to make the varnish. This may be done by adding 1 part rectified turpentine to 3 parts mastic solution.

Mastic varnish will dry in 1 hour.

Copal Varnish and copal medium are becoming increasingly difficult to find because amber has become semiprecious and rare. It is being replaced by such synthetics as alkyds or unspecified tree-root resins.

Copal varnish makes an excellent isolating varnish, when used in moderation, and a very hard-surface final varnish. However, copal varnish is more often produced as a convenient source of liquid copal for use in media than as a final

protective varnish. Since it has been found that copal varnish darkens and often cracks with age, even without the driers that are commonly added, most recipes call for the use of stand oil or sun-thickened oil to reduce the risk of cracking. The following is a recipe for copal-oil varnish.

COPAL-OIL VARNISH

2 parts dry copal resin

3 parts stand oil or sun-thickened oil

The oil should be heated to approximately 482°F, or 250°C, for 45 minutes to 1 hour. A sign of readiness is the darkening of the oil. Heat copal resin separately until it melts (between 356° and 644°F, or 180° and 340° C). Then slowly add the hot oil, stirring with a wooden spoon. Allow the medium to cool, then store in wide-mouth bottles.

Shellac is a resin gathered from the lac insect, *Laccifer lacca*. The best shellac is called "true orange shellac," and it is not dyed to look orange. Shellac is insoluble in turpentine, but is soluble in alcohol. It dries to a hard, tough, flexible film when applied to something other than the surface of a painting. On paintings it tends to crack and to darken with age. It can be useful as a sizing or an isolating varnish between paint layers (especially egg tempera). It is also a good, cheap fixative for charcoal and other drawings. It dries in about thirty minutes.

Synthetic Varnishes are, in most cases, composed of ketone or acrylic resins dissolved in mineral spirits. The advantages are that they dry rapidly, are crystal clear (unless a wax is added to create a matte finish), and are nonyellowing. The disadvantage is that, with the exception of polycyclohexanone, they can be used only as a picture varnish.

Polycyclohexanone is a synthetic damarlike resin, developed recently in Germany, that can be used alone or in conjunction with damar for media or varnish. It is prepared in the same way as damar. The advantage is that it is optically clearer than, and yellows less than, damar. It also forms a harder and more durable paint film. However, it is slightly more brittle than damar and, consequently, is often used with other, more flexible resins. The polycyclohexanone adds clarity, and resins like damar add flexibility.

Soluvar is a synthetic varnish composed of acrylic resin produced by Binney & Smith Company, which is available in both matte and gloss. It is used as a final, protective picture varnish on both oil paintings and acrylic paintings. It is receiving greater recognition because it can easily be removed if the picture needs to be cleaned or restored.

Matte Varnishes are made by adding to a varnish a flattening agent, which is usually a wax (such as beeswax or a fossil wax) or a waxlike substance such as aluminum stearate. Winsor & Newton's wax varnish and Dorland's Wax Medium are thick and are applied by rubbing the medium onto the surface of the painting and polishing it with a soft brush or silk cloth when dry. Liquid matte varnishes are made by suspending a wax in a varnish. The application of this kind of varnish is facilitated by warming the varnish until the cloudiness disappears and then applying it with either a soft brush or a warmed airbrush.

The advantage of a matte varnish is that there is no surface glare to interfere with viewing artwork. This has become an important consideration for many contemporary abstract artists. A slight sheen can give the illusion of a secondary color where there is none. This is less of a consideration in figurative artwork where there are usually many variations in color and shape, which help to camouflage the shiny spots on the surface.

The disadvantages of matte varnish are that too much can leave a milky or cloudy appearance on the surface, which is also easily damaged by rubbing.

APPLICATION OF VARNISHES

When applying varnish, the first consideration is whether the painting is really dry. Although a painting may feel dry to the touch within days or weeks, the layers below the surface may not be thoroughly dry. A paint film dries by reacting with the oxygen in the air. If a painting is varnished before this reaction is completed in the paint layers below the surface, these paint layers are sealed off from their source of oxygen and cannot complete their drying process. The painting may remain soft and sticky for a considerable length of time and, with improper drying, the paint film may not bond properly to other film layers. Another problem caused by premature varnishing is that the solvent of the varnish may penetrate the paint layers that are not completely dry, thus softening them and affecting the appearance as well as the stability of the paint films.

Most paintings of average thickness and painted with a lean medium will be ready for varnishing between six months and a year after completion. Unless driers were used throughout the painting, one year is usually the safest choice when in doubt. If the paint is thick, one year will not be long enough. Never heat or place a painting in the sun to accelerate the drying process. Because drying of oil paint is a chemical reaction with oxygen, rather than evaporation, rushing the process can cause wrinkling and other horrors. It is best to store the painting where there is light, ventilation, warmth, low humidity, and loving care.

Paintings that must be displayed before they are thoroughly dry can be shown either unvarnished or coated with a retouch varnish, which will even the surface appearance and will provide some protection. It will also slow the ultimate drying time, but will not prevent proper oxidation.

During the lengthy drying process, the surface of the painting may collect dust or dirt, which must be removed before varnishing. Any cleaning must not involve the use of water because the water can penetrate the paint layers, thus

reaching the ground and causing it to swell. This will weaken the bond between the ground and the paint and can result in serious cracking. The best way to remove dust is first with a feather duster or a pigeon wing. Then take a loaf of fresh bread and pull out the center, squeeze it into a ball, and roll this over the surface of the painting. If there are slight grease stains, they may be removed by blotting with mineral spirits. If there are problems beyond those described here, professional advice is preferable to experimentation.

When the painting is dry, has a clean surface, and is in a dust-free, dry, warm environment, the varnish can be applied. The two basic methods of application are spraying and brushing. Spray varnishing can be successful when applied to a surface that has a minimum of texture, but a spray cannot cover textural irregularities as well as a brush. If a spray is held too close to the surface, the application will be too heavy and may run or pool. If the spray is too far from the surface, some of the particles of spray may partially dry en route to the surface and give it a frosted or powdered look. If you begin to spray off the surface and then move evenly onto the surface, pooling can be avoided on the surface because the areas where you start, stop, or change direction will be outside the painted area. Two thin coats are superior to one thick coat.

For textured and irregular surfaces, brush application of varnish is best. The varnish can be worked into areas that are not easily accessible with a spray. For a heavily textured surface, a hog or bristle brush is necessary to force the varnish into difficult areas. Ox hair is excellent for smoother surfaces.

After the application of the varnish, the painting should be laid flat to dry for one or two days. The surface should be protected from falling particles and dust. This may be accomplished by laying a board over some books or strips of wood placed on opposite sides of the painting. This will bridge the painting and will keep the protective covering a few inches off the surface.

FRAM
AND ST

For the artist, dealer, and collector the primary purpose of picture framing is to protect artwork, which is often an expensive proposition. In the past, mostly for economic reasons, protecting the artwork was often given a low priority and, in some cases, even ignored. Recent lawsuits, however, involving the deterioration of artwork through improper framing and storage have helped put things back into perspective.

Artwork, if it is to have a reasonable chance of surviving decades or even generations, needs to be protected from acid air pollution, acid migration, mold, excessive humidity, ultraviolet light, infrared light, dramatic changes in temperature, insects, and metals such as iron and copper. Attempting to protect artwork from all these things is difficult, even for a museum with unlimited funds. Deciding what is reasonable protection for a particular piece of artwork that you have created or collected involves balancing various levels of protection against economic necessities. Complete protection can cost more than the current as well as the future value of the artwork. The level and type of protection selected should, therefore, be based on the type of damage that is most likely to occur. For example, framing an oil painting executed on canvas with a sheet of ultraviolet-light-filtering acrylic when the artwork will be exposed only to normal room lighting seems extreme. Since more artwork is seriously damaged by being framed or stored in contact with nonarchival materials, it would seem this area should have the highest priority.

Conservation framing, particularly with artwork executed on paper, can create an almost self-contained environment that provides reasonable protection against the most common hazards like acid pollutants, acid migration, mold, and insects.

I have compiled several rules, as well as reasons for the rules, which relate to the proper protection of paintings and drawings. If these guidelines are followed or modified, with common sense, to your own needs, your artwork should be reasonably protected. I have also supplied the latest technical information about the materials used for framing. (The chapters *Paper*, pages 85 to 111, and *Paper Boards*, pages 113 to 125, as well as the section on the application of varnishes, pages 271 to 273, should be read before proceeding.) All this information will allow you to make a balanced decision about the protection a particular drawing or painting needs.

It is important to understand that the whole area of conservation framing, particularly of paper, has developed only recently. New materials for framing and conservation are being invented all the time, and guidelines for their use are constantly redefined. Until the nineteenth century, when papermaking machinery was invented, paper was not a material commonly available to artists. This invention made paper easily affordable and profitable for the first time. What followed was a great conversion of papermaking materials from primarily rag and linen to ground-wood pulp, which was sized with an alum-rosin combination. This conversion to less permanent and highly acidic materials peaked during the 1860s and its significance did not become clear until the turn of the century. Prevention and cures for the problems associated with the use of these materials were slow to develop, and it was not until the late 1960s that information on conservation framing began to appear in trade magazines for framers and artists. Unfortunately, most framers, as well as most artists, have not kept up to date and continue to use materials improperly or to use the wrong materials altogether. It is therefore entirely possible to find a frame shop that has been owned for generations by the same family producing fine-looking framing, yet using materials that not only do not protect the artwork but accelerate the aging process.

If you are not already a picture framer, this chapter is not designed to turn you into one. However, if you are an artist who wishes to protect your artwork properly, or a collector wishing to protect your collection, this chapter will help you understand the logic behind why and how certain materials and procedures are used in framing and storage.

Rules Concerning Paper Art

MATTING WAS originally developed as a method of protecting artwork by isolating the surface of the artwork from the surface of the glass, as well as away from the edge of the wood frame.

This is important because the glass tends to condense moisture and provide an ideal environment for mold to grow on the surface of the artwork. Also, wood becomes increasingly acidic over a period of time and acid migration can occur to the artwork. It was some time after its functional invention that the decorative qualities of matting seemed to overcome the original purpose. If a mat is considered undesirable for whatever reason, some means of separating the surface of the artwork from the surface of the glass is still necessary. Setting the artwork back away from the glass can be accomplished by using a wood or plastic spacer of approximately ¼ inch along the frame between the backing and the glass.

In setback framing, I mount the backing board to the support board, because I have seen too many backing boards creep out from the edge of the setback material. This happens because of mishandling or the natural expansion and contraction that these boards may undergo with changes in humidity. Particularly with setback framing, contemporary galleries often frame with wooden support bars built into the back of the picture frame for added strength.

Cross Section of Framing with a Mat

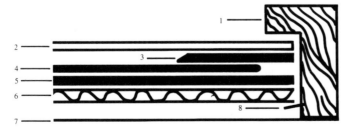

1. FRAME
2. GLASS OR PLASTIC
3. MAT
4. ARTWORK
5. BACKING BOARD
6. SUPPORT BOARD
7. PAPER DUST COVER
8. FASTENER (nail or staple)

Cross Section of Framing with a Setback

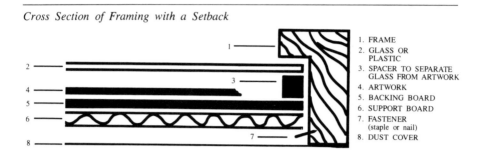

1. FRAME
2. GLASS OR PLASTIC
3. SPACER TO SEPARATE GLASS FROM ARTWORK
4. ARTWORK
5. BACKING BOARD
6. SUPPORT BOARD
7. FASTENER (staple or nail)
8. DUST COVER

This is often necessary for frames that are large and/or will be handled a great deal. Support bars are a particularly good idea when glazing with clear acrylic sheeting in larger sizes because plastic sheeting tends to bow and can pop out of a picture frame.

The following rules apply to most paper, fabric, and any work that needs to be protected from the atmosphere and mechanical abuse.

1. *Never mount permanently any valuable or potentially valuable artwork,* unless the artwork requires the support, such as a collage or a piece of artwork that cannot support its own weight. If it cannot be held in two places without risk of tearing or distortion, it should be considered for mounting. If you do choose to mount, you should regard the artwork and the mounting board as one piece permanently.

The definition of conservation mounting seems to be undergoing some revision. The old definition is that the adhesive should be pH neutral, water reversible, and of vegetable origin. The original reason behind the use of vegetable-based adhesive was that other pastes were of animal origin and tended to become acidic as they aged as well as less reversible with water. The pH neutrality is important because acidity breaks down cellulose and weakens the paper. If there are lignins (the natural glues that hold plant cells together) still present in the paper, the paper will turn brown. Acidity can also affect many dyes and pigments dramatically by changing their colors. Recent studies show that an adhesive may appear to be pH neutral to start with, but that there are no guarantees it will remain so over many years. Reversibility with water was important to conservators because the adhesive could easily be washed out without damaging the artwork. Today, however, a large variety of materials may be used to produce a piece of artwork. There are many pieces that would be destroyed or seriously altered if washed in water but would not be if washed in other solvents. Finally, there are now chemical adhesives that indicate the possibility of aging characteristics equivalent to vegetable-origin adhesives.

So, you may ask, "What do I do?" If you must mount the picture, decide which will affect your artwork the least—water or organic solvents. Watercolors, for example, would be affected less by organic solvents, while etchings would be less affected by water, if removal of the artwork from the support became

necessary in the future. Select an adhesive that has a good record for nonyellowing and for maintaining pH neutrality over time, and that will be least harmful to your artwork if you have to remove it.

2. *Never use pressure sensitive tapes, such as masking, drafting, magic, surgical, and packing tapes.* All these tapes will self-destruct and severely damage artwork wherever it is touched by the tape. There are currently only two exceptions to this rule—tapes produced under the name Filmoplast by Hans Neschen GmbH & Company in Germany and Archival Aids Document Repair Tape made by Ademco Products in England.

3. *Never secure artwork in more than two places.* Exceptions to this rule should be made only with extremely wide pieces and with the understanding that for every additional place the artwork is secured you risk having twice the number of ripples. This is because the natural expansion and contraction of paper from variations in temperature and humidity will be restricted. Recommended methods for securing artwork will be discussed later.

4. *Never use any ground-wood pulp-board or paper, chipboard, or cardboard as backing or storage for artwork.* These boards, especially corrugated cardboard and chipboard, are highly acidic, contain iron and copper, and have been known to damage artwork, even without direct contact. The acids can even bleed through four-ply museum boards.

5. *Never use conventional wood pulp boards for matting or backing of original or valuable artwork. Instead, use museum or conservation boards.* Unless the boards are of 100 percent rag or are of lignin-free alpha wood pulp that has been buffered to remain acid-free, they will damage the artwork. Such damage can be seem as soon as six months, and may in some cases be irreversible. Pulp boards may be used only if they are not in direct contact with the artwork and are separated by a four-ply museum or conservation board. With matting, the edge of museum board should extend at least ¼ inch past the edge of the wood-pulp board to prevent any acids in the wood-pulp board from cascading over the edge of the museum board.

Cross Section of Framing with Strainer

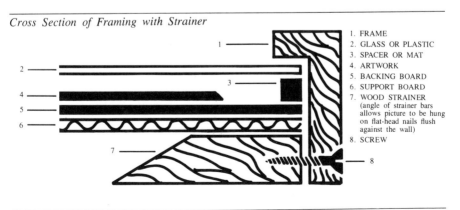

1. FRAME
2. GLASS OR PLASTIC
3. SPACER OR MAT
4. ARTWORK
5. BACKING BOARD
6. SUPPORT BOARD
7. WOOD STRAINER
 (angle of strainer bars allows picture to be hung on flat-head nails flush against the wall)
8. SCREW

6. *Never use single-strength glass larger than 36" × 48".* If you have not already guessed the reasoning behind this rule, you should first consult an insurance agent regarding the extent of your insurance coverage.

7. *Never glaze with acrylic sheeting for artwork done in charcoals and/or pastels.* Plastic sheeting can develop a powerful static electrical charge and can lift a significant amount of material off the paper on to the plastic surface. You should also be aware of the fire hazards of plastic sheeting and its ability to give off poisonous gases when burning with insufficient oxygen.

8. *Never put original or valuable artwork, especially glossy photographs and acrylic paintings, in direct contact with the glass in a picture frame.* Glass tends to collect moisture on its surface, and when it comes in contact with the surface of paper artwork it can provide an ideal environment for the growth of mold. Foxing, which is the appearance of small brown spots on artwork, is most often attributed to mold. However, foxing can also be caused by iron deposits in reprocessed wood-pulp backing boards. Photographs and acrylic paints, primarily due to the nature of their surface films, tend to adhere to glass over a period of time and the surface of the artwork can be damaged if the picture has to be removed.

9. *Never allow the edges of a piece of artwork to touch the edge of a wood frame.* Wood has lignin, which breaks down and becomes acidic. Moreover, many woods, such as oak, are naturally highly acidic. The artwork should be at least ¼ inch away from the edge of the wood.

10. *Never cut, trim, or in any way alter an original piece of artwork without the clear consent of the owner.* In California, it is a violation of the law even for the owner to alter a recognized piece of artwork without the consent of the artist! California passed the Art Preservation Act of 1979, which was amended in 1982 and became the model for similar acts in New York and Massachusetts. The law provides for actual and punitive damages as well as attorneys' fees for willful disfigurement or destruction of fine artwork.

11. *Leave restoration to a recognized professional restorer.* Most professional restorers spend a great deal of their time correcting the work of self-appointed amateurs.

Rules
Concerning
Art on Canvas
and Panels

ARTWORK DONE with oil paint or acrylic is usually painted on a support of stretched or mounted canvas. In a small percentage of cases it is painted on wood or metal panels. This type of artwork, if properly varnished, does not have to be framed with glass because the surface is more easily cleaned and is less subject to permanent damage from mechanical disturbances. Nevertheless, a certain amount of additional protection is needed, which can be supplied by the edge of the moulding used to make the picture frame. The moulding covers the edge of the painting and protrudes above the surface of the painting. This helps to protect against the most common form of mechanical abuses and problems in handling.

Paper artwork, from the outset of its development, was framed for protection first and for decoration second. This is not true in the case of early frescoes and paintings done on panels. The earliest picture frames were made to create a focal point or atmosphere in which the artwork could be seen. The oldest known frames were doorways or archways that served as a focal point through which to view a scene or to outline some architecture, as well as serving as an entrance or exit. Today, a carpenter's term for the process of installing a door is still "framing a door." It was not until the late seventeenth century, when painting had developed the technology to be portable, that the notion of protection came to be a major consideration. The following rules apply to art on canvas and panels with oil paints or acrylics.

1. *Never attempt a perfect fit; you must leave sufficient breathing space for expansion and contraction of the artwork and the materials used in framing it.* The standard allowance for paper art with glass is $1/16$ inch and for stretched art it is ⅛ inch if possible. Some commercial mouldings, because of the width of the "rabbet" (the lip of the moulding into which the artwork is installed), do not allow for ⅛ inch and you may have to settle for $3/32$ inch to prevent the edge of the picture from showing. The larger allowance is recommended because stretched artwork is not sealed from atmospheric conditions and is more subject to variations in temperature and humidity. In addition, the wood or metal used

Cross Section of Framing a Stretched Painting

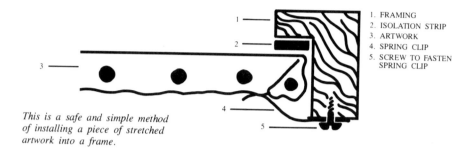

1. FRAMING
2. ISOLATION STRIP
3. ARTWORK
4. SPRING CLIP
5. SCREW TO FASTEN SPRING CLIP

This is a safe and simple method of installing a piece of stretched artwork into a frame.

as a support for the painting is rarely the same as that used for the frame. Consequently, each will expand and contract differently and will need the allowance so that one does not restrict the other and lead to warping and damage.

2. *Never nail, toe nail, staple, or screw into or through a canvas support to secure a picture to a frame. Do not do anything that rigidly locks the two together.* After you have given an appropriate allowance, you should not defeat it by locking the picture to the picture frame or weaken the support by drilling or nailing. One desirable method employs flat metal strips that attach to the frame at one end, while the opposite end can be bent over the back of the stretcher bars or the back edge of the panel, as shown in the illustration above. These strips should be strong enough, after being bent into shape, to act like springs to hold the artwork into the frame with pressure.

Another method employs triangular steel spring wire clips (see the illustration right), which if used in a similar manner will accomplish the same results.

There are two advantages to this method of installation. One is that the picture is secured, but still allows for expansion and contraction. The other is that the spring clips or metal strips can be swiveled in or out of place and the picture can be installed or removed easily without damage to it or to the frame.

3. *Never put the surface of a valuable piece of artwork directly against wood moulding; use strips of four-ply museum board or felt to isolate the two.* It is possible that the finish, gilding, or even bits of wood might adhere to the surface of the painting. Most conservators feel that although the felt or museum board may also adhere to the surface, it is easier to remove from the artwork without damage.

4. *Never put screw eyes into the support or the auxiliary support of the painting, but into the frame.* It is popular today to use thin mouldings to frame paintings. This makes this rule difficult to comply with. If the painting is very heavy, and the auxiliary support is required to bear the weight of the frame as well as itself, it may warp.

Even if weight is not a serious problem, the installation of screw eyes or brackets may weaken the support. However, if you must screw or nail, drill first carefully before screwing them in so that the auxiliary support does not split.

5. *Never attempt to restretch an old canvas or unwarp an old panel. This comes under the heading of restoration.* As a painting ages and the paint film becomes more brittle, all mechanical adjustments can produce fine cracks that may not be seen at first. These cracks will inevitably become larger and more serious. A professional restorer knows how to soften the paint film carefully to make the necessary adjustments slowly. If the painting is still in the earlier stages of curing (three months to one year), adjustments may be made with less risk. This may be done by warming the unstretched painting on the back with an iron, set on low, to soften the paint film, but be aware that this will rob the painting of some of its life. Then the painting may be stretched, but not too tightly. Whenever possible I do this part by hand, because pliers may exert too much tension, especially on small canvases.

Spring Wire Clips in Framing

1. BACK OF STRETCHED CANVAS
2. BACK OF FRAME
3. SPRING WIRE CLIPS

Results of Attaching Hanger to the Auxiliary Supports (Stretcher Bars)

ADDITIONAL NOTES ABOUT STRETCHED ARTWORK

Should the back of a stretched canvas painting be sealed? A stretched work must breathe, so sealing the back can seal in moisture and dust, which may lead to mildew. Sealing also prevents easy inspection for the many problems that can arise. Nevertheless, the greatest dangers to a stretched artwork are dents, perforations, and tears from accidents and mishandling. If you feel that you need the extra protection of a backing, there is one method you should consider. Select a thin board—chipboard, masonite, or plywood, drill holes in it for air circulation, and place gauze over the holes to prevent dust from entering. This backing can be fastened to the frame along with the painting either by using spring clips, or by installing a strainer as shown below.

Stretcher bar keys are little triangular pieces of wood, which are placed into the inside corner spaces of the stretcher bars and are tapped into place to force open the corners. This creates slightly more tension, which will remove sagging and wrinkles. Before hitting the keys, put a piece of cardboard between the canvas and the stretcher bars. If you slip, you will not damage the painting. Remove the protective cardboard pieces after you have adjusted the keys. On older paintings, even small dents may lead to serious cracks over the years. Just because you cannot see damage now does not mean it has not taken place. After

Installation of Protective Backing

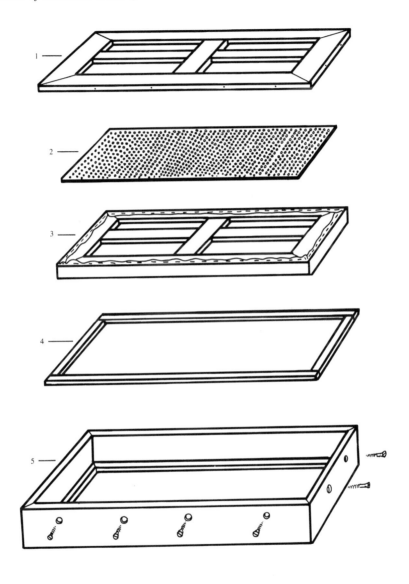

1. SUPPORT BACKING WHICH IS ATTACHED TO THE FRAME WITH SCREWS
2. PEG BOARD (fiberboard with holes)
3. PAINTING ON STRETCHED CANVAS
4. FELT OR MUSEUM BOARD LINING TO ISOLATE THE PAINTED SURFACE FROM THE FRAME
5. FRAME

your protective board is in place, give the keys a few gentle taps. If the wrinkles do not come out easily, give up!

Although it is rare that stretcher bar keys can fall out and locate themselves between the inside of the canvas and the stretcher bar, most conservators will take some precaution against this. There are two methods. The first one is to place tiny screw eyes in the keys and support bars and connect them with wire. The other is simply to tape them to the stretcher bars. The tape method is riskier because most pressure-sensitive tape adhesives age poorly, weaken, and fail.

Taping Keys to Stretcher Bars

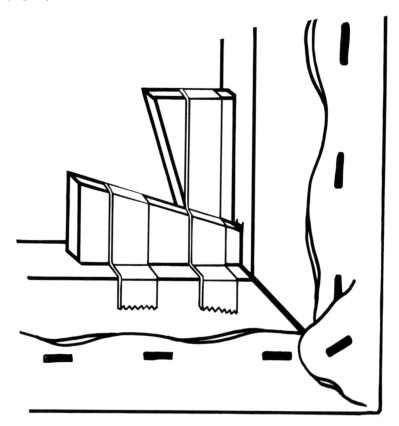

Technical
Information

IN THE FOLLOWING, the properties and proper uses of the primary material used in framing are explained. There are two basic methods of mounting artwork, and various materials are available for each method. Also discussed are the types of glass, plastic, and moulding that can be used in picture framing.

MOUNTING SYSTEMS

A mounting system is a method of holding a piece of artwork in place. Artwork can either be hinged, which involves attaching it loosely so that it can easily be removed, or glued flat.

Hinge Mounting has the function of securing the artwork either to the backing board or to the mat board without permanently altering the artwork. Hinges should also be removable with either water or a small amount of alcohol. A hinge should be made of a stable material with sufficient strength to hold the artwork in place, yet it should tear free if the picture is dropped. The reasoning behind this is that it is better for the hinge to tear than for the artwork to tear. The most common materials used for hinges are Japanese rice papers, archival pressure-sensitive tapes, and linen tape.

Japanese papers made from the traditional fibers have been known for their pH neutrality, strength, lightness in weight, and excellent aging characteristics. Today, however, most Japanese papers are no longer made from only the bast fiber of kozo, mitsumata, or mulberry. Sulfite pulp is commonly used as a filler in many of the traditional papers and, in some instances, the paper is all sulfite pulp. It is therefore important to establish the content of the Japanese paper when selecting it to use as a hinge for fine artwork.

One reason the Japanese papers are selected for making hinges is that when they are hand torn they give a frayed edge. When attached to the back of artwork, this kind of edge tends to show less on the front side. The adhesion of the artwork to the hinge is accomplished with the use of a water-based adhesive, such as the one described below. Careful control of the amount of paste is important or the moisture may deform the paper, which will show up as little bumps on the front side of the artwork.

The following is a recipe for the preparation of a wheat- or rice-starch paste and the making of a Japanese-paper hinge.

WHEAT- OR RICE-STARCH PASTE

1 level teaspoon deglutinated rice or wheat flour

$1/8$ cup distilled water, at room temperature

1. Mix enough distilled water with the flour to form a mixture that has the consistency of heavy cream.

2. Boil the remaining water and add it to the mixture, stirring constantly.

3. Heat the mixture, in the top of a double boiler, stirring constantly until the mixture clears and thickens.

4. Tear up rice paper made of pure kozo fiber into the shape of small rectangles (the size depends on the weight of the artwork and your level of experience).

5. After the paste has cleared, thickened, and cooled, apply the paste in a thin coat to the hinge. Allow the adhesive to penetrate the hinge and dry out slightly. At this point it may be attached to the artwork, mat, or backing with the aid of a brush or a piece of card stock.

6. Immediately after application, apply pressure or a weight protected by a slip sheet until dry, usually between 30 and 40 minutes.

The illustration above right shows the wrong way to attach artwork to the mat or backing. This procedure will trap the artwork, and will eventually force the artwork to develop ripples and buckles. The illustration below right shows the right way to attach artwork. The figure on the left shows how to attach it to the mat and the other shows the hinges hidden with the artwork floating on the backing.

There are two types of hinges. One is the folded hinge and the other is the pendulum hinge. The illustration on page 290 shows both types.

The folded hinge has the advantage of allowing the artwork to be lifted more easily to inspect the back. However, folded hinges have the disadvantage of holding the artwork rigidly at the point of attachment. This can result in a small but noticeable ripple between the two hinges. I prefer the pendulum hinge.

Although this hinge may make it more difficult to inspect the back of the artwork (in any case, this is rarely necessary), it does allow the artwork to hang with less restriction. I feel the pendulum hinge results in a more lasting, natural appearance.

Whatever material you choose for your hinges, the hinges should be ½- to ¾-

Wrong Method of Attaching Artwork to the Back of a Mat

Correct Method of Attaching Artwork to a Mat or Backing

A. ARTWORK ATTACHED
TO THE BACK OF A MAT

B. ARTWORK ATTACHED
TO BACKING WITH
HIDDEN HINGES

inch wide and in the shape of a T. This T shape, or pendulum hinge, allows the artwork to breath.

The new, archival, pressure-sensitive tapes have the great advantage of easy application. Since it is a dry transfer, requiring no water for application, there is no risk of bumps or ripples showing on the front side of the artwork. The disadvantage is that most of these tapes are not as easily water-reversible as the manufacturers would have you believe. The tapes produced under the name Filmoplast become less reversible as they age, and sometimes require the assistance of alcohol for removal. At this time I feel that this is not a serious drawback. Filmoplast comes in three weights. Filmoplast P is the lightest weight, and is intended for document repair and the lightest of hinging jobs. It should be

The Folded Hinge

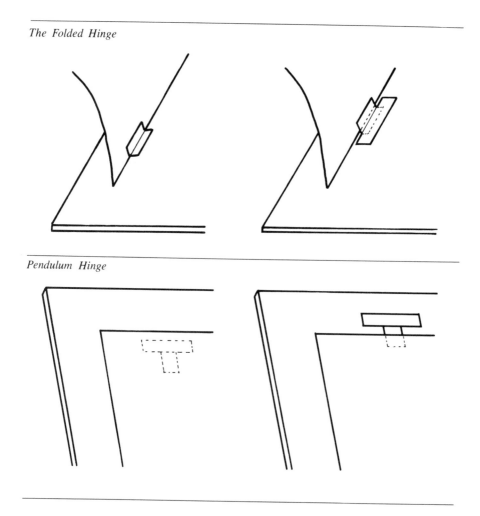

Pendulum Hinge

lightly burnished after application. Its adhesive strength improves a few days after application to allow you to correct any errors in application. Filmoplast P-90 is the medium weight of these tapes and the most commonly used. It should also be burnished lightly after application even though this tape has a much higher tactile strength. (In other words, it is stickier.) Filmoplast SH or SHIRTING is the heaviest. It is composed of a linen carrier and should be used only when you do not wish the tape to tear or break free. This tape should also be burnished to activate it.

A product similar to Filmoplast P is made under the name Archival Aids Document Repair Tape by Ademco Products in England. This product has a high tactile strength (much stickier from the outset), and is alcohol-reversible. It is thin and translucent in appearance. Because of its light weight, its tendency to become invisible, and its high tactile strength, it works well with delicate pieces such as artwork on thin rice papers. You should be cautioned, however, that

because of the high tactile strength, repositioning is difficult without dissolving the adhesive with alcohol.

Lineco Inc. has recently introduced several new products for archival framing. Among them are an acid-free gummed linen tape, a self-adhesive (all their self-adhesive products are based on an inert acrylic adhesive) linen cloth tape, a pressure-sensitive frame-sealing tape, a gummed sealing tape, a self-adhesive mounting/hinging tissue, and archival mounting corners. All of these products look promising and will, it is hoped, deserve and win acceptance.

The illustrations below show two methods of attaching paper artwork to a mat with backing.

The illustration on the left shows the artwork hinged to the backing with the mat folding over the artwork. It is more difficult to keep the mat registered over the artwork using this style, but it is safer if the matted artwork will be handled a great deal. The illustration on the right shows the artwork attached to the mat itself. This method allows precise registration of the artwork, but more care must be taken. Both styles have the backing taped to the mat with a linen tape (this is more commonly done when a piece of artwork is matted but not framed).

The illustration below shows a suggested attachment of a Cibachrome photographic print to a backing before the mat is placed over it.

Cibachromes are notorious for their ability to expand and contract with the slightest change in temperature and humidity. The one hinge with four corner envelopes has given the best results of any method I have used so far. It works especially well on large prints. Lineco Inc. produces an archival mounting corner made from strips of Mylar® that have been prescored for folding. The ends have a nonyellowing, pressure-sensitive adhesive, which fixes the hinge to the backing board.

Dry Mounting is the use of a dry tissue adhesive that is activated by heat from a heat press or an iron to bond artwork or a piece of fabric to a mounting board. The tissue is placed between the object to be mounted and the board. A high

Installing Artwork into Mat with Backing

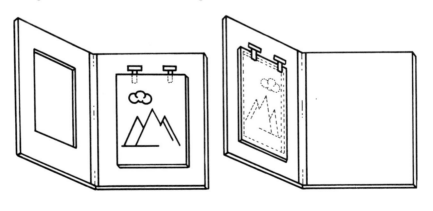

Installation of Cibachrome-type Prints

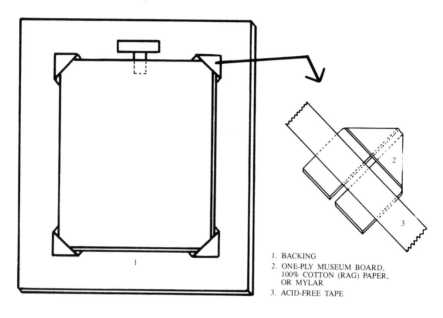

1. BACKING
2. ONE-PLY MUSEUM BOARD,
 100% COTTON (RAG) PAPER,
 OR MYLAR
3. ACID-FREE TAPE

temperature is used to liquify the tissue. Depending on the type of tissue used, the bonding occurs in the press or after removal.

Dry mounting is primarily used to mount photographs, posters, and any artwork that is water-sensitive. This system of mounting flattens the artwork to give a clean look. It is easier, faster, and more versatile than wet mounting. The disadvantages of dry mounting are that it is not reversible in some cases and not easily reversible in other cases. If it is reversible, it is not reversible in water. The high temperatures often attained in dry mounting may cause bubbling and may prematurely age photographs as well as scorch fabrics. Dry mounting is not generally considered an archival method of mounting. (Photographs dry mounted to museum board are considered an exception to the rule by some conservators of photography collections.)

Dry mounting is a rapidly changing field. There are continual improvements and nothing should be taken for granted. The current leading supplier to the framing industry is Seal Inc. The type of products it offers and the evolution of its products provide us with a ground for comparison. The use of its product names in the following discussion is for convenience and is not a product endorsement.

Fotoflat is a removable, thermoplastic adhesive tissue, which was developed more than thirty-five years ago. It consists of a piece of thin tissue paper, which is used as a carrier for the adhesive which has been sprayed on both sides. The adhesive melts at 180°F to 225°F (82° to 107°C) and has the advantage of not scorching and providing ease of removal with low heat. It bonds as it cools, at

about 150°F (66°C). The disadvantage is that mounted works exposed to the heat of direct sunlight or left in a hot car could separate from the mounting board.

MT5 is a nonreversible (cannot be removed) adhesive tissue used for permanent mounting. The bonding is activated between 225°F and 275°F (107°C and 135°C) and must be cooled under pressure. This tissue overcomes the problem of accidental separation in exposure to heat. It may, however, injure the artwork because of the high temperatures needed for the mounting process.

ColorMount was developed to work with resin-coated photography papers that came on the market in the 1970s. This tissue must be used within a narrow temperature range, 195°F to 205°F (91°C to 96°C). If the temperature rises to 212°F (100°C) the moisture in the photograph will begin to boil and the resin coating will prevent its evaporation, thus creating blisters and bubbles. Temperature-indicator strips can help check the temperature settings.

Fusion 4000 is a newly developed thermoplastic without a tissue carrier. It is designed to resolve the problems inherent in the other products, which it does, but it also has some working difficulties of its own. The adhesive tends to be a bit runny in the press when it melts. This means that the artwork could shift position slightly, and/or some of the adhesive could be transferred to the face of the artwork if the instructions for use of cover sheets are not followed precisely. Bonding takes place while cooling under pressure.

To prevent bubbling in the use of any of the products mentioned, it has been suggested that the mounting board and artwork be predried in the dry mount press for best results.

The attempt by 3M to deal with the multitude of problems presented by dry mounting has resulted in a product it calls ProMount. This product was introduced in 1979 for general-purpose mounting and for the mounting of resin-coated photographs and Cibachromes. The manufacturer makes many claims: that it may be used on a large variety of surfaces; that no hot tacking iron is needed; that predrying is not necessary; that the adhesive is pH neutral; that removal can be accomplished by reheating; that cooling weights and pretrimming are not needed; and, best of all, that there is a five-minute "open time" to reposition the artwork before cooling. It sounds marvelous, and I hope time will confirm all these claims.

Products such as these require the reading of all technical literature and instructions on handling. Unfortunately, most visual artists rarely do this before proceeding. Materials like these do not lend themselves to impulsive creativity. Small errors will probably end in large disasters.

Vacuum Mounting utilizes an adhesive in combination with pressure to mount and flatten the artwork. The adhesive is usually applied to the back of the artwork, which is then placed on the mounting board and both are put into a vacuum mount press. The vacuum mount press removes the air to create a vacuum, which in turn presses the mounting board up against the top glass cover with tremendous pressure, flattening the artwork and forcing the adhesive into the two surfaces. This creates a strong bond. There are a number of special advantages to this system. Heat, for example, which might accelerate the aging

process, is not used. In addition this system can be used for wet as well as dry mounting with a spray, not with tissue.

In wet mounting, blotter papers are used in the vacuum mounting press to keep the work flat and to accelerate the drying time. The vacuum forces some of the moisture into the blotter paper covering the artwork in the press, and, if the blotters are changed frequently, the drying time is greatly decreased. This is important because if the mounted artwork takes too long to dry, mold may set in and damage the artwork. A wet mount in the vacuum mount press is usually reserved for jobs that require a water-reversible archival mounting.

There are a few companies that make vacuum mount sprays. 3M offers a spray, which is currently the brand of choice. A vacuum mount spray is designed to allow you "open time" of two to eight minutes to reposition the artwork for placement. This means that after the back of the art has been sprayed there are approximately two to three minutes of waiting time until the tack is reduced so that the surface is sticky, but will not bond firmly without pressure. The next two to eight minutes may be used to position the artwork. This unique feature allows precision mounting, and I have used it with a number of contemporary artists to creat artworks that could not have been created in any other way. After ten minutes from first spraying you must place the artwork in the press for permanent bonding. The 3M Vacumount Spray Adhesive is pH 6.8 (which is essentially pH neutral), holds up well under accelerated aging tests, and is only reversible in organic solvents, not in water. It is important to note, however, that the use of sprays such as these require the use of personal protective equipment and proper ventilation. (See *Hazards*, pages 317 to 320.)

Vacuum mount presses are available in sizes up to 48"×84", but the most common are those that will handle up to 40"×60" boards. The system allows for the use of almost any type of mounting board, even sealed wood up to ⅜-inch thick, but, as with any product such as this, the technical specification and limitation must be read first and followed accurately and completely.

Wet Mounting involves the use of a water-based adhesive to bond the artwork to the mounting board. Although this is the least expensive method of mounting, requiring minimal investment, it is the most difficult to master. The moisture in the paste that is used can also affect artwork in such unpredictable ways as temporarily changing the size, shape, and character of the paper or board to be mounted. It can permanently affect watercolors, inks, dyes, and the sizing in the paper or board, and will definitely ruin artwork done with charcoal and/or pastel. Sometimes, however, wet mounting is the only system that will work for a particular job, such as in the classical form of water-reversible archival mounting.

A brief description of the technique involved will give you a perspective on this kind of mounting. One of the greatest difficulties is in learning what consistency of paste is most workable for you and will give you the best possible results. Some people like the paste thick so it can be rubbed in with the ball of the hand. Others like the paste thinner so that it can be spread with a scrap of board, and still others like it so thin that it can be brushed on. One thing to

remember is that a strong bond can be accomplished with very little paste, if it is applied correctly. I recommend that you first try thinning the paste to a consistency that is pourable, like a thick maple syrup.

When you have the desired consistency of paste, it may then be applied either to the board or to the back of the artwork. Some artwork that has buckled or is wrinkled may have to be softened by dampening just before it is mounted. Dampening with an airbrush and water or an atomizer and water will allow the paper to return somewhat to its original flat shape. After you have applied the paste, the artwork should be laid over the mount with the center touching first and the sides held in your hands gently released. Cover the artwork with a sheet of Kraft paper and flatten it out in a "sunburst" pattern, working from the center outward. If the paper is thin, hard, and absorbent, and has not been predampened, you may introduce new wrinkles at this point in mounting. This is where experience counts the most. The mounted artwork has to be covered with a blotting paper and then weighted down. A thick sheet of glass is usually used for the weight. The mounted artwork should be allowed to dry in this manner (changing the blotter paper several times) over a forty-eight-hour period.

Most wet mountings require countermounting. A countermount involves mounting a piece of paper similar in weight (most people use a 40 to 50 lb. Kraft paper) to the opposite side of the mounted piece. This will reduce the tendency of the mounted piece to warp by the shrinkage of the artwork upon drying.

Spray Mounting, which involves the use of spray adhesives, is not considered a professional form of mounting, nor is it considered archival. However, it can be effective if used, with caution, on a small scale for mock-ups, models, small photographs, and collages where the convenience outweighs the disadvantages. The problem is that when a spray is used, the adhesive tends to collect on the topmost fibers of the surface. Even when the artwork is pressed out by hand during the mounting procedure, the adhesive still does not penetrate as fully as it will with other mounting methods. Consequently, the mounting is taking place between the top fibers of one surface and the top fibers of the other. As the temperature and humidity change and the artwork and the backing expand and contract at different rates, the artwork may pull away and bubble. Beyond a certain size of artwork, the expansion and contraction would be so strong that, even if the spray were used correctly, lifting and bubbling would inevitably occur. For this reason, many sprays cannot be used with artwork above a certain size. Technical information such as this is usually printed on the spray can. Read the instructions for the brand you are using and follow them completely.

ADHESIVES

There are many adhesives that may be used in the construction of a piece of artwork, including methylcellulose, epoxy, PVA, and acrylic polymers. The adhesives discussed here are generally accepted as safe and effective for general use in picture framing.

Water-Based Adhesives. There are many water-based adhesives available for

the purpose of mounting paper, paper products, canvas, and fabrics with a natural fiber content of 50 percent or more. Animal glues, PVA (polyvinyl acetate, wheat or rice paste, and methyl cellulose are among the pastes most commonly used by framers.

Animal Glues are generally made from the gelatinous tissues found in the bones, skins, and intestines. Animal glues are used because they are inexpensive, have a longer shelf life than vegetable adhesives, and are usually comparatively low in water content (less moisture is advantageous because it means the paper tends to buckle less during application). Animal glues are not, however, considered archival because they tend to yellow, acidify, and crystallize (become brittle) with age. Increased awareness of these drawbacks has greatly diminished the use of animal glues.

PVA Emulsions, commonly known as "white glues," were the precursor to the development of acrylic polymer emulsions and paints. Their advantages include low cost, a long shelf life of several years, and easy application. Some undesirable characteristics of PVA adhesives are that they are not water-soluble when fully dry, and they contain a larger percentage of water than animal glues. This high degree of moisture contributes to the buckling and wrinkling of paper during mounting. Alcohol can be used to redissolve the adhesive within the first few years of application. The lack of water reversibility prevents this adhesive from being classed as archival.

Wheat Paste and Rice Paste are starch pastes, which have to be made fresh each time before use. (A recipe is given on page 288.) These vegetable pastes are water-soluble, archival, and therefore safe for hinging, mounting, and repairing paper or paper products used in making fine art. Vegetable pastes tend to be more hydroscopic than animal pastes, which means that vegetable pastes tend to retain more water per weight of paste, and when the paste is used it will tend to impart that moisture to the paper or board being mounted. This may lead to more buckling and difficulty in mounting. Vegetable pastes form a stronger bond with paper products than animal pastes. Some control can be exercised over the moisture by using less paste, thereby reducing the tendency of the paper to buckle. Beware of ready-made wheat or rice pastes, which have a very short shelf life and may become acidic.

Methylcellulose is like a vegetable paste with the vegetable part completely removed. It is pure adhesive. It mixes easily with cold water and the resulting substance looks very much like colorless Jello. It is nonstaining, water-reversible, pH neutral, and completely archival. The only drawback is that methylcellulose is very hydroscopic, and this high content of water can easily be imparted to the paper or board used, causing wrinkling and buckling. Most people use far too much of this adhesive during application. Since this material is nothing but adhesive and water, very little is needed. Methylcellulose is new on the market, and although it makes an ideal paste for archival mounting, some experimentation and practice is needed to learn how to keep problems of moisture to a minimum.

Lineco Inc. and Seal Inc. have recently offered waterborne, water-reversible, neutral pH adhesives that are ready to use without special preparations, and that

they claim meet archival standards. Lineco's adhesive is made of a modified dextrine base, which is reactivated when wet. If these products gain acceptance they will certainly ease the difficulty of wet mounting.

Spray Adhesives. Always read the instructions on the container of any spray adhesive *before* use. This cannot be emphasized too strongly.

There are many factors that can affect the quality of the bonding when using a spray adhesive. The most important ones are texture, moisture, temperature, and the flatness of the object(s) to be mounted. Texture can be a problem if insufficient adhesive is used and inadequate pressure is applied. The "valleys" as well as the "hills" in the texture of the surface have to be part of the bonding process if the mounted object is to be held permanently.

The moisture content and temperature of the objects to be mounted together have to be the same or they may expand or contract differently from one another and cause adhesive failure. This simple problem can be avoided by storing the objects to be mounted in the same location for several hours before and after mounting. If you have to soften the object to be mounted by humidifying it, then humidify the mount, too.

In spray mounting, the adhesive does not set as quickly as it does with heat-activated dry mount tissue because the solvent has to evaporate fully before the adhesive can bond firmly. Nonporous materials inhibit this process slightly. Wrinkles and fold lines may exhibit "memory" for those blemishes and pull away from the mounted surface before the adhesive can bond firmly. Therefore, it is very important that the object to be mounted be as flat as possible before mounting. The process of flattening is referred to as "stress-relief." Stress relief may be accomplished by using the heat from a dry mount press, or humidifying in a vacuum mount press, or using weights or weights with moisture.

The spray adhesives produced by 3M are currently the industry standard; thus its products are useful for the purpose of discussion. Recently, 3M changed the names of a number of the sprays; therefore if you have older products, re-read the information provided on the can before use. The two sprays that are accepted for use in picture framing have not been changed. They are Photomount No. 6094 and Vacumount No. 6096. The other sprays are for hobbies, graphics, and industrial uses and they are not recommended for use in picture framing with fine artwork. Photomount and Vacumount are nonyellowing with a pH range of 6.8 to 7.0. They have performed well under accelerated aging tests. They are not water-reversible and are therefore not considered archival in the classical sense. Because of this and because accelerated aging tests may not accurately predict what will happen in fifty to one hundred years, 3M will not recommend them for conservation mounting.

There are a number of small but significant differences between Photomount and Vacumount. Photomount is designed to be used on artwork 16"×20" or less without the use of expensive equipment. The name "Photomount" would seem to imply that the sole intended use of this product is for mounting photographs, but this is not the case. Photomount is a versatile adhesive, intended for multi-purpose use. Other than the size limitation, the only other restriction would be

with the use of oil- or resin-impregnated paper, or boards such as chipboard or newsboard, tempered Masonite, tracing papers such as Clearprint, and genuine parchments. (I have also had poor results with all-plastic foam boards). Photomount has an "open time" of two minutes. This means that you have up to two minutes to position the artwork before the adhesive sets.

Vacumount is basically the same as Photomount except that its size limitation is determined only by the size of the vacuum press you are using, and the open time is extended up to ten minutes for positioning. Vacumount does have a higher bonding strength than Photomount, but you cannot take advantage of this without the use of a vacuum press.

Removal of items mounted with either of these sprays may be accomplished with the use of heat or a solvent such as rubber-cement thinner or lighter fluid. You may also find an extra pair of hands necessary to accomplish the recommended techniques. 3M recommends that you lay the mounted object down on a table and use a commercial heat gun or a hair dryer to heat one of the corners. The heat source should be 4 inches or more away from the object. A thin spatula or knife can be worked carefully under the corner to begin the process of lifting off the mounted piece. Continue to lift the corner while heating the point of removal. The object should be lifted off during this heating process, not peeled off.

As for the solvent method of removal, 3M recommends that you stand the mounted object in a vertical position and drip some solvent onto the corner. After it has soaked into the corner, begin to lift off the object with a thin spatula or knife. Continue to drip solvent into the point of removal and lift at the same time. After removal, you may wish to wash off all traces of the adhesive with the solvent.

Although these methods are effective, it is difficult to accomplish them without affecting the object. However, this would be true of virtually any removal process; the challenge is to minimize that.

These aerosol spray adhesives and solvents present a serious health hazard if used without proper precautions.

GLASS AND PLASTIC

Glazing means to fit with glass or glasslike material. There are several types of glass and plastic available to glaze pictures, and the following discusses these materials.

Glass. There are two weights of glass commonly used in picture framing, picture glass and single-strength glass. Picture glass is lighter and not as strong as single strength. Picture glass was popular some years ago because it is thinner and therefore occupies less space; the popular mouldings of that time were not as deep and space was a consideration. The lightweight characteristic of picture glass had an advantage in larger frames, but at a certain point, its reduced strength became more important than the weight factor. Today, quality picture glass is expensive and hard to find. All of this has discouraged its use.

Single-strength glass comes in two grades, A and B. B is the same as A except that it is not inspected before it is packed. Single-strength is the glass most commonly used today. Double-strength glass, which is approximately 20 percent stronger, is rarely used even for larger pictures because of its heavy weight and slight, but noticeable, green tint. Glass transmits about 80 to 83 percent of light, and the greenish tint varies in degree depending on the thickness of the glass.

Nonglare glass, which is glass whose surface has been etched to diffuse the reflection, is most effective when the artwork is placed up against the glass (which violates one of the basic rules about paper artwork). The greater the space between the artwork and the nonglare glass, the fuzzier the image becomes. In most cases the space created by a single mat will not make the image sufficiently fuzzy to disturb most people, and there are circumstances where reflection is a serious problem. In these situations nonglare glass may be considered. I prefer a crystal clear image with reflection to paying more and getting a fuzzy image with a diffused reflection.

A new product called Denglas, made by Denton Vacuum, Inc., which has a metalized coating, would be the ideal solution, except for its extremely high price tag. Regular glass has an approximately 8 percent reflection. Denglas has a 1 percent reflection and can also absorb some ultraviolet light. Each sheet of glass is apparently made with a coating of metallic particles applied in a vacuum chamber and it is this coating of the surface of the glass that produces this effect. Denglas was originally developed for scientific apparatus. Its effectiveness is particularly startling when used with very dark images. Because the cost of using this glass could double the price of framing, it is primarily reserved for use with very valuable artwork, or where light reflection is an overwhelming problem.

Plastics. There are three types of plastic sheeting used most frequently in the picture framing industry: polystyrene, polycarbonate, and acrylic. (Plexiglas is the trademark of Rohm & Haas for clear acrylic sheeting.) Polystyrene is a relatively soft plastic used in the making of such mass-produced moulded plastic products as plastic cups, plastic toys, and inexpensive box frames. This product is not ideal for valuable artwork because it yellows as it ages. It is also more brittle than polycarbonate and acrylic.

Polycarbonate, because it is virtually unbreakable, is used in protecting valuable artifacts or artworks that are on public display. It is rarely used in conventional framing because of the high cost and because it must be cut on a table saw using a special blade manufactured for this purpose. A ventilation system is necessary to protect against toxic vapors that may arise in the heat produced during cutting. In general, using polycarbonate in conventional framing is considered overkill.

Clear acrylic (polymethyl methacrylate) sheets in ⅛ inch, and ³/₁₆ inches for works over 40″×60″, are the most common replacement for glass in picture framing when the possibility of breakage outweighs other concerns. The advantages of acrylic are that it is lighter weight than glass, it can be scored and

broken to size without expensive equipment, it is far less breakable in a picture frame than glass, and it is clearer and transmits more light (90 percent) than glass. The disadvantage is that acrylic cannot be used with chalk, charcoal, or pastel artwork due to the static charge it develops, which can lift a significant amount of material off the surface of the artwork and adhere it to the surface of the acrylic sheet. Exposure to strong ultraviolet light can yellow acrylic, but this is of more serious concern to institutions and industries that are using such special lighting as mercury vapor lamps. Acrylic also scratches easily and is a fire hazard. When plastics such as these are heated or burned without sufficient oxygen (which would be the case in most ordinary room fires), they give off large quantities of toxic and suffocating vapors.

Regular acrylic sheeting, like glass, provides little protection of artwork from the effects of ultraviolet light, one of the major contributors to the fading or darkening of artists colors. Virtually all artists' colors, in varying degrees, are sensitive to the visual light spectrum and to the invisible ultraviolet spectrum. Ultraviolet light is of greater concern because of its higher energy, which, besides fading or darkening a color, can produce chemical changes that include making artwork more brittle and structurally weaker. These changes can also occur from the higher energy levels of the visible light spectrum such as violet and blue, but not to the same degree as ultraviolet. The major sources of ultraviolet light are direct sunlight and fluorescent light.

In most cases, it is not difficult to avoid exposure to direct or even a large amount of reflected sunlight. It is usually just a matter of placement. Exposure to ultraviolet light from fluorescent light fixtures, which is a common form of lighting in institutions, is a problem. To solve this problem, especially for dealing with artwork or artifacts that are particularly sensitive, ultraviolet-filtering clear acrylics were developed. (The only form of acrylic that will filter both ultraviolet light and visible light comes only in black. So, as long as you wish to see your artwork you will have to accept the effects of most of the visible light spectrum.)

There are two basic types of clear acrylic that will filter ultraviolet light. One type can filter all ultraviolet light as well as part of the visible violet light range. (Visible violet light is part of the visible light spectrum, which can also have a considerable effect.) This type of acrylic can reduce the damage caused by ultraviolet light by 95 percent; nevertheless, it has a faint, somewhat distracting, visible yellow tint. The other type of acrylic has no effect on the visible light range and will protect against most, but not all, the ultraviolet light spectrum, thus reducing possible damage from this part of the spectrum by 90 percent. Since ultraviolet light is invisible, so is the protection and therefore there is no objectionable yellow tint.

Ultraviolet filtering acrylic is currently used only in special situations where exposure to this type of light will cause severe or long-term damage. The high cost of this material prevents its indiscriminate use. Rohm & Haas produces the two types of products for filtering ultraviolet light, Plexiglas UF-1, which has the yellow tint and provides the most protection, and Plexiglas UF-3, which provides a reasonable amount of protection without the yellow tint.

MOULDINGS

Mouldings, which may be either wood or metal, are ornamental contours given to an object. Mouldings for framing do more than decorate—they hold the glazing, picture, and backing together so that the artwork can be properly protected and displayed.

Wood Mouldings have height, width, a back, lip, and rabbet. The illustration below shows what these terms refer to.

In the recent past, basswood was one of the most popular woods used in modern framing. But this wood has continued to increase in cost, limiting its use to finer-quality decorative mouldings. From the linden tree, basswood is a soft wood ranging from white to cream in color, and of the many woods used in framing, it has the least apparent grain. Basswood resists splitting, does not warp easily, and can be sanded to a fine finish. It also accepts gold leaf well. Because of its softness, however, basswood is not considered to be the best choice for gallery-style framing. (Gallery-style framing is that which can be handled a great deal without being damaged easily.) Poplar is used as a substitute for basswood because of its similarities, but it tends to warp more.

Kiln-dried pine (if pine is not dried properly, its natural resins can leak) is used mostly in less expensive mouldings because of its abundance, although its large resin canals make working with it more difficult. Resin canals sometimes deflect nails, which can result in splitting and the nail can also end up in the wrong place. These canals also make it difficult for even sanding and finishing. Fir is often used as a substitute for pine because of the similarity, but it has a wider grain, which adds to the splitting problem during the nailing of the frame.

Although most of these woods are not as soft as basswood, they are soft enough to be of concern if they are to be handled in a gallery situation. Their great advantage is that because of their softness they are more easily worked

Terms Used to Describe Mouldings

1. LIP
2. RABBET WIDTH
3. RABBET HEIGHT
4. MOLDING WIDTH
5. MOLDING HEIGHT

without expensive equipment. Flaws in cutting the miter are easily covered by compressing the two corners during their joining.

Hardwoods do not compress and small flaws in the cutting of hardwoods will not go away. There are many beautiful hardwoods, including padouk, cherry, walnut, maple, and mahogany, that are used as mouldings for picture framing because of their unique textures and colors. The woods discussed here are those most commonly used for picture framing.

Ash is a hardwood that is easier to work with than most of the woods in this category. Its color ranges from a cool gray-white to a brownish-red. In the lighter tones the grain looks like a darker version of poplar and in the darker tones, the grain resembles that of oak. Ash does not split easily when nailed or otherwise worked with, which is why many people prefer to use this wood whenever possible.

Oak has three color varieties consisting of white, red, and brown. The characteristic coarse grain and pores makes oak one of the most easily recognized woods. It is more popular for decorative artwork than for contemporary artwork because of its strong appearance. It is hard and heavy, has a tendency to split, and is one of the most acidic of woods.

Ramin is an evenly grained, light, cream-colored wood. This wood, a recent introduction to the framing industry from southeast Asia, is lighter in weight than most, and does not split as easily as oak. Ramin does not stain well, but can be easily sanded and finished. Because of its soft neutral look, this wood is rapidly becoming popular.

Working with raw woods without expensive equipment is within reason for an artist with some basic knowledge of woodworking. Most artists who get a taste of do-it-yourself picture framing, however, usually proceed to go out and find a good professional framer to do it for them. If you are one of the dedicated few who wish to work with raw woods as opposed to finished mouldings, you will have to seal them to help protect against shrinkage, splitting, dirt, and moisture. After mechanical abuse, shrinkage is the next major cause for corners coming apart. Unsealed wood can shrink as much as 5 percent along its length. Raw wood can easily be sealed with hot paste wax, liquid wax, woodworking oils, or any commercial product made for this purpose. As for gesso, lacquer, gold leaf, staining, and painting of woods for picture framing, unless you wish to have a second career as a picture framer, I recommend that you purchase what you want from a picture framer. There are many picture framers who will sell you moulding by the length, or moulding cut and mitered, or moulding cut, mitered, and joined, so that you may assemble the rest yourself.

Joining mouldings to make a frame is most easily accomplished by gluing and nailing. It is a common misunderstanding that the nails hold the corners together. The nails only assist in houlding the corners together while the glue dries. It is the glue that will ultimately hold the corners together over time, so using large nails or many nails is not necessary and can even weaken the wood. I recommend yellow carpenter's glue, which is an aliphatic resin. This glue is water-soluble, sets quickly, and is a strong wood glue. Water solubility makes it

Metal Mouldings

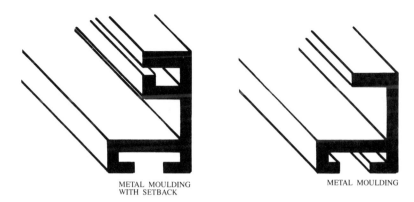

METAL MOULDING
WITH SETBACK

METAL MOULDING

easy to clean up excess glue that might affect the wood's ability to accept stains or finishing oils. Aliphatic resins are more brittle than white glues, which are composed of polyvinyl acetate. I feel that with the exception of very large frames, the brittleness of an aliphatic resin is an advantage because it allows a frame to be taken apart for repairs without being destroyed.

To avoid splitting and nails working their way to the surface of the moulding, holes should be drilled for the nails before hammering. I recommend, again with the exception of large frames, that you place the nails into the corner in one direction. This will allow you to take the frame apart for repairs. Use the smallest and shortest nails that you can work with and still get the job done.

Metal Mouldings are much easier for an amateur framer to work with. They can be purchased precut or cut to order and can be assembled with simple hand tools. If you follow the rules of framing that I have outlined, you can end up with professional results. The major difference between a wood and a metal frame is that you cannot have an airtight seal with a metal frame. This can be a serious consideration if the artwork is sensitive to moisture or air pollutants. In most cases, artwork that is framed with metal, if not placed in a bathroom, on a boat, or in a smoked-filled room at a political convention, should not be greatly affected.

Building a setback into a wood frame can be difficult and, if you are paying to have it done, expensive. There are metal mouldings that are made with a setback built into them. (See the illustration above.) This allows for a relatively inexpensive form of conservation framing where the artwork could be float-mounted to museum board and kept away from the glass.

Aesthetics in Framing

THE AESTHETICS of framing is a subjective area, but the following guidelines will give you something to follow.

1. *Look first, then see.* To look first at the artwork and at possible selections for framing means to perceive it without preconception and storylines. To see is to grasp relationships and ideas. If you look and then see, you have perceived what is actually there and then related it to your ideas. If you see first and then look, you often perceive only your ideas and frame them, not the picture.

2. *Frame to the picture first.* Although most people change their decor several times during a lifetime, few reframe a picture to match those changes. If you frame to the picture, you will always have at least one match.

3. *Beware of framing that is too interesting or too beautiful.* It is very easy to select framing that overwhelms the picture. If you find youself looking more at the frame than the picture, your selection is out of balance.

4. *Remember the original purpose of picture framing, which is to protect the artwork.* Avoid creative framing at the expense of common sense. Stay within the rules of good framing.

5. *The width of a mat should be clearly larger than the width of the moulding.*

6. *Double mats and fabric mats, when used conservatively, can create a focal point and a sense of depth.* This is particularly true with photographs.

7. *If you wish to bring out a particular color, choose a mat of a complementary color, not the same color.*

8. *A little more space should be given at the bottom of a mat.* Artwork such as prints that are signed at the bottom are not usually given this extra space because of the extra space created by the signature.

9. *A mat should be the same or one shade darker in appearance than the brightest part of the artwork.* Exceptions to this rule may be made if the mat is made extra large (3½ inches to 6 inches).

10. *Artwork that has a rough or deckled edge should be considered for float mounting to show the edge; artwork with a cut edge should considered for overmatting.* A proper choice will bring a piece of artwork to life.

Hanging Artwork

BELOW ARE several guidelines for safe picture hanging.

1. *Do not hang a picture over a working fireplace.* The exposure of artwork to the heat, smoke, and ash of a fireplace can result in serious damage. For artwork that is framed under glass and sealed from the atmosphere, you need only worry about the heat, which causes rapid acceleration of the aging process. Unprotected artwork will collect soot and will also be subject to the alkali of ash and the acids that result from the sulfur dioxide and hydrogen sulfide gases that are produced by the fire.

2. *Do not hang a picture over a heater or under an air conditioner.* Rapid changes in temperature, which are often accompanied by rapid changes in humidity, will cause premature aging.

3. *Do not hang artwork on walls that are prone to dampness or mildew.* Outside walls of a house are more prone to dampness and to the development of mildew. When a piece of artwork is placed over a damp wall, the combination of dampness and darkness becomes a fertile ground for mold and mildew. Mildew is like cancer to artwork; once the artwork has it, it is difficult to get rid of it permanently.

4. *Do not hang artwork where it will be exposed to direct sunlight. Avoid exposure to fluorescent lighting and strong indirect lighting.* Light is the major cause of fading in artwork. Ultraviolet light, which is most concentrated in sunlight and fluorescent light, causes not only fading but unpredictable photochemical changes in artwork as well.

Storing Artwork

OVER THE YEARS I have come across a number of novel methods of storing artwork. One of the more noteworthy was that of a collector who stored his art collection in his wine cellar; after all, the paintings were old and valuable like the wine. Unfortunately, the artwork was not sealed in bottles like the wine, and was subject to mildew, mold, rot, insects, and rodents.

Storage of artwork involves protecting it from excessive humidity and excessive dryness, and from insects, rodents, and acids. In addition to the archival boards and papers, there are materials such as storage boxes and envelopes for Mylar encapsulation, that are specially designed for use by museums and conservators. Such materials are primarily for the storage of collections that are not, for whatever reason, to be left on exhibition. Some of these materials can also be useful to artists who wish to use such ready-made storage containers rather than make their own. These products have yet to work their way into the average art supply store, and it is not within the scope of this book to review these products. However, there are several mail-order companies that deal in these materials and a catalogue can be had upon request. The Light Impressions Corporation, 439 Monroe Ave., P.O. Box 940, Rochester, NY 14603, is among the more commonly known mail-order houses from which a catalogue can be had.

Below is a list of suggested remedies for the most common storage situations that the average artist and collector confronts.

1. *Framed artwork and stretched artwork should be stored in racks that will allow for the circulation of air and exposure to some light to prevent the growth of fungus.*

2. *Unframed paper artwork should be stored in flat file drawers that are lined with museum board and contain packets of boric acid.* The flat drawers will protect against mechanical damage. The museum board will protect against any acids present in the drawers, particularly in wooden drawers. The boric acid will prevent silverfish. (The General Pest Service Company produces Dekko Silverfish Paks, which contain boric acid and are easy to use.)

3. *Paper artworks may be stacked upon one another if they are separated by pH neutral slip sheets.*

4. *Unstretched canvas paintings may be stored rolled if they are first allowed to dry thoroughly, then rolled around a thick tube with the painted side out and the surface protected with a glassinelike paper.* The painted side is placed on the outside because any cracks that might form from this type of storage will be pushed back together when the canvas is unrolled. If the painted side is rolled inside the tube, the paint film might cure in this compressed state and larger cracks may result when the painting is later unrolled.

5. *Metal flat file drawers are best when insects are of primary concern, and wooden flat file drawers are best when humidity is the primary concern.*

Part Eleven

HAZAR

You would be outraged if someone brought into your home industrial solvents, chemicals containing high concentrations of heavy metals, and coal-tar derivatives—in other words, materials known to cause nerve damage, emotional disorders, and cancer. Yet, as an artist, you commonly bring such materials into your living and working environment, and then proceed to bathe your hands in them, breath their dusts or vapors, or ingest them, allowing these toxic materials to contaminate your body and your environment.

Unfortunately, there is a long history of artists poisoning themselves. Over the years it has become so commonplace for artists to damage their health with their materials that the stereotype of an artist's personality consists of chronic depression, irritability, aberrant behavior, frequent colds or flulike symptoms, low back pain, and headaches. These characteristics are the symptoms of low-level poisoning, as well as of psychological stress. However, most art dealers, historians, and collectors tend to attribute these aberrations to creative genius. Van Gogh is a prime example of the way poisoning may have affected not only the artist's health but the appearance of his artwork as well. One of the symptoms of lead poisoning, from which he was certainly suffering, is the swelling of the retina of the eye, which is said to give the illusion that objects have halos around them.

The toxic nature of materials is certainly better understood today (although it was not unknown in Van Gogh's time), primarily among chemists, medical doctors, a few government agencies, and those who have been injured. Unfortunately, this understanding has not been effectively communicated to artists or to art institutions. The first such article on this subject was not even published until 1963, when it appeared in *Art News*.

Artists are using many more hazardous materials in more unusual ways than ever before. Just a few examples are the use of plastic resins in cast resin sculpture; such solvents as hexane, benzene, and toluene in graphic arts materials; metal fumes from welding; and heavy metals and carcinogens, which are inhaled

during airbrushing of watercolors, acrylics, and oil paints. In 1981, The National Cancer Institute studied the deaths of 1,598 artists and found that among many other chronic illnesses, they have two to three times above the average rate for cancer.

Naiveté and poor product labeling combine to cause this situation. When it comes to hazards, most artists have either adopted a fatalistic attitude or believe that the manufacturer or some benevolent organization is protecting them from hazardous materials. The truth is that, in practical terms, there are no institutions actively protecting you. The Occupational Safety and Health Administration (OSHA), for example, regulates toxic chemicals only in the workplace, while the Consumer Products Safety Commission deals only with the labeling of products that cause acute illnesses such as poisoning. Artists' concerns center on chronic toxicity and are, therefore, in a no-man's land as far as federal protection is concerned.

The only local regulation enacted at the time of this writing is the amendment to the California Hazardous Substance Act, Assembly Bill No. 3438, which came into effect, after several delays, in February 1986. It is supposed to provide for the seizure and banning of all improperly labeled art and craft materials that contain hazardous substances. This act is a trial balloon for other states where legislation is pending. Six months after this amendment had gone into effect, it had yet to be enforced. Although there is no direct funding for its enforcement, no agreement as to what constitutes proper labeling of specific hazardous materials, or even exactly what is hazardous, the major manufacturers of artists' materials are scrambling to comply. The predictions for the effects of this law range from the creation of black markets, to the total absence of professional materials from California until a standard is agreed upon, to no enforcement at all.

What is happening now and what is likely to continue to happen is that the available variety of materials is shrinking. Certain traditional materials that may be questionable and for which there is no adequate replacement are simply no longer being offered by manufacturers. Additionally, smaller manufacturers, particularly foreign competitors, are bowing out of the California marketplace. Although legislation such as this has proven successful in other areas of our society, there is an inherent problem in attempting to adapt it to a profession whose major driving force is creativity. All labeling and regulation is based on *intended use*. If artists used everything as it was intended to be used, I wonder if there would be any new art. Airbrushing, for example, which is one of the fastest-growing methods for applying artists' paints, violates the intended use of most artists' paints. State legislation such as this also works best when the consumer supports it. Most creative people would not fancy restrictions on their freedom of expression by the banning of certain irreplaceable, as well as traditional, pigments and colors, and would look outside the state for mail-order suppliers.

Although I support proper labeling and I have lectured for years on the hazards involved with artists' materials, I feel that the professional artist should not rely on either legislation or improved labeling. An example of how unreliable

labeling has become under new regulations involves one company, which, when confronted with the possibility of strict requirements, produced an ideal label. It had a large black X on an orange field with the word "harmful" in seven languages. It listed the major hazardous ingredients and stated, in three languages, "Harmful by inhalation, in contact with skin and if swallowed. Danger of cumulative effects. Keep out of reach of children. Contains barium. Should not be used on surfaces liable to be chewed or sucked by children." However, after the enactment of regulations the new labels for the same product have none of this information, and, in fact, state that no United States health label is required.

Your only real defense is through self-education about methods of personal protection and a fundamental change in attitude to one that treats all materials as hazardous or potentially hazardous. The primary purpose of this chapter is to help you do these two things. I will discuss how we contaminate ourselves and our immediate environments, and will provide practical remedies for these problems. Since it would be impossible to describe all the hazardous materials and situations encountered, I will emphasize an approach that will immediately reduce the overall level of hazard for the artist who paints and draws. Additional information can be obtained in *Artist Beware*, a book by Michael McCann, Ph.D., or by contacting the Center for Occupational Hazards (COH), 5 Beekman Street, New York, NY 10038, (212) 227-6220, which is a national clearinghouse for research and education regarding hazards in the arts.

Attempts to solve the problem by substituting nonhazardous materials for hazardous materials have rarely been successful because, even when a possible substitute can be found, its quality and characteristics are often unacceptable to the professional artist. At times it almost seems to be a law of nature that the better the artists' material, the more hazardous it is. The art materials manufacturing trade's attempts to deal with hazards has centered almost entirely on labeling, and if you have made a recent purchase you may have noticed that there is rarely any notification on the product as to its hazardous, or nonhazardous, nature. When such notification is found, it is often unclear and in some cases even misleading to the average consumer. When you consider that 80 to 90 percent of artists' materials are in *some way* hazardous, as well as the incredible diversity of these materials and the types of possible exposure, it would appear to be an insurmountable task for any organization to create a set of guidelines to which all the different manufacturers throughout the world would agree to conform, and then be able to place such information on or with such materials as sticks of pastels and half-pans of watercolor.

Recently, the American Society for Testing and Materials (ASTM) has recommended a set of voluntary guidelines for the labeling of hazardous substances in artists' materials. These recommendations are set down in ASTM D 4236, *Standard Practice for Art Materials for Chronic Health Hazards*. A copy of this five-page document is available for a small fee from ASTM Sales Services Dept., 1916 Race St., Philadelphia, PA 19103. The document itself does not provide any information on what substances are hazardous, or how hazardous material should or should not be used. The ASTM does no testing of products and relies primarily on manufacturers for information and testing. The work accomplished

by this society is tempered by the fact that these guidelines are voluntary and not mandatory. Because these guidelines are to be incorporated into legislation in some states, it is thought that most manufacturers will eventually comply. Many products are now being labeled with only the *minimum* information required by ASTM D 4236 so that they may be allowed to state that the product "Conforms to ASTM D 4236." From my experience it is not clear what such labeling as "Conforms to ASTM D 4236" conveys to the average consumer, particularly when clarification can only be found by sending money to a relatively unknown society with an address that is not readily available.

The Art and Craft Materials Institute Inc., 715 Boylston Street, Boston, MA 02116, has expanded its role and set itself up to review products to see if they indeed conform to ASTM D 4236. If a product does conform, the label may say so using either the abbreviation CL for Certified Labeling or a longer version "Health Labeling Conforms to ASTM D 4236 Certified by Art & Craft Institute, Boston 02116." Their certification process primarily involves the submission by a manufacturer of a formula for a product for review by the institute's toxicologist; actual testing of materials is not done.

Today the whole situation is so confused and in flux with terms being redefined and differing proposals for labeling among various states that it is not unusual to find products that contain teratogens, or suspected carcinogens, labeled nontoxic. A case in point involves the use of phthalocyanine pigment. In theory, phthalocyanine blue or green in its purest form is not considered hazardous. However, polychlorinated biphenyls (PCBs), byproducts formed during its manufacture, are rarely removed. PCB is a suspected carcinogen and has been associated with chloroacne (skin eruptions). PCB-free phthalocyanine is used almost exclusively in cosmetics, and is rarely used in the manufacture of paint because of its great cost. In fact, not all paint manufacturers even know about the possibility of PCB contamination, which occurs in the production of several other organic pigments. There are many other examples where hazardous contaminates can be found, such as arsenic in some mineral pigments and asbestos in pastels, yet they are not presented with appropriate labeling. Even the new California labeling law will, in most cases, permit toxic contaminants up to 1 percent by weight without notification on the label.

In addition to the presence of hazardous contaminates in certain products, there are cases where the pure form of a chemical is nontoxic only in a particular molecular arrangement. And if that arrangement is accidentally changed through heating or the use of certain solvents or through contact with other substances, it can become toxic. The major ingredient in a product may, therefore, have undergone some undesirable change somewhere during the manufacturing process, or during the actual use of the product, yet the product may still carry a nontoxic label. Furthermore, most people do not realize that the label "nontoxic" does not mean completely safe or nonhazardous in any case, and refers only to exposure to adults, not children.

According to Professor Michael McCann, the author of *Artist Beware*, "It is estimated that we are exposed to over 20,000 known toxic chemicals, and 500

new chemicals are introduced into the market every year, most of which have never been tested for their long-term effects on the human body." In addition to the introduction of new chemicals, many older chemicals once considered safe are now being questioned and frequently moved to the list of hazardous substances. Cadmium colors, for example, have been used since before the turn of the century, yet until recently were not considered highly toxic. The change in attitude about cadmium is due in great part to the illnesses contracted by artists that were traced back to contamination with this heavy metal.

Even with all the advances in artists' materials through the centuries, artists' health, if not their very survival, still depends on taking personal responsibility to deal with the dangers associated with the materials in use. If it were only a matter of a one-time exposure or, even in some cases, occasional exposure to some of the hazards described, there would be little cause for serious concern. Most artists are beyond eating and drinking artists' materials, as well as applying them directly to the skin. What does require serious concern is the fact that we are repeatedly exposing ourselves over decades to hazardous and potentially hazardous material without adequate safeguards, and since there is so much uncertainty about what really is safe and not safe, the single best way to protect yourself is simply to treat *all* artists' materials as hazardous.

It is also important to keep some perspective about the relative danger involved in the use of artists' materials. I have reviewed our hazardous situation with a microscope and we should pull back and look around at other dangers. On June 2, 1986, *Newsweek* reported that 43,500 people were killed in automobile accidents in the United States in 1985, 150 died in their own bathtubs in 1984, and 25 were killed overseas in terrorist attacks. When you compare that information with the fact that there has never been any death proven (many have been attributed, but not proven) to be caused by artists' materials, it is difficult to maintain a high degree of panic. However, I would suggest a high degree of concern accompanied by common sense.

Terminology

BEFORE PROCEEDING any further, it would helpful to be define a number of health-related terms. The following are working definitions and are not intended to be exact legal or medical definitions. Also, the definition of "toxic" with regard to art and craft materials is being redefined by new legislation in a few states to include suspected carcinogens, carcinogens, and teratogens. At this time such changes are not yet universally accepted and the following terms have been defined as they have been in the past.

Adequate ventilation is *not* just opening all the doors and windows. It is having constant exchanges of air, with fresh air replacing the contaminated air approximately every fifteen to twenty minutes. This is generally accomplished only by being outdoors or by having a general ventilation system.

Acute means a single pronounced event, such as an "acute exposure." In terms of health an "acute illness" would be an immediate and severe reaction by the body.

Chronic is long-lasting or repeated, as in "chronic exposure." In terms of health, a "chronic illness" is an ongoing illness or one that surfaces from time to time.

Carcinogens are substances that will produce cancer.

General ventilation is a system whereby the hazardous materials in the air are reduced through dilution. An exhaust fan is set up as the sole exit for the contaminated air, and an entrance for a supply of fresh air is established as far away from the fan as possible. This supply of fresh air traveling from one side of the room to the other will dilute the contaminates that accumulate in the air in the room.

Highly toxic means that serious injury or death will result from contact or absorption of a small amount, such as a mouthful, by a healthy adult.

Inorganic refers chemically to compounds that do not possess hydrocarbons (a water-carbon chemical structure), but do include oxides and sulfates of carbon. Water, nitric acid, calcium carbonate, and alum are examples of inorganic chemicals used in the process of making artists' materials or included in the product itself.

Local ventilation is a system whereby the hazardous material are removed before they have an opportunity to disperse into the room's air. Most local ventilation systems bear a certain resemblance to a large vacuum cleaner, and often contain a hooded area in or under which the work is performed.

Moderately toxic means that temporary to permanent minor injury will result from contact with, or absorption of, a small to moderate amount by a healthy adult.

Mutagens are substances that will produce genetic changes.

Nontoxic means that no detectable injury will occur from contact with, or absorption of, small to moderate amounts by a healthy adult. *This term does not mean nonhazardous.* Carcinogens and mutagens are rarely considered in nontoxic labeling. And, a nontoxic substance may produce a toxic effect when combined with other substances, or may have a cumulative effect from long-term chronic exposure.

Organic refers chemically to all carbon-based chemicals. Benzene, toluol, turpentine, and carbontetrachloride are examples of common organic solvents that contain carbon and are used in artists' materials.

Slightly toxic means that temporary minor injury will result from contact with, or absorption of, a small to moderate amount by a healthy adult. Larger quantities of exposure could, however, cause greater damage.

Synergistic effect is when two or more substances cooperate to produce an effect that is greater than the effect that would have been produced had the substances acted independently of one another. Drinking alcoholic beverages while working with solvents is a good example.

Teratogens are substances that will cause severe birth defects or malformations.

Total Body Burden is a term that refers to the burden on the defense mechanism of the body, or the cumulative effects of a particular substance on the body. For example, the body may be able to detoxify itself from infrequent exposures to moderate amounts of a toxin, yet be unable to deal with frequent exposures to small amounts of the same material. The body often needs time to recover from an exposure, and the cumulative effects of small exposures can add up rapidly to overwhelm the body's defenses.

Toxic means poisonous, or having the ability to destroy life or health on contact or by absorption. There are various degrees of toxicity, such as high, moderate, slight, and nontoxic. The degree of toxicity is determined not only by the nature and the quantity of the substance but by the type of contact or absorption. For example, genuine cadmium red, although an irritant, is considered nontoxic when in contact with the unbroken skin. However, it is highly toxic if the dust from the dry pigment is inhaled or ingested, even in such small a quantity as a mouthful.

Types of Exposure

MANY ARTISTS WORK in their homes or live in their studios. Consequently, their living environments are often almost as contaminated as their workplaces and exposure to hazardous materials can be a twenty-four-hour affair. Although the human body is quite resilient when exposed to damaging substances, if it doesn't have time to recover, the effects become cumulative. The first step to reducing your level of exposure is to isolate your workplace, or at least hazardous materials, from your living environment. In addition, allotting only eight hours to each work day will provide an opportunity for your body to recover from exposure to hazardous materials.

Many artists use materials in a way that either overwhelms or slips by the natural protective mechanisms that the body has developed during the course of its evolution. When this happens, acute or chronic illness results. Some examples of these protective mechanisms are the outer layer of watertight skin, the sense of smell that detects odors, fine hairs in the respiratory tract that can provoke a cough reflex to rid contaminants, and the liver, which breaks down toxins and renders them harmless. It is important to understand how the body's protective mechanisms work and how they can fail so that measures can be taken that will help provide the necessary protection.

INGESTION

"I don't eat my paints" is one of the most common responses made by artists when confronted with the toxic nature of the materials they use. However, artists frequently, though unintentionally, ingest their paints. Small amounts of paint that collect on the hands and under the nails can be ingested by people who smoke, eat, or bite their nails while they work. A single exposure of this type would not be considered significant, but chronic exposure over the course of a lifetime could have very serious cumulative effects.

Another way that artists often ingest hazardous materials is when working with dry pigments or soft pastels and particularly with an airbrush, where aerosols of fine particles are created, which often remain suspended in the air for several hours. These particles can collect in the mouth or nasal passages and then be swallowed. They can also collect on the hair and clothes and later fall into food.

Good housekeeping and personal hygiene are the keystones to preventing accidental ingestion. Not eating, smoking, or biting nails in your workplace are the most basic rules. They are also the rules most commonly violated. There are industrial hand creams (also toxic if ingested) that are helpful in cleanup. Many can also be used as a weak protective hand cream while working. The hand cream should be washed off thoroughly with soap and water when cleanup is complete. Solvents should be avoided for cleaning the hands or any other area of the body because many of them are absorbed by the skin or cause allergic reactions. Although gloves would be the most complete protection from collecting paint on the hands, most painters cannot bear the reduced sensitivity in touch.

Protection from ingestion of the dust of dry pigments and airbrushing is best accomplished with a local ventilation system, which can eliminate the need for dust masks and protective clothing and prevent the general contamination of the workplace. A general ventilation system, by itself, would not be adequate in this case and would have to be supplemented by respiratory equipment (masks) and a separate set of clothing, which can be left in the workplace. The workplace should be isolated from the living space and have its own shower.

Artists' paint should never be applied to parts of the body, such as the fingers, or applied directly to the body. Brushes that have been used with paint should not be pointed using the mouth.

INHALATION

Airbrushing; working with powdered pigments, ceramics, and paper mâché; and the sanding of a lead-based painting ground are examples of ways in which hazardous dusts are created in the studio. Hazardous vapors are generated during the use of spray adhesives and fixatives that contain toxic solvents, as well as through the use of paint solvents. Such dusts and vapors are a more insidious problem than the problems asssociated with paints. Dusts are barely visible and can remain suspended in the air indefinitely and larger particles that do settle are easily stirred up again. Although the body's respiratory tract is provided with tiny hairs to catch and repel, through a cough reflex, fine particles that work their way in, this protective defense is easily suppressed with chronic exposure. Smokers best exemplify how quickly the cough reflex can be suppressed. It is also not unusual to work in a dust-filled environment and adapt to the air pollution and thereby conclude that the air is safe, when actually the body's defense is simply no longer functioning.

Vapors from organic solvents, welding, acids, or alkali can also suppress the cough reflex after repeated low-level exposure. Greater levels of exposure will induce choking and possible respiratory failure, but, unless large quantities of these materials are being used, such as in industrial uses, the exposure is more often chronic than acute. There is also a phenomenon called "olfactory fatigue," which contributes to a false sense of safety. An odor, such as that produced by an organic solvent, or any distinct odor, is only detected for the first few minutes and then becomes unnoticed unless the nasal sensors are given a rest. A common scenario involves an artist who walks into the studio and smells a

strong odor of solvent or thinner, proceeds to open a window or two, then takes a few sniffs of air and finds the odor rapidly disappearing. Several hours later, a friend comes to visit. Upon entering the studio, the friend coughs a few times and says "How can you work in here?" The artist is confused by the friend's remarks because he or she no longer smells any odor or coughs.

The use of organic solvents in artists' materials is pervasive. Permanent markers, rubber cement, rubber-cement thinner, spray fixatives, spray adhesives, turpentine, petroleum distillates, lacquer thinners, model cements, polyester resins, and epoxy glues can all produce chronic and acute illnesses. Use of these materials without proper precautions can lead to such illnesses as asthma, emphysema, bronchitis, leukemia, aplastic anemia, liver damage, kidney damage, and neurological damage. It is often the more pleasant-smelling solvents, such as the aromatic hydrocarbons, that are the most dangerous.

Acrylic emulsion paints, once considered a safe alternative to oil painting because they lacked hazardous solvents and their accompanying vapors, are now not considered so safe. It has been found that when acrylic emulsion paints are used in large quantities, some of the acrylic emulsion does vaporize along with the water and can be inhaled into the lungs. Moreover, the inhalation of the acrylic emulsion during airbrushing is, in some cases, potentially more hazardous that the inhalation of the paint's pigments.

When you ingest hazardous materials there is some hope that they may pass through your system, causing little or no damage. Solid particles have no place to go once they've entered the lungs. When autopsies were performed on stonecutters, and the lungs were opened and inspected, a sandlike material would often come pouring out. Many containers for solvents and sprays have a warning that the product should be used with "adequate ventilation." Adequate ventilation means that the air in the environment is exchanged for fresh air at least every fifteen to twenty minutes. This does not take place by simply opening the windows and doors. For proper ventilation there must be a constant stream of fresh air flowing through the environment with only one entrance and one exit at opposite extremes. Adequate ventilation can be obtained by one of two systems—a general exhaust system or a local exhaust system.

Protection from the inhalation of small particles, like dusts, or small amounts of solvent vapors can be achieved with the use of a localized ventilation system. If the scale of the artwork is beyond the scope of a local exhaust system, however, then it is necessary to have a general ventilation system supplemented with an air-purifying respirator, such as a mask, as well as a separate set of work clothes that can be left in the workplace. In painting or printing, a general exhaust system may be the only practical possibility.

The purpose of ventilation by a fan is to pull air through the environment, not blow air into it, which simply mixes the air rather than exchanges it. There are two types of exhaust fans that are used to pull air through the environment and expel the contaminated air to the outside. The first is the axial flow fan, which is used primarily in general ventilation systems. This fan looks like a standard household fan with a propeller driving the air. There are explosion-proof varieties of axial flow fans, where the electric motor is protected to prevent sparks

Diagrams of Fans

PROPELLER FAN or
AXIAL FLOW FAN

CENTRIFUGAL FAN

from the motor igniting a fire when large volumes of flammable solvents are used. The blades are also made of a material that will not spark if they become loose and strike the cage. The second type of fan is the centrifugal fan. This type of fan is primarily used in local exhaust systems that are designed to remove dust and is found in the common hair drier.

Almost all fans of this type are sold directly by the manufacturer or through a wholesaler to licensed contractors, who are hired to install them. If you are in a position to have a system installed professionally, do so. Most cities have strict building codes, which are often easily violated, and you may involve some legal risk by designing and installing your own system. However, many of us do not have the financial means to hire a professional yet may have some background in basic construction. I have had some success in ventilating small areas with the type of fan used to ventilate household cooking areas, sometimes called a kitchen fan. Many of these fans, which can be purchased at most retail building supply stores, are easy to install and hook up to either rigid or flexible ventilating ducting. For less than fifty dollars I was able to acquire a fan that was rated for 230 cubic feet per minute (CFM). This means that this fan, if properly installed, could change the air of a 10' wide × 12' long × 8' high room in a little more than four minutes. Nevertheless, it is important to understand that general ventilation is based on dilution and if hazardous material is in the air, it would take considerably longer than four minutes to remove it. Using the type of fan I mentioned in a local ventilation system could result in quick removal. More sophisticated fans or ventilation systems will require special ordering through a friendly hardware store.

When installing an exhaust fan it is important to consider where the expelled

air is going, and care must be taken so that contaminated air is not reentering the studio or entering a neighbor's studio.

Air-purifying respirators purify the air as it is drawn through filters or cartridges when you inhale and are the type of respirator commonly used by artists for respiratory protection. An air-purifying respirator should never be the primary source of protection, but should be used only as a backup for a ventilation system. OSHA forbids the use of respirators as a general-use primary protection in industrial workplaces. A respirator does not completely purify the air that passes through it, but rather reduces the level of hazardous materials to what is considered safe by the government. A respirator is also easily overwhelmed if the concentration of hazardous materials is great. Consequently, a respirator should always be used in conjunction with a ventilation system.

There are three types of air-purifying respirators. The first type is for such particulate matter as dusts, mists, and metal fumes. These respirators work by filtering the particles from the air. Each kind of filter is coded to indicate what type of particles it performs with best. A is for asbestos, which is found in chalks, pastels, and clays. M is for mists found in airbrushing. D is for dusts, which are found when working with dry pigments. F is for fumes such as those found in stained glass welding. Filters are also combined, such as DM for dusts and mists.

Filter masks are not effective against chemical vapors such as turpentine. To protect against vapors and gases, a second type of air-purifying respirator, which has a chemical cartridge, is needed. Such a cartridge will absorb or chemically react with vapors and gases to remove them from the air. Just as there are specific types of filters for different types of particles, so there are different cartridges. The two models that most concern the artist are the organic vapor (OV) cartridge for evaporating solvents like turpentine and mineral spirits, and the paint, lacquer, and enamel mist (PLE) cartridge, which is used primarily for airbrush paints and lacquers that are dissolved organic solvents.

The third type of air-purifying respirator is a combination of the preceding two. A filter is placed over the cartridge to protect against hazardous materials that have more than one characteristic; airbrushing with an oil paint, for example, creates both mists and vapors.

The fit of a respirator is as important as selecting the correct filter or cartridge. If it does not fit well, it is useless. A proper fit may be impossible for men with beards or people with prominent cheekbones. You should test the fit before use.

Do not remove an air-purifying respirator from your face until the air is no longer contaminated. A respirator containing cartridges should be stored in a plastic bag because the cartridges work all the time whether or not you are using them.

When acquiring an air-purifying respirator, check the expiration date and read the literature about how to test for worn-out cartridges.

SKIN CONTACT

Toxic substances can enter the body through cuts or abrasions in the skin as well as through direct absorption. Genuine vermilion, which is mercuric sulfide, is

one of the few pigments that can be absorbed directly into the skin. Even such mild solvents as turpentine have recently been found to cross the skin barrier, enter the body, and cause serious health problems. Such solvents as turpentine, which are used to thin paint, can help other chemicals that otherwise would not penetrate the skin to do so. Some chemicals can react directly with the skin and cause burns. Moreover, skin allergies to artists' materials are more common than most artists realize.

Like the skin, the eyes, nasal passages, and mouth are parts of the outer body that are often the first points of contact with hazardous substances. They are most sensitive to exposure, as well as most easily damaged. Additionally, the mouth and nose allow hazardous vapors and solid particles to pass more easily into the blood stream.

Just as there are chemically specific cartridges for respirators, there are specific types of gloves designed to protect the skin from specific chemical groups. For the painter who uses turpentine, paint thinner, and mineral spirits, gloves made of neoprene rubber provide adequate protection. The latex gloves widely available in drugstores as well as in some art supply stores are not effective with any of these solvents.

Gloves of any type are unpopular among artists because of the reduced sensitivity to touch. Although not as effective as gloves, protective hand creams are used as an alternative. There are two types of protective hand creams, water-soluble and water-insoluble. The water-soluble hand creams protect against organic solvents. When using this form of protection, the cream should be washed off frequently and reapplied to insure that it is acting as an effective barrier. Before eating, all hand creams should be thoroughly removed and the hands washed.

As for the protection of the eyes, nose, and throat, adequate ventilation is best.

ALLERGIC REACTIONS

Allergic reactions can mimic both acute and chronic poisoning and it is often difficult to distinguish between the two. It is not unusual to have a low-level chronic health problem either masked or exaggerated by an allergy. It is important to distinguish between the two because the prevention and medical treatment is different for each. Substances that cause strong allergic reactions often have to be eliminated, rather than reduced, because even minimal exposure can cause a significant reaction.

Despite the symptomatic similarities, many people are able to distinguish between toxic reactions and allergic reactions. Allergic reactions are often immediate and usually out of proportion to the type of exposure. A person using small amounts of turpentine, for example, may react with asthmaticlike symptoms, and when a substitute solvent, such as petroleum distillate, is used the symptoms are gone. Less severe reactions require professional assistance to determine the cause.

In Case
of Illness

IN ADDITION TO the basics, such as having a first aid kit, posting emergency phone numbers—fire department, doctor, hospital, and Poison Control Center—it is important to have a working relationship with a physician who has some sympathy for the occupational hazards inherent in being an artist. Establishing such a relationship is not as simple as it sounds for few physicians are familiar with treating individuals exposed to hazardous materials in general. Even fewer are acquainted with the hazards specifically involved with the creation of professional artwork. Most artists will be unable to find a physician with this special knowledge and will have to come to terms with a local general practitioner or internist.

There are some guidelines that I have found helpful in establishing a relationship with a personal physician. Because symptoms of chronic, low-level poisoning are vague, they may easily be attributed to hypochondria. You may well be a hypochrondriac, or become one after reading this chapter, but you do not wish to be written off as one before there is any proof. You must therefore be as specific as possible in describing your complaint, whenever possible, using the chemical names of the major ingredients of the materials that you have been exposed to and explaining exactly how that exposure has taken place. If you just say that you believe the source of the problem is from the artists' materials that you are using, most physicians will simply associate the term "artists' materials" with some category of hobby and craft materials rather than with industrial solvents and chemicals. There are now specific tests for the detection of many of these chemicals, but if you are not specific, a nonspecific test may be performed, which will generate inconclusive results.

In general, the more "professional" your behavior, the more likely that your physician will work effectively with you. It is important to strike a balance between panic and fatalism. You have lived long enough to read this, despite the materials that you have been exposed to. However, it is important to have regular health checkups and tests for the materials to which you are exposed.

In Case
of Fire

A FIRE EXTINGUISHER and a smoke detector are musts for any workplace where flammable materials are used. The extinguisher should be rated for the type of fire that may occur, based on the types of materials in use. There are four classes of fire extinguisher: type A—for wood and paper; type B—for flammable liquids and paints; type C—for electrical fires; type D—for metals. Using the wrong type of extinguisher may not only be ineffective, but spread the fire. Today, thanks to the miracle of plastics, there are several inexpensive, disposable extinguishers on the market that can be used on several kinds of fires.

Be sure to check the pressure gauge on the extinguisher once a year.

Bibliography

GENERAL INFORMATION

Borgeson, Bet. *The Colored Pencil*. New York: Watson-Guptill Publications, 1983.

Chieffo, Clifford T. *The Contemporary Oil Painter's Handbook*. New York: Van Nostrand Reinhold, 1982.

Cooke, Hereward Lester. *Painting Techniques of the Masters*. New York: Watson-Guptill Publications, 1972.

Gettens, Rutherford J., and Stout, George L. *Painting Materials: A Short Encyclopedia*. 1942. Reprint. New York: Dover Publications, 1966. Primarily historical information, some of which is still current.

Hirayama, Hakuho. *Sumi-E Just for You*. Tokyo: Kodansha International, 1979.

Huges, Sukey. *Washi–The Wonderful World of Japanese Paper*. Tokyo: Kodansha International, 1978.

Hyman, Richard. *The Professional Artist's Manual*. New York: Van Nostrand Reinhold, 1980. Emphasizes the business aspects of being an artist.

Jackson, David P., and Jackson, Janice A. *Tibetan Thangka Painting Methods and Materials*. Boulder, CO: Shambhala Publications, 1984.

Kan, Diana. *The How and Why of Chinese Painting*. New York: Van Nostrand Reinhold, 1974.

Kay, Reed. *The Painter's Guide to Studio Methods and Materials*. Englewood Cliffs, NJ: Prentice-Hall, 1983.

Long, Paulette. *Paper–Art and Technology*. San Francisco: World Print Council, 1979. Excellent information on the composition and nature of paper.

Massey, Robert. *Formulas for Painters*. New York: Watson-Guptill Publications, 1967.

Mayer, Ralph. *The Artist's Handbook of Materials and Techniques*. 3rd ed. New York: Viking Press, 1970. Original copyright 1940. Although revised several times, most of the information, albeit interesting, is dated.

———. *A Dictionary of Art Terms and Techniques*. Rev. ed. New York: Barnes & Noble, 1981. First published in 1966.

———. *The Painter's Craft*. New York: Penguin Books, 1979. First published in 1948.

Pomerantz, Louis. *Is Your Contemporary Painting More Temporary Than You Think?* Chicago: International Book Company, 1962.

Studley, Vance. *Making Artist's Tools*. New York: Van Nostrand Reinhold, 1979.

Taubes, Frederic. *The Painter's Dictionary of Materials and Methods*. New York: Watson-Guptill Publications, 1971.

Thomas, Anne Wall. *Colors From the Earth*. New York: Van Nostrand Reinhold, 1980. A guide to natural earth pigments.

Usui, Masao. *Japanese Brushes*. Tokyo: Kodansha International, 1979.

Wehlte, Kurt. *The Materials and Techniques of Painting*. New York: Van Nostrand Reinhold, 1975. One of the best overall reference books on painting, particularly mural painting.

Wong, Frederick. *The Complete Calligrapher*. New York: Watson-Guptill Publications, 1980.

―――. *Oriental Watercolor Techniques*. New York: Watson-Guptill Publications, 1977.

HAZARDS

McCann, Michael. *Artist Beware*. New York: Watson-Guptill Publications, 1979.

―――. *Health Hazards Manual for Artists*. New York: Nick Lyons Books, 1985.

ARTICLES

American Society for Testing and Materials. *Standard Practice for Labeling Art Materials for Chronic Health Hazards/D 4236-83a*. Philadelphia, January 1984.

―――. *Standard Specifications for Artists' Oil and Acrylic Emulsion Paints/D 4302-83*. Philadelphia, January 1984.

―――. *Standard Test Methods for Lightfastness of Pigments Used in Artists' Paints/ D4303-83*. Philadelphia, January 1984.

Bender, Marilyn. "High Finance Makes a Bid for Art." *New York Times*, February 3, 1985.

Brown, Hilton. "The History of Watercolor." *American Artist*, February 1983.

―――. "Quality and Permanence of Artists' Paints." *American Artist*, June 1984.

California Assembly. *Bill No. 3438*. February 16, 1984.

Center for Occupational Hazards. *The Hazards of Solvents–A Supplement to OSHA Report*. New York, March 1978.

Jenkins, Cate. "Organic Pigments." New York: Center for Occupational Hazards, 1978.

Kotz, Mary Lynn. "The Campaign for Art Hazards Legislation." *Artnews*, December 1985.

Luke, Joy Turner. "Health Protections." *American Artist*, June 1984.

McCann, Michael. "Commercial Art." New York: Center for Occupational Hazards, 1978.

―――. "Ten Safety Rules for Artists and Craftspeople." New York: Center for Occupational Hazards, 1978.

McGill, Douglas C. "Art-Supply Makers to Label Hazardous Items." *New York Times*, February 3, 1985.

Rossol, Monona. "Air-Purifying Respirators." New York: Center for Occupational Hazards, 1982.

CATALOGUES AND PRODUCT INFORMATION

Andrews/Nelson/Whitehead Catalog. Long Island City, NY: Andrews/Nelson/Whitehead, 1986. Contains excellent descriptions of a large variety of both Western and Oriental papers.

Archivart Catalogue. Rutherford, NJ: Process Materials Corporations, 1984.

Artist Canvas–Beyond the Brush. Lawrenceville, GA: Fredrix Artist Canvas, 1984.

Daniel Smith Catalog. Seattle: Daniel Smith, 1986.

Fomeboards Product Information Catalog. Fomeboards Company, 1985. The best available descriptions of foam-centered boards.

How to Mix and Use Color. Easton, PA: Binney & Smith, 1983.

Light Impression Archival Supplies Catalogue. Rochester, NY: Light Impressions Corporation, 1984.

Media, Varnishes, Oils and Various Auxiliary Materials. Apeldoorn, Holland: Royal Talens Company.

Winsor & Newton Notes on the Composition and Permanence of Artists' Colours. London: Winsor & Newton, 1977.

PICTURE FRAMING

Clapp, Anne F. *Curatorial Care of Works of Art on Paper.* Oberlin, OH: Intermuseum Conservation Association, 1978.

Dolloff, Francis W., and Perkinson, Roy L. *How to Care for Works of Art on Paper.* Boston: Museum of Fine Arts, 1977.

Frederick, Paul. *The Framer's Answer Book.* St. Louis: Commerce Publishing, 1976.

———. *More Answers for the Framer.* St. Louis: Commerce Publishing, 1981.

The Freshman Framer Revisited, Books 1-3. St. Louis: Commerce Publishing, 1978. A collection of articles that appeared in *Decor* magazine.

Haney, William F., II. *Handbook of Paper Art Conservation.* Sonoma, CA: Academy of Professional Art Conservation & Science, 1982.

Keck, Caroline K. *A Handbook on the Care of Paintings.* Nashville: American Association for State and Local History, 1965. Primarily about storage and restoration.

Ontario Museum Association and Toronto Area Archivists Group. *Museum and Archival Supplies Handbook.* Toronto: OMA-TAAG, 1979. Technical information on archival materials for paper.

Index

Edited by Bonnie Silverstein and Amy Handy
Designed by Bob Fillie
Graphic Production by Ellen Greene